100 THINGS
SUPERMAN
FANS

SHOULD KNOW & DO
BEFORE THEY DIE

JOSEPH McCABE

TRIUMPH
B O O K S

This book is available in quantity at special discounts for your group or organization. For further information, contact:

Triumph Books LLC
814 North Franklin Street
Chicago, Illinois 60610
(312) 337-0747
www.triumphbooks.com

Printed in U.S.A.
ISBN: 978-1-62937-186-3
Design by Patricia Frey
Photos courtesy of Joseph McCabe and Sophia Quach McCabe unless otherwise indicated

For my darling wife, Sophia Quach McCabe.
Sassy as Lois, sweet as Lana, a Supergirl in every way.

Contents

Foreword

When I was a kid, Superman quite literally saved my life.

I have always been a devotee. Captivated by superhero comics when I was no more than four years old, they became the foundation of my existence. They always buoyed me in times of trouble, but even they couldn't elevate me when I was hitting high school. I was from a broken home, I was incessantly bullied in school, I wasn't handling any of it well, and the darkness of my depression had me—and I am not exaggerating, forgive me—suicidally depressed that no one really gave a damn about me and no one ever would.

And in that mood, on a January afternoon in 1979, I went to see *Superman: The Movie*, and it changed everything. I sat through it twice, full of a joy I have rarely experienced since. I knew Superman was a fictional character. I knew Christopher Reeve was an actor. But together, alchemically, magically, they communicated something profound to me: Superman cared. He cared about everyone.

Even me.

When I left that theater, I still wasn't sure what I was supposed to do with the rest of my life, but the one thing I *did* know was that Superman had to be a part of it.

Since that day, I've read and re-read and watched and listened to every Superman story ever spun, from every comic book and graphic novel to every available radio broadcast of the 1940s and every film and cartoon and TV show, from the novels published as early as 1942 to the impossibly rare, read-by-maybe-10-people-in-the-world "Superman in the Jungle" story trading card set from 1966. And along the way, I've been lucky enough to have been allowed to add tales of my own invention to that vast canon. I've written, proudly, dozens of comic books starring the Man of Steel

over the past 30 years. In fact, my very first assignment as a comics writer, in 1985, was a Superman story, and that published credit remains my greatest professional thrill.

Someday, hopefully soon, the author of this book and I will challenge one another to an epic Superman trivia throw-down. Based on what he's written, it seems stunningly likely that he'd prove a worthy opponent. I can count on the fingers of one hand the number of Kryptonophiles who have plumbed the depths of Super-research as deeply as has Mr. McCabe, and the knowledge he's about to lay down upon you is as entertaining as it is uncommon. But until he can prove to me that he, too, knows Lana Lang's mother's maiden name or can tell me the names of both of Mister Mxyzptlk's wives, he will writhe in the ashes of defeat. No one loves Superman more than I do. No one.

But by the time you finish this book, you might be close.

—Mark Waid

Mark Waid has written a wider variety of well-known characters than any other American comic book author, from Superman to the Justice League to Spider-Man to Archie and hundreds of others. His award-winning graphic novel with artist Alex Ross, Kingdom Come, *is one of the best-selling comics of all time.*

Introduction

They say you can't please everybody. Yet somehow, in his 77-year career, Superman has.

While little about his appearance and personality has changed since he was created by writer Jerry Siegel and artist Joe Shuster, the Man of Steel has served as a 20th century Moses, a social reformer, a patriot, a Big Blue Boy Scout, a Christ figure, an Action Ace, a Man of Tomorrow, a romantic hero, a teen heartthrob...even a peanut butter pitchman. No fictional character provides a better lens through which to view sociological and technological change than Superman, having inspired newspaper strips, radio shows, cartoons, novels, film serials, TV shows, blockbuster movies, hit songs, theme park rides, and enough action figures to fill the Fortress of Solitude.

Most importantly, Superman has been a dream. A vision of how life *should* be. In the 1950s, at the height of his popularity in the Silver Age of Comics, the Man of Steel had three principles in his moral code: don't lie, don't kill anybody, and help people when you can. Simplistic? You bet. But there are worse codes to live by.

Superman himself, however, has never been simple, forever teetering on the brink between alien and human, solitude and community, desire and obligation. Internal conflicts have informed his mythos as much as any battle with Brainiac. And this book attempts to examine all facets of that mythos, while offering a series of conversations with the men and women—writers, artists, actors, filmmakers—who've built his world. Dreamers all, they've made it as fully realized as any in popular culture. Long may it spin. Long may he soar. Up, up, and away.

1 Jerry Siegel and Joe Shuster

Superman had two fathers, Jerome Siegel (born October 17, 1914, in Cleveland) and Joseph Shuster (born July 10, 1914, in Toronto). The two met in 1931 at Cleveland's Glenville High School, after the latter's struggling family had moved to the northern Ohio city. Siegel, a passionate devotee of pulp magazines and an amateur science fiction writer, and Shuster, a nearsighted bodybuilding enthusiast, shared a love of movies and newspaper comic strips. That love inspired them to create their own hero for the funny pages. From the start, however, fate worked against them.

In 1932, Siegel's father suffered a heart attack and died as a result of a robbery that occurred at the family store. The teenager published a short story called "The Reign of the Superman," about a megalomaniacal telepathic villain, in the third issue of his fan magazine *Science Fiction: The Advance Guard of Future Civilization* (published in 1933 under the pseudonym Herbert S. Fine, with illustrations by Shuster). Shortly thereafter, he spent a sleepless night brainstorming ideas and ran to his friend's home the following morning, where the two created a comic story called "The Superman" and sent it to Consolidated Book Publishing. But Consolidated had already stopped publishing comics. Joe, heartbroken, destroyed all but the cover of their story, while Jerry re-envisioned it as a newspaper strip. Despite their persistent efforts to sell it, no one was interested.

Major Malcolm Wheeler-Nicholson finally gave the boys their big break when he purchased several of their comic book stories for his National Allied Publications in 1935. Siegel and Shuster's career in comics had begun. But in 1936, Wheeler-Nicholson

partnered with his distributors Harry Donenfeld (a former pulp magazine producer) and Donenfeld's business manager Jack Liebowitz. The two proceeded to wrestle control of National from the Major. Max Gaines of the McClure Syndicate—via National's associate editor Vin Sullivan—brought Superman to Donenfeld's attention. Encouraged by Sullivan, Donenfeld agreed to publish the story, and Shuster reformatted the strip's art into 13 comic book pages for publication in June 1938's *Action Comics* #1. Siegel and Shuster were paid $10 for each page and signed a contract granting National all rights to the character. The superhero comic book was born.

Superman proved to be a massive hit, and a flood of imitators followed. The character won his own comic book with June 1939's *Superman* #1 (also by Siegel and Shuster), as well as, at long last, a newspaper strip on January 16, 1939. Shuster opened an art studio in Cleveland to keep up with the demand for more Superman, while Siegel married his 18-year-old neighbor—and fellow Glenville High School grad—Bella. The two had a son named Michael in 1944. Shuster, meanwhile, bought his family, with whom he still lived, a new home.

Jerry created other comic characters during this time, including the Spectre (introduced in February 1940's *More Fun Comics* #52). But although the two creators were making a decent living, they'd lost a great deal of merchandise money, while National was netting millions from the character they'd invented. In 1943, Siegel was drafted, and the company began taking control of Superman's production from Shuster, who was always the more acquiescent of the two men. By the time Siegel returned, the company had, without notification, introduced Superboy—an idea he and Shuster had pitched in 1938. In 1947, a lawsuit was filed for $5 million, as well as the rights to Superman and payment for Superboy. But in 1948 the New York Supreme Court upheld the original Superman agreement, though it agreed that compensation was owed for Superboy.

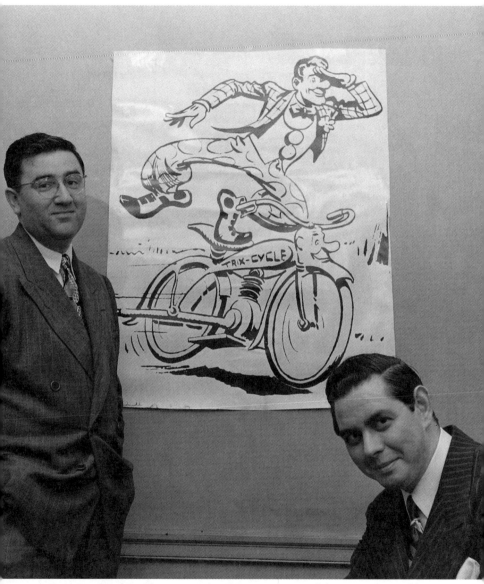

Jerry Siegel and Joe Shuster introduced Superman, one of the most recognizable fictional characters of all time, in 1938's Action Comics #1. *Here they are with their later comic book creation, the short lived Funnyman.* (Getty Images)

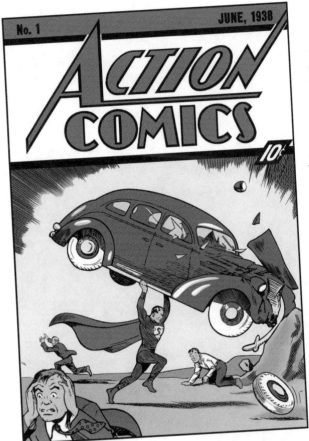

Superman first appeared in Action Comics #1, *the most famous and valuable comic book in history.* (Cover art by Joe Shuster)

Siegel and Shuster agreed to a settlement of $94,000, and National kept the rights to the Boy of Steel. Immediately afterward, the two were fired and lost their creator credits in National's comic books.

One bright spot occurred after Siegel's wife filed for divorce. Though she held on to most of his savings and kept custody of their son, Siegel was then free to marry Joanne Carter; as Jolan Kovacs, she had modeled for Shuster when he was designing Lois Lane. The couple remained married for the rest of Jerry's life. Jerry went on to edit, albeit briefly, Ziff-Davis' line of comics. Shuster too found

some additional comics work, as well as a job drawing S&M illustrations for a series of under-the-counter magazines published in the 1950s called "Nights of Horror" (reprinted in author Craig Yoe's 2009 book *Secret Identity: The Fetish Art of Superman's Co-creator Joe Shuster*, published by Harry N. Abrams). But Shuster's vision soon deteriorated to the point of blindness.

When Ziff-Davis folded, Joanne Siegel told National of the bad press the company would receive should Superman's creator die penniless. The company took Siegel back, and he penned a series of memorable Silver Age Superman stories, though for considerably less money than he'd been paid when he left, and with no printed credit. He again tried to win back ownership of Superman, but National fired him once again. In 1968, Jerry and Joanne Siegel moved to Los Angeles, and he took a job as a file clerk for an annual salary of $7,000. In 1975, with a Superman feature film in the planning stages, National implied it would offer Siegel and Shuster some form of financial compensation. But when the company dragged its feet, Siegel issued a press release condemning their actions, which put him and Shuster in the public eye once more. Warner Brothers, which now owned DC (the official name for National as of 1977), agreed to a $20,000-a-year pension and medical insurance, as well as the restoration of their byline as Superman creators. "About as much as a well-paid secretary," says comic book artist Neal Adams, who'd championed their cause.

Shuster eventually joined the Siegels in Los Angeles. He died there on July 30, 1992, at the age of 78. Jerry Siegel died on January 28, 1996, at 81. Though the compensation they received for their creation was far below even the stingiest miser's definition of fair, the two lived long enough to see Superman become the most popular fictional character in Western culture; the character who gave his very name to the word superhero.

2 The Genesis of Superman

Superman's name was first used by Friedrich Nietzsche in his 1883 book, *Thus Spoke Zarathustra*, in which it was referred to as *Übermensch*, an ideal the German philosopher believed mankind should ultimately strive for. It's doubtful that writer Jerry Siegel and artist Joe Shuster—both the sons of Jewish immigrants—embraced a concept frequently referenced by Adolf Hitler and the Nazis in creating Superman. But the Man of Steel wasn't born in a vacuum.

Siegel and Shuster's Jewish background came into play with Superman's origin, that of an immigrant orphan destined to save his adoptive people, reminiscent of the Bible story of Moses (though other mythological figures like Samson and Hercules, both known for their extraordinary strength, also came into play). Additionally, the two men were tremendous fans of pulp magazine heroes like Doc Savage, the "Man of Bronze." Created by Street & Smith publisher Henry W. Ralston, editor John L. Nanovic, and writer Lester Dent, the character's first appearance was in March 1933's *Doc Savage Magazine* #1. In this issue's story, Doc was said to have an arctic retreat called the Fortress of Solitude. Another pulp hero, Edgar Rice Burroughs' John Carter, gained super strength and the ability to leap tremendous distances when he was transported from Earth to his adoptive home, the planet Mars.

Superman's creators were also huge movie fans, particularly of Douglas Fairbanks, the swashbuckling silent film star, who frequently stood with hands placed firmly on hips, laughing in the face of danger. While Fairbanks' influenced the Man of Steel's design, Superman's secret identity, Clark Kent, was based on bespectacled silent film comedian Harold Lloyd. Clark's first name was derived from film legend Clark Gable, and his last from B-movie idol Kent

Taylor. His city, Metropolis, took its name from the titular locale in director Fritz Lang's 1927 science fiction classic *Metropolis*.

Siegel and Shuster were also devotees of newspaper comic strips. Shuster's drawing style in the 1930s owed a great deal to strip artist Roy Crane, best known for his *Wash Tubbs* and *Captain Easy, Soldier of Fortune*. Superman's cape was most likely inspired by that of master draftsman Alex Raymond's '30s hero *par excellence* Flash Gordon. Shuster has said that the cape helped convey a feeling of motion when the Man of Steel burst into action. And Siegel, like most of America, admired the super-strong sailing man of the strips, E.C. Segar's Popeye.

But the biggest influence on Superman may have been reality itself. Siegel and Shuster were children of the Great Depression, and Siegel's own father died of a heart attack in the wake of a robbery at his store. It's no wonder then that Superman's early years were spent in the service of social reform, fighting for underdogs against war profiteers, abusive husbands, and corrupt politicians. On radio, he would even take on the Ku Klux Klan. Even after decades of fighting supervillains, this reformist Superman would return, most notably in the 1998 graphic novel *Superman: Peace on Earth* and the 2003 limited series *Superman: Birthright*.

Superman's Suit

As befitting a character of unwavering virtue, the Man of Steel's suit has, compared with those of most superheroes, changed very little since it was designed by Superman co-creator Joe Shuster.

Shuster modeled the outfit after the boots, briefs, and tights of circus strongmen. A cape was added to give it a sense of motion,

and his shirt sported an emblem, originally an "S" contained within an oversized police badge, to give Superman an immediately recognizable sense of authority. As seen on the cover of June 1938's *Action Comics* #1, the super suit featured a blue shirt and tights, red briefs, belt, and boots, and a yellow emblem with a red "S." Inside the issue, however, Superman wore blue boots (reminiscent of Roman gladiator sandals), a yellow belt, and a yellow "S" inside his emblem. By June 1939's *Superman* #1, he had red boots, and his emblem consisted of a red "S" inside a triangular yellow shield. In the years that followed, the shield widened and curved, while its background color changed to black (a look used when the Man of Steel made his first screen appearance in the 1941 Fleischer Studios animated short *Superman*), and then back to yellow.

By the mid-1940s the suit's colors stabilized (though its shade of blue, and the size of its briefs, continued to vary), and the shape of its shield settled into that which is best known today—a large diamond with a slim red border. By the '50s, a yellow "S" inside a yellow shield was added to the center of Superman's outer cape.

Superman's "S" shield usually resided atop his chest but in the 1986 limited series *Man of Steel*, writer-penciller John Byrne enlarged it so it occupied half of his torso, a detail continued by most comic artists since. Following the 1992 "Death of Superman" storyline, the Last Son of Krypton returned in a capeless black bodysuit with silver "S" shield, wrist bands, and boots, as well as a Samson-like mane of hair. Fortunately, neither this look, nor the electric-blue-and-white design of 1997's "Superman Blue" energy being, lasted long. Nor did the "S" shield belt buckle of 2006's *Superman Returns*, also employed for a time in the comics.

The most radical change made to Superman's costume in recent years has been the super suit designed by DC Comics co-publisher Jim Lee for the company's "New 52" reboot of the character in

2011. Lee removed Superman's briefs altogether, gave him a red belt, and added an unnecessary matrix of piping to his costume, as well as—the most controversial of choices—a high military collar.

4 Superman's Powers

Superman has demonstrated a stunningly diverse array of powers since he first appeared, from super ventriloquism (established in January-February 1950's *Superman* #62) to *Superman II*'s amnesia-inducing super kiss (introduced in November 1963's *Action Comics* #306). Many of these powers are simply extensions of normal human abilities, such as super intelligence, super hearing, and telescopic vision. Their levels have increased and decreased over time (the most significant reduction came with the 1986 limited series reboot *Man of Steel*). All of Superman's powers can be inhibited by the presence of a red sun, magic, or kryptonite. Nevertheless, here are seven of the most essential.

Flight
In June 1938's *Action Comics* #1 (written by Jerry Siegel and illustrated by Joe Shuster), Superman could only "leap one eighth of a mile." But the filmmakers at Fleischer Studios found leaping awkward to animate, so his power of flight was established in their *Superman* animated shorts of the 1940s.

Invulnerability
Again in *Action Comics* #1, it was stated that "nothing less than a bursting shell" could penetrate Superman's skin. In January-February 1946's *Superman* #38, he survived an atomic bomb explosion.

Super Strength

Like his invulnerability, Superman's strength increased exponentially. Initially able to lift "tremendous weights" (*Action* #1 shows him hoisting a steel girder over his head with one hand), he could, by 1951—as Les Daniels points out in *DC Comics: Sixty Years of the World's Favorite Comic Book Heroes*—"toss a skyscraper into space, and a few years later he was pushing planets."

Super Speed

Superman's ability to "run faster than an express train" in *Action Comics* #1 gave way to running "faster than a speeding bullet" in *The Adventures of Superman* radio show of the 1940s. Eventually he surpassed Mach 1 and the speed of light.

X-ray Vision

Introduced in November 1939's *Action Comics* #18 ("Superman's Super-Campaign," by writer Jerry Siegel and artist Paul Cassidy), it was first called "Superman's X-ray eyesight." It cannot be used to see through lead.

Super Breath

Superman's super breath made its debut in January 1940's *Action Comics* #20 ("Superman and the Screen Siren," by writer Jerry Siegel and penciller Joe Shuster). It led to his famous freeze breath.

Heat Vision

The solar energy today's Man of Steel emits from his eyes began as a byproduct of his X-ray vision in July 1949's *Superman* #59. It was established as a distinct superpower in April 1961's *Action Comics* #275 ("The Menace of Red-Green Kryptonite!" by writer Jerry Coleman and penciller Wayne Boring). In April 2015's *Superman* (Vol. 3) #38 ("The Men of Tomorrow, Chapter Seven: Friends and Enemies," by writer Geoff Johns and penciller John Romita Jr.), an

extension of heat vision, called a "super flare," was introduced. The result of solar energy stored in every cell of Superman's body, he's powerless for 24 hours after using it.

5 Clark Kent

Superman's secret identity is more than a mask behind which he sometimes hides when he wants a break. The mild-mannered Clark Kent often serves as the human heart of the Man of Steel, the personification of his adoptive parents' values, and a constant tether to the world he's chosen to call home.

Kent—and Superman—first appeared in June 1938's *Action Comics* #1 ("Superman, Champion of the Oppressed," by Jerry Siegel and artist Joe Shuster, who, like the character he designed, wore glasses). The two based his appearance on bespectacled silent film comedy star Harold Lloyd. Initially portrayed as a milquetoast, Clark's fellow reporter Lois Lane agrees to go on a date with him out of pity. But that night, as they're dancing at a club, a thug named Butch tries to cut in. Lois slaps him across the face; Clark whispers to himself, "Good for you, Lois!" while saying aloud, "Lois—don't!" Butch turns to Clark and demands the "weak-livered pole-cat" fight. Lois storms out, telling Clark, "You asked me earlier in the evening why I avoid you. I'll tell you why now: because you're a spineless, unbearable coward!" Soon after, Butch abducts Lois, and Superman flies to her rescue, prompting her to fall madly in love with him. Thus begins the most famous love triangle in comic books, a love triangle between two people.

Throughout most of the 1940s, Clark was portrayed as a competent reporter but also a nebbish who longs for Lois, who in turn

only has eyes for Superman. The persona was strongly felt in *The Adventures of Superman* radio show and the *Superman* cartoons of Fleischer Studios, both of which featured actor Bud Collyer. The high point of Collyer's performance was his ability to drop the pitch of his voice mid-sentence when transforming from Clark to Superman, announcing, "This looks like a job—*for Superman!*"

As the screen's first live-action version of the character in the *Superman* film serials, Kirk Alyn also portrayed a timid Clark Kent. But in the 1950s *Adventures of Superman* TV show, George Reeves played a much more confident and assertive version of the character, one who could be almost as dynamic as the Man of Steel. Reeves' interpretation slowly filtered into the comics, and Clark's personality grew stronger throughout the '50s, '60s, and '70s. October 1962's *Adventure Comics* #301 featured a "Private Life of Clark Kent" story ("Lex Luthor and Clark Kent: Cell-Mates!" written by Edmond Hamilton and pencilled by Curt Swan) that served as the springboard for a series of such tales that ran as a backup feature in the pages of *Superman* (starting with #186 in May 1966) before moving to *Superman Family* (in June 1979's #195). In these stories, Clark would demonstrate his ability to solve problems without changing into Superman.

In 1978's *Superman: The Movie*, Christopher Reeve won praise for returning Clark Kent to his socially awkward roots. In his 1999 autobiography *Still Me*, Reeve admitted to basing his Clark on Cary Grant's submissive paleontologist in director Howard Hawks' 1938 screwball comedy classic *Bringing Up Baby*. The battle between Reeve's innocent Clark and a synthetic kryptonite-corrupted Superman is the highlight of *Superman III*.

When Superman was rebooted in October 1986's *Man of Steel* #1 ("From Out the Green Dawn," by writer-penciller John Byrne), George Reeve's interpretation was used as inspiration for a Clark who was a football star in high school and a take-charge newsman after moving to Metropolis. Prior to *Man of Steel*,

Superman's identity was known only by a few trusted allies like Batman and Supergirl. But in the rebooted mythos, it was known by his high school friend Lana Lang, and—years later, after they're engaged—Lois Lane. In one of the best post-reboot stories, found in February 1987's *Superman* #2 ("His Secret Revealed," by writer-penciller Byrne), Lex Luthor's computer learns of the secret identity, but Luthor's ego prevents him from believing someone with Superman's godlike abilities would disguise himself as Clark.

Man of Steel's Clark Kent has been used in most versions of Superman since, both in print and on screen, including *Lois & Clark: The New Adventures of Superman*. As that show's Superman, played by Dean Cain, explains to Lois Lane in the episode "Tempus Fugitive," "Superman is what I can do. Clark is who I am." *Superman: The Animated Series*, *Smallville*, and 2013's *Man of Steel* followed suit in their approach to Clark. In the latter film, Lois knows Clark's secret from the start, thus eliminating the love triangle that had been at the heart of the mythos since *Action Comics* #1.

Nebbish or not, Clark Kent has always been Superman's greatest ally, so it's fitting that Clark was the first mainstream superhero's secret identity to receive his own action figure, a mail-away exclusive in Kenner's 1980s Super Powers Collection.

6 Lois Lane

The most famous reporter in fiction, Lois Lane is unquestionably the most important person in the Man of Steel's life, as well as the single greatest continuing inspiration for carrying out his never-ending battle.

Like Superman, Lois was created by writer Jerry Siegel and Joe Shuster, who based her design on Jolan Kovacs, a model the two hired for $1.50 an hour. (Jerry later married her, and she became Joanne Siegel.) Lois' personality was inspired by that of a crime-busting reporter named Torchy Blane, who featured in a series of films in the 1930s. One of the actresses who portrayed Torchy, Lola Lane, inspired Lois' last name, while her first is believed to come from Lois Amster, a girl whom Siegel had a crush on while in high school. Lois' first appearance in June 1938's *Action Comics* #1 immediately establishes a love triangle that would last for decades: Clark pursues Lois, who only has eyes for Superman, who in turn shows little interest in the *Daily Planet*'s (originally the *Daily Star*'s) leading journalist.

Lois' personality developed throughout the '40s in a variety of media. Joan Alexander provided her voice in *The Adventures of Superman* radio show and the animated shorts of the Fleischer Studios, displaying an obvious chemistry with Bud Collyer, the voice of Clark and Superman. Noel Neill was the first live-action Lois, playing her in two *Superman* film serials opposite Kirk Alyn. In 1951's B-movie *Superman and the Mole Men*, and the *Adventures of Superman* TV show it spawned, Phyllis Coates portrayed Lois as a woman with a will as strong as that of George Reeves' Superman. A fitting heroine for the film noir–inspired tales of the show's first season, Coates was reminiscent of Rosalind Russell's tough-talking newswoman Hildy Johnson in the 1940 Howard Hawks film classic *His Girl Friday*.

Unable to return for a second season due to prior commitments, Coates was replaced by Neill, whose sweeter, softer presence was more in keeping with the domesticity expected of women in the Eisenhower '50s. This gentler Lois was mirrored in the comics of the day, in which her primary interests were proving Clark was Superman and marrying him before her rival Lana Lang could do so. Such comics included Lois' own title (the first awarded to a male

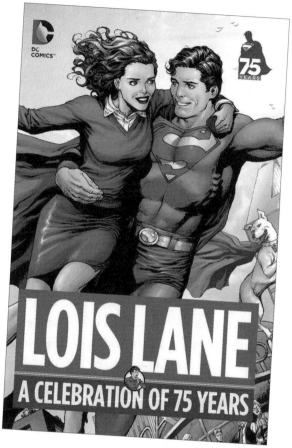

Lois Lane has been a constant in the life of Superman since she first appeared alongside him in 1938's Action Comics #1.

superhero comic book's leading lady)—*Superman's Girl Friend, Lois Lane.* The first issue, dated April 1958, featured three stories, all of which were pencilled and inked by Kurt Schaffenberger, the artist most associated with the book, and the one who rendered what many consider the definitive Silver Age Lois. The title soon became one of DC Comics' most popular.

Superman's Girl Friend, Lois Lane ended with its October 1974 issue (#137), but Lois' solo adventures continued in *The Superman Family* (its first issue dated April-May 1974). The character grew

stronger throughout the feminist movement of the 1960s and '70s (or at least as strong as a lady written entirely by men could be written), and was once more an investigative journalist who didn't require a Man of Steel to validate her. Margot Kidder's performance in 1978's *Superman: The Movie* perfectly captured the ambitious career woman who balked at the idea of having kids but welcomed romance.

The Lois Lane of the comic books continued to grow during the 1980s, especially after the reboot of 1986's *Man of Steel* limited series, whose Lois appeared inspired in part by Kidder's character. By the 1990s, Lois had learned Clark's secret, and became an equal partner in her relationship with Superman. That relationship was sometimes challenged by her father, Sam Lane, an Army general distrustful of the Last Son of Krypton.

In the 1993 TV series *Lois & Clark: The New Adventures of Superman*, Teri Hatcher's take complemented Dean Cain's Superman/Clark, and worked well within the framework of a romantic comedy, culminating in the couple's marriage during the show's fourth and final season. (Their comic counterparts tied the knot in 1996's *Superman: The Wedding Album*.) But with the charm of Hatcher's Lois came a display of self-doubt and insecurity that sometimes thwarted her role as award-winning journalist. More successful in this regard was the Lois Lane of 1996's *Superman: The Animated Series*, voiced by Dana Delany, who again recalled *His Girl Friday*'s Rosalind Russell in her quick-witted efficiency. There's a case to be made that Delany's Lois is the definitive screen version of the character.

Erica Durance was a fearless if occasionally clumsy Lois when she debuted on TV's *Smallville* during its fourth season in 2004, though her appearances were limited at first by Warner Brothers (who had plans for the character, in the form of a single mother played by Kate Bosworth, in 2006's *Superman Returns*). Durance would become a regular in the show's fifth season, and wound up

marrying Tom Welling's Clark Kent in the series' 2011 finale, when the two became permanent colleagues at the *Daily Planet*.

2013's *Man of Steel* presents a Lois, played by Amy Adams, who knows Clark's secret from the start. Yet rather than make for a stronger character, this removes the mystique at the center of the Superman mythos. A more intriguing 21^{st} century revision of the character exists in, of all mediums, young adult literature. In author Gwenda Bond's 2015 novel *Lois Lane: Fallout* (the first in a series of *Lois Lane* novels published by Switch Press), Lois is depicted as a high school reporter solving mysteries á la *Veronica Mars*, with the help of her online buddy Smallvilleguy. It's a novel twist on a well-worn formula; and it offers further proof that no matter the scene, setting, or era, Lois Lane remains as timeless as the Man of Steel himself.

7 Lex Luthor

If a hero can be judged by the quality of his enemies, there exists no greater means by which to measure Superman than archvillain Lex Luthor. Since his first appearance, Lex has been the Man of Steel's greatest foe—whether scientist, businessman, or even president of the United States.

Lex wasn't the first bald supervillain to battle the Last Son of Krypton. That title goes to the Ultra-Humanite (his name a variation on Superman's own), who challenged him in his first few years. But Luthor made for a more menacing pulp-inspired genius when he began his infamous career in April 1940's *Action Comics* #23, written by Jerry Siegel and illustrated by Joe Shuster. Initially a redheaded madman set on conquering Earth from his flying

dirigible (reminiscent of Jules Verne's *Master of the World*), Luthor proceeded, through a series of inventions and political schemes, to match his brains against the Man of Steel's brawn. The polar opposite of Superman, he chose to use his supreme powers to enslave the planet rather than save it.

Lex first appeared completely bald in May-June 1941's *Superman* #10. His baldness was later linked to his origin in April 1960's *Adventures Comics* #271 (written by Siegel). Lex, it turned out, was once a friend of Superboy's, and used his scientific prowess to find a cure for kryptonite poisoning. But when a laboratory accident caused him to lose his hair, he blamed the Boy of Steel's interference, and became his mortal enemy. While this origin may sound silly in hindsight, it brought a depth to Superman and Lex's relationship that informed other versions of the tale, like those in writer Elliot S. Maggin's novel *Last Son of Krypton*, in TV's *Superboy* and *Smallville*, and the 2003 limited series *Superman: Birthright*, written by Mark Waid and pencilled by Leinil Francis Yu.

"This idea that Luthor and Superman could have been best friends," says Waid, "but Superman screwed up, and it cost the world one of the great minds of the 21st century, is something that I love. I love that concept. It's tragic. I think those are the moments Superman's life needs."

A self-absorbed egomaniac by nature, the only person Lex truly cared for in the comics of the 1960s and '70s was his younger sister, Lena Thorul, from whom he concealed his evil nature. Her last name, an anagram of Luthor, came from her parents, who'd disowned Lex. Though Lex's intellect was never in doubt, he eventually built himself a battle suit—designed by artist George Perez and introduced in June 1983's *Action Comics* #544 ("Luthor Unleashed!" by writer Cary Bates and penciller Curt Swan)—that made him a physical threat to Superman, if not quite his equal.

The 1986 limited series *Man of Steel* (by writer-penciller John Byrne) rebooted Superman's continuity, and reintroduced Lex as a billionaire corporate tycoon in the decade of "greed is good"; he controlled most of Metropolis through his company LexCorp. Eventually said to be a victim of abuse while growing up with his former friend Perry White in Metropolis' Suicide Slum district, this new Lex maintained an unrequited romantic interest in Lois Lane. *Man of Steel's* Lex carried over to TV's *Lois & Clark: The New Adventures of Superman* and 1997's *Superman: The Animated Series*, and informed most subsequent screen interpretations of the character. It was this Lex who was also elected president of the United States, until he was outed by the Man of Steel and the Dark Knight in a storyline that culminated in public humiliation and bankruptcy, in the "Public Enemies" arc of the comic book series *Superman/Batman*.

The first screen incarnation of Lex was played by a burly Lyle Talbot in the 1950 film serial *Atom Man vs. Superman*. Though he was absent in the *Adventures of Superman* TV series of the 1950s, Lex made a comeback in the form of Gene Hackman, who headlined 1978's *Superman: The Movie*, in which he played Lex as a comical though cunning car salesman with a penchant for wigs and toupees. *Superman* producers Alexander and Ilya Salkind subsequently cast Scott James Wells (in Season 1) and Sherman Howard (in Seasons 2 through 4) as Luthor in their *Superboy* TV series.

John Shea made for the most appealing Lex yet seen in 1993's *Lois & Clark*. Oozing charm enough to hide his sociopathy, Shea's Lex was a believable romantic rival to Dean Cain's Man of Steel for the affections of Teri Hatcher's Lois Lane. Shea's Lex was a regular in the show's first season, which almost culminated with his marriage to Lois and instead ended with his suicide. (That didn't stop him from returning several times for the remainder of the show's run.)

"Lex thinks of Superman as a trust fund baby," says Shea, "as someone who was given these powers because of an accident of birth. Whereas Luthor came up the hard way and earned what power he has. So, in a funny way, Luthor feels superior to Superman."

Michael Rosenbaum was an equally charismatic young Lex in 2001's *Smallville*, his life complicated by domineering father Lionel Luthor (played by John Glover) and an increasingly uneasy friendship with the teenage Clark Kent. When Rosenbaum left the show, Lex's sister, Lutessa Lena Luthor (aka Tess Mercer, played by Cassidy Freeman), became a key player in its unfolding drama.

Superman Returns in 2006 saw Kevin Spacey re-create Gene Hackman's Lex with verve for an unofficial sequel to *Superman II*. Though Lex was absent from the next Superman film, 2013's *Man of Steel*, he returns with a vengeance in 2016's *Batman v Superman: Dawn of Justice*, in which he's played by Jesse Eisenberg.

In animation, Ray Owens provided the voice of Lex in the 1960s animated series *The New Adventures of Superman*, and Mark Rolston did so in the 21st century fan-favorite cartoon series *Young Justice*. But the best animated Lex was voiced by Clancy Brown in the Bruce Timm–produced *Superman* and *Justice League* series of the DC Animated Universe. Smooth, cruel, and cunning as a cobra, Brown creates a villain for the ages with his voice alone.

Daily Planet Exclusive

Michael Rosenbaum

Even among heavyweights like Gene Hackman and Kevin Spacey, Michael Rosenbaum remains one of the most popular actors ever to take on the role of Lex Luthor. Through the first seven seasons of *Smallville*, as well as the show's 10th and final season, Rosenbaum redefined Superman's former friend and eternal archnemesis through his thoughtful and understated performance. He further explored the DC Universe as the voice of the Flash on *Justice League*. As of this writing, he stars in the TV Land sitcom *Impastor*.

Looking back on the experience, how much fun was it to play the quintessential bad boy in American pop culture?
You know what's funny? Thank God I didn't think of it like that as I was filming. I went into the show not really having that much knowledge about comic books or the Superman mythology. I honestly think it helped. Because I didn't go into it with the idea that "This is how people want me to play it" or "This is how it's been played and this is how I should play it." I really just said to myself, "Read the lines, make it real, be honest and vulnerable and sincere. And when you're angry, be *really* angry." There's a lot that that character taught me. I think everybody has different relationships with their parents. I had a father who was tough. I'm not gonna say he didn't love me. But he was of the old school where they didn't tell you they loved you and it was just hard love. When you hear, "Hey, you're good. Hey, you're great. Hey, I'm really proud of you. Congratulations"—I never heard that. So when I had to say these lines and deal with this overbearing father, Lionel Luthor, who was geniusly played by John Glover, I tapped into something that I could relate to. That's what ultimately made Lex Luthor, or my rendition of Lex Luthor, work. Because it was real. I was trying to really tap into something there.

Was that an intense experience over so many seasons?
It was exhausting. It was amazing and I was blessed. But as much of a gift as it was, it was an incredible amount of work, psychologically and physically. You'd wake up, you'd shave your head for two hours, and they put tons of makeup on you. You're wearing suits all day and

you're playing this dark character. Or you're in straitjackets and you're screaming. You're sword-fighting your father and you're drowning in a lake...I mean, it was a very taxing show—mentally, emotionally, and physically. For everybody on the show. We knew how blessed we were, we knew how lucky we were. But we also said, "Hey, this is a job. We're getting paid, but we're working for it. We're earning it."

I'm super, super proud of what I did on that show. And I'm super, super proud of everybody who worked on it and made it the show it was. And I'm super proud of the show! A lot of times when an actor does a show, and people recognize him from that, they're like, "Well, I want to be recognized for other things." With me, maybe that was there, but for a small amount of time. Ultimately I got over myself and then completely went the other way. I thought, *How lucky am I?* and I embraced the character. Now people come up to me and say, "You're Lex Luthor," and I say, "Yes, I am!" [Laughs.] I'm 42. What was *Smallville*—a sixth of my life? That's a long time. Playing an iconic character like that is a once-in-a-lifetime thing. I mean, how many people get to play Lex Luthor in live action opposite Superman? Me, Gene Hackman, Kevin Spacey, [John Shea], and Jesse Eisenberg...Four or five guys. It's very cool.

The most memorable relationship in Smallville is arguably that between Lex and Clark. And much of the show's bittersweet nature comes from seeing that relationship deteriorate over time.
The dynamic really was that Lex never lied to Clark. Clark lied to Lex, and kept these secrets from him. Ultimately it turned Lex on Clark. So really, if you look at it, in a lot of ways Lex is the hero. Their relationship is built on lies. Obviously, for the right reasons—Clark couldn't trust him. But if he did trust him early on, things would have been different. Because they'd have worked together to help humanity. Because early in the relationship, Lex was a pretty good guy. In fact, for the first three seasons, people were saying, "I don't want to see him go bad!" I talked to Al Gough and Miles Millar about it, because they created it. Yeah, it was a tragic story. But that's what makes it so interesting. It's the story behind the story. *This* is why they became mortal enemies, and this is why Lex became the ultimate villain. But when people see that backstory, they say, "I can't hate Lex Luthor anymore." When people watch *Smallville* they really don't hate Lex, because they understand why he became that way. That's pretty cool.

8 Jor-El and Lara

Though they perished immediately after sending their infant son to Earth, Superman's Kryptonian parents—Jor-El, who foresaw his planet's doom, and his wife, Lara—have played a significant role throughout the Man of Steel's history.

Superman creators Jerry Siegel and Joe Shuster first used Jor-El's name—as "Jor-L"—for an interplanetary detective character in the January 1937 issue of *New Adventure Comics* (in the story "Federal Men of Tomorrow"). Superman's father wasn't seen when he debuted in June 1938's *Action Comics* #1 (and the character was described only as "a scientist"). But the two creators introduced "Jor-L" in the first installment of their *Superman* newspaper strip on January 16, 1939. Here, like all residents of Krypton (described as "a race of Supermen"), the character is shown having powers similar to those of Superman. His wife is also introduced in the strip as "Lora."

In the first novel featuring the Man of Steel, 1942's *The Adventures of Superman* (by George Lowther), Jor-El's name was given as "Jor-el" and Lora became Lara. In January 1945's *More Fun Comics* #101, their first comic book appearance and the first appearance of Superboy (in "The Origin of Superboy," credited to Siegel and Shuster), Jor-el became Jor-El and Lara was given a last name, Lor-Van (eventually said to be the name of her mother).

Jor-El and Lara were again seen, along with their home city of Kryptonopolis, when Superman's origin story was expanded for August 1948's *Superman* #53 ("The Origin of Superman," by writer Bill Finger and penciller Wayne Boring), and when Superman learned of his own origins in November 1949's *Superman* #61 ("Superman Returns to Krypton!" by Finger and artist Al Plastino).

The couple made more frequent appearances in the Man of Steel's Silver Age heyday, when it was revealed that Jor-El discovered the Phantom Zone (earning him a seat on Krypton's ruling Science Council), and invented a means of imprisoning criminals in it. Unbeknownst to Jor-El and Lara, they wound up befriending their son when he again visited his home planet in November 1960's *Superman* #141 ("Superman's Return to Krypton!" by writer Jerry Siegel and penciller Wayne Boring).

In the early 1970s, Jor-El and Lara began appearing in "The Fabulous World of Krypton: Untold Stories of Superman's Home Planet" (a backup feature in the monthly *Superman* comic). In the feature's first installment in January 1971's *Superman* #233 ("Jor-El's Golden Folly," written by E. Nelson Bridwell with art by Murphy Anderson), readers were told how the couple first met. Lara was an aspiring astronaut who stowed away on board a spaceship in order to test its anti-gravity drive, invented by Jor-El. When her ship was lost on one of Krypton's moons, the young scientist raced to her rescue, and the two fell in love.

Jor-El and Lara again took on a more prominent role in the very first comic book limited series, 1979's *World of Krypton* (written by Paul Kupperberg and pencilled by Howard Chaykin), which offered a definitive version of their homeworld, and followed the release of 1978's *Superman: The Movie.* The film—in which the two were played by a commanding Marlon Brando and a sympathetic Susannah York—presented a colder version of Krypton than had been seen in comics, one wrought by production designer John Barry. It paved the way for the even chillier version offered when Superman's continuity was rebooted in October 1986's *Man of Steel* #1 ("From Out the Green Dawn"). Writer-penciller John Byrne made this Krypton a world in which logic ruled and emotions were suppressed (similar to *Star Trek*'s Vulcan) and in which children were conceived in vitro. After sending their son to Earth in a "birthing matrix," Jor-El confesses to Lara, "I have felt an

unknown emotion stirring in my heart…And even though we die, I am content, so long as we die together…For I have always loved you…"

1996's *Superman: The Animated Series* took its cue from the pre-Byrne version of Krypton, presenting a more inviting planet, and Jor-El and Lara (voiced by Christopher McDonald and Finola Hughes) as a much more loving couple. The 2003 limited series reboot of the Man of Steel, *Superman: Birthright* (by writer Mark Waid and artist Leinil Francis Yu), also drew inspiration from the pre-Byrne version. It's notable for making Lara a much more assertive figure who plays a greater role in her son's survival. Unfortunately, *Birthright*'s vision was ignored when Superman's continuity was rebooted yet again in 2009's *Superman: Secret Origin*.

Jor-El and Lara were first brought to life in the 1940s *The Adventures of Superman* radio show by actors Ned Weaver and Agnes Moorehead. They two were first played on screen by Nelson Leigh and Luana Walters in the 1948 *Superman* film serial. In the 1952 *Adventures of Superman* TV show, they were played by Robert Rockwell and Aline Towne; in *Lois & Clark: The New Adventures of Superman* by David Warner and Eliza Roberts. In *Smallville*, *Superman II*'s Terence Stamp and Kendall Cross provided Jor-El and Lara's voices for one episode ("Memoria"), and Julian Sands and Helen Slater later played them on screen. In the 2013 film reboot *Man of Steel*, the couple was played by Russell Crowe and Ayelet Zurer.

9 Jonathan and Martha Kent

Though Superman's powers are due to his Kryptonian body's exposure to Earth's yellow sun, his decision to use those powers for the benefit of mankind is the result of his upbringing in Smallville by Jonathan and Martha Kent.

Unlike most of the people in the Man of Steel's life, Ma and Pa Kent's names weren't created from whole cloth. In fact, in their first appearance in June 1939's *Superman* #1 (by Superman's creators, writer Jerry Siegel and artist Joe Shuster), Pa Kent isn't even named, while Martha is named Mary. In the first Superman novel, 1942's *The Adventures of Superman* (by author George Lowther), their names are given as Eben and Sarah Kent (formerly Sarah Clark), which were used in the George Reeves–starring *Adventures of Superman* TV show in the 1950s. The novel also saw Jonathan Kent on his deathbed imploring Clark to use his powers for good. When Superman's origin was retold and expanded for his 10th anniversary, in July-August 1948's *Superman* #53 ("The Origin of Superman," written by Batman co-creator Bill Finger and pencilled by Wayne Boring), the names given were John and Mary Kent. This issue marks the first time in which the Kents were said to have adopted the infant after they found his crashed spaceship and took him to an orphanage.

When Siegel and Shuster's Superboy made his debut in January 1945's *More Fun Comics* #101, Ma and Pa Kent's roles in the young Clark Kent's life were expanded. The name Jonathan was first given to Pa Kent in a Superboy story in February 1950's *Adventure Comics* #149, while the name "Marthe" was given to Ma Kent in January-February 1951's *Superboy* #12 (soon after, it became Martha). The *Superboy* comic established that Jonathan

and Martha were farmers when they found their son, and that they moved with him to Smallville and opened a general store. While Martha made Superboy's costume, Jonathan helped him develop his dual identity. Since the Kents were then portrayed as an active middle-aged couple, a reason was needed to explain their absence in the adult Clark Kent's life. In May 1963's *Superman* #161 ("The Last Days of Ma and Pa Kent!" by writer Leo Dorfman and artist Al Plastino), it was revealed that the two acquired a disease from a buried treasure chest they found while vacationing after Clark finished high school.

After the 1985 *Crisis on Infinite Earths* miniseries, the DC Universe was rebooted and Jonathan and Martha were kept alive (and again made farmers) by writer-penciller John Byrne in 1986's *Man of Steel* miniseries to witness Clark's career as Superman. This version was incorporated into TV's *Lois and Clark: The New Adventures of Superman*, where the couple was played by Eddie Jones and K Callan. It was also used in *Superman: The Animated Series*, where they were voiced by Shelley Fabares and Mike Farrell (who were married in real life).

In TV's *Smallville*, the Kents were portrayed in their forties by John Schneider and Annette O'Toole (who'd played Lana Lang in *Superman III*). This version helped inspire 2003's *Superman: Birthright* limited series (by writer Mark Waid and artist Leinil Francis Yu), in which Jonathan is a blond and Martha a redhead. Because *Birthright*'s Jonathan disapproved of Clark using his powers to help humanity, this time around Martha took a more active role in helping their son create his identity as Superman, though in the 2009 *Superman: Secret Identity* reboot (written by Geoff Johns with art by Gary Frank), Jonathan again joins Martha in helping Clark establish Superman. In DC's 2011 "New 52" reboot, the couple were killed in a car accident by a drunk driver before Clark became Superman.

The first actors to play Jonathan and Martha Kent on screen were Ed Cassidy and Virginia Carroll in 1948's *Superman* film serial. In 1978's *Superman: The Movie*, they're played by Glenn Ford and Phyllis Thaxter, both of whom create unforgettable portraits in just a few scenes. (Pa Kent's moving speech to Clark just moments before he dies would influence scores of successive superhero movies.) Eva Marie Saint takes on the role of the widowed Martha in 2006's *Superman Returns* (a pseudo sequel to *Superman: The Movie* and *Superman II*). In 2013's *Man of Steel*, Kevin Costner and Diane Lane play the Kents, with Lane returning for 2015's *Batman v Superman: Dawn of Justice*.

The importance of Jonathan and Martha Kent cannot be overstated—had they not instilled their own values in Clark, the world would never have a Superman.

10 Be a Hero

It's sad but true that writer Jerry Siegel and artist Joe Shuster were never properly compensated for creating the greatest superhero of them all. Like far too many comic book legends, they spent years suffering while others profited off their legacy. But there's a way you can help those creators who are in need today—by donating to The Hero Initiative.

Founded in 2000, The Hero Initiative is a not-for-profit group, the first of its kind, that assists the comic creators, writers, and artists most in need of "emergency medical aid, financial support for essentials of life, and an avenue back into paying work."

The Hero Initiative can be found at comic book conventions across the country, where some of the field's top talents help raise

funds on its behalf by signing autographs or drawing sketches in exchange for donations from fans.

Of course, you don't have to attend a convention to donate. Just visit www.heroinitiative.org to find out how you can be a hero. There's no better way to honor the first superhero creators than by helping those creators who are still with us.

Krypton

In the endless reaches of the universe, there once existed a planet known as Krypton, a planet that burned like a green star in the distant heavens. There, civilization was far advanced and it brought forth a race of supermen, whose mental and physical powers were developed to the absolute peak of human perfection. But there came a day when giant quakes threatened to destroy Krypton forever...

So begins the opening narration of Fleischer Studios' 1941 animated short *Superman*, an eloquent description of the Man of Steel's homeworld. Though the planet was indeed destroyed immediately after Superman's father, Jor-El, sent him to Earth in June 1938's *Action Comics* #1 ("Superman, Champion of the Oppressed," by writer Jerry Siegel and artist Joe Shuster), eventually—by traveling through time and by discovering its lost city of Kandor—Superman came to learn as much about Krypton as he did the world on which he was raised.

Originally described as "a distant planet" that "was destroyed by old age," Krypton was formally named in June 1939's *Superman* #1 ("Clark Kent Gets a Job," also by Siegel and Shuster). As explained in July-August 1948's *Superman* #53 ("The Origin of

Superman," by writer Bill Finger and penciller Wayne Boring, in which it's described as Earth's "sister world"), Krypton had a core of uranium whose rupture caused its demise.

In the Golden Age comics of the 1940s, the planet's high gravity was deemed responsible for all of its people's powers; in the Silver Age of the 1950s and '60s, it was said that the Earth's yellow sun caused Superman's powers to emerge, and that a red sun like Krypton's Rao—named after its people's mythological god of light—would inhibit them.

Also in the Silver Age, Krypton's geography was established in a series of stories written under notorious DC Comics editor Mort Weisinger's tenure. (Though a micromanager, Weisinger also oversaw such innovations as Supergirl, Brainiac, Krypto, the Phantom Zone, Kandor, and the Legion of Super-Heroes.) Readers discovered the planet's enchanting Fire Falls (in October 1961's *Action Comics* #281), Scarlet Jungle (in March 1964's *Action Comics* #310), Jewel Mountains (in July 1964's *Superman* #170), Meteor Valley, Gold Volcano, and Rainbow Canyon (all three in November 1960's *Superman* #141, "Superman's Return to Krypton!" featuring the most luscious Silver Age depiction of the planet, by penciller Wayne Boring).

Among Krypton's fauna were such unique species as the flame beast (introduced in August 1958's *Superman* #123), the flame dragon (January 1961's *Superman* #142), the venomous mutant fish-snake of the Fire Falls (October 1961's *Action Comics* #281), the horned rondor (November 1962's *Superman* #157), the hippo-esque metal-eater (October 1959's *Superman* #132), the telepathic hound, and the feathered nightwing and flamebird (the latter three in January 1963's *Superman* #158, "Superman in Kandor"). Several of these creatures came to reside in the alien zoo Superman maintained in his Fortress of Solitude.

Krypton's government was advised by its Science Council, of which Jor-El was a member, after winning his seat by discovering

the twilight dimension of the Phantom Zone—a preferred alternative to capital punishment or placing criminals in suspended animation and exiling them into space. Though Krypton was, in most respects, more scientifically advanced than Earth, it was only beginning to develop interplanetary travel when it was destroyed, its Council refusing to heed Jor-El's warnings of doom.

After its capital city of Kandor was stolen by the space villain Brainiac, a new capital, Kryptonopolis, was named, in which Jor-El's son, Kal-El, was born. Kal-El's cousin Kara Zor-El, who would become Supergirl, was born in domed Argo City. Hurled into space when the planet perished, Argo was later doomed by a meteor shower.

When Superman's continuity was rebooted in writer-penciller John Byrne's 1986 limited series *Man of Steel*, Krypton was reimagined as a sterile, cerebral world, inspired in part by its depiction in 1978's *Superman: The Movie* (in which it was destroyed by a supernova). Its once violent people had come to repress their emotions, and their over-reliance on technology contributed to its demise. In 2004's *Superman: Birthright* limited series and 2009's *Superman: Secret Origin* limited series—both of which established new origin stories for Superman—Krypton's pre–*Man of Steel* mythology was again utilized, along with elements from *Superman: The Movie*.

12 The Superman Logo

Next to his "S" shield and costume, perhaps the most famous piece of visual imagery associated with the Man of Steel is his principal logo, a telescoping SUPERMAN that perfectly captures the feel of the character in flight, soaring away from the viewer.

The logo first appeared, as did Superman himself, in prototypical form in an unpublished story in 1933 by creators Jerry Siegel and Joe Shuster. It was later streamlined for June 1938's *Action Comics #1*, written by Siegel and illustrated by Shuster. That issue also marked the debut of the *Action Comics* logo, a beautiful art deco design by Ira Schnapp, who'd carved the Roman lettering on the New York Public Library's main branch (MDCCCXCV—THE NEW YORK PUBLIC LIBRARY—MDCCCCII) in 1911, as well as the inscription on the front of the James A. Farley Post Office Building, the main US Postal Service building in New York City (NEITHER SNOW NOR RAIN NOR HEAT NOR GLOOM OF NIGHT STAYS THESE COURIERS FROM THE SWIFT COMPLETION OF THEIR APPOINTED ROUNDS).

Schnapp later perfected Shuster's Superman logo for the cover of September 1940's *Superman #6*. His version lasted until 1983, when DC altered the logo's "S"; this latter version is still in use. Schnapp would go on to create countless other logos for DC Comics, where he worked from 1938 to 1968. His best known are those for *Superboy* (with its cheerful elongated fonts), *The Flash* (a sprinting typeface), *Green Lantern* (rendered in emerald flames), and *Justice League of America* (emblazoned on a star-spangled shield). Schnapp also designed the DC bullet and the company's house ads, as well as the Comics Code Authority stamp. Schnapp died in 1969, a year after his retirement.

13 Kryptonite

So well known is kryptonite, the Achilles' heel of the Man of Tomorrow, that it's synonymous with real-world weaknesses of all kinds, and inspired everything from songs (3 Doors Down's

Over the years, Superman's many foes have attempted to exploit his vulnerability to kryptonite in a variety of ways.
(Cover art by Curt Swan)

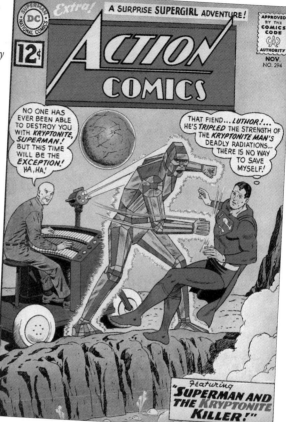

Grammy-nominated 2000 hit "Kryptonite") to sweets (light-up "Kryptonite Candy," produced by Cap Candy in 2006) to bicycle locks (the Allegion-owned brand of u-lock).

The irksomely ubiquitous meteor fragments of Superman's home planet first landed on Earth in the form of "K-Metal," in a 1940 story by Superman co-creator Jerry Siegel. Unpublished (perhaps because this tale also saw Lois Lane learn Clark Kent's true identity), the story was later dubbed "The K-Metal from Krypton" by author Gerard Jones in his seminal 2004 history *Men of Tomorrow: Geeks, Gangsters and the Birth of the Comic Book.*

Kryptonite made its official debut in *The Adventures of Superman* radio show. In the June 6, 1943, serial "The Meteor from Krypton," it was introduced as a means of giving star Bud Collyer some vacation time. Its first comic book appearance was in November 1949's *Superman* #61 ("Superman Returns to Krypton!" by writer Bill Finger and artist Al Plastino). First portrayed as red, the lethal mineral was colored green in August 1951's *Action Comics* #161.

The red form of kryptonite properly debuted in September 1958's *Adventure Comics* #252 ("The Super-Sentry of Smallville," by writer Alvin Schwartz and artist John Sikela). Introduced as a non-lethal version, the space rock was soon used as a means of subjecting Superman to a variety of temporary physical and mental transformations. Other forms of kryptonite followed, including blue kryptonite (which only affects Bizarro), gold kryptonite (which renders Kryptonians permanently powerless), jewel kryptonite (which intensifies the mental powers of those trapped within the Phantom Zone), white kryptonite (which kills only plant life), anti-kryptonite (which kills non-superpowered Kryptonians), and x-kryptonite (an invention of Supergirl, which gives superpowers to her cat, Streaky).

Kryptonite has been used by countless supervillains against the Last Son of Krypton, including Metallo—whose cybernetic body is powered by the substance—and Lex Luthor, who, in the late 1980s, wore a kryptonite ring that wound up giving him cancer. The superfoe most visibly associated with kryptonite was the Kryptonite Kid (later the Kryptonite Man). Introduced in September 1960's *Superboy* #83 ("The Dreams of Doom," by writer Jerry Siegel and artist George Papp), this space criminal passed through a gaseous cloud in outer space that gave him the power to turn any object he touched to green kryptonite.

14 Celebrate Superman Day

Though Superman fans celebrate the Man of Steel most every day of the year, there's no question that the world's first and greatest superhero deserves an official holiday. But which day is Superman Day?

Author Elliot S. Maggin suggested such a day in his 1981 Superman novel *Miracle Monday* (his second after 1978's *Superman: Last Son of Krypton*). In this story, Superman saves the world from a magical entity from Hell on the third Monday of May, prompting humanity to celebrate the day for thousands of years. In October 1984's *Superman* #400 (also written by Maggin), it's revealed that Miracle Monday is still celebrated in the year 5902. On that night at dinner, a plate of food is set aside—"Superman's dish, which we reserve for his return to us!"

In the real world, DC later declared June 12, 2013, to be Man of Steel Day; it was the Wednesday (the day on which new comics arrive in US comic book stores) before June 14, the day director Zack Snyder's *Man of Steel* landed in theaters. Fans were given a free copy of writer Grant Morrison and artist Frank Quitely's *All-Star Superman #1 Special Edition* (a reprint of the acclaimed issue that first appeared in 2005).

But a couple of months prior, on Superman's 75th anniversary, Cleveland mayor Frank G. Jackson officially declared Superman Day to be April 18, 2013. At 1:00 PM that day, a Superman flag was hoisted over Cleveland's City Hall, while red, yellow, and blue lights shined upon it. It's this day that's best suited for the holiday, for it's the day that *Action Comics* #1 (in which writer Jerry Siegel and artist Joe Shuster's creation first appeared) arrived on newsstands in 1938.

15 The Adventures of Superman Radio Show

While Superman soared on screen through the Fleischer Studios cartoons of the early 1940s and the movie serials at decade's end, the Man of Tomorrow also took flight in the '40s *without* the aid of visuals in the children's radio serial *The Adventures of Superman*.

First broadcast three times a week in 15-minute installments (though the frequency and length of its episodes would often change throughout the show's 11-year run), *The Adventures of Superman* featured Clayton "Budd" Collyer as the voice of Clark Kent and his famous alter ego. Its first episode, which debuted on February 12, 1940, begins with narration that would become forever linked to the Last Son of Krypton:

Faster than an airplane. More powerful than a locomotive. Impervious to bullets…

> *Up in the sky! Look!*
> *It's a bird!*
> *It's a plane!*
> *It's Superman!*

And now, Superman—a being no larger than an ordinary man, but possessed of powers and abilities never before realized on Earth. Able to leap into the air an eighth of a mile at a single bound, hurdle a 20-story building with ease, race a high-powered bullet to its target, lift tremendous weights, and rend solid steel in his bare hands as though it were paper. Superman, a strange visitor from a distant planet, champion of the oppressed, physical marvel extraordinary. Who has sworn to devote his existence on Earth to helping those in need.

By the end of the show's run, on March 1, 1951, the words, set to appropriate sound effects and music, were streamlined to the more familiar:

Faster than a speeding bullet. More powerful than a locomotive. Able to leap tall buildings in a single bound.
 Look! Up in the sky!
 It's a bird!
 It's a plane!
 It's Superman!
 Yes, it's Superman—strange visitor from the planet Krypton, who came to Earth with amazing physical powers far beyond those of mortal men, and who, disguised as Clark Kent, mild-mannered reporter for a great metropolitan newspaper, wages a never-ending battle for truth and justice.

In its premiere episode, "The Baby from Krypton," the show demonstrates radio's unique ability to allow listeners to illustrate their own comic book panels in their minds:

As we near Krypton, we see gleaming walls and high turrets. We approach the magnificent Temple of Wisdom. And there in a great hall, Jor-L, Krypton's foremost man of science, is about to address a meeting of the planet's governing council...

The Adventures of Superman differed slightly from the comics on which it was based. Baby Kal-El (then "Kal-L") grew to adulthood in his rocket ship to Earth, and Clark Kent kept the mere existence of Superman a secret from the show's other regular characters throughout much of the first year. The existence of Collyer—who would deepen his voice when milquetoast Clark changed into scrappy, tough-talking Superman—was also downplayed at first; his name was omitted from the program's credits for

the first half of its run. Several actresses portrayed Lois Lane until one was settled on. Rollie Bester first played the role for a scant two weeks, followed by Helen Choate for two months. Joan Alexander then became the intrepid "girl reporter" for the remainder of the series' run. Like Collyer, with whom she displayed an obvious chemistry, she would go on to voice her character in the Fleischer Studios cartoons.

The Adventures of Superman introduced many characters and concepts that would become part of the DC Comics canon. Lois and Clark's boss, *Daily Planet* editor Perry White, was created for the show's second episode ("Clark Kent, Reporter") on February 12, 1940. Copyboy Jimmy Olsen got his start in the six-part serial that began April 15, 1940 ("Donelli's Protection Racket"). Superman's fellow crime-fighter Inspector Henderson, as well as the Man of Steel's powers of super hearing and "telescopic eyesight" (which would evolve into telescopic X-ray vision before splitting into two separate abilities) were also introduced. But the show's greatest contribution to Superman lore is kryptonite, his Achilles heel, introduced in the seven-part "The Meteor from Krypton," which began June 3, 1943.

Equally historic is the first meeting of the World's Finest team of Superman and Batman (along with his sidekick, Robin) in any medium, which occurred in the second episode of the 12-part "Mystery of the Waxmen" on March 1, 1945. Stacy Harris provided the Caped Crusader's voice in his radio debut. The two heroes would team up for the first time on September 10, 1945, in the fifth episode of the 14-part "Dr. Blythe's Confidence Gang." In the years that followed, Batman would appear in numerous storylines, including the program's most famous, the epic 38-part "The Atom Man" (which began October 11, 1945). It featured the deadliest foe Superman would fight on the radio—the titular radioactive Nazi agent (voiced by Mason Adams), whose veins are filled

with kryptonite. It would help inspire the second of two Superman movie serials—1950's *Atom Man vs. Superman.*

The Adventures of Superman's finest hour, however, came when Superman returned to his comic book roots as a social crusader, and battled a very real threat—the Ku Klux Klan—in "Clan of the Fiery Cross" (starting June 10, 1946). This 16-part serial helped expose the hate group's rituals and practices, and is credited with hindering its recruitment and expansion in post-war America.

16 The *Daily Planet*

A testament to the same virtues embodied by the Man of Steel, the "great metropolitan newspaper" the *Daily Planet* has served as the beating heart of Superman's city since it was introduced in April 1940's *Action Comics* #23 (written by Jerry Siegel and pencilled by Joe Shuster).

Clark Kent's first job in Metropolis was at the *Daily Star.* First depicted in May 1938's *Action Comics* #1, its editor-in-chief George Taylor, it was named and modeled after the *Toronto Daily Star,* at which Superman co-creator Joe Shuster was once a newsboy. When the *Superman* newspaper comic strip debuted in January 1939, the paper was given a new name, one that no real newspaper used. Perry White, introduced in *The Adventures of Superman* radio show in February 1940, was made the *Daily Planet*'s editor-in-chief in November 1940's *Superman* #7.

The *Daily Planet* Building, in which the newspaper is head-quartered in downtown Metropolis, is easily identifiable by the gigantic globe mounted on its topmost roof, a ring of letters around it spelling out the paper's name. The roof is easily accessible to

Planet employees, as seen by the number of times Clark Kent, Lois Lane, Jimmy Olsen, and Perry White have met there.

The *Planet*'s publisher when Clark Kent first worked at the paper was Burt Mason, introduced in Summer 1940's *Superman* #5. The paper was bought by Galaxy Broadcasting president Morgan Edge in 1971, and merged with Edge's WGBS-TV, for which the media mogul made Clark Kent the nightly news anchor. Kent was soon joined by fellow Smallville high alum Lana Lang. Steve Lombard, the *Planet*'s sports editor, was introduced in June 1973's *Superman* #264 ("Secret of the Phantom Quarterback!" by writer Cary Bates and penciller Curt Swan).

After the 1985 limited series *Crisis on Infinite Earths*, which led to a reboot of the entire DC Universe, the *Daily Planet* was given a new history, one in which it was owned by Lex Luthor prior to Clark Kent's hiring. Thanks to Perry's ingenuity, it was purchased by TransNational Enterprises, which installed White as editor-in-chief. White's friend Franklin Stern was made its publisher. Also introduced at this time—in January 1987's *Adventures of Superman* #424 ("Man O'War," by writer Marv Wolfman and penciller Jerry Ordway)—was vivacious gossip columnist Cat Grant, Lois' rival for Clark's affections.

Stern eventually sold the paper, and it was purchased by Lex Luthor, who proceeded to fire most of its staff, and replace the *Daily Planet* with LexCom. But Lois bartered with Luthor, and was able to return the *Planet* to Perry. It was next sold to Bruce Wayne. In the 2009 limited series reboot *Superman: Secret Origin*, it was established that Luthor owns every media outlet in Metropolis *except* for the *Daily Planet*. In DC's 2011 "New 52" reboot, Galaxy Broadcasting's merger with the paper was reintroduced into the current continuity.

Los Angeles City Hall is used for the exterior of the *Daily Planet* in the 1950s *Adventures of Superman* TV show. The exterior and lobby of New York City's News Building (formerly the New

York Daily News Building) is used in 1978's *Superman: The Movie*, the opening narration of which is a tribute to the newspaper itself:

> *In the decade of the 1930s, even the great city of Metropolis was not spared the ravages of the worldwide depression. In the times of fear and confusion the job of informing the public was the responsibility of the* Daily Planet. *A great metropolitan newspaper, whose reputation for clarity and truth had become a symbol of hope for the city of Metropolis.*

Vancouver's Marine Building exterior was used for the *Planet's* exterior in *Smallville*, and the Chicago Board of Trade Building was used in 2013's *Man of Steel*. For *Lois & Clark: The New Adventures of Superman*, the *Daily Planet's* exterior was constructed on the Warner Brothers Studios lot in Burbank (its trademark globe mounted above the front entrance to the building).

17 The Fleischer Studios *Superman* Cartoons

While Superman has appeared in numerous screen incarnations, for many connoisseurs the character's finest remains his very first—in the animated shorts of brothers Max and Dave Fleischer. The first of which, titled simply *Superman*, debuted in theaters on September 26, 1941, a mere three years after the Man of Steel first appeared in print and a little over a year and a half after *The Adventures of Superman* radio serial premiered.

Best known for their Betty Boop and Popeye cartoons, Fleischer Studios was asked to adapt Superman by Paramount Pictures. Prior to that time, no major American studio had produced an animated

short that wasn't a musical or comedy, and that relied entirely on realistically drawn and animated human figures. According to author Leslie Cabarga in his *The Fleischer Story* (DaCapo Press, 1988), "When Paramount proposed that the studio tackle Superman, Dave Fleischer was at first reluctant. For one thing, it would be very expensive to animate human anatomy successfully. So, hoping to dissuade them, Dave told Paramount it would cost $90,000 to make each cartoon (according to Dave, a typical cartoon short cost $25,000 to make and grossed [an] average of $90,000). To his surprise, Paramount approved the budget and Superman went into production."

The first short, which was nominated for an Academy Award, opens with a field of stars, against which red-and-blue comets speed in every direction. "Up in the sky, look!" cries a man. "It's a bird!" shouts a woman. "It's a plane!" proclaims another man. "It's Superman!" screams a third man. One of the comets explodes across the screen, spelling out the film's title in electrified letters to the accompaniment of composer Sammy Timberg's rousing theme.

Viewers are then shown the planet Krypton, which "burned like a green star in the distant heavens," home to a "race of super-men." After the planet explodes and the infant Superman rockets to Earth, an announcer intones, "Faster than a speeding bullet. More powerful than a locomotive. Able to leap tall buildings in a single bound. The infant from Krypton is now the Man of Steel, *Superman!* To best be in a position to use his amazing powers in a never-ending battle for truth and justice, Superman has assumed the disguise of Clark Kent, mild-mannered reporter for a great metropolitan newspaper..."

A villain is then introduced, "the mad scientist" (the name by which the short is often referred to), along with reporters Clark Kent and Lois Lane (voiced, as in the Superman radio show, by Bud Collyer and Joan Alexander, respectively). Upon learning the scientist plans to strike the city at midnight with an

Considered by many to be the finest representation of Superman ever on screen, the animated shorts produced by Fleischer Studios in the 1940s remain beloved to this day.

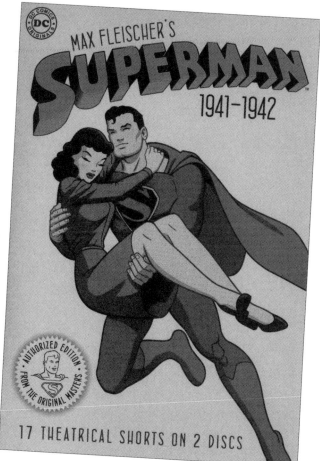

"Electrothanasia-Ray" (it's unclear for what purpose), Lois dons a helmet and goggles and flies a plane to his mountaintop lair. There, using lab equipment out of a '30s Frankenstein film, the villain holds her captive as he destroys a suspension bridge with his weapon. Back at his office, Clark Kent races into a stock room. "This looks like a job...*for Superman!*" he states, his voice deepening dramatically on the last two words. He emerges in a familiar uniform and launches himself skyward. After preventing a sky-scraper from toppling over, he collides head-on with the scientist's

ray, literally punching it back to its source. He frees Lois and puts the madman behind bars. The next morning, she gets the story, but Clark gets to share a knowing wink with the viewer.

The studio created a total of nine shorts over the next 12 months, each directed by Dave Fleischer and produced by Max Fleischer, and each a masterpiece of noir lighting, art deco design, and effects animation. (An additional eight shorts of lesser quality, featuring World War II–related antagonists, were produced by the Fleischers' successor, Famous Studios.) Though the human figures are partly animated through Max Fleischer's patented rotoscoping technique, Lois and Superman are every bit as appealing as in the comics published at that time: she a doe-eyed, Disneyesque heroine with limitless moxie, he the ultimate in physical perfection. The second and best of the shorts, *The Mechanical Monsters*, finds Superman battling a squadron of flying bank-robbing robots (the look of which would inspire the automaton in animation maestro Hayao Miyazaki's *Castle in the Sky*). It contains such iconic images as Superman shielding Lois beneath his cape from a poured vat of molten metal, and the first on-screen depiction of X-ray vision and of Clark Kent changing into Superman in a phone booth.

The Fleischer shorts would influence both *Superman: The Animated Series* and *Batman: The Animated Series*, and the look of their Superman's chest symbol—a red "S" against a black background—would be used by Alex Ross for his Man of Steel in *Kingdom Come*. But their greatest contribution to Superman lore is undoubtedly the gift of flight, since they mark the first time the character flew, instead of leapt, into action. Seventy-five years later, like Superman himself, they still soar.

Superboy

They say youth is wasted on the young. But why waste the world's greatest set of superpowers on an adult? Such must have been the line of reasoning when Superboy debuted in January-February 1945's *More Fun Comics* #101 ("The Origin of Superboy," credited to Superman creators Jerry Siegel and Joe Shuster, though Siegel was in the Army at the time).

Initially rendered as a child, the Boy of Steel was made a teenager by the time he received his own title, with April 1949's *Superboy* #1, in which he starred in three stories (written by Ed Herron, Edmond Hamilton, and William Woolfolk, and pencilled by John Sikela, Ed Dobrotka, and George Roussos). Though the idea that Superman wore a cape and costume as a teen threw a monkey wrench into the world established back in *Action Comics* #1, in which the Man of Steel revealed his presence on Earth as a grown man, Superboy made possible pleasures that Superman's adventures did not. Chief among them was the presence of the always supportive Jonathan and Martha Kent, who had died in Golden and Silver Age canon before Clark Kent adopted his alter ego. Superboy stories also introduced a new leading lady in Lana Lang, who first appeared in *Superboy* #10 ("The Girl in Superboy's Life!" written by Bill Finger and illustrated by John Sikela).

Lana, the Kents, his friend Pete Ross, and his superdog, Krypto, made Superboy's hometown of Smallville the perfect place to live. Named for the first time in May 1949's *Superboy* #2, in which the town hosts "Superboy Day" (in "The Stunts of Superboy!"), Smallville is described by author Les Daniels in his 1995 history *DC Comics: Sixty Years of the World's Favorite Comic Book Heroes* as representative of "innocent, pre-war, small-town

America…a dreamworld that was already disappearing." Other elements introduced in *Superboy* were Bizarro and the Boy of Steel's "brother" Mon-El.

Superboy proved popular enough to earn a spot in a second comic book, *Adventure Comics*, which saw the first appearance of General Zod and the Phantom Zone (in #283) and the Boy of Steel's superpowered friends from the 30th century, the Legion of Super-Heroes (in #247). The Legion eventually proved popular enough to take over the title. When *Adventure Comics* ceased publication, the team moved into *Superboy*, and, after sharing it with their friend, took over that book as well in 1980. A third Superboy title, *The New Adventures of Superboy*, ran from 1980 through 1984. It was followed by a four-issue limited series, *Superman: The Secret Years*, that presented Clark Kent's college days and showed Superboy's transition into Superman.

During DC's 1985 *Crisis on Infinite Earths* limited series, another version of Superboy was introduced; he hailed from our Earth, Earth-Prime (in which Superman is fictional). The character, dubbed Superboy-Prime, inspired writer Kurt Busiek's 2004 *Superman: Secret Identity* limited series.

In the wake of *Crisis*, Superman was rebooted, and in this new continuity Superboy never existed. But the Boy of Steel was brought back in the 1993 "Death of Superman" storyline, albeit in another form, ultimately revealed as genetically engineered Conner Kent, aka Kon-El. Kon-El starred in his own *Superboy* title from 1994 through 2002. Posing as the nephew of Jonathan and Martha Kent, he joined the Teen Titans, Young Justice, and the Legion of Super-Heroes. In DC's 2011 "New 52" reboot, Conner was killed off, and a new Superboy, the son of Clark Kent and Lois Lane in a parallel universe, was introduced. Kon-El also appeared in the 2010 *Young Justice* animated series.

The original Superboy featured in an unaired pilot for the live-action *The Adventures of Superboy*, in which he was first played on

screen by actor Johnny Rockwell. The Boy of Steel first *officially* appeared on screen in a series of 1966 TV cartoon shorts—also dubbed *The Adventures of Superboy* (with Bob Hastings supplying the character's voice). In 1988, Superboy earned his own eponymous live-action TV show, its four seasons produced by *Superman* movie producers Alexander and Ilya Salkind. John Haymes Newton starred in the show's first season, and was replaced by Gerard Christopher for its remaining three. The most famous Superboy TV show, however, is one in which the character isn't referred to as such—the 10-season *Smallville*, starring Tom Welling as the young Clark Kent.

19 The Fortress of Solitude

It's fitting that the world's greatest champion should have the world's greatest man cave. So although Superman lives in Metropolis, when he needs a break from the pressures of saving the planet, he heads to his Fortress of Solitude.

The Fortress' existence is hinted at as early as January 1941's *Action Comics* #32 ("The Preston Gambling Racket," by writer/ Superman co-creator Jerry Siegel and artist Jack Burnley), in which Clark Kent is revealed to have a secret laboratory, in which he creates a Krypto-Ray gun. July 1942's *Superman* #17 ("Muscles for Sale," written by Siegel, with art by John Sikela) marked the first appearance of Superman's "secret citadel," a mansion he built on a mountaintop in an undisclosed location. But it wasn't until May-June 1949's *Superman* #58 ("The Case of the Second Superman," its writer unknown, pencilled by Wayne Boring) that the name "Fortress of Solitude" was first stated, and located in the "polar

wastes." Like the Man of Steel himself, who was inspired in part by the "Man of Bronze," Superman's retreat took its name from the arctic headquarters of pulp hero Doc Savage, who also had a Fortress of Solitude.

The name, however, would not be mentioned again until the 30th anniversary of Superman's first appearance—in June 1958's *Action Comics* #258 ("The Super-Key to Fort Superman," by writer Jerry Coleman and penciller Wayne Boring), which offered a detailed look at the Fortress that's known throughout the world today. "Here," says Superman, "I can keep the trophies and souvenirs I've collected from other worlds. Here I can conduct secret experiments with my super-powers…and keep souvenirs of my best friends!" *Action* #258 also introduced the means by which Superman enters the Fortress: a great gold "super-key that weighs tons—and that no one else can lift," which fits into "a gigantic door so heavy that no human on Earth could move it an inch!"

Released in 1976, the tabloid-sized *Limited Collectors' Edition* #C-48 ("Superman vs. the Flash") includes detailed plans of the three floors that make up the Fortress, courtesy of artist Neal Adams. On the first level of the sanctuary, one could find enormous statues of Jor-El and Lara lifting a model of their planet, and a Kryptonian memorial room, as well as Superman's trophy room, communications room, collection of superweapons ("confiscated from villains of many worlds"), and disintegration pit. On the second level were his archives, supercomputer, the Bottle City of Kandor, an interplanetary zoo, a lab, and the Phantom Zone viewer and projector. The third level contained Superman's private quarters. Like most of Superman's Silver Age mythology, this version of the Fortress of Solitude last appeared in a two-part story in September 1986's *Superman* #423 and *Action Comics* #583 ("Whatever Happened to the Man of Tomorrow?" written by Alan Moore and pencilled by Curt Swan).

Following the 1985 *Crisis on Infinite Earths* miniseries, and the subsequent reboot of the DC Universe, the Fortress was introduced by writer-penciller John Byrne in the 1986 miniseries *Man of Steel* as—Clark Kent himself! Byrne reasoned that Superman's alter ego offered enough of a retreat for him. (TV's *Lois & Clark: The New Adventures of Superman* also lacked a Fortress, since it took its cue from the post-*Crisis* reboot.) A Fortress similar to the original, however, was re-introduced in December 1989's *Adventures of Superman* #461 ("Home," by writer-penciller Dan Jurgens). This Fortress proved less durable than its predecessor, and was rebuilt several times, first as a mobile headquarters, and then as a base of operations in South America. In DC's "New 52" reboot, the Fortress was again located in the Arctic.

The Fortress of Solitude made its screen debut in spectacular fashion in 1978's *Superman: The Movie*, when it grew from a Kryptonian crystal sent to Earth in the baby Kal-El's spaceship, and brought to the arctic by Clark Kent. Here it was programmed with Jor-El's memories, and served as a location for Clark to learn of his Kryptonian heritage from a hologram of his birth father before becoming Superman. This crystal-based version of the Fortress was again used in *Superman II*, *Superman IV*, TV's *Smallville,* and in *Superman Returns*. In *Superman: The Animated Series*, the Fortress housed the knowledge of Krypton in an information sphere once possessed by the villainous Brainiac, while in 2013's *Man of Steel*, the Fortress was a crashed Kryptonian ship found in the Arctic by Clark.

There's no doubt that the Fortress of Solitude has evolved over the years, but whatever form it takes it remains a place for the Last Son of Krypton to catch his breath and collect his thoughts before continuing his never-ending battle.

Lana Lang

As Charlie Brown had his "little red-haired girl," so Superman had his own scarlet-tressed temptress. Introduced in 1950's *Superboy* #10 ("The Girl in Superboy's Life!" written by Batman co-creator Bill Finger and illustrated by John Sikela), Lana Lang was young Clark Kent's friend, classmate, and crush, Smallville's quintessential girl next door. The daughter of archaeology professor Lewis Lang and his wife, Sarah, in her early years Lana served as a teenage version of Lois Lane, forever trying to discover the secret identity of Superboy, with whom she was smitten.

As an adult, Lana joined the writing staff of the *Daily Planet* in Metropolis, where she competed with her frenemy Lois for Superman's affections, á la Archie's Betty and Veronica. In the '60s she, like Clark, became a newscaster for TV station WMET-TV. In post–*Crisis on Infinite Earth* DC Comics continuity, Lana's relationship to Clark was inverted and it was revealed that she long harbored a crush on him, and chose to remain in Smallville into adulthood while remaining his confidante, and one of the very few people to know his secret.

Eventually Lana married Superman's boyhood friend Pete Ross, with whom she had a child named Clark. When Ross became president of the United States, Lana became First Lady. And when Lex Luthor was removed from LexCorp, Lana replaced him as CEO, a position which strained her relationship with Clark. She grew to become friends, however, with the post-*Crisis* Supergirl, who took on the identity of Linda Lang, Lana's niece, while Lana became business editor of the *Daily Planet*. In DC's "New 52" continuity, Lana and Clark were attracted to each other as youngsters,

but parted ways when Lana left Smallville, ultimately becoming an electrical engineer.

Lana first appeared on screen in 1961 in the form of blonde actress Bunny Henning, in the unsold TV pilot *The Adventures of Superboy*. In 1966, she became a regular character (voiced by Janet "Judy Jetson" Waldo) in three seasons of animated *Adventures of Superboy* segments in Filmation's various *Superman* animated TV series. Her big-screen debut came (albeit briefly) in 1978's *Superman: The Movie*, in which she was played by Diane Sherry. But Lana was promoted to leading lady status in 1983's *Superman III*, which saw her as a divorced, single mom still attracted to Clark. One of the film's brightest spots was the charismatic performance by Annette O'Toole (who went on to star as Clark's adoptive mother Martha in *Smallville*). Producers Alexander and Ilya Salkind's 1988 *Superboy* series also made Lana a leading lady, in the form of actress Stacy Haiduk, whose popularity proved at least as great as that of Clark Kent himself, played by actors John Haymes Newton and Gerard Christopher.

Following *Superboy*'s final season in 1992, Lana appeared in one 1996 episode of TV's *Lois & Clark: The New Adventures of Superman* (the third season's "Tempus, Anyone?"), where she was once more portrayed as a blonde by *CSI: Miami*'s Emily Procter. Lana also made appearances as both a teenager (voiced by Kelley Schmidt) and an adult (sitcom star Joely Fisher) in several episodes of *Superman: The Animated Series*. This time around, the character was a flirtatious fashion designer who knows Clark's secret.

In 2001, TV's *Smallville* brought Lana into the new millennium via brunette Canadian teenager Kristin Kreuk, the first regular cast on the show. Kreuk's performance endeared her to a generation of viewers, and her character's on-again-off-again relationship with Tom Welling's Clark lasted a full seven seasons. Throughout her run on *Smallville*, Lana—here, like Clark, an orphan (her parents were killed in the meteor shower that brought

him to Earth)—found herself possessed by the spirit of a French witch ancestor, married to Lex Luthor, and placed in a coma by Brainiac. She left the show in 2008, but returned for five additional eighth-season episodes. Her storyline culminated with her saving her friends at the *Daily Planet* by absorbing kryptonite radiation, the permanent presence of which in her skin made physical contact with Clark impossible.

Another appearance in 2013's *Man of Steel* film (where she's played in flashbacks as a tween by Jadin Gould) offers further proof that, so long as there's a Clark Kent, there will be a Lana Lang. Helping a young boy become a man, and a man become a Superman.

21 The *Superman* Film Serials

Superman wasn't the first superhero to star in movie serials (those weekly matinee chapter plays that preceded television). *Adventures of Captain Marvel*, featuring the World's Mightiest Mortal, debuted in 1941, and *Batman* followed in 1943. But Columbia's *Superman*, as author Les Daniels points out in *DC Comics: Sixty Years of the World's Favorite Comic Book Heroes* (published by Bulfinch in 1995), "was the most successful serial in history."

The first of *Superman*'s 15 chapters debuted on January 5, 1948, and marked the live-action debut of the Man of Steel and Clark Kent, both played by former dancer Kirk Alyn—uncredited, as Bud Collyer had been in *The Adventures of Superman* radio serial, from which *Superman*'s credits claimed it was adapted. Lois Lane, Jimmy Olsen, and Perry White also appeared on screen for the first in live action—played by Noel Neill, Tommy Bond, and Pierre

Watkin, respectively—as did Jor-El and Lara (Nelson Leigh and Luana Walters); Clark's adoptive parents, the Kents (here named Eben and Martha, and played by Edward Cassidy and Virginia Caroll); and kryptonite. *Superman*'s antagonist was a ho-hum gang leader known as the Spider Lady (played by Carol Forman). The serial was directed by Spencer Gordon Bennet and Thomas Carr, the latter of which went on to direct the *Adventures of Superman* TV show.

While its plot meandered and Alyn's acting was not quite on par with his physicality, *Superman*'s visuals are its weakest element. Produced by Columbia's notoriously parsimonious B-movie king Sam Katzman, all 15 of its chapters were lensed in Los Angeles in just four weeks. Shots were usually done in one take, and animation was employed to depict Superman in flight, much of it reused throughout the serial.

The film's sequel—1950's *Atom Man vs. Superman*—was more interesting, due largely to the first screen appearance of Lex Luthor, played by Lyle Talbot. Though the title was pulled from the hugely popular radio serial, this Atom Man is Luthor himself, who invents a device that disassembles human atoms and reassembles them elsewhere, similar to *Star Trek*'s transporter, and uses it to blackmail Metropolis. The film also features a synthetic form of kryptonite, like that used in *Superman III*.

Atom Man vs. Superman's flying sequences continued to draw criticism, but it's worth noting the use of animation for flight has since become widely used in superhero films, from *Superman Returns* to *Iron Man*.

22 The *Adventures of Superman* TV Series

When the last episode of *The Adventures of Superman* radio serial was broadcast in March 1951, the show's legion of fans didn't have too long to wait before the Man of Steel next entered their homes. After conquering radio, comics, and film, the series' producer Robert Maxwell was next tasked by DC's managing editor Jack Leibowitz with bringing the character to the new medium of television.

Maxwell produced and wrote (under the pseudonym Richard Fielding) the B-movie *Superman and the Mole Men* as a test vehicle for star George Reeves and a pilot for the TV series. Directed by Lee Sholem and released on November 23, 1951, the film concerns Superman's efforts to help its four titular humanoids as they confront fear and bigotry in the small town of Silsby, after a newly installed oil well drives them out of their subterranean home. Crude even by the standards of the day, it was enough to demonstrate Reeves' effectiveness as Superman and Clark Kent, as well as that of co-star Phyllis Coates as Lois Lane. The *Adventures of Superman* TV show entered production shortly thereafter.

Filmed in 1951 in a matter of weeks at Culver City's RKO-Pathe Studios, the show premiered on September 19, 1952—initially sponsored, as was the radio serial, by Kellogg's—introduced with the radio show's opening narration, but with a third reason for Superman's never-ending battle: "the American way." *Adventures of Superman*'s first season would prove to be its best, with a gritty film noir approach to its violent tales of crooks, kidnappers, arsonists, and mobsters, one that perfectly suited its tough-as-nails Lois and grimly determined Superman. Reeves made for an equally dynamic Clark Kent, whose presence contributed

to the first successful American scripted ensemble-cast TV show set in a workplace (as so much of the series transpired at the *Daily Planet* offices). Rounding out the series' cast was John Hamilton as tough-but-fair editor-in-chief Perry White and Jack Larson as charismatic cub reporter/comic relief Jimmy Olsen. Robert Shayne lent support as Superman's frequently befuddled police contact Inspector Henderson.

After the first season proved a hit, a second was ordered, but Coates was unavailable. So Noel Neill, who'd played Lois in the *Superman* film serials, was brought in as a gentler but still very likable replacement. Robert Maxwell also left, and was succeeded by Whitney Ellsworth, who would serve as producer for the remainder of *Adventures of Superman*'s six-season run. Episodes continued to be quickly and cheaply produced (budgets of $15,000 to $17,000 per episode have been reported). The cast wore the same outfits throughout entire seasons, so that all scenes taking place within a certain location could be shot at once. The second season (the show's second-best, featuring the classic "Panic in the Sky") was again shot in black and white, but Seasons 3 through 6 (consisting of half the number of original episodes) were filmed in color in order to take full advantage of the TV market; though the series would not be televised in color until it was broadcast in reruns in the 1960s.

Shots in which Superman took to the sky were first achieved with wires and later by launching Reeves on a springboard onto off-camera padding. Shots of Superman in flight were achieved by having Reeves lie on a flat piece of glass—later a "frying pan" sculpted to his beefy physique—footage of which would be matted against different backgrounds. The show's color seasons employed a cyclorama backdrop for such shots.

Plots became sillier and increasingly repetitive as the series progressed (with Lois and Jimmy captured and in need of rescuing week after week), and Reeves grew famously disenchanted with the

limited film roles he was offered during breaks between seasons. But the cast continuously displayed an obvious affection for one another that made the show a welcome presence in American homes long after its last episode aired on April 28, 1958.

"When I do the conventions," says Neill, "a lot of people come up to me and sort of look at me and I look at them, and I say, 'Don't be afraid. You grew up with me, didn't you?' They say, 'Yes, yes, yes!' They didn't want to insult me for being older. But they're very nice. One thing they said was, 'We think it's wonderful that you all seemed to be a family doing this television series, because you seemed to like each other.' I said, 'Well, we really did!' We worked together so many years off and on that we became very fond of each other. I guess it comes through."

23 Superman: The Movie

If 1978's *Superman: The Movie* didn't exist it would be necessary to invent it. The first very big-budget American superhero film, director Richard Donner's retelling of the Man of Steel's origin and early days not only offers the definitive live-action interpretation of the character, it's responsible for every comic book epic that's arrived since. But it wasn't easy for the film to make good on its promise "You'll believe a man can fly."

Superman began when producers Ilya and Alexander Salkind and Pierre Spengler purchased the movie rights to the character in 1974 from DC Comics. Mario Puzo, coming off his red-hot *The Godfather*, was contracted to write the film's script, as well as that of its sequel, *Superman II*, since the producers planned to make both films back to back as they had 1973's *The Three*

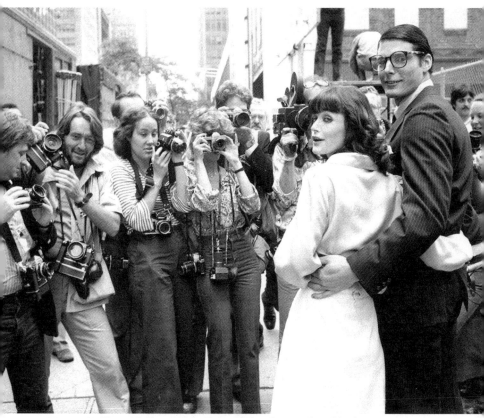

Margot Kidder and Christopher Reeve displayed an undeniable chemistry as Lois Lane and Superman/Clark Kent in 1978's Superman: The Movie. (Getty Images)

Musketeers and 1974's *The Four Musketeers*. After Puzo turned out a 500-page script in 1975, *Bonnie and Clyde* screenwriters Robert Benton and David Newman (both of whom also wrote the 1966 Broadway musical comedy *It's a Bird...It's a Plane...It's Superman*) were brought in to prune his work. Assisted by David's wife, Leslie (who'd go on to write 1983's *Superman III* with him), they produced a leaner revised script in 1976.

Filmmakers from Sam Peckinpah to Steven Spielberg were considered to helm the picture, until James Bond director Guy

Hamilton was settled on, and pre-production began in Rome's Cinecittà studios. Marlon Brando was hired to play Superman's father, Jor-El (at an eventual cost of $19 million for just 12 days of work), resulting in Gene Hackman signing on as criminal mastermind Lex Luthor. The production, however, was then forced to relocate to England, since Brando was charged with obscenity in Italy following 1972's X-rated *Last Tango in Paris*. This resulted in the loss of Hamilton, a tax exile from England.

The producers were impressed by the critical and commercial success of Donner's 1976 thriller *The Omen*, and hired him to direct *Superman* for $1 million. Donner was horrified by the camp tone of the screenplay he was given, and called on his friend, screenwriter Tom Mankiewicz, to produce another draft. Like Donner, Mankiewicz (though he would be credited only as "creative consultant") was determined to treat the subject as sincerely as possible. In Donner's office, a large sign was hung featuring Superman soaring around the word VERISIMILITUDE.

Though every actor in Hollywood—including Al Pacino, Clint Eastwood, and Sylvester Stallone—was reportedly considered, Donner decided that Superman should be played by an unknown. Casting director Lynn Stalmaster found him 24-year-old New York stage actor Christopher Reeve. In 1977, Reeve was hired to play the role that defined his career. On March 28 of that year, production on the two films began at Pinewood Studios, eventually lasting 19 months (by which time the bulk of *Superman II* was shot). The crew, a who's who of veteran film artists, included *2001: A Space Odyssey*'s cinematographer Geoffrey Unsworth, *Star Wars*' production designer John Barry (as well as its art director Norman Reynolds), *The Spy Who Loved Me*'s model maker Derek Meddings, Donner's *Omen* editor Stuart Baird, and composer John Williams.

Completing the cast were Margot Kidder as dogged *Daily Planet* reporter Lois Lane, Marc McClure as photographer Jimmy

Olsen, Jackie Cooper as editor-in-chief Perry White, Susannah York as Superman's mother Lara, Phyllis Thaxter and Glenn Ford as Jonathan and Martha Kent, Valerie Perrine and Ned Beatty as Lex Luthor's minions, the sexy Eve Teschmacher and the bumbling Otis, and Jeff East as the teenage Clark Kent (his voice replaced by Reeve's in the final film). The Krypton sets were constructed at Pinewood, while the Fortress of Solitude was created at both Pinewood and Shepperton Studios. Metropolis exteriors were shot in New York City, and Alberta, Canada, was used for Smallville.

The film's biggest production challenge (besides a falling out between Donner and the producers, resulting in the director's removal before *Superman II* was completed) was making Reeve fly convincingly, a feat that proved only slightly less difficult than sending an astronaut into space. Dummies were fired out of cannons, remote control models were tested, even animation was tried. Eventually a combination of wire work, blue screen, and front-projection shots were employed. Effects artist Zoran Perisic patented a new photographic process (known as Zoptic) in which both camera and background projector were mounted with synchronized zoom lenses to create the illusion of Superman flying toward the viewer.

The resulting film, with a budget of $55 million—the biggest of any movie yet made at the time of its release—grossed over $300 million worldwide. By the time it left theaters, *Superman: The Movie* was the sixth-highest-grossing film of all time. Fans were captivated by Reeve's dual performance as Superman and Clark Kent, by the romance between Superman and Lois Lane, and by scenes that brought comic book superhero action faithfully to life on screen for the very first time. Its visual effects were honored with a Special Achievement Oscar.

Superman: The Movie did more than make audiences believe a man could fly. It made them believe one could soar.

Daily Planet Exclusive

Richard Donner

Richard Donner has, over the course of his career, directed such crowd-pleasing favorites as *The Omen, The Goonies*, and the *Lethal Weapon* movies. But *Superman: The Movie* holds a special place in his oeuvre. The 1978 blockbuster not only introduced the world to Christopher Reeve, who would define the Man of Steel for decades in the public's consciousness, but it proved to be the first wholly successful feature film within the superhero genre, paving the way for the *Spider-Man, X-Men, Iron Man,* and *Avengers* franchises. In the opinion of many, myself included, it remains the finest.

Your motto in making *Superman: The Movie* was "Verisimilitude." Was that the key to balancing the film's emotional content with its action and spectacle?
I was brought up on Superman. When they sent the script to me, I read it, and my first reaction was, "They're destroying an American hero." In this particular [case], these people were not demeaning him. But they were Europeans, [and] it was almost a comedy. I've been quoted a lot about this, but it may have had scenes where Superman is looking for Lex Luthor and he's over Metropolis. He flies down and he sees a baldheaded guy, and he taps him on the shoulder, and it's Telly Savalas. Who was in a very popular series called *Kojak.* Do you know *Kojak*?

Oh yes.
So he hands Superman a lollipop…When I read it, it continued like that. I said, "Uh oh." My response to them was, "Look, I would like to do this. But to me it's a major rewrite." They said, "No, no. We're very happy with everything." I said, "I gotta pass." They said, "You can't pass." I said, "Yeah, I can pass." Obviously no one there had said "no" to them before. They said, "Well, what do you want?" I said "It's not a case of what I want. It's what it needs. What it needs is a good writer." I wanted to bring somebody on and rewrite the screenplay. It took a lot of fighting, but they finally agreed. The guy that I wanted, who I got, was Tom Mankiewicz.

Tom and I sat down, and there were two things we decided it had to be. One was you really had to believe a man can fly. There was just no two ways about it. The effects had to be fantastic. What they had at that point, after quite a few years of pre-production, was terrible. It was like bad TV. The other thing we said was, "It's gotta be a love story. There's gotta be some sort of unrequited love." Because you want to care about these people, as if they are human, and they are human in their own [world].

So with those things in mind, Tom sat down and started that screenplay. He really worked on it diligently for most of the time, while I was preparing to shoot the movie. Because they had commitments to [Marlon] Brando and Gene Hackman. So I had to prepare even before we had a script. The outcome was a great screenplay. It was something that I really loved, and it was a love story. With his father, with his mother…We had Margot Kidder as Lois Lane. It was an impossible, unrequited love. It was much like the film I followed it with shortly thereafter, called *Ladyhawke*. It was another unrequited love. That's always kind of a wonderful note. We wanted them to have their own humanities. So verisimilitude came in, in that they had a reality and we had to stay within it. Of course it could be funny. But it had to be straight.

It's long been rumored that Clint Eastwood and Robert Redford were briefly considered for the role of Superman. And that Nick Nolte was almost signed.
I have no idea what these guys did before me. Although I do know, because some people would come up to me and say, "Oh yeah, I was thinking about doing that." I said, "What do you mean?" They said, "Well, they came to me." I thought everybody they suggested to me was wrong, because you had to believe a man could fly. And when you think of Robert Redford or [Sylvester] Stallone or any of them, they may have been great for the role, but I can't believe them in the wardrobe flying. If you didn't have that, you didn't have the movie. If for a second that failed, you didn't have the film. So, for me, I was desperate for an unknown. We looked at everybody available; we had this great casting director, Lynn Stalmaster. But it had to be a new face or you were out of business, and it had to be a face that believed in himself.

You championed Christopher Reeve, an unknown at the time, in the role that made him a star. What did you first see in him that told you he was Superman?

Honesty. He was so true in his performance to the character he was playing that it was extraordinary to me. I met him when our wonderful casting director brought him in. I immediately cottoned to him. I thought he was really a fascinating kid. He was in a play in the middle of New York where he played a much older character, like a grandfather. It was a typical New York, Off-Broadway play. I went to the theater and I just couldn't believe how wonderful he was. How he just jumped off the stage. So I decided I wanted to screen-test him. His screen test was really tough, because the wardrobe was like a ballerina's outfit that we threw together. His hair was blond—we dyed his hair with shoe polish. He was thin as a rail because he wanted to act and not be a male model. He swore to me, "I can put the weight on. Honest." So all in all, Chris was so sincere, so honest. I totally believed he could do it. And he didn't fail me.

What accounted for the remarkable on-screen chemistry between Christopher Reeve and Margot Kidder? Was it magic, skill, or something in their personalities?

They fell in love with each other...I don't mean [the usual] 'in love.' They so respected each other, they so cared for each other. Margot used to get such a kick out of Chris' dedication to the role. Margot was wonderful, and she was a great comedienne, and she could turn it on or turn it off with Chris. She used to tease the daylights out of him...But what it was was they really loved each other. They were beautiful together. They cared for each other. She was very, very careful that nobody offended him in any way, and he her. They were just as loving off screen as they were on. It was just a very natural, almost impossible, relationship to build. But they built it on the magic of just their humanities. That was on the screen.

Do you have a favorite shot in the film?

Do you have children? Could you say which one is your favorite? That's what it boils down to. Every frame in a picture you put your heart into, you put your love. You have a great cameraman, you work it out, you think it through. It just doesn't happen. It happens because

it becomes part of the movie itself. So it's hard to say what's your favorite shot. The things that are favorites to me are the shots—in the days before the computer, which is kind of my history—that made people say, "Holy sh*t! How did you do that?" Things that you figure out, that had to be done physically. Today, there isn't anything that the writer, director, actor, producer, cinematographer thinks of that can't be done. Because it just takes money. Computers can do it. There was a time when you couldn't do that stuff. It just wasn't possible. Or if it was, it was so time consuming and expensive that it was prohibited. So in *Superman* there's a shot I'm extraordinarily proud of. In those days, when I would go out on tours or lecture at schools, I was surprised at how many people stopped and said, "How did you do that?"

There's a scene where Superman takes Lois Lane flying from her balcony. Then he lands her and she's thunderstruck. She's so consumed by this unbelievable character that she can't think straight. He flies off, leaving her on her balcony. She hears a knock. She makes her way straight to the interior of her apartment. She opens the door, and there's Clark Kent. Her confusion is obvious in the way she talks…Today that's a cinch, but how do you do it in those days? We had no computers. How do you have Chris Reeve, the actor, fly off in one scene, and 13 or 14 seconds later be in a totally different wardrobe, totally different makeup, and at her front door. Nobody questions that today. But it took us a month to figure out how to do it. It's a very complicated process if you want to hear it.

Yes, please.
Okay…What we had to do was build the balcony of her apartment way early, way before we got to that scene. He brings her in and they land. That's done on that balcony. They separate, and as they separate I cut, obviously, so I could do a reverse. But then when I came back around across Lois and Superman, it became an entity. That entity was…Superman's standing there, he climbs on the balcony, he says, "Good-bye, Lois," and he flies away. You see him go from right to left flying through buildings. We hold on Lois for a minute, she turns, she starts to walk, but she kind of stops. I don't know if you notice, but there's a little bit of a blur, a slight blur. Now what happened was, that was a separate piece of film, over

her shoulder of him flying away and her starting to walk. When we shot the scene of her inside, opening the door, we start outside. So what we did was we took that piece of film, of him flying away, and we took the whole background away from her porch, but instead of a background there, we had a screen, a projection screen. On that screen we projected with a massive, probably 1,500-pound projector, called a front projector, and this projector could beam through a piece of glass which bounces the image back. We shot across this projector with a real camera, and the projector was projecting on that screen, in front of Lois, Superman getting up and flying away. As he's flying away, now we photograph Lois, who turns. As she turns, we take that little blurred moment…What we did was we got our motion picture camera away from the front projection camera and dollied it and followed her inside, where Christopher Reeve was waiting. In a totally different outfit obviously, because it was a month later.

Now, it's easy to draw it up, but I don't know if you can understand it. If you can understand it, it was a feat. I mean, we figured that damn thing out, it worked. None of us could believe it! It took forever, but we had a great director of photography named Geoffrey Unsworth, who's since passed away, and we pulled it off…So when you say, "What's your favorite shot?" It's so hard to pick one. But things like that, where we accomplished things that couldn't be done, and had to be done. I'm an old fart, I think. Because I miss all that stuff. I miss the challenge of making movies. Because today I find the majority of films being made, although there are some great ones, so much of it is effects for the sake of effects. The passion is gone, the caring for people, the reality. It all seems to be gone. It bugs the hell out of me. It takes a helluva good movie to convince me today that I'm missing something. I ain't missing nothing. [Laughs.]

What does Superman mean to you?
He personifies hope. He's as pure as the day is long. To the extent of being a total square. That's the beauty of it. There are people like that who walk the Earth today…When I hear Donald Trump—who I try not to listen to—talking on television, I think, *Oh, my God. This is the kind of evil that Superman was on Earth to eliminate.* There's a sense

of evil in the world today, and these people are it. Superman, he's so pure, so honest, to a fault. He'll go on like this forever and ever and ever. Because he personifies something that's very American. It's like waving a flag. I'm not good at it, but I think people just yearn for it. Where did it disappear to? Why isn't it there today? I'm as big a liberal as anyone, I did my years as a hippie and everything else. But what makes Superman keep going? A desire for some sort of wonderful Americana that we had, and has gradually been taken away from us. I'm always saying, "Where are you, Superman, when we need you?" He'll show up again. Believe me.

24 John Williams' "Superman March"

In a career that spans seven decades, John Williams has composed some of the greatest motion picture scores of all time, among them *Jaws, Star Wars, Close Encounters of the Third Kind, Raiders of the Lost Ark, E.T.: The Extra-Terrestrial, Jurassic Park, Schindler's List,* and *Harry Potter and the Sorcerer's Stone.* But his finest score is arguably that of 1978's *Superman: The Movie,* most memorable for its five-minute "Superman March" (or "Main Title March" on the film's soundtrack). It can be heard during the opening and closing credits, as well as numerous times throughout the film. It is a piece of music as intrinsically linked to the Man of Steel as the "James Bond Theme" is to 007.

As director Richard Donner has remarked, Williams' "March" does what the great Superman themes that preceded it—including Sammy Timberg's music for the Fleischer Studios animated shorts of the 1940s and Leon Klatzkin's theme for the *Adventures of Superman* TV show of the 1950s—had done; it seems to actually say the word "Superman." Performed by the London Symphony

Orchestra and recorded in July of 1978, the "March," like most of Williams' finest themes from the period, is credited with re-establishing symphonic music in motion pictures.

Though it shows the influence of 19th century German composer Richard Wagner's *The Ring of the Nibelungen*, the "Superman March" distinguishes itself with a whirlwind of moods and emotions, some in direct contrast to each other. The fanfare is by turns dynamic, suspenseful, commanding, whimsical, romantic, nostalgic, patriotic, witty, sweet, bittersweet, hopeful, triumphant, elegant, and inevitable. In short, it's ideal for both the film and Christopher Reeve's performance as the Last Son of Krypton.

As Reeve himself remarks in the soundtrack album's liner notes, "By the middle of 1978 I had been filming *Superman* for nearly a year and a half and had lost my objectivity about it. But when I went to John Williams' first recording session with the London Symphony Orchestra and heard his score for the opening titles, my spirits soared. His soundtrack for the film is perfect and will always remain a classic."

25 Christopher Reeve

Christopher Reeve never set out to be a superhero or a role model. But the actor wound up epitomizing heroism both on and off screen, and inspiring anyone capable of appreciating courage, hope, and a smile that stretched from here to Krypton.

Reeve was born Christopher D'Olier Reeve on September 25, 1952. The son of a wealthy New York City family that traced its lineage back to the *Mayflower*, he began acting in school plays at the age of nine; he later attended Cornell University and the Juilliard

School (alongside his friend Robin Williams). He first appeared on the big screen in a minor role in the 1978 Charlton Heston naval thriller *Gray Lady Down*.

While acting in the play *My Life* at the Circle Repertory Company in New York, Reeve was invited to audition for 1978's *Superman: The Movie*. Championed by the film's casting director Lynn Stalmaster, the 6-foot-4 blond-haired actor impressed director Richard Donner, screen-tested in London, and won the role. Reeve was much skinnier than the Man of Steel was traditionally portrayed but he promised Donner he'd bulk up, a promise he kept with the help of British actor/bodybuilder David Prowse (best known for playing Darth Vader in the original *Star Wars* trilogy). "I tried to downplay being a hero and emphasize being a friend," said Reeve of *Superman: The Movie* in his 1998 *New York Times* best-selling autobiography *Still Me*.

When the film was released in the United States on December 15, 1978, critics and audiences were transfixed by the almost preternaturally handsome Reeve's tour de force dual performance as the socially awkward Clark Kent and the godly Superman. Reeve followed the blockbuster with a turn in the 1980 romantic fantasy *Somewhere in Time* (co-starring Jane Seymour) and director Richard Lester's 1981 sequel *Superman II*, much of which had been shot by Donner during the filming of the first *Superman*. In *Still Me*, Reeve states, "I think *Superman II* may be the best of the series, because it has some effective comedy but it also has Donner's 'verisimilitude' and respect for the mythology."

Other films followed, including Sidney Lumet's 1982 thriller *Deathtrap* and the Merchant Ivory drama *The Bostonians*, along with more theater work. Reeve returned to play the Last Son of Krypton in Lester's *Superman III*, which he described as "more a Richard Pryor comedy vehicle than a proper Superman film." His final turn in the role was in 1987's ill-fated *Superman IV: The Quest for Peace*, based on Reeve's idea to have Superman rid the world of

nuclear weapons. "The less said about *Superman IV*, the better," said the actor.

Reeve also starred in, among other films, 1987's *Street Smart* (with Morgan Freeman) and 1993's *The Remains of the Day* (with Anthony Hopkins). Soon after, however, his life changed completely. Having learned to ride a horse for the 1985 TV movie *Anna Karenina*, he'd competed in numerous equestrian events since 1989. But on May 27, 1995, he was thrown from his horse, and suffered a cervical spinal cord injury that left him paralyzed from the neck down.

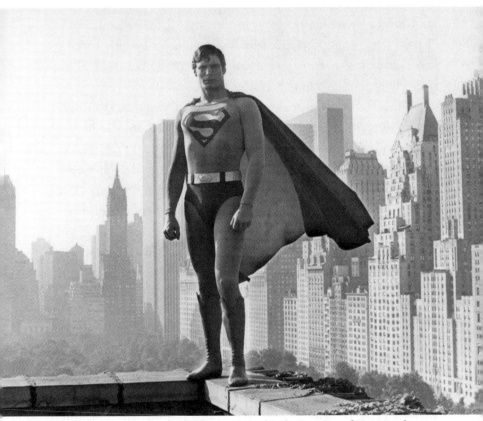

Believing he needed an unknown actor to play the Last Son of Krypton, director Richard Donner cast Christopher Reeve as his star in Superman: The Movie. *It was the role of a lifetime.* (Getty Images)

Reeve briefly considered ending his life, but credited his wife, Dana, with giving him the support necessary not only to go on living but to become a crusader for stem cell and spinal cord injury research. Reeve had long been active in charity work. Now, although a paraplegic confined to a wheelchair, he hosted the 1996 Paralympics, and addressed a Senate Appropriations Subcommittee and the Democratic National Convention. He was elected chairman of the American Paralysis Association and vice chairman of the National Organization on Disability; co-founded the Reeve-Irvine Research Center; and created the Christopher Reeve Foundation (now the Christopher and Dana Reeve Foundation), as well as the Christopher and Dana Reeve Paralysis Resource Center in Short Hills, New Jersey. He also played an integral role in the establishment of the California Institute for Regenerative Medicine.

All the while, Reeve continued to act, with roles in the 1998 TV movie remake of *Rear Window* and in *Smallville* (in the episodes "Rosetta" and "Legacy"), playing Dr. Virgil Swann; he informs Tom Welling's Clark Kent of his Kryptonian heritage. Reeve also started directing, helming 1997's HBO film *In the Gloaming* and the 2004 A&E movie *The Brooke Ellison Story*. He even wrote two books—*Still Me* and 2004's *Nothing Is Impossible*.

Reeve, to his doctor's amazement, slowly began regaining motor function in his body, and was again able to move his left index finger. Sadly, on October 10, 2004, he died of cardiac arrest, the result of an antibiotic administered for one of the numerous systemic infections from which he suffered. Just 17 months later, Dana died of lung cancer. Reeve is survived by his son William, and his two children from his prior partnership with Gae Exton, Matthew and Alexandra—both of whom are now on the Christopher and Dana Reeve Foundation's board of directors.

Reeve refused to be defined by his injury, and never stopped helping others deal with theirs. In that, he demonstrated a strength of will that more than made him a real-life Superman.

Daily Planet Exclusive

Margot Kidder

Margot Kidder had starred in seminal genre films prior to *Superman: The Movie*, most notably the horror classics *Black Christmas* and *Sisters*. But her turn as the world's most famous fictional newswoman, opposite Christopher Reeve's Superman/Clark Kent, forever linked her to the Man of Steel. Kidder has often remarked that she gave the quick-witted, sharp-tongued Lois Lane of director Richard Donner's blockbuster and its three sequels her own personality. In so doing, she became the definitive Lois Lane for generations of fans. Here the acclaimed actress shares her thoughts on working with Reeve and the legacy of the Last Son of Krypton.

Do you ever get tired of talking about Superman?
Well, it's sort of Phase 3 or 4 or something. So it goes in phases. There are times where you just go, "Ugh. Enough already." But now that I've done something my grandkids can watch, I think that's pretty wonderful.

***Superman: The Movie* was Christopher Reeve's first film, but you had done a number of movies. What was your initial take on him?**
That he was this skinny, geeky nerd, and I couldn't figure out why he was playing Superman. He was very awkward and very thin. And his Oxfords were big and bulky with those little holes in the toes, and then pant legs several inches above the ankle. So I was a bit surprised. Then watching him bloom and grow into the part was quite wonderful. Chris is not only a wonderful actor in the movie, he looks more like Superman than was humanly possible. We became very close.

Over the years the two of you maintained your relationship.
A brother-sister relationship. It was like a quibbling brother and a sister who were really close and quibbled a lot. [Laughs.] He was compulsive and tidy and neat, and my dressing room across the hall was mayhem. Then we'd meet up over chess games, and he would get very annoyed when I beat him.

What was your reaction when you first heard of his injury?
Shock, and I wondered if he was gonna be emotionally capable of
rising to the level of spiritual strength that something like that would
take. He rose and surpassed. I mean, I think the second half of his life
was the half to remember. Not the Superman part. Because he really
overcame a lot of hurdles in himself that I know about, that other
people don't, to get to that level of heroics. It was extraordinary.

**Like Christopher Reeve, you appeared on *Smallville*. What was that
experience like?**
Well, unfortunately I wasn't reunited with Chris, which would have
been fun. I would have enjoyed that. The character they gave me was
kind of dull. So it just didn't work out as one hoped. I had hoped at
some point to act with Chris, but then of course he died.

**When he finally did pass away, it seemed as though they wanted to
make your character address his death on *Smallville*.**
They were being really tacky. Let's call a spade a spade. They wanted
the publicity that comes from *TV Guide*, of the real Lois Lane, who was
also a friend of Chris, coming on and announcing Chris' character's
death. I just thought that was pretty shabby.

What have you been up to lately?
I did a couple of conventions. I've mostly been a Montana
grandmother, and loving every moment of my life in a way I never did
when I was wildly ambitious and working all the time. So it's either
getting sane or it's simply this phase of my life. But boy, I like this
getting older stuff. You get rid of a lot of baggage. You just say what
you think and you are who you are, and the crap is left in the dust.
I'm just doing life these days.

**Is there any sort of message that you believe the *Superman* films
impart?**
I think what they do is pretty simple. I think they're morality tales—in
the same way the old Greeks had good-and-evil morality tales—and
they're teaching tools. So for the same reason that people need Jesus
and God in their lives, they need superheroes, frankly. It's basically
wonderful morality, with all of the trappings and the side effects of

71

religion. They learn from that. They learn what's good and what's bad. We all need those. It's almost the purpose of theater, down to its most basic. So I think they're terrific. I think when you get into whole movies about Superman's dark side or something, you're kind of in trouble. Because you've missed the point of a heroic character; that we can never in our own lives live up to, but that we can aspire to, and it makes us all a little bit better.

26 Support the Christopher and Dana Reeve Foundation

For most of us who saw *Superman: The Movie* or *Superman II* when we were children, Christopher Reeve will always be Superman. But the actor embodied his character's strength and courage in his own life as well, never more so than after the 1995 horse riding accident in which he suffered a spinal cord injury that left him a ventilator-dependent quadriplegic for the last 10 years of his life.

Rather than end his life or let his injury crush his spirit, Reeve became as great a symbol for hope as the Man of Steel himself—by continuing to act and direct, and by lobbying for all who experienced injuries such as his. With his devoted wife, Dana, he founded the Christopher and Dana Reeve Foundation.

Headquartered in Short Hills, New Jersey, this charitable organization is, per its mission statement, "dedicated to curing spinal cord injury by funding innovative research, and improving the quality of life for people living with paralysis through grants, information, and advocacy."

Before he passed away in 2004, Reeve explained his belief in the Foundation: "When the first Superman movie came out, I gave dozens of interviews to promote it. The most frequent question

was: What is a hero? My answer was that a hero is someone who commits a courageous action without considering the consequences. Now my definition is completely different. I think a hero is an ordinary individual who finds the strength to persevere and endure in spite of overwhelming obstacles. They are the real heroes, and so are the families and friends who have stood by them."

To learn of the many ways in which you can join Team Reeve and support the Foundation, visit www.christopherreeve.org.

27 Visit the *Daily Planet*

Have you ever wished you could walk in the footsteps of Clark Kent and Lois Lane? Well, you can when you visit the *Daily Planet*.

Used as the exterior of the newspaper's headquarters in both *Superman: The Movie* and *Superman II*, The News Building (aka The New York Daily News Building) is located at 220 East 42nd Street between Second and Third Avenues in Midtown Manhattan. It's a short walk from the 42nd Street subway stop, and an even shorter walk from Grand Central Station. A 476-foot-tall skyscraper, it was completed in 1930 from designs by John Mead Howells and Raymond Hood. In 1989, it was designated a National Historic Landmark by the National Park Service.

The News Building still looks much as it did when the films were shot in the 1970s, with its distinctly detailed front edifice still intact. Its lobby (and revolving door) was also used for an interior shot in the first *Superman* film, in which Lois and Clark leave work for the day and converse while walking around a large globe. In reality, it's the world's *largest* indoor globe, positioned beneath a black domed ceiling. A nearby guard should be able to take your

The News Building at 220 East 42nd Street in Manhattan was used as the exterior of the Daily Planet's *headquarters in both* Superman: The Movie *and* Superman II.

photo as you stand next to it (if you ask politely). Along one wall of the lobby, you'll find a display of photographs illustrating the history of The News Building. Among them is a behind-the-scenes still featuring Christopher Reeve and Margot Kidder during the production of *Superman: The Movie.*

After leaving the building, feel free to swing by nearby Grand Central Station. It too is featured in the film, during the scene in which a pair of ill-fated cops follow Lex Luthor's henchman Otis.

If you'd like to visit the *Daily Planet* from the 1950s *Adventures of Superman* TV show, you'll have to fly to California. It's the Los Angeles City Hall Building, located at 200 North Spring Street in downtown Los Angeles. In 2013's *Man of Steel*, the Chicago Board of Trade Building and Willis Tower served as the paper's exterior and interior lobby, respectively.

28 Supergirl

Unlike her famous cousin, the Maid of Might first saw print in a couple of prototype versions, before arriving in the form for which she's best known. In fact, the first Supergirl, introduced in 1949's *Superboy* #5 ("Superboy Meet Supergirl," by writer William Woolfolk and artist John Sikela), wasn't superpowered at all. Instead, she was the very human Lucy, "girl queen" of the Latin American kingdom of Borgonia. A superb athlete and scholar who was unhappy in her role as monarch, she enrolled incognito at young Clark Kent's school in Smallville, where she soon became friends with Superboy and won the hearts of his town's citizens, who dubbed her "Supergirl." She returned their affection by giving a fund-raising performance of "super-tricks" while garbed

in an orange version of Superboy's own costume (garnished with a queenly fur trim). Sadly, Lucy chose to return to her kingdom and govern it after a tyrant seized power in her absence.

The second proto Supergirl was conjured into existence in 1958 by Jimmy Olsen. After hearing Superman tell Lois she could never be his wife due to the "constant round of super-action and danger" in his life, Jimmy rubbed a jewel on an ancient totem and wished for a companion for Superman with powers equal to his own. Unfortunately, the resulting "Super-Girl," as she's called in *Superman* #123's "The Girl of Steel" (by Otto Binder and Dick Sprang), wound up sacrificing herself (in what would prove to be a bit of foreshadowing) to protect the Man of Steel from a chunk of kryptonite.

The third Supergirl, and the one known around the world today, first appeared the following year, in *Action Comics* #252 ("The Supergirl from Krypton!" by Otto Binder and Al Plastino). Like Kal-El, Kara (blonde, as were her predecessors) was born to Kryptonian parents: Alura and Zor-El, who survived the destruction of their planet when a large domed chunk of it, Argo City, was hurled into space. Eventually, however, a meteor shower pierced the lead covering the surface of the city, and exposed Argo's residents to deadly kryptonite. Taking his cue from his brother Jor-El, Zor-El sent his daughter to Earth, where she emerged from her crashed rocket clad in a blue skirted version of Superman's own costume. Upon finding his cousin, Superman gave her a brown wig and took her to Midvale Orphanage, where she was introduced under the alias Linda Lee. Soon after, she was adopted by Fred and Edna Danvers. Trained by Superman, for whom she served as a "secret weapon," her identity was finally revealed to the universe in 1962's *Action Comics* #285 ("The World's Greatest Heroine!" by Jerry Siegel and Jim Mooney), in a special broadcast from the Fortress of Solitude, followed by a

worldwide tour on which she was welcomed by then President John F. Kennedy.

In the decades that followed, Supergirl fought all forms of injustice, while modifying her costume with the changing times. Like Superboy, she joined the Legion of Super-Heroes, and also fell in love with fellow Legionnaire Brainiac 5. Meanwhile, Linda Danvers worked a variety of jobs, from schoolteacher to TV soap opera star. At first appearing in backup stories in *Action Comics*, she headlined *Adventure Comics* from May 1969 until October 1972, and followed it with a short-lived eponymous title and a stint in *The Superman Family* anthology, which ran through 1982. She then starred in *The Daring New Adventures of Supergirl* (eventually shortened to *Supergirl*) through 1984, when *Superman* movie producers Alexander and Ilya Salkind cast teenaged Helen Slater as the Girl of Steel in their *Supergirl* spinoff film. Directed by Jeannot Szwarc, the film was a box-office disappointment but Slater drew praise for her performance. The actress later portrayed Kal-El's birth mother Lara on TV's *Smallville* and Linda's adopted mother Eliza Danvers on the *Supergirl* TV show. In October 1985's heartbreaking *Crisis on Infinite Earths* #7, Supergirl met her end while saving Superman from the Anti-Monitor. After 25 years, DC Comics management had decided that Superman should once more be the sole survivor of Krypton.

Another Supergirl was introduced by writer-artist John Byrne in his post-*Crisis* Superman reboot. A shapeshifter named Matrix from an alternate universe, she assumed the form of Lana Lang and eventually merged with a new Linda Danvers. This character starred in her own *Supergirl* series, written by Peter David, from 1996 through 2003, eventually sporting a white-topped, two-piece uniform also worn by the Supergirl of *Superman: The Animated Series* (voiced by Nicholle Tom). A new Kara Zor-El then appeared, and received her own title from 2005 until 2011, followed by the *Supergirl* of the rebooted "New 52" DC Universe.

Laura Vandervoort played Supergirl when she made her live-action TV debut on *Smallville*, and became a regular in the show's seventh season in 2007. In 2015, Supergirl finally received her own well-earned TV show, in which she's played by actress Melissa Benoist.

"Superman doesn't remember Krypton," says *Supergirl* executive producer Andrew Kreisberg. "He was born there, but he came here as a baby. As far as he's concerned, aside from the fact that he's an alien, he really is from Kansas. But Kara remembers growing up on Krypton. She remembers her family. So for her it's not this abstract thing. That makes her very different from Superman, and leads to some incredible drama."

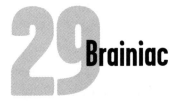Brainiac

Few Superman foes have wreaked as much havoc, or undergone as many significant changes, as Brainiac. But no matter the form he takes, the space villain has from the start held a contempt for humanity, as well as the Man of Steel.

Created by writer Otto Binder and penciller Al Plastino, Brainiac first appeared in July 1958's *Action Comics* #242 ("The Super-Duel in Space"). His appearance in this story—that of a green-skinned, green-and-pink-garbed, white-collared alien—doesn't exactly strike terror, nor does his traveling companion, a white, antennaed, mute monkey named Koko. But the self-proclaimed "master of super-scientific forces" nonetheless provided a challenge to Superman when he shrunk Paris, Rome, London, and New York, and added them to the collection of miniaturized metropolises with which he planned to repopulate his plague-ravaged homeworld, over which

he once ruled. Within Brainiac's collection, the Man of Steel first discovered Kandor, the former capital of Krypton. Though he succeeded in returning Earth's cities to their original size, Superman was, sadly, unable to restore his fellow Kryptonians and their home. On the cover of *Action Comics* #242, Brainiac wore a set of red diodes on his bald cranium, which he did not sport in this debut story. Those diodes soon became part of his Silver Age signature look and backstory.

Brainiac's home planet was said to be the planet Bryak in July 1963's *Superboy* #106, though it was revealed as Colu when the villain underwent his first reboot in February 1964's *Superman* #167 ("The Team of Luthor and Brainiac!" by writers Edmond Hamilton and Cary Bates and penciller Curt Swan). Here, it was explained that Brainiac was actually a computer in humanoid form, free of all human emotion, and built by the Computer Tyrants of Colu (aka Yod) as part of their plan to establish a galactic empire. His diodes were explained as electric terminals. As part of his new background, he was given an adopted son, Vril Dox, to aid him in his tasks; this son, dubbed "Brainiac II," revolted and led an overthrow of the Computer Tyrants. His 30th-century descendant is the Legion of Super-Heroes member Brainiac 5.

Brainiac's next major reboot occurred in June 1983's *Action Comics* #544 ("Rebirth!" by writer Marv Wolfman and artist Gil Kane). In this story, Brainiac inadvertently destroys his physical form, and his "molecular essence" drifts through space, acquiring all the knowledge in the universe before being reborn into something "imbued with life," something "greater than machine." In a chrome exoskeleton, Brainiac sought to conquer the multiverse, requiring the combined might of the Justice League and the New Teen Titans to stop him. This Brainiac was finally destroyed when he took control of Lex Luthor in September 1986's *Superman* #423 and *Action Comics* #583 ("Whatever Happened to the Man of Tomorrow?" by writer Alan Moore and penciller Curt Swan).

Brainiac's first appearance after DC's company-wide reboot of its comic book universe following 1985's *Crisis on Infinite Earths* miniseries was in March 1988's *Adventures of Superman* #438 ("The Amazing Brainiac," by writer John Byrne and penciller Jerry Ordway). This time, Brainiac was said to be scientist Vril Dox, who tried and failed to seize control of Colu from the Computer Tyrants, and whose mind found refuge in the body of human mentalist Milton Fine, whose stage name was Brainiac, and who secretly possessed psychic abilities he used to battle Superman. Dox was eventually forced to find a robotic host body, called Brainiac 2.5, before getting upgraded by his time-traveling future self into Brainiac 13.

Yet another Brainiac was introduced in August 2008's *Action Comics* #866 ("Brainiac (Part I of V)—First Contact," by writer Geoff Johns and penciller Gary Frank). This one was reminiscent of the character's depiction in *Superman: The Animated Series*, a sentient computer that roams the cosmos, stealing cities and laying waste to their planets. The Bruce Timm–produced show's Brainiac—certainly the best screen version of the character to date (chillingly voiced by Corey Burton, who channels *2001: A Space Odyssey*'s HAL 9000 computer)—was built by Jor-El on Krypton, making him a kind of evil brother to Superman.

Brainiac first appeared on screen in Filmation's 1966 cartoon series *The New Adventures of Superman*, and was a member of the Legion of Doom in Hanna-Barbera's 1978 *Challenge of the Super Friends* (voiced by *The Addams Family*'s Ted Cassidy). He also appears in Warner Bros.' 2006 direct-to-video animated movie *Superman: Brainiac Attacks* (voiced by Lance Henriksen). In live action, in TV's *Smallville*, he was played by *Buffy the Vampire Slayer*'s James Marsters.

The most recent iteration of the supervillain, that of DC's "New 52" reboot, draws from various prior versions. But whether man, machine, or something greater than either, Brainiac remains second only to Lex Luthor as the Man of Steel's greatest enemy.

30 Bizarro

Biazzro is the imperfect reflection of Superman. Like Frankenstein's monster, he is a creature to be both pitied and feared, with origins that recall those of the golem of Jewish folklore.

The chalk-white countenanced creation of one Professor Dalton's duplicator ray, Bizarro first appeared in October 1958's *Superboy* #68 (written by Otto Binder and drawn by George Papp). He possesses all of the Man of Steel's powers and most of his memories, though his mind is nowhere near as sharp. Clad in his own Superman suit (originally an exact copy, it came to be a darker version of the Man of Steel's), the adult Bizarro arrived in the daily *Superman* newspaper strip, in "The Battle With Bizarro" storyline, starting August 25, 1958. (It was written by Alvin Schwartz, who insisted he'd come up with the initial idea for the character.) Bizarro's words are the opposite of normal spoken English. "He says 'Hello' when he leaves, 'Good-bye' when he arrives," explains Jerry to Elaine in the *Seinfeld* episode "The Bizarro Jerry." (She responds, "Shouldn't he say 'Bad-bye'? Isn't that the opposite of 'good-bye'?")

Immune to green kryptonite but vulnerable to blue kryptonite, Bizarro eventually paired with Bizarro-Lois, created by Lois Lane with the duplicator ray in order to divert the attention of the creature, who'd become smitten with her. Together, the two Bizarros had children with whom they lived on the cube-shaped Bizarro planet htraE. (Introduced in April 1960's *Action Comics* #263, "The World of Bizarros!" again written by Binder, and illustrated by Wayne Boring.) Since all of the Bizarro world's residents were initially Bizarro duplicates of Superman and Lois, Bizarro wore a medallion around his neck that proudly declared he was "Bizarro No. 1." Beginning in June 1961, "Tales of the Bizarro World" was

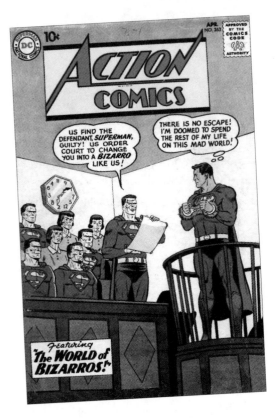

Introduced in 1958, Bizarro is the distorted mirror image of Superman, and one of his most frequent foes.
(Cover art by Curt Swan and Stan Kaye)

a regular backup feature for 15 issues of *Adventure Comics* (#285 through #299), written by Superman co-creator Jerry Siegel and drawn by John Forte. In writer Alan Moore's farewell to the Silver Age Superman, "Whatever Happened to the Man of Tomorrow?" (in September 1986's *Superman* #423 and *Action Comics* #583), it's revealed that Bizarro destroyed his world, since Superman's own native planet Krypton had been accidentally destroyed.

After DC's *Crisis on Infinite Earths* reboot, Bizarro continued to appear in Superman comics, including, most notably, writers Richard Donner and Geoff Johns and artist Eric Powell's three-part tale "Escape from Bizarro World" (in *Action Comics* #855-857), and in the limited series *All-Star Superman* (written by Grant Morrison and illustrated by Frank Quitely). He finally earned his

own series in 2015's humorous *Bizarro* comic (by Heath Corson and Gustavo Duarte).

The character made his television debut in 1978's *Challenge of the Super Friends* cartoon, in which (voiced by William Callaway) he was a member of Lex Luthor's Legion of Doom. He first appeared in live action (portrayed by Barry Meyers) in the 1988 *Superboy* series. Versions of Bizarro also surfaced in *Lois and Clark: The New Adventures of Superman* and *Smallville*. The most affecting Bizarro stories told on screen, which took him back to his roots as a pitiable victim of fate, were featured in *Superman: The Animated Series*, where he was voiced by the same actor as Superman himself, Tim Daly.

Wretched as he is, Bizarro remains a constant presence in Superman's life, evidence that even a Man of Steel can be distorted, if only in a reflection.

31 George Reeves

George Reeves didn't always have the physique one would expect of Superman. According to actress Noel Neill, who played Lois Lane alongside Jack Larson's Jimmy Olsen and Reeves' Man of Steel in the 1950s TV favorite *Adventures of Superman*, "George always had to kind of get back in shape and work out before each [season]." Indeed, Reeves' costume sported padded muscles. But what the actor lacked in abs he more than made up for in charisma, as the screen's first truly beloved Superman.

Born January 5, 1914, in Woolstock, Iowa, as George Keefer Brewer, Reeves began acting in high school. He appeared in a number of films after debuting as one of the Tarleton twins (better known as Scarlett O'Hara's admirers) in the opening scene of

1939's *Gone with the Wind*. In 1951, after *Superman* film serial star Kirk Alyn chose not to reprise his role on TV, Reeves signed on to star in *Adventures of Superman*, which was launched with the B-movie/pilot *Superman and the Mole Men*. Reeves brought a warmth and charm to the role, and ended many episodes with a conspiratorial wink to young viewers. He was also pleasant to those who met him during the personal appearances he made to subsidize his low salary, and gamely guest-starred as Superman on *I Love Lucy* (in the 1956 episode "Lucy Meets Superman"). But Reeves' restrictive contract, and the typecasting that came from playing the most famous fictional character in America, limited the amount of film work he could obtain during *Adventures of Superman*'s six seasons. Fate was also unkind.

"George Reeves had done many good movies," says Neill, "with people like Paulette Goddard. And he got a good part in *From Here to Eternity*. He was so happy: 'A part! A part! A real part!' But when they first ran the movie—for a select group, product buyers or whatever—every time he came on you would hear people [whispering], 'That's George Reeves! That's Superman!' The people who produced the movie just freaked out. So they cut out all of his parts in the movie, and just kept one little identifying part, because he was in the credits. He was just sick about it. I mean, naturally, you know? He was just brokenhearted. Because it was finally a good part away from Superman."

Reeves had an affair with ex-dancer Toni Mannix—the wife of Eddie Mannix, MGM's general manager—with whom he campaigned to raise funds to combat the neuromuscular disease myasthenia gravis. After Mannix and Reeve broke up in 1958, he became engaged to socialite Leonore Lemmon. Shortly before their wedding, with production on a seventh season of *Adventures of Superman* about to begin, Reeves was shot in the head at his Los Angeles home on the morning of June 16, 1959. He died at the age of 45. Speculation still runs rampant regarding who fired the

George Reeves is the definitive Superman for an entire generation of fans. His Adventures of Superman *TV series ran from 1952 to 1958.* (Getty Images)

gun that killed Reeves. Some believe it was Lemmon, or a hitman hired by Eddie Mannix. Others believe an official inquiry's ruling of suicide. All three scenarios were explored in the 2006 film *Hollywoodland*, starring Ben Affleck as Reeves, Diane Lane as Toni Mannix, and Robin Tunney as Lemmon. (Affleck and Lane would later appear in other Superman related films, as Batman/Bruce Wayne and Martha Kent in 2016's *Batman v Superman: Dawn of Justice* and 2013's *Man of Steel*, respectively.)

"Occasionally, people will want to know what happened to George," says Neill, "and they'd have us on a TV show. But Jack would always say, 'Just don't ask us that. Because we don't know!'"

Daily Planet Exclusive

Noel Neill

The first actress to play Lois Lane in a live-action production, Noel Neill starred as the intrepid reporter in two film serials (1948's *Superman* and its sequel, 1950's *Atom Man vs. Superman*), as well as the 1950s *Adventures of Superman* TV show with George Reeves. In the following interview, conducted in 2005, she shares her memories of being a pioneer working woman, and her thoughts on all the Supermen in her life.

You were first cast as Lois Lane in the Superman serials...
Yes, with Kirk Alyn. Right. The thing is, I had worked for that producer [Sam Katzman] before. He did a series of serials for Columbia, and I had worked in a couple. So he knew me, and he told my agent, "Well, she'll be Lois Lane." So I did a couple [of serials]. We did two years of it. We did 15 the first year, and they sold well for Columbia, so we did another 15. Kirk Alyn was very nice. He'd been a dancer in New York I gather, in ballet. So he could leap and jump around. He was okay. We were friends. Of course, I'm fondest of George [Reeves], because I worked with him so long.

How did Kirk Alyn and George Reeves differ in their approach to the role of Superman?

Kirk was very athletic from his dancing—jumping, leaping around, and whatever. But I think George was a much better actor. He was an extremely good actor, and had worked in some big movies before this series. Which I think just buried him. But he grew to say, "Well, that's showbiz, you know?" He was a very, very good actor. I think that was the main difference.

Did you try to approach the role of Lois any differently in the TV show than you had in the serials?

Well, no, not really. In fact, when I did the first one for the producer, I said, "Oh gosh, Lois Lane…" I wasn't into the comics. I think it was a real boys' thing in those days. So I had to go out and find a Lois Lane comic book. [Laughs.] I didn't know what she looked like or how she dressed or wore her hair or whatever.

When I joined the series with George Reeves, the producer had called me and said, "Hi Noel. This is Mr. Whitney Ellsworth." He was sent out to take over everything after they got rid of the producer on the first 26 episodes. He said, "Hi. How would you like to do Lois Lane again?" I said, "Sure, fine, wonderful. Of course. I'd love it!" It was just that simple. I pretty much stayed the same. From the scripts, there wasn't much more you could do. You and Jack [Larson] would just bubble around the office, and be nasty to Clark Kent, and then get tied up somewhere by the heavies, and then Superman would come to save us. But I didn't really change much. It was sort of just being a working woman. A lot of ladies along the way—when I was doing college tours—they said, "Oh, because of you and Lois Lane we had gotten into the men's club." They became workers, in television and TV and radio and theater, whatever. I said, "Oh, it's good to know we did something good!" [Laughs.] They just appreciated it. It made you feel good. It's nice to be loved.

In addition to George Reeves, you and Jack Larson had a terrific chemistry together.

Of course they called us "the kids" on set. Because John Hamilton, the chief, our boss [Perry White], was such a consummate actor. But he didn't look down his nose at us, and he was such a great actor

himself that we kind of felt, "Aw, whatever." But we got through all of that. We became good friends. Jack and I had the same agent. The same bad contract, the same bad agent. So it made us friends. [Laughs.] In fact, we were even closer after we worked together. Because we worked long hours, and you said, "All I want to do is get home, eat, and go to bed." Oh, bless his heart. Jack is a wonderful, wonderful actor.

While the series was in production you also worked on a number of films…
Yes, we had a strange contract. We did 26 chapters in 13 weeks. Then we had a contract from the New York office that gave them two years on us, so to speak, to call us back if it sold, because Kellogg's had gotten into it, and then they had to sell a lot of cereal. We had two years off in between each 26 chapters. So then we were free to do whatever we wanted to. I did a lot of Westerns and a lot of little parts here and there. Then we'd get together again for another 26 weeks. So I worked '53, '55, '57, and '59, but not steady. [Laughs.] But it was kind of nice that way. It broke the monotony. And we all remained friends until the bitter end, so to speak.

Did you ever feel typecast?
It did type us. But I was happy with it. It didn't matter. I had no trouble. When you do a Western, a horse doesn't know what girl's riding on him. [Laughs.]

Initially, our agent called Jack and said, "Jack, I've got a part for you. Thirteen weeks." He said, "Oh, I just wanted to go to New York and Europe again." Because he worked there quite a bit. His agent said, "Jack, do the pictures, do the series, take the money, go back to New York. Nobody will ever see the show." [Laughs.] So he went back to New York. He said, "I was there for just a couple of weeks, and they opened it in syndication in '53 in New York…" And he could not ride the subways or walk down the street! Everybody would say, "Jimmy Olsen! Jimmy Olsen!" We've always laughed about that. And he said it's gonna be on his tombstone. Of course at that time it was in syndication but not really as big as it got. It just went on and on and on and on.

Then I started doing the conventions, which I'd heard about from some of the people who had worked on them. They said, "Oh, you should go out and do them." I found that very fun and entertaining. You travel and meet nice people. I'm Miss Metropolis until I die, they say. [Laughs.] The other business, both Jack and I tried commercials, but that didn't work out too well. So we just hung it up.

When you returned to the world of Superman with cameos in 1978's *Superman: The Movie* and 2006's *Superman Returns*, you apparently had a chance to meet Christopher Reeve...
Oh yes. In fact, it was funny. We filmed in Canada all the childhood stuff for Superman—the young boy and our stuff. Christopher and Margot [Kidder] were working in England. They shot it all at Pinewood Studios. This happened shortly after I worked for them in Canada. I talked to the publicity people and I said, "Gosh, I'll be going through London on my way to Egypt, as a matter of fact." They said, "Oh, why don't you stop and meet Chris and we'll get a little publicity out of that?" I said, "Oh, okay!" So we got to London and called the studio. They said, "We'll send a car and you'll come out and have lunch with Christopher and Margot." I said, "Fine, wonderful." So we did that. My girlfriend and I went out in London. We went out and met him. He was awfully nice, a very nice person. We went on the set, which of course wasn't my thing to do, but [my girlfriend] wanted to do it. I was so surprised. They were still using wires. They had a big stage at Pinewood rigged up. The ceiling had all these tracks with wires, so that they could move from place to place, spot to spot, and still fly. We watched for a while. Chris tried to pick Lois up off a balcony and fly off with her. They did it over and over. I thought, *Oh my gosh. Why didn't they use the frying pan?* That's what I called what they had used to make George Reeves fly.

How do you feel Christopher Reeve compared with George Reeves?
Well, of course he was such a different type. He was very quiet. Once I was doing a show in Atlanta, Georgia, for a school, and somebody found out that Christopher was doing a movie close to us. He had flown in on his own plane. So I said, "Oh, we'll call and maybe he can come and you can introduce him and he'll talk on the auditorium stage." Sure enough, bless his heart, he came over. He was a very quiet person...I

just think that George kind of—maybe because we did it earlier—gave it a little more spark. Christopher was always that type in most of his movies. He was a very quiet actor, and very nice looking. I think that was kind of the main difference. That George tried to put more into that, so he could change to Clark Kent.

When I was doing the college shows, when I'd do a Q and A thing from the audience, it was always fire and fall back. The kids would ask you anything. So I finally had to think of a lot of good answers. Because they would always say, "Oh now. Come on, come on. Didn't you and Superman, um...?" I said, "No, no, no. He had a lady friend who was bigger than I and richer than I." They said, "Oh, okay then." They understood that. [Laughs.]

What do think is the reason for the continued success of Superman and Lois Lane?
Well, people I've talked to say, "When are they ever gonna make any more shows like that?" You know, nice shows that we all can enjoy and remember from our childhood, that children can see. Jack always says, "The world needs a hero." They don't have any. All the movies and things they show now...I don't know. I watch old movies, because there's nothing else. All the destruction from cars breaking, aliens coming down, things blowing up. We didn't do that. We had to keep it quiet and non-bloody because Kellogg's had joined the group. Of course, they wanted to keep it basically a children's show, because the people who sold the cereal were selling us, too. People always have wonderful remembrances, and some of them say, "Oh yes, I used to have a cape, and Mother would be unhappy that I'd be jumping off roofs." They say, "There isn't anything like that that's interesting to watch anymore." So I have to go along with them. Bless their hearts.

32 Mister Mxyzptlk

The most offbeat of all Superman's antagonists, Mister Mxyzptlk has been a thorn in the Man of Steel's otherwise impenetrable side since he first appeared in September 1944's *Superman* #30 (in "The Mysterious Mr. Mxyzptlk," written by Superman co-creator Jerry Siegel and drawn by Ira Yarborough). He first appeared before the public, however, on February 21, 1944, in the daily *Superman* comic strip story "The Mischievous Mr. Mxyzptlk" (written by Whitney Ellsworth and drawn by Wayne Boring).

Born at a time when Supes' enemies (like the Toyman and the Prankster) tended toward the sillier side of supervillainy, this reality-bending, arguably magical trickster figure from the 5th Dimension usually takes the form of a bald, purple-derbied imp. As the living embodiment of chaos within Superman's world, he possesses a pathological need to torment Earth's ultimate symbol of order and justice. He returns to his home only when Superman can outsmart him in a battle of wits, the terms of which "Mxy" himself sets. In DC Comics' pre–*Crisis on Infinite Earths* continuity, Superman was usually required to get Mxyzptlk to say his name backward. Upon so doing, Mxy would retreat for 90 days.

In his later comic appearances, Mxy often broke the fourth wall. He battled his fellow 5th Dimensioner Bat-Mite (Batman's own imp antagonist) in DC's *World's Funniest* one-shot comic, and had his powers stolen by the Joker in the "Emperor Joker" comics storyline. His darkest moment, however, comes in writer Alan Moore's capstone to the Silver Age Superman legend, "Whatever Happened to the Man of Tomorrow?" In that story, after spending 2,000 years as a mischief maker, the immortal Mxyzptlk decides to try being purely evil for a change, and begins killing Superman's friends and foes.

Mxy first entered the dimension of television in "Imp-Practical Joker," a first-season episode of the 1966 cartoon series *The New Adventures of Superman*, in which he was voiced by Gilbert Mack. He also made guest appearances in the *Super Friends* and *Batman: The Brave and the Bold* cartoons. A version of the character appeared in the live-action *Superboy* TV show (played by Michael J. Pollard), *Lois & Clark: The New Adventures of Superman* (as Howie Mandel), and *Smallville* (Trent Ford).

But Mxy's finest TV outing by far is "Mxyzpixilated," a second-season episode of *Superman: The Animated Series*, written by Paul Dini and directed by Dan Riba. Voiced by comedian Gilbert Gottfried (who pronounces his name "Mix-yes-spit-lick"), with a bombshell girlfriend (Ms. Gsptlsnz) performed by Sandra Bernhard, this Mxy is pure id and energy. He provides a perfect counterbalance to Tim Daly's calm, rational Kal-El and is the most entertaining of the show's many villains.

33 *Superman II*

Superman II is one of the great flawed films of the 20th century. Most of it was shot by director Richard Donner while filming his 1978 blockbuster *Superman: The Movie*. But, after a breakdown in his relationship with Alexander and Ilya Salkind, the producers fired Donner upon completion of the first film and replaced him with Richard Lester. Lester had worked with the Salkinds on 1973's *The Three Musketeers* and 1974's *The Four Musketeers* (also shot simultaneously), and served as middleman between the producers and Donner on *Superman*.

In order to receive credit for directing *Superman II*, Lester was required to direct 51 percent of the film, which necessitated reshooting a portion of Donner's footage. With Donner's removal, star Gene Hackman refused to return, and so a double was used for additional shots of Lex Luthor. Marlon Brando too did not return as Superman's father Jor-El, after suing the Salkinds for grossed profits on the first *Superman*. Susannah York, who played Superman's mother Lara, was then brought back, her holographic image replacing Jor-El's in scenes set in the Fortress of Solitude. Other behind-the-scenes changes included cinematographer Robert Paynter replacing the late Geoffrey Unsworth, John Victor-Smith replacing Stuart Baird as editor, and Ken Thorne subbing for composer John Williams (though Williams' themes were again used).

The film's story concerns the blossoming romance between Superman (Christopher Reeve) and Lois Lane (Margot Kidder), and the Man of Steel's decision to give up his powers in order to live his life with the woman he loves. This decision coincides with the accidental release of Kryptonian criminals General Zod (Terence Stamp), Ursa (Sarah Douglas), and Non (Jack O'Halloran) from the Phantom Zone, to which they were banished in the opening scene of *Superman: The Movie*. Refusing to turn his back on his adoptive planet in its hour of need, the Man of Steel regains his powers with the use of the crystal with which he first built his Fortress, outwits his enemies in a showdown at the Fortress of Solitude, and removes Lois' memory of his secret identity and their love affair via a super kiss.

Though released in Australia in December 1980 and in the UK in April 1981, *Superman II* did not open in the US until June 1, 1981. Reviews were strong and audiences embraced its action. It offered the first battle between a superhero and supervillains ever seen in a big-budget mainstream movie. In its original form, however, *Superman II* hasn't aged all that well. Lester's tendency toward camp humor contrasts (jarringly so in the case of the

film's battle scene) with Donner's more sincere approach. There's also a sloppiness to many of Lester's scenes, with British actors retaining their native accents as they play residents of Houston and Metropolis. The reshot footage is also sometimes flat in its cinematography, and often doesn't match Donner's footage, with Lois Lane and Jimmy Olsen (Marc McClure) looking markedly different.

Thankfully, Donner was given the opportunity to produce his own version of the film using his discarded footage, and the result was *Superman II: The Richard Donner Cut*, released on home video on November 28, 2006. While not a perfect film—since *Superman II*'s intended ending, in which Superman turns back time, had long since been used for *Superman: The Movie*—the *Donner Cut* succeeds in making the film's villains more chilling and the Man of Steel's love affair with Lois more heartfelt. And, consequently, that much more tragic.

"*Superman II: The Richard Donner Cut*—that's the sequel," says Marc McClure. "We were all signed for seven movies at the very beginning. We all signed for seven movies. Donner would love to have stayed on. But it was personalities with the Salkinds, and the Salkinds thought Donner was getting a little higher than them or something. The Salkinds pulled the trigger on him, and the rest is history. The movies were never the same."

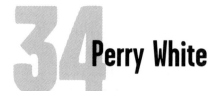

Perry White

The third member of Clark Kent's triumvirate of friends at the *Daily Planet* (after Lois Lane and Jimmy Olsen) is the paper's thundering, cigar-chomping editor-in-chief Perry White. Though

Perry was not Kent's first boss when he became a professional reporter—that honor fell to George Taylor, editor of the *Daily Star*—the character has been a constant in his universe since he first appeared in the February 14, 1940, episode of *The Adventures of Superman* radio serial ("Clark Kent, Reporter"), voiced by New York actor Julian Noa.

Perry made his comic book debut that same year—November 1940's *Superman* #7 ("The Three Kingpins of Crime," by writer Jerry Siegel and penciller Wayne Boring). In pre–*Crisis on Infinite Earths* continuity, White was the reporter who broke the news of Superboy's origin (for which he was awarded a Pulitzer Prize) and of his move to Metropolis. While Clark Kent attended Metropolis University, Perry was promoted to editor-of-chief of the city's newspaper of record. In post-*Crisis* continuity, Perry was given an origin story. Raised in Metropolis' Suicide Slum (aka Southside) area, Perry was a schoolmate of Lex Luthor, who worked his way up from copyboy at the *Planet*. He married Alice Spencer, with whom he had a son, Jerry. But when Jerry reached adulthood, Perry learned he was actually the son of Luthor, who once had an affair with Alice when Perry was believed dead. Both Alice and Jerry first appeared in May 1987's *Adventures of Superman* #428 ("Personal Best," written by Marv Wolfman and pencilled by Jerry Ordway), though Jerry was killed off just a few years later. The Whites later adopted a young orphan named Keith.

The first actor to portray Perry on screen, in the 1948 *Superman* serial, was Pierre Watkin. In 1952, John Hamilton played Perry opposite George Reeves' Clark Kent in the *Adventures of Superman* TV show, and wound up defining the role for decades. It was Hamilton's Perry who made famous the newsman's signature expression "Great Caesar's Ghost!" (parodied to hilarious effect by comedian Phil Hartman in *Saturday Night Live*'s 1992 "Superman's Funeral" sketch), as well as his recurring cry of "Don't call me chief!"

In 1978's *Superman: The Movie*, actor Jackie Cooper made Perry a lovable curmudgeon, and appeared in the film's three sequels. Cooper was succeeded in 1993 by Lane Smith in TV's *Lois & Clark: The New Adventures of Superman* (whose own expression was "Great shades of Elvis!"). In *Smallville*, Michael McKean (the real-life husband of the show's Martha Kent, actress Annette O'Toole) took on the role. Frank Langella played Perry in 2006's *Superman Returns*, in which his son, Richard White, is engaged to Lois Lane. Laurence Fishburne portrayed him in 2013's *Man of Steel* and in 2016's *Batman v Superman: Dawn of Justice*.

Manager, mentor, confidante, and sometimes paternal figure to Lois Lane, Jimmy Olsen, and Clark Kent, Perry White is the heart and soul of the *Daily Planet*, and the living embodiment of its mission to report the truth.

35 Superman and Batman: The World's Finest Duo

The Man of Steel, a shining figure of hope and optimism. The Dark Knight, a grim avenger of the night. They might sound mismatched, but the two comic book icons have long enjoyed one of the most enduring partnerships in pop culture history, due in no small part to their status as outsiders and orphans. But while both lost their parents at a young age, Superman was too young when Krypton exploded to be traumatized by the deaths of his mother and father, and his childhood was a happy one thanks to his adoption by the Kents. The young Bruce Wayne, whose parents were murdered in cold blood in front of his eyes, did not fare as well. The divergent worldviews that resulted from these experiences has sometimes made their relationship an uneasy one.

The Metropolis Marvel and the Gotham Guardian first appeared together (along with Batman's sidekick Robin the Boy Wonder) on the cover of July 1940's *New York World's Fair Comics* #2, as rendered by Jack Burnley. The two made an encore appearance on the cover of March 1941's *World's Best Comics* #1, illustrated by Fred Ray. Both titles were anthology comics, in which the characters would appear in separate stories. With its second issue in June 1941, *World's Best Comics* became *World's Finest Comics*, the covers of which Superman and Batman would appear on throughout the '40s.

Though it was little more than a cameo, Superman and Batman first appeared together in a comic book story when they joined the Justice Society of America in the pages of October 1941's *All-Star Comics* #7 ("$1,000,000 for War Orphans," by writer Gardner Fox and artist Everett E. Hibbard). The two served only as honorary/reserve members of the Golden Age superhero team.

Their first formal meeting was in *The Adventures of Superman* radio show, in the March 2, 1945, episode, the third installment of "The Mystery of the Waxmen" serial. Batman (whose voice was initially supplied by actor Stacy Harris) appeared frequently with his young sidekick on the program, often in order to give the voice of Superman, Bud Collyer, some time off from the show, which was then broadcast every weekday.

Superman and Batman finally partnered together in a comic book story in June 1952's *Superman* #76 ("The Mightiest Team in the World," written by Edmond Hamilton and pencilled by Curt Swan). They began appearing regularly together in stories with July 1954's *World's Finest* #71 ("Batman—Double for Superman!" by writer Alvin Schwartz and penciller Curt Swan); they starred together in every issue of the title until it ended its run in January 1986. The origin of their partnership was retold for the comic book boom of the Silver Age in June 1958's *World's Finest* #94 ("The Origin of the Superman-Batman Team!" by Hamilton and

penciller Dick Sprang). The first team-up between their archenemies, Lex Luthor and the Joker, occurred in May 1957's *World's Finest* #88 ("Superman's and Batman's Greatest Foes!" also by Hamilton and Sprang).

World's Finest ended its run with January 1986's #323—the cover of which depicts the two heroes bidding each other adieu—and the DC Universe was rebooted following the events of the *Crisis on Infinite Earths* limited series. While they had been the best of friends before *Crisis*, in this new universe Superman and Batman served as the most reluctant of allies. Their relationship deteriorated to the point where they fought each other to a standstill in the climactic battle of Frank Miller's landmark 1986 four-issue prestige-format limited series *The Dark Knight Returns*, set 10 years after Batman's retirement, when Superman has become a government flunkie. Writer Mark Waid and artist Alex Ross' 1996 *Kingdom Come* limited series offers another future vision of their falling out. "In a different reality, I might have called him 'friend'," muses Batman to himself as he reflects on their philosophical differences at the end of their first post-*Crisis* meeting in November 1986's *Man of Steel* #3 ("One Night in Gotham City," written and pencilled by John Byrne).

The two form a new, yet still uneasy alliance in the 1990 *World's Finest* limited series, written by Dave Gibbons and gorgeously pencilled by Steve Rude. Writer-artist John Byrne's 1999 Elseworlds limited series *Superman & Batman: Generations* reimagines the two heroes as having first worked together in 1939 at the New York World's Fair (the occasion of their first joint cover appearance). This series, and its 2001 and 2003 sequels (*Generations* 2 and 3), follows Superman, Batman, and their descendants over the course of hundreds of years. Finally, in 2003, the duo received a new monthly team-up book that ran through 2011. Titled *Superman/Batman*, the best of its stories were those written by Jeph Loeb (who'd penned the memorable *Superman*

Superman and Batman have been appearing together in print, on the radio, and on screens since the 1940s. In 2016, they met for the first time in live action in Batman v Superman: Dawn of Justice. (Cover art by Steve Rude)

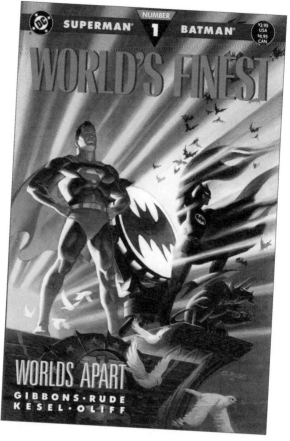

for All Seasons and *Batman: The Long Halloween* limited series) and pencilled by Ed McGuinness. An ongoing *Batman/Superman* monthly was launched in 2013 as part of DC's "New 52" reboot.

As of this writing, the definitive screen version of Superman and Batman's first meeting can be found in the 1997 three-part "World's Finest" episode of *Superman: The Animated Series* (later titled *The Batman/Superman Movie* for its home video release). The two titans meet for the first time in live action in the 2016 feature film *Batman v Superman: Dawn of Justice*, which draws inspiration from Miller's *The Dark Knight Returns* for their confrontation.

36 Darkseid

There's an argument to be made that Darkseid poses an even greater threat to the Man of Steel than his archenemy Lex Luthor; while Luthor, like most of his foes, wants to destroy him, Darkseid has *corrupted* Superman—by turning him into that which he hates most, a force of destruction.

When Jack Kirby left Marvel Comics (after creating much of the Marvel Universe, including the Avengers, the Fantastic Four, and the X-Men), the writer-artist went to DC, where he created his "Fourth World" mythology, introduced in October 1970's *Superman's Pal, Jimmy Olsen* #133 ("Jimmy Olsen, Superman's Pal, Brings Back the Newsboy Legion!"). The homeworld of the old gods (theorized by some to include Kirby's Thor) faced a Ragnarok and was split in two. Two new worlds resulted—New Genesis, a paradise led by the kindly Highfather, and Apokolips, a planet of despair pockmarked by firepits and ruled by the tyrant Darkseid.

Darkseid first appeared in a cameo in November 1970's *Superman's Pal, Jimmy Olsen* #134 ("The Mountain of Judgment!"), and went on to be the primary villain in Kirby's Fourth World titles—*New Gods, Forever People,* and *Mister Miracle.* A gray-stone-countenanced, jackbooted warlord with glowing red eyes, from which are emitted deadly Omega Beams, Darkseid sought to control the entire universe via the Anti-Life Equation, which he believed could be solved by conquering Earth's inhabitants.

In order to do so, Darkseid called on his many followers, including his army of flying parademons, his counselor/torturer Desaad, Granny Goodness (leader of the Female Furies), the mind-controlling Glorious Godfrey, the Apokolips-armed Earth criminals

Intergang, and his own brutish son Kalibak. Opposing them were Darkseid's other son, the moody Orion (given to Highfather when he was a baby as part of a peace agreement), Mister Miracle (Highfather's own son given to Darkseid in exchange for Orion), Big Barda (Mister Miracle's amazon-like wife), the high-flying Lightray (who can soar at the speed of light), and the heroes of Earth, including Superman.

Even after Kirby departed DC (the Fourth World titles were not huge hits), both sides clashed numerous times. But their conflict grew more personal for Superman when the DC Universe was rebooted in the wake of the 1985 miniseries *Crisis on Infinite Earths*. In the 1986 crossover miniseries *Legends* (written by John Ostrander and Len Wein and pencilled by John Byrne), Darkseid sent Godfrey to Earth in an effort to turn the planet's citizens against its superheroes. In March 1987's *Superman* #3 ("O, Deadly Darkseid!" by writer-penciller John Byrne), he succeeded in capturing Superman. And in the follow-up story, March 1987's *Adventures of Superman* #426 ("From the Dregs," written by Marv Wolfman, Jerry Ordway, and Byrne, with art by Ordway), Darkseid, with the help of Godfrey's sister Amazing Grace, brainwashed Superman into using his powers in his service. Thankfully, the Man of Steel's mind was restored by Orion and Lightray.

Soon after, Superman had one of his greatest confrontations with Darkseid, in May 1988's *Action Comics* #600 ("Different Worlds," written by John Byrne and lushly illustrated by Byrne and George Perez), after the despot turned Wonder Woman against the Man of Steel. Darkseid has returned to the DC Universe on several occasions since, most notably 2008's *Final Crisis* crossover miniseries (written by Grant Morrison and pencilled by numerous artists), in which he tried to conquer reality itself.

Darkseid first appeared on screen in 1984's *Super Friends: The Legendary Super Powers Show* (voiced by Frank Welker), a tie-in with Kenner's Super Powers Collection of action figures.

He debuted alongside the other villains of Apokolips in the line's second series (released in 1985), the largest of all the Super Powers figures.

The character proved to be the Man of Steel's greatest opponent in *Superman: The Animated Series* (in which he was voiced by actor Michael Ironside). In the two-part episode "Apokolips...Now," he succeeded in doing what none of Superman's other enemies had done—he killed one of his friends, Dan Turpin, of the Metropolis Police Department's Special Crimes Unit. (Turpin's design and personality were based on Jack Kirby, as an homage to the creator.) In the series' two-part finale, "Legacy," a tale apparently inspired by the events of *Legends*, Darkseid convinced Superman he was his son and set him against Earth, turning the public against him. In a final duel, Superman defeated Darkseid, but to the Man of Steel's shock, the oppressed citizens of Apokolips rescued their fallen ruler, having long grown used to his tyranny.

37 Visit Superman's Home

Only one city in America can lay claim to the title "The Hometown of Superman"—Metropolis, Illinois. But the town has much more to offer the Man of Steel's fans than just a familiar name.

Founded in 1839 and located on the Ohio River in southern Illinois, Metropolis has drawn plenty of inspiration from its fictional namesake and its most famous citizen. Officially recognized as the Man of Steel's home in 1972 by both DC Comics and the Illinois State Legislature, the town was once intended as the location for a Superman theme park, to be called "The Amazing World of Superman." Though the plans for this nirvana—concept art

Superman fans from around the world make the pilgrimage to Metropolis, Illinois, each year for the town's annual Superman Celebration. (Getty Images)

for which, illustrated by Neal Adams, was featured in 1973's *The Amazing World of Superman, Metropolis Edition*—fell through (a result of the decade's gas crisis), Metropolis found other ways to celebrate the Last Son of Krypton.

When one drives into town, they're greeted by an enormous METROPOLIS—HOME OF SUPERMAN billboard featuring Adams' version of the Man of Steel in flight. Located nearby, at 111 E. Fifth Street, is the town's newspaper, the *Metropolis Planet*—named in honor of the *Daily Planet*—complete with a gold globe on its front lawn, the word PLANET encircling it in red.

But Metropolis' biggest tribute is a 15-foot, bronze, full-color statue of Superman, hands planted firmly on hips, the words

TRUTH—JUSTICE—THE AMERICAN WAY chiseled into its base. Standing just outside the town's courthouse, on Superman Square, it makes for the best photo op in the city. (If you're looking for a photo to use on your next Christmas card, visit in December when the statue wears a giant Santa Claus hat.) Located across the street from the statue is the Super Museum, at 517 Market Street, housing one of the world's largest collections of Superman artifacts from the character's entire history, as well as a gift shop. Just a few blocks away, at the corner of Eighth and Market streets, is a life-size bronze statue of Noel Neill as Lois Lane, whom the actress played for five seasons on TV's *The Adventures of Superman* in the 1950s.

Neill has been given the title of "First Lady of Metropolis," in part because of her frequent support of the city's Superman Celebration. Held annually the second weekend of June, the Superman Celebration is hosted by the Metropolis Chamber of Commerce, and attracts admirers from all over the world, as well as celebrity guests from Superman movies and TV shows and Superman comic book creators. To learn more about the event, visit www.supermancelebration.net. Metropolis is a pilgrimage all fans should make at least once in their lifetime.

38 The *Superman* Newspaper Strip

Superman was the first comic book superhero, but he wasn't created for comic books. Writer Jerry Siegel and artist Joe Shuster intended for the Man of Steel to debut in a newspaper comic strip. Like many creators of their era, the two revered adventure strips crafted by the likes of Hal Foster, Milt Caniff, Alex Raymond, and Roy Crane. So the Cleveland teenagers took their brainchild to the

McClure Newspaper Syndicate, the first such syndicate in America. Though McClure initially rejected the character, when Superman proved a hit in comic books, the company launched a daily strip devoted to his adventures on January 16, 1939, mere months after *Action Comics* #1 debuted in April of 1938. A color Sunday strip was added on November 5, 1939.

Unlike most of the syndicate's strips, McClure allowed DC to oversee *Superman*, which was first produced by Siegel and Shuster. Assistants from Shuster's studio began working on the strip in 1939, with penciller Wayne Boring and inker Stan Kaye the most prolific contributors throughout the 1940s. When Siegel was drafted into service during World War II, his fellow writers Whitney Ellsworth and Jack Schiff filled in for him. Following the war, Alvin Schwartz became the strip's most prolific writer. A *Lois Lane, Girl Reporter* strip was created to run across the top of the *Superman* strip, and to serve as filler in case the latter strip ran late.

Win Mortimer and definitive Silver Age Superman artist Curt Swan supplied most of the strip's art in the 1950s, the latter's work some of his finest. Jerry Siegel returned to the strip in its later years, and Batman co-creator Bill Finger was a frequent writer on it throughout the 1960s. The strip's last installment saw print on May 1, 1966.

Among the strip's major contributions to Superman lore were the first bald Lex Luthor, (introduced on November 16, 1940), the first mention of the *Daily Planet* (on November 13, 1939), and the first appearance of Mxyzptlk (in "The Mischievous Mr. Mxyzptlk" serial, which began on February 21, 1944). Other core elements of the Man of Steel's mythos introduced in the strip included the name Krypton and the names Jor-L and Lora (which later became Jor-El and Lara), all of which were given in its first installment on January 16, 1939. The strip's greatest departure from its source material occurred in 1949 when it depicted the marriage of Clark Kent and Lois Lane 47 years before the couple officially wed in

comic books. Two and a half years after it took place, the marriage was revealed to be a dream.

Superman returned to newspapers on April 3, 1978, as a part of the Chicago Tribune-New York News Syndicate's *The World's Greatest Superheroes* strip, which ran until February 10, 1985. The last two and a half years of the strip were devoted to the Man of Steel.

39 Metallo

Among Superman's enemies, there's no greater metaphor of hatred than the "Man with the Kryptonite Heart," better known to the world as Metallo.

Though the name "Metalo" (spelled with one "l") was first given to the titular antagonist in "The Man of Steel versus the Man of Metal," in June 1942's *World's Finest* #6 (written by Superman creator Jerry Siegel and pencilled by John Sikela), and later (as "Metallo") assigned to a robot that fought the Boy of Steel in June 1956's *Superboy* #49 ("Metallo of Krypton," written by Otto Binder and pencilled by Sikela), the best known version of the character debuted in May 1959's *Action Comics* #252 ("The Menace of Metallo," written by Robert Bernstein and pencilled by Al Plastino).

The supervillain began his career as a crooked reporter named John Corben, who was critically injured in a car accident and awoke to find his brain in a near indestructible metal body constructed by Professor Vale. Since his heart was injured beyond repair, the "human robot" was given a synthetic one that could be powered by uranium or kryptonite. After getting a job at the *Daily*

Planet, and attempting to woo Lois Lane, Corben ran afoul of the law when he carried out a series of uranium robberies. Realizing that kryptonite was the more efficient of the two power sources, he stole a supply of it from a Superman exhibit in a Metropolis museum, but suffered a fatal heart attack when it turned out the stolen kryptonite was a mere prop.

Another Metallo, Roger Corben (the brother of John), was introduced in April 1977's *Superman* #310 ("The Killer With the Kryptonite Heart!" by writer Martin Pasko and penciller Curt Swan). This cyborg, like many of Superman's recurring Silver and Bronze Age foes, met his end in September 1986's "Whatever Happened to the Man of Tomorrow?" (in *Superman* #423 and *Action Comics* #583, by writer Alan Moore and penciller Swan).

A third incarnation was introduced in January 1987's *Superman* #1 ("Heart of Stone," by writer-penciller John Byrne), the first issue of a new monthly title launched in the wake of DC's multiverse-shattering *Crisis on Infinite Earths*. This time, John Corben was a petty criminal, again injured in an auto accident and rebuilt with cybernetic technology by Vale, who feared Superman had arrived on Earth to conquer it.

Other iterations followed. In 2009's Superman reboot mini-series *Secret Origin*, John Corben was a US Army sergeant serving under Lois Lane's father (who encouraged his daughter to date him). Injured while attacking Superman in LexCorp armor, he was rebuilt by Lex Luthor into the revenge-minded Metallo. A similar version of the character exists in the more recent "New 52" reboot.

Abandoning the military origin but retaining Luthor's role in his reconstruction, *Superman: The Animated Series* featured the most memorable Metallo in recent decades. Voiced by Malcolm McDowell, who gives the character a cold monotone that perfectly suits his unfeeling body, his strength rivals that of Superman himself. "The Man with the Kryptonite Heart" made

his live-action debut in the *Superboy* TV series (in which he was played by Michael Callan), and returned in *Lois & Clark: The New Adventures of Superman* (actor Scott Valentine), and *Smallville* (Brian Austin Green).

40 The Phantom Zone

Since Superman is the most powerful being on Earth, it hasn't always been easy for comic book writers to create villains who pose a genuine threat to him. The cleverest means of doing so involves the fabled Phantom Zone, a "twilight dimension" containing Krypton's most dangerous citizens.

The Zone began simply enough. Created by writer Robert Bernstein and artist George Papp, it first appeared in a Superboy adventure in April 1961's *Adventure Comics* #283 ("The Phantom Superboy!"); it was discovered when Lana Lang's father, an archaeology professor, found a large, lead-lined metal box in the New Mexican desert. Superboy recognizes the lettering on the box as Kryptonese, and opens it to find a cache of weapons launched into outer space by his father, Jor-El, who's deemed them too destructive to keep. In addition to a disintegrating ray gun and an enlarging device, the Boy of Steel finds a projector used for punishing Krypton's criminals by transporting them to the Phantom Zone, in which they're rendered immaterial and can only observe but not physically affect life outside the Zone. They also cannot age.

The first lawbreakers introduced, via a "thought helmet" in the box, are Dr. Xadu (later Xa-Du), who placed his fellow Kryptonians in suspended animation, from which he was unable to revive them, in the interest of scientific research, and the former military leader

General Zod, who used a duplicator ray to create an army to overthrow the Kryptonian government. When a lizard presses the button that starts the Zone projector, Superboy is transported into the Zone. He escapes by focusing his thoughts on a typewriter and telekinetically typing a letter to Pa Kent, in which he explains how to use the projector to return him to Earth.

Soon after, in June 1961's *Superboy* #89 ("Superboy's Big Brother," also by Bernstein and Papp), Superboy met Mon-El, an extraterrestrial ally with powers similar to his own, whom he at first mistakenly thought was his brother. When Mon-El was exposed to lead (which is as deadly to his race as kryptonite is to Superboy), Superboy saved his life by projecting him into the Phantom Zone. There, Mon-El resided for years, sharing space with mass murderer Jax-Ur, the destructor of Krypton's moon, introduced in October 1961's *Adventure Comics* #289 ("Clark Kent's Super Father," again by Bernstein and Papp); the monster-making geneticist Professor Vakox (later Va-Kox), introduced in January 1962's *Action Comics* #284 ("The Babe of Steel!" by Bernstein and penciller Curt Swan); Jor-El's cousin Kru-El, introduced in May 1962's *Action Comics* #288 ("The Man Who Made Supergirl Cry!" by writer Leo Dorfman and penciller Jim Mooney); and Rog-Ar, who slayed Krypton's endangered species of Rondor beasts in order to profit from the healing powers of their horns, introduced in November 1962's *Superman* #157 ("The Super-Revenge of the Phantom Zone Prisoner!" by writer Edmond Hamilton and penciller Swan). Also introduced in this issue was Quex-Ul, whom Rog-Ar framed for his crime, and who, after being freed from the Zone by Superman, was rendered amnesic while saving the Man of Steel. Superman then found him a job at the *Daily Planet*, where he worked under the name "Charlie Kweskill," unaware of his Kryptonian background.

Later villains included the Kryptonian martial arts master and homicidal misandrist, Faora Hu-Ul, who first appeared in June

1977's *Action Comics* #472 ("The Phantom Touch Of Death!" by writer Cary Bates and artist Swan), and inspired the character of Ursa in *Superman: The Movie* and *Superman II*—which also saw the first appearance of General Zod, as well as the Phantom Zone itself, in live action. The Zone first appeared on screen in a 1978 episode of TV's *Super Friends* ("Terror from the Phantom Zone").

It was revealed in April 1963's *Superboy* #104 ("The Untold Story of the Phantom Zone," by writer Hamilton and artists Papp and Swan) that Jor-El, Krypton's greatest scientist, discovered the Zone and convinced his planet's government to use it as a humane alternative to their previous form of punishment, which involved sending convicts into orbit in a state of suspended animation while a form of mind control was used to eliminate their criminal tendencies (Krypton had no death penalty). After his solution was implemented, however, the sentenced criminals used telepathic hypnosis in an attempt to force Jor-El to free them, prompting him to launch the projector into space.

The villains at long last successfully orchestrated a complete breakout, coordinated by General Zod, in the memorable four-issue *Phantom Zone* limited series (January–April 1982), by writer Steve Gerber and penciller Gene Colan. In this story, Quex-Ul sacrifices himself to save Superman, and, ultimately, Earth. In the series' coda, September 1986's *DC Comics Presents* #97 ("The Final Chapter," by Gerber and penciller Rick Veitch), it's explained how Jor-El first discovered the Phantom Zone, while searching for a means to save his family upon learning of Krypton's imminent destruction.

The Phantom Zone and its inhabitants have since appeared in DC's rebooted post–*Crisis on Infinite Earths* continuity and in the company's "New 52" reboot, as well as on screen in the 1984 *Supergirl* movie, the 1988 Ruby-Spears *Superman* cartoon, *Smallville*, *Superman: The Animated Series*, and the film *Man of Steel*. In the *Supergirl* TV series, Kara Zor-El travels through the

Zone en route to Earth, which causes her to arrive at the same age at which she left Krypton, while her baby cousin Kal-El has since grown up to become Superman.

 General Zod

Some villains take longer to achieve infamy than others. But few have taken a route as unique as one of Superman's most infamous foes—General Zod.

Krypton's would-be conqueror appeared in just three flashback panels of the issue in which he debuted, April 1961's *Adventure Comics* #283 ("The Phantom Superboy," by writer Robert Bernstein and artist George Papp). Described as a traitor who "used a duplicator ray to create a private army to overthrow the government" (each of his soldiers a Bizarro version of Zod himself), the General was sentenced to 40 years in the Phantom Zone. "Down with Krypton!" he shouted as the Phantom Zone Projector sent him into the limbo-like prison. "Someday I'll enslave all its people!"

Zod later tried to take over Earth when Superboy released him from the Phantom Zone after he'd served his sentence, and he gained powers like the Boy of Steel's. But Superboy sent him back to the twilight realm. Zod, whose full name was later revealed to be Dru-Zod, appeared infrequently throughout the 1960s and 1970s, and always in collaboration with other Phantom Zone criminals like Jax-Ur and Faora Hu-Ul. But the warlord's popularity received a major boost when he was chosen as the principal antagonist of the 1981 feature film *Superman II*.

Introduced in the opening scene of 1978's *Superman: The Movie*, in which he was imprisoned in the Phantom Zone by

Jor-El, the character—memorably played by a deadpan Terence Stamp—had goals consistent with those of his comic book counterpart. He also had two henchman, the spiteful Ursa (Sarah Douglas) and the mute, brutish Non (Jack O'Halloran), as well as a much-quoted signature phrase: "Kneel before Zod!"

Though *Superman II* ended with Zod's defeat, the film gave the character a new lease on life. He soon took on a more prominent role in the comic books, leading a cabal of his fellow Kryptonian criminals in the 1982 limited series *Phantom Zone* (written by Steve Gerber and pencilled by Gene Colan).

When the DC Universe was rebooted after the 1985 *Crisis on Infinite Earths* limited series, it was decided that Superman should again be the sole survivor of the planet Krypton. So for 20 years the versions of Zod that the Man of Steel encountered came from parallel universes. The "real" Zod returned in the 2006 *Action Comics* story arc "Last Son" (written by Geoff Johns and *Superman: The Movie* and *Superman II* director Richard Donner, with art by Adam Kubert). This tale marked the comic book debut of Non and Ursa, the latter of whom had a child with Zod, named Lor-Zod. Renamed Chris Kent by Clark Kent and Lois Lane when he arrives on Earth and the two decide to adopt him, Zod's son sent his father back to the Phantom Zone after the events of 2008–09's "New Krypton" storyline. Zod appears in a new incarnation in DC's more recent "New 52" continuity, in which he's again freed from the Zone and imprisoned by Superman in the Fortress of Solitude.

In addition to Terrance Stamp's portrayal, Zod has appeared on screen in TV's *Smallville* (in which he's played by Callum Blue) and in the 2013 film *Man of Steel* (in which he's portrayed by Michael Shannon). The latter's sequel, 2016's *Batman v Superman: Dawn of Justice*, sees Zod return as a major plot element.

42 Wayne Boring

While Joe Shuster designed Superman, and was the man most responsible for the character's look throughout his early years, the artist who came to define him visually throughout the 1950s was Wayne Boring.

Boring—who was born in Minnesota on June 5, 1905, and attended the Minnesota School of Art and the Chicago Art Institute—was recruited by Superman creators Shuster and Jerry Siegel to work in their Cleveland studio, as one of Shuster's ghost artists. Speaking with Richard Pachter in *Amazing Heroes* #41 (February 15, 1984), Boring explained how he and Shuster collaborated on layouts: "At first, Joe would sketch it out pretty lightly and we'd work over it. Later, he developed something wrong with his hand and his eyes were very bad. He already wore thick glasses."

After starting on Siegel and Shuster's Slam Bradley and Doctor Occult stories, Boring came to work on the Man of Steel, illustrating both the character's comic book and newspaper-strip adventures, the latter of which he also inked. "We had an office about 12' by 12' with four drawing boards set up there. Jerry had a desk in the anteroom. But it was the smallest office in Cleveland," Boring said.

Boring's style developed, and the team moved to New York City in 1940. Though he was initially uncredited for his work, his take on Superman grew to be unmistakable. Handsome, with a narrow face and a barrel chest, almost godlike in stature, his was the first version of the character completely true to his Nietzschean namesake. In 1942, the artist was hired by National Comics, and his version of Superman became the company's most prominent.

Boring was the principal Superman illustrator for the 1950s, seeing the character into the Silver Age of Comics.

One of his most seminal stories was "The Origin of Superman"—written by Batman co-creator Bill Finger—for the character's 10th anniversary in *Superman* #53 (August 1948). In it, he presented his version of Krypton, a shining, futuristic world of super science that would influence generations of comic book creators to come. Boring was also the first artist to draw the Fortress of Solitude, in June 1958's *Action Comics* #241 ("The Super-Key to Fort Superman," written by Jerry Coleman); the first to draw Bizarro World, in April 1960's *Action Comics* #263 ("The World of Bizarros," written by Otto Binder); and the first to draw Superman's "mermaid sweetheart" Lori Lemaris, in May 1959's *Superman* #129 ("The Girl in Superman's Past!" written by Bill Finger). His best Superman tale saw him reunited with Jerry Siegel—November 1960's *Superman* #141 ("Superman's Return to Krypton!"), in which the Man of Steel travels through time and space to meet his parents, and winds up falling for a Kryptonian actress named Lyla Lerrol amidst the beauty of his native planet.

Boring was dismissed from DC by the company's notorious Superman editor Mort Weisinger in 1967. After contributing for several years to Hal Foster's *Prince Valiant* newspaper strip, he got a job as a part-time security guard at a bank in Florida, pencilled a few final Superman stories in the 1980s, and died February 20, 1987, at the age of 81. In 2007, 10 years after his death, he was inducted into the Will Eisner Hall of Fame at the San Diego Comic-Con International. His name will echo forever from the great halls of the Fortress of Solitude to the Fire Falls and Rainbow Canyon of Krypton.

43 Lois & Clark: The New Adventures of Superman

Sweet, funny, and sexy, TV's *Lois & Clark: The New Adventures of Superman* proved, in its four seasons, that the Superman mythos could be as meaningful to fans of romantic comedies as it was to action junkies.

The show's pilot, a double-length episode retelling Superman's origin, aired the night of September 12, 1993. Inspired by the post–*Crisis on Infinite Earths* reboot of the character, *Lois & Clark* featured a more assertive and charismatic Clark Kent than had been traditionally portrayed in comics, played by 27-year-old, 5-foot-11½, former college sports star Dean Cain, opposite 29-year-old former *MacGyver* star Teri Hatcher. From the start, the two photogenic actors had an undeniable chemistry that earned *Lois & Clark* a loyal (if not overwhelmingly large) following. The post-*Crisis* businessman persona of Lex Luthor was portrayed in live action for the first time by John Shea, who gave the villain a debonair charm to hide his twisted heart, putting him in sharp contrast with Cain's wholesome, earnest Man of Steel. Hatcher's comic timing would eventually land her a lead role in the hit *Desperate Housewives*. Additional charisma was supplied by the show's supporting cast, with Lane Smith as a rambunctious Perry White, Michael Landes as a game Jimmy Olsen (succeeded by Justin Whalin in Seasons 2 through 4), Tracy Scoggins as the first live-action Cat Grant, and Eddie Jones and the quirky K Callan as Jonathan and Martha Kent.

The show's first season was its strongest, due in large part to the love quadrangle between Lois, Clark, Superman, and Luthor, which concluded with Lois leaving Luthor at the altar for Clark. Unfortunately, Shea, Scoggins, and creator Deborah Joy Levine

left the show after its first season (though the actor would return for a few additional episodes throughout its run). And the original villains that succeeded his Luthor were never as threatening; the series featured the live-action debut of the Toyman (Sherman Hemsley), and appearances by Metallo (Scott Valentine) and Mister Mxyzptlk (comedian Howie Mandel). Actor Richard Belzer portrayed Inspector Henderson in four episodes, and genre veteran David Warner appeared in two as Jor-El.

The titular lovebirds finally married in the fourth-season episode "Swear to God, This Time We're Not Kidding," which aired October 6, 1996. That same week saw the arrival of *Superman: The Wedding Album*, a one-shot special in which the couple's long courting comic book counterparts also tied the knot. But sagging ratings soon prompted ABC to pull the plug on *Lois & Clark*, and its final episode aired on June 14, 1997. It lives on as a favorite of the hopeless romantic subset of Superman fans.

"I loved Deborah Joy Levine," says John Shea. "I loved her. Deborah Joy Levine was on the same wavelength, and was happy that I understood what she was driving toward, then was open to my own contributions regarding how Lex Luthor should be interpreted. All I can tell you is that I had a real creative collaborator, who, while she paved the way, was open to ideas from everyone. That's just the way she was. She was fantastic."

Daily Planet Exclusive

Dean Cain

Dean Cain was planning a career in professional sports when an injury led him to pursue acting. He wound up being the first actor to portray the Man of Steel on screen in a live-action production after Christopher Reeve—opposite Teri Hatcher's Lois Lane in 1993's *Lois & Clark: The New Adventures of Superman*. He returned to Superman's TV universe, playing the villainous Dr. Curtis Knox, in *Smallville*'s seventh-season episode "Cure," and, most recently, Jeremiah Danvers, Kara Zor-El's foster father, in CBS' *Supergirl*. The following interview was originally conducted for *SFX* magazine in September 2007.

Did you get any souvenirs from the *Lois & Clark* set?
Yeah, I have a suit. I have a suit with a cape and boots. I have an actual suit.

Would you ever want to go back to the role?
Superman? I love the character. It was a lot of fun. So would I consider it? Sure.

Where do you think your Superman would be now?
I think he would be where I was hoping the show would have gone. I think Lois and Clark would have a few children, and I think they'd be absorbed in their children's lives. Most parents are absorbed with their children's lives. I think they'd have some kids, some super kids, and they'd have some superpowers, things like that. I think that would be an awful lot of fun. But they would have still kept their individuality and still maintained doing the thing that they were doing—being journalists, fighting for truth, justice, and the American way—while raising a few kids who would have their own super problems. I wish that we had explored there, got into that. They touched on it in *Superman Returns*—the kid had half-superpowers. That's where I was hoping we'd go with the show.

Would any of Superman's skills have helped you in real life?
It would be nice to fly like he does. Traffic wouldn't be an issue, being able to help somebody wouldn't be an issue. That'd be really fantastic.

What would it say on Superman's headstone?
It would say Still Alive and Kicking Evil's Ass. And—if you want a more serious one—Superman Will Never Die. Because Superman will never die. He's an ideal.

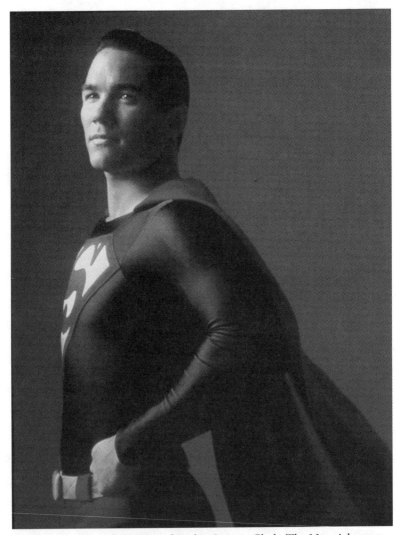

Dean Cain portrayed the Man of Steel on Lois & Clark: The New Adventures of Superman *from 1993 to 1997.* (Getty Images)

Daily Planet Exclusive

John Shea

The first person to make Lex Luthor sexy, actor John Shea brought a charm and elegance to Superman's archenemy on TV's *Lois & Clark: The New Adventures of Superman* that made for a memorable love triangle with Dean Cain's Man of Steel and Teri Hatcher's Lois Lane. At the same time, he balanced the show's upbeat escapism with a steady undercurrent of wickedness.

Did you grow up with comics?
I was a Superman fan. I grew up in Massachusetts, in a city called Springfield, which was a relatively provincial city. We were educated but we didn't have movie theaters. So comic books were the one thing I could afford as a young guy, and also lose myself. So certainly I knew the Superman mythology as a kid. But when I went to college and started studying Karl Jung and Freud and symbols of the subconscious, and Nietzsche, I began to understand what Siegel and Shuster had tapped into. Which was something primordial in the collective unconscious—the need to create larger-than-life archetypes that played on the grand stage of human drama the way the Greek gods did for the Greeks and the Roman gods did for the Romans. I remember watching George Reeves on an old black-and-white TV and thinking, *Oh my God, how great is this? Faster than a speeding bullet and able leap tall buildings in a single bound...* This became a litany to me as much as the rosary did going to Catholic church.

How did you come to play Lex?
Believe me when I tell you that I never dreamed that I would ever play in any version of the Superman mythology. But I was living in Los Angeles in the early '90s, and I can remember the script arriving and thinking, *This is really interesting.* Because it was very different in tone than the Superman mythologies that had been recently done, that Chris Reeve had done.

Chris and I were friends. We had the same agent in New York, and we had come up through the New York theater together. So I was aware very much of that big-screen version of Superman. I remember

seeing the Gene Hackman version of Lex Luthor and thinking, *That's a very interesting take on it.* Then as I read Deborah Joy LeVine's script...I saw how Lex Luthor dressed. I knew that he looked and acted kind of like Cary Grant, and that he thought like Richard III, who I think was one of the great villains ever written. But William Shakespeare's Richard III is usually played by a guy with a hunchback and you kind of figure out that he is a villain from the moment he comes out on stage. I knew that what Deborah Joy Levine had in mind was very different from that, and I knew that modern villains don't look like villains. They look like the guy next door. They look like your friendly banker. They look like the heads of major American corporations.

The other thing I knew that came to mind as I read the script for the first time was that Lex Luthor was a classic sociopath. Sociopaths are people who are driven by unconscious appetites, appetites that they're not even aware of. They, like spiders, weave webs into which people fall when they cross an invisible line that the sociopath has drawn for them. I thought, *How interesting it would be if Lex Luthor was driven by similar appetites. But that he didn't give it away, except privately at certain moments.* He kind of looked like a leading man, but thought like a villain.

I called my manager and I said, "Oh god, I know how to play this guy. I want to go over to Warner Brothers. I want to meet with them." I went into my closet and I put on my best Armani suit, and my best tie, and my really expensive shoes, and I drove to Burbank. And I went in to meet the casting director and I met Leslie Moonves, the head of Warner Brothers television at that time. Leslie was like, "Wow, okay. That's good." Then I met with the people at ABC. I went into the audition with a certain amount of Luthorian confidence. By the time I got home my phone had rung and I'd been offered the part. All I can tell you is that it changed my life.

What were your thoughts on your co-stars?
When I came to the first reading of *Lois & Clark* at Warner Brothers, sitting opposite me was Teri Hatcher. We had the same management company and it turns out we had the same agent. So we were kind of on the same team in Hollywood. I was very happy that it was Teri because I had met her before and I knew she was a terrific actress. Of course, the new guy was Dean Cain. And Dean, what a fantastic

guy. Incredibly smart, very charming, the chiseled young hero you'd imagine Clark Kent/Superman to be. That was the first meeting, and we knew the minute we finished reading the first script as we all sat around the big table at Warner Brothers that it was gonna be great.

One of the great things about your Lex is how his surface zest for life contrasts with Superman and the pleasure he denies himself. What interested me about Lex was that yes, he enjoyed life and he had a sense of humor and charm and he loved playing that political and social game. But I honestly felt that deep down he was unhappy. Because one, he lacked real love. Because when you are Lex Luthor, you don't really trust anybody to love you for yourself. And two, he's bored. He's a competitor and he got to the top because he fought his way to the top. I really liked that he was a self-made man. But he's bored. In the pilot, Superman flies up on his balcony in a suit and says, "I know who you are." And Luthor says, "Let the games begin." Because he is so happy. [Laughs.]

44 The Death of Superman

One of the biggest events in comic book history, the "Death of Superman" was born out of necessity. Superman editor Mike Carlin's stable of writers and artists were gearing up for the long-awaited wedding of Lois Lane and Clark Kent. But when *Lois & Clark: The New Adventures of Superman* was announced, the team was asked to postpone the nuptials so that they would eventually coincide with those on the show. A new storyline was conceived, with a decidedly less pleasant outcome for the couple.

Presented in seven chapters, the "Death of Superman" (sometimes referred to as "Doomsday!") ran through five titles dated December 1992 and January 1993: *Superman: Man of Steel*

(written by Louise Simonson and pencilled by Jon Bogdanove), *Justice League of America* (written and pencilled by Dan Jurgens), *Superman* (written and pencilled by Dan Jurgens), *Adventures of Superman* (written by Jerry Ordway and pencilled by Tom Grummett), and *Action Comics* (written by Roger Stern and pencilled by Jackson Guice). A four-part prologue was featured in the four Superman titles the month prior. The story centered on Superman's efforts to stop a mysterious monster of unknown origin named Doomsday from destroying Metropolis, after his teammates in the Justice League failed to do so. The pace builds steadily throughout the tale via the page layouts used, with four panels per page in Part 4, and the number of panels decreasing in each successive issue until there's only one panel per page in the seventh and final chapter (with the last two panels spread across two pages each). The final image of Superman's torn cape billowing in the wind was used on the cover of the concluding issue in January 1993's *Superman* #75, which featured the Man of Steel's actual death.

Two versions of this issue were made available to readers—a regular newsstand edition and a collector's edition available in comic book stores. The latter consisted of a black plastic bag emblazoned with a bloody "S" shield, inside of which were sealed the comic, a memorial poster, commemorative stamps, a trading card, Superman's obituary in the *Daily Planet*, and a black "mourning armband." (A third, numbered edition was made available to comic retailers.)

An estimated 6 million copies of the story were sold, and a media frenzy erupted on November 18, 1992, the day of the book's release in stores. CNN covered the event, radio stations played music tributes to the fallen superhero, and, across America, comic shops were packed, with lines of speculators running out their doors. Since many of these customers didn't regularly buy comics—and were apparently unaware of the common practice of resurrecting characters—there were more than a few folks

Fans flocked to comic book stores in 1993 to read about "The Death of Superman." Those unfamiliar with comic books were surprised when his afterlife proved to be short-lived.

(Cover art by Dan Jurgens and Brett Breeding)

disappointed to see Superman return to life the following year. Some claim the "Death of Superman" contributed to the collapse of the comic book speculator market in the mid-1990s.

Several adaptations followed, including *The Death and Return of Superman* video game, a novel by Roger Stern (*The Death and Life of Superman*), a *Superman: Doomsday & Beyond!* radio drama in the UK, and a *Saturday Night Live* sketch parodying Superman's funeral. The actual funeral occurred in the follow-up storyline "Funeral for a Friend" (collected as *World Without a Superman*), which in turn was succeeded by "Reign of the Supermen!" (in which four newcomers sought to become Metropolis' protector), and, finally, "The Return of Superman," which concluded in October of 1993.

A direct-to-video animated film adaptation, *Superman: Doomsday*, was released in 2007, produced by Bruce Timm

and featuring Adam Baldwin as the voice of the Man of Steel. Doomsday himself made his screen debut in Timm's *Justice League* animated series (voiced by Michael Jai White). His live-action debut occurred in TV's *Smallville*, in which, as the eighth season's villain, he was played by Sam Witwer (as a human) and Dario Delacio (as Doomsday). The character was introduced on the big screen in *Batman v Superman: Dawn of Justice*.

While "The Death of Superman" may have disappointed speculators, it accomplished its primary goal of renewing the world's fascination with the Man of Steel, demonstrating once more that the most powerful man on Earth would give his life for all people.

The Five Greatest Superman Spoofs

Almost everyone has made fun of Superman at one time or another. Here are five of the most successful attempts.

Super Rabbit

Released on April 3, 1943, by Warner Bros., *Super Rabbit* is one of legendary animation director Chuck Jones' earliest Bugs Bunny shorts, created just a couple of years after Fleischer Studios released its first *Superman* cartoon. It finds the wisecracking hare subject to laboratory testing that gives him superpowers, which he immediately uses to battle rabbit hunter (and Yosemite Sam prototype) Cottontail Smith. Produced at the height of America's involvement in World War II, it ends with Bugs running off to join the US Marines—who, in real life, inducted the wascally wabbit into their ranks to show their appreciation.

"Superduperman"

Cartoonists Harvey Kurtzman and Wally Wood's "Superduperman," which debuted in *Mad* #4 (April-May 1953), was the first time the Man of Steel encountered Captain Marvel—or at least versions of the characters met. The tale of "Clark Bent" (who lusts after "Lois Pain"), it lampooned DC's then current lawsuit in which the company forced Fawcett Publications to cease printing the good Captain's adventures. It was also the first of the groundbreaking humor magazine's stories to parody a specific fictional character as opposed to an entire genre. And its depiction of less than perfect superheroes helped inspire Alan Moore to write *Watchmen*.

"Bicycle Repair Man"

This first-season *Monty Python's Flying Circus* sketch (first broadcast on October 19, 1969) presents a world in which everyone is a superman; the fellow who does the most menial of tasks, repairing bicycles, is admired above all. "Is it a stockbroker? Is it a quantity surveyor? Is it a church warden?! No! It's Bicycle Repair Man!" The title character is played by Michael Palin, who later played Adolf Hitler in a 1979 *Saturday Night Live* spoof that asked the question, "What if Superman grew up in Germany instead of America?" There's not much of a punchline here, but watching *Python* sketches for punchlines is like reading the Bible for its stock tips.

"Superman's Funeral"

Saturday Night Live has offered a handful of memorable Superman-themed sketches in the last 40 years, including 1979's "Superhero Party," with Margot Kidder reprising her *Superman: The Movie* role as Lois Lane, and 2000's "Clark Kent," in which The Rock (aka Dwayne Johnson) plays the most careless mild-mannered reporter ever. But the best of them is "Superman's Funeral," which bowed on November 21, 1992, in the wake of the Man of Steel's death in *Superman* #75. The sheer number of famous performers playing

comic book staples makes it a must see, including Al Franken as Lex Luthor, David Spade as Aquaman, Adam Sandler as the Flash, Tim Meadows as Green Lantern, Phil Hartman as cigar-chomping Perry White, Dana Carvey as a bawling Batman (with Chris Rock as his Robin), and Sinbad as Black Lightning—who arrives late, gets thrown out, and sneaks back in in order to steal food. Best of all is Chris Farley as the Hulk, who admits he's "not good with words," until he whips out a pair of reading glasses and delivers a eulogy with perfect diction.

Mighty Mouse: The New Adventures

Mighty Mouse has been a parody of Superman since he was created by producer Paul Terry for the 1942 short *Mouse of Tomorrow* (in which he was called Super Mouse). The character's 1987 TV series, however, produced by adult animation maverick Ralph Bakshi, remains his finest hour. Not only did it re-introduce madcap comedy to American TV animation after the medium had served for years as mere toy advertisement, but it ushered in a new generation of talent that would reshape the cartoon landscape in the years that followed; among them *Ren and Stimpy* creator John Kricfalusi and Bruce Timm, who would produce *Superman: The Animated Series*.

46 The First Superman Novel

Since the Man of Steel was inspired in part by pulp heroes like Doc Savage, it was only a matter of time before Superman's exploits, like those of his forebears, were captured in a prose novel. The first Superman novel ever published was penned by George Lowther, a

scriptwriter, narrator, and director for *The Adventures of Superman* radio serial.

Illustrated by Superman co-creator Joe Shuster (or, more likely, his studio of artists) and published in 1942, *The Adventures of Superman*'s story, intended for children, is unexceptional—Kal-El is sent to Earth from Krypton and becomes Clark Kent, who in turn becomes Superman and foils Nazi spies. But it contributed greatly to the Man of Steel's early mythology. Krypton was depicted in detail for the first time, and Lowther gave the names Eben and Sarah to Superman's adoptive parents—the names later used in the George Reeves–starring *Adventures of Superman* TV show. Those names didn't stick, but the names Lowther gave Superman's birth parents did: the previously used Jor-L and Lora became Jor-el and Lara.

Additionally, Lowther's book marked the first time that Clark Kent's first name was said to be Ma Kent's surname before she married, as well as the first time that Pa Kent, as he takes his final breath, tells his son to use his mighty powers for good.

47 Krypto the Superdog

Krypto! The name alone brings a smile to every Superfan's face, just as the snowy white Dog of Steel has brought joy to Clark Kent since his debut in March 1955's *Adventure Comics* #210 (written by Otto Binder and illustrated by Curt Swan). Originally the baby Kal-El's pet on Krypton, Krypto was used by Jor-El to test the rocket with which he would save his son from their planet's destruction. Instead, the pooch's ship was knocked out of a trial run by a meteor, and he eventually landed on Earth. To Superboy's

delight, Krypto became the first of his fellow Kryptonians to appear on his adopted planet. Like his master, with whom he communicated via a form of barked Morse code, Krypto possesses the powers of flight, super strength, invulnerability, and X-ray vision, as well as a vulnerability to kryptonite. Emulating Superboy, he built his own fortress retreat, the Doghouse of Solitude, located in deep space. He also founded and led a group of similarly powered animals, the Legion of Super Pets (introduced in February 1962's *Adventure Comics* #293), whose ranks include Supergirl's pet cat Streaky and her horse Comet, along with Beppo the Super-Monkey and (pub trivia night participants, take note) a shapeshifting lump of alien protoplasm known as Proty II (yes, there were two such creatures).

First depicted on screen in the "Adventures of Superboy" segment of Filmation's animated *The New Adventures of Superman* in 1966, versions of Krypto went on to feature in episodes of the *Legion of Super Heroes*, *Batman: The Brave and the Bold*, and *Young Justice* cartoons, as well as in the live-action *Smallville* and in the video games *DC Universe Online*, *Lego Batman 3: Beyond Gotham*, and *Infinite Crisis*. In March 2005, Krypto finally received a TV show of his very own: *Krypto the Superdog*, in which the title character (voiced by Sam Vincent) was rendered in the Hanna-Barbera animation style of *Scooby-Doo* and *Dynomutt*. Developed by *Superman: The Animated Series* producers Paul Dini and Alan Burnett, the series ran for two seasons, in which the Dog of Steel battled evil alongside his animal friends, including Batman's canine companion, Ace the Bat-Hound.

"I just think Krypto's a very big part of Superman's history," says Dini, "that humanized Superman very much. Superboy was fine, because a boy and his dog. But the fact that Krypto was still around when Superman was an adult, I always liked that…Krypton has flying rhinoceros-dragon beasts, so why not a dog?"

Al Plastino

Quick—what do Supergirl, Brainiac, Metallo, the Parasite, kryptonite, the Bottle City of Kandor, and the Legion of Super-Heroes have in common? The answer is that they were all first drawn by artist Al Plastino.

Wayne Boring succeeded Superman co-creator Joe Shuster as the character's principal illustrator, and Boring in turn was succeeded by that most prolific of all the character's artists, Curt Swan. But things often happen in threes, and there's no doubt that Plastino was the third-most-important renderer of the Man of Tomorrow throughout the Silver Age of Comics.

Born December 15, 1921, in New York City, Plastino served in the Army during World War II. As was the case with so many artists who served, his skills were noticed by his commanding officers and put to use in the military. His earliest Superman work was done in imitation of Boring's. But Plastino was gradually permitted to use his own style on the character, distinguishing his stories at a time when comic artists were all too often encouraged to be interchangeable clones. Plastino's approach was just a little more cartoony than Boring's and Swan's, and his faces a little less angular, less fussy. Like the best minimalists, he could accomplish in just a few lines what appeared to take others untold amounts of ink.

His first significant Superman tale was "Superman Returns To Krypton!" written by Batman creator Bill Finger, in *Superman* #61 (November 1949), in which the Man of Steel first learned of his native planet, as well as his most famous weakness (kryptonite had appeared previously on the character's radio show). Plastino later followed it with such classics as "The Legion of Super-Heroes,"

written by Otto Binder, in *Adventure Comics* #247 (April 1958)—in which Superboy meets the 30th century's Cosmic Boy, Lightning Boy (later Lightning Lad), and Saturn Girl; "The Super-Duel in Space" in *Action Comics* #242 (July 1958)—wherein Superman first battles Brainiac, and discovers the space villain has shrunken the former capital of Krypton; and "The Supergirl from Krypton!" in *Action Comics* #252 (May 1959)—introducing Superman's cousin Kara from Krypton (whose blonde bob was based on that of Plastino's wife, Anne Marie).

Plastino's most moving Superman story became so, sadly, due to circumstance. "Superman's Mission for President Kennedy," written by E. Nelson Bridwell, saw the Man of Steel reveal his secret identity to the 35th president of the United States while promoting physical fitness to the country's young people. Intended for *Superman* #168, in which it would have been illustrated by Curt Swan, its publication was cancelled after President Kennedy's assassination in November 1963. At the request of President Lyndon B. Johnson, DC proceeded to publish the story, this time pencilled and inked by Plastino, in July 1964.

Plastino would go on to illustrate the *Superman* newspaper comic strip (as well as the *Batman* strip). His last Superman art can be found in the pages of the one-shot special *Superman: The Wedding Album* (December 1996), showcasing the long-awaited wedding of Lois Lane and Clark Kent. The artist died on November 25, 2013, at the age of 91.

"I did my job, and I never took comics that seriously," said Plastino in *The Legion Companion* (Glen Cadigan, TwoMorrows Publishing, 2003). "It was a job and I did it, and that was it."

Though his job is long completed, Plastino's legacy, like that of Superman himself, is never-ending.

49 Superman: The Animated Series

The perfect amalgam of the almost six decades of Superman history that preceded it, Warner Bros. Animation's *Superman: The Animated Series* cherry-picked from numerous iterations of the character's mythos while adding elements of its own to create a narrative and version of the Man of Steel that many fans consider definitive in any medium.

A spinoff of producers Bruce Timm, Paul Dini, and Alan Burnett's hugely popular and just as sublimely stylized *Batman: The Animated Series, Superman* premiered on September 6, 1996. Featuring Tim Daly as the voice of Superman/Clark Kent, Dana Delany as Lois Lane, and Clancy Brown as Lex Luthor, the series began with a three-part origin story, "The Last Son of Krypton." Viewers were introduced to a more positive version of Krypton than the cold world presented in *Superman: The Movie* and in DC comic books since the Man of Steel's universe was rebooted after 1985's *Crisis on Infinite Earths* limited series. Kal-El's parents, Jor-El (Christopher McDonald) and Lara (Finola Hughes), were shown as a loving couple, adding to the tragedy of their world's destruction, and sharply contrasting them with the chilling Brainiac (Corey Burton). Here the evil AI was explained to be Krypton's world-wide supercomputer, which chooses to save itself—along with the collected knowledge of the planet—rather than confirm Jor-El's findings about its impending doom.

As in pre-*Crisis* continuity, Clark is raised on Earth by Jonathan and Martha Kent (real-life couple Mike Farrell and Shelley Fabares). But, like in the post-*Crisis* continuity, the Kents are still alive to witness Clark's career as Superman. Also as in post-*Crisis* comic books, Superman is not completely invulnerable, is required

to breathe, and must use his Kryptonian rocket to transport himself across great distances in space, while archenemy Lex Luthor is the wealthiest citizen in Metropolis, and one of its most respected.

Intended primarily for young people, *Superman: The Animated Series'* stories are action vehicles—Superman spends more time

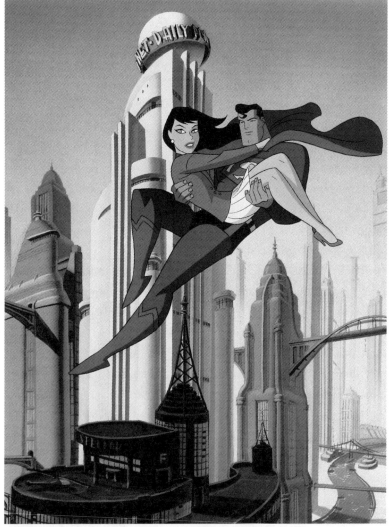

Featuring the voices of Tim Daly as Clark Kent/Superman and Dana Delany as Lois Lane, Superman: The Animated Series *is an overlooked gem of the DC Animated Universe.* (Photofest)

with his S.T.A.R. Labs ally Professor Emil Hamilton (Victor Brandt) than Lois Lane in the show's early episodes—but intelligent ones, with richly characterized villains. In addition to Luthor and Brainiac, fans were treated to memorable tales of Metallo (Malcolm McDowell), Mister Mxyzptlk (Gilbert Gottfried), the Parasite (Brion James), and Bizarro (Daly, doubling up brilliantly). Best of all is the series' use of comic creator Jack Kirby's Fourth World characters and mythology, including the wicked world-conquering despot Darkseid (Michael Ironside).

It's Darkseid who gives the show its most shocking moment, by killing Superman's friend, the Metropolis Special Crimes Unit's Dan Turpin (voiced by Joseph Bologna, and based on Kirby himself) in the two-part "Apokolips...Now!" episode. It's one of the few times a regular or recurring character has been killed off on an American animated series on commercial television. Also noteworthy is the show's depiction of Turpin's partner Maggie Sawyer (Joanna Cassidy) as arguably the first openly gay character in such a series (her partner is shown at her hospital bedside in "Apokolips...Now!").

After a thrilling two-part showdown with Darkseid ("Legacy"), *Superman: The Animated Series* ended its four-season run on February 12, 2000. But its characters—including Luthor, Brainiac, and Darkseid—returned in Timm and company's next DC Animated Universe series, 2001's *Justice League*.

"Much in the same way we had created what we felt was an all-inclusive version of Batman, we wanted to do the same with Superman," says Dini. "But we also wanted to do something stylistically that we hadn't done with Batman. We wanted the show to be a bit brighter. We wanted the action to be a bit bigger, more over the top. Because, when all's said and done, Batman is just a mortal man. You can put him in fantastic situations, against fantastic backgrounds. But he can't rip a building apart, and he can't move a planet around."

Daily Planet Exclusive

Paul Dini

Emmy Award–winning writer-producer Paul Dini—working with fellow producers Bruce Timm and Alan Burnett—turned decades of often complicated, sometimes convoluted DC Comics mythology into a smooth, single, linear narrative in 1992's *Batman: The Animated Series*. They did it again with 1997's *Superman: The Animated Series*. Dini also brought his storytelling expertise to the Man of Steel in the 1999 graphic novel *Superman: Peace on Earth*, painted by Alex Ross.

***Superman: The Animated Series* is the most underrated of the DC Animated Universe shows. It seems to suffer from middle child syndrome, because it fell between *Batman: The Animated Series* and *Justice League*.**

If *Superman* had come first, I think it'd be like, "Oh god, *Superman*'s great! When are you guys gonna do *Batman*?" But we started at 11 with *Batman*, and *Superman* was a nine plus or a 10. With *Batman* we just hit the ball out of the park. With *Superman*, we definitely won the game. But it came after *Batman*. It's like following a really good comedian on stage.

What elements of the Man of Steel's vast mythos did you want to include when the series began?

We wanted the scale of the action to be big. The villains in Batman's world were criminals, psychotics, things like that. With Superman, we wanted the villains to be more physical, to be larger-than-life challenges. Still some basic criminal types, but when it comes right down to it, Batman is not gonna last too long against Darkseid. Superman can give him more of a fight. But that said, we also wanted to examine the differences between characters like Superman and Darkseid. To deal with things like triumph and disillusionment. What it means to really have these powers.

Yet you still found room for humor. Mister Mxyzptlk's introduction ("Mxyzpixilated") is one of the series' strongest episodes.

There always is a reluctance to use that character. He's never showed up in the movies, and I think that filmmakers can't wrap their minds around it. They see him for what he is—a little elf type character.

Or else they go the other way, the Alan Moore way, where he's a malevolent god. I don't buy that version either. I believe he's a phenomenally powerful person who comes from a race of creatures, and he's the one who keeps messing with the anthill when everyone else would rather not. In a way, he's sort of a parallel to Superman. That's what makes him a good adversary. Apart from the fact that he's got the magic and the weird abilities and everything. I read a lot of the Mxyzptlk stories when I was a kid. I liked the character. I had a toy of him. So when we did the *Superman* show, that became a personal thing for me. I wanted to figure him out.

One of your other most successful, albeit quieter, characters on the show was Lex Luthor's henchwoman Mercy Graves, whom you created. She's the polar opposite of Harley Quinn, whom you'd invented for *Batman: The Animated Series*.
Yeah, well, with Mercy, we definitely didn't want to do what we did with Harley. We did not want a Miss Teschmacher from the movies. We wanted somebody to really kind of reflect Lex, and be cool and deadly. Almost like a weapon, in a very unsuspecting form. So we made her very capable, very responsible, and I think she worked out very well. Harley is a fun reflection of who the Joker is, and there's this tragic side to her, where you realize that she's basically been seduced by him and transformed into this strange henchperson. But Mercy is somebody who been trained by Luthor, and she really is like a part of him. Luthor is not a joke-around guy, and neither is Mercy.

But that said it was fun to throw them together every once in a while. I remember writing the scene—it was fun—where Superman and Batman team up [in "World's Finest"], when Luthor and the Joker are really mad at each other. But instead of them fighting we had the girls fight. [Laughs.] It's a bit sexist, but on the other hand it was funny. "Let's have the henchpeople fight it out while we talk like civilized men." When it's villains doing it, they're badly behaved anyway. I don't think that there's a stigma upon it, and it was fun to watch.

Dana Delany told me she became the voice of Lois Lane because she was a friend of yours.
That made it easier. I'm very good friends with Arleen Sorkin, who does the voice of Harley. And Arleen is very good friends with Dana. We all

love Dana Delany, and I think Arleen paved the way a bit. Either she brought it to Dana and said, "These guys are kind of interested in doing it," or Dana was impressed with Arleen saying that the show was good. So we brought her in and she was just very wonderful. A terrific actress, very sweet person, and she just really loved the role. You could tell the affection for the character came out in her performance. She really is my favorite Lois Lane.

Tim Daly was also quite good as Clark Kent and Superman. There's a calm, a confidence, and an innocence to his voice.
Yes. I really did like the idea that he had that going. And that he was able to find a shift between Superman and Clark. Perhaps it wasn't as great as Kevin Conroy's shift between Batman and Bruce Wayne. But it's more of a way of dealing. Like, "I see the world as Clark this way, and I see the world as Superman this way." So it's almost like when he becomes Superman, it's like, "Okay, Dad's getting a little more serious here." I always thought that was the best quality of Superman—he is assured where Clark is hesitant, he is resourceful where perhaps Clark is a bit wishy-washy. And Tim captured that split brilliantly.

You brought Supergirl into the show, and wrote half of her two-part debut episode. Your Kara was a different Supergirl than those we'd seen previously. One who wasn't related to Superman, but simply another survivor of the planet Krypton.
I liked the idea that she was a cousin by origin. A kinsman. She had come from the same world and everything. But when they introduced her in the comics they'd already killed off the Kents. So they came up with a similar surrogate family. But we had John and Martha still alive. So I thought, *"Why not go back there? They know how to raise a Kryptonian kid."* Also, it's a different dynamic. They had Clark as a baby and helped guide his mind-set and raised him with their ethics. Now you're getting a teenager who is headstrong and wants to do things her own way and is going to make mistakes, who's going to be a bit more of a handful than Clark. And she's a girl, and there's just a different dynamic there. Whereas Clark I imagine was very happy to stay down on the farm, and it was almost sort of like that was as much a Fortress of Solitude to him as any place else he had, Kara wanted to get off the farm pretty bad.

Regarding the show's Lex Luthor...Though he bears a resemblance to Telly Savalas, Clancy Brown made the role his own.
He did. He's very suave. He's almost got a kind of gentleman-like attitude, where you almost believe he couldn't be as smart as he is. But he usually is. So it was a perk on all levels. He does have the thick-lidded, heavy lips, almost European kind of facial features that Bruce [Timm] uses. He used that to a degree on Harvey Dent in *Batman*. I think it harkens back to the older look of leading men in the '30s. A really strong-looking face. It made him a different version of Luthor than the guy who just hates Superman because his hair fell out. I never could buy that. I mean, it's like, Luthor, you can travel through time, shouldn't you be able to clone yourself some hair or something?

Why do you and Bruce Timm work so well together?
A lot of it is we have a mutual affection for the source material. And I think a lot of that comes through with the treatment of the characters. We've spent, throughout our lives, a lot of time thinking about these characters. Probably more time than we needed to. So whenever we sat down to talk about them, the ideas flowed very easily. We knew the lore backward and forward. So we knew what we didn't want to do, and also places where we thought we could forge some new ground. With myself and Bruce, especially with *Batman* and *Superman*, when we were on the trail of good ideas, then they would flow very naturally. It's almost like tennis. You'd hit the ball back and forth. Then suddenly it would make sense and it would be like, "Okay, that prompts good ideas for me to write and exciting things for Bruce to draw."

I could say the same thing about [producer] Alan Burnett, who was key and indispensable, and actually the main reason why the writing was so good. He's been more behind the scenes, but he's just as strong a part, especially since he fashioned the quality of the stories on the show. I really couldn't ask to work with any better collaborators than Alan and Bruce. They really are fantastic. Bruce always thinks of the big picture, what hasn't been done before, and the big visual. What's exciting, what takes people by surprise. And Alan comes up with, "Okay, how do the nuts and bolts work?" Then we also just sort of work on it together.

When it ended its run in 1997, *Superman: The Animated Series* had something few American cartoons did—an ending [in the two-part episode "Legacy"]. It utilized your version of Darkseid, a scarier one than we'd usually seen at that time.

Jack Kirby certainly left us a wealth of ideas to work with. In the comics, Darkseid was never really a primary Superman villain, although he was tangential to his world, and he certainly grew as a villain in Superman's world. So when we were thinking of villains for Superman, we knew Lex Luthor would be the recurring guy. The usual bad guy. There's Brainiac, who's kind of like a big special event—you bring him in for the world-shaking stuff. There's Mxyzptlk for the one-offs. Same with Bizarro. But Darkseid really has a presence and a power to him. If Superman were a lone cop, Darkseid is the head of the mob.

The villains of '80s cartoon shows are kind of snickering, all-powerful bad guys. And you don't get a lot of one-on-one. It's all, "I'll get you next time, He-Man!" or whoever. They never really have the big punch-out with them. With Darkseid, I didn't really want to do that. I wanted to show that he was powerful and didn't have to engage in action himself. But when we did the final episodes with Superman, it was very important to me to have a one-on-one between Superman and Darkseid.

It wasn't because I wanted Superman to win. I wanted to show the ideologies between them, and I wanted to show what happens if Superman lets it loose and he goes against somebody he perceives as the source of all evil. It's going to cost him more to do that than he ever could have hoped to admit. I wanted it to be a sobering experience for Superman, to say, "Okay, this is the one time I gotta go in, I gotta rip this guy apart, I gotta beat him senseless, I'm going to liberate his world, and I'm going to be everything I shouldn't be. Which is the guy who settles wars and frees people and helps people achieve their destiny."

I don't think it could have been any more powerful than forcing the omega beams back into Darkseid, taking his body, throwing it off the parapet, and saying to the people of Apokolips, "You're free." They look at Superman, they look at Darkseid, they pick him up, and they put him on their backs. At that point he realizes how hollow a victory it is to meet him on those terms. It accomplishes nothing. His

first reaction is, "I'm gonna go back and do it again." Then Supergirl, who's been wounded in the fight, says, "Stop. You're gonna destroy something and it's not gonna be [him]. You've got to walk away." Ultimately it doesn't make him a loser, it just makes him wiser. It gives him a scale of, "I can't kill. I can't use tyrant's methods. I have to come up with my own methods. I have to settle big problems, and hope that people can figure it out for themselves."

Because otherwise...
"I will be Darkseid. One of these days. Maybe not tomorrow, but one of these days, somebody's gonna be pulling me off that throne." That's a hard thing for him to see. That episode was important to show how human he is, and how Superman can learn. And how he really can have those moments that test him beyond his physical abilities. To test who he is and what he thinks about.

How did *Superman: Peace on Earth* come about?
Peace on Earth came about through Alex Ross' desire to tell stories that honored the four iconic DC superheroes [Superman, Batman, Wonder Woman, and Captain Marvel/Shazam] on their 60th anniversaries. It was important to Alex and myself that the stories returned each hero to their origins and told a story that sprang from their inspiration and primary characterizations. Thus, we did not want to do the ultimate Superman vs Luthor battle story, but rather a story that dealt with who Clark Kent was at his core. Alex had the basic story idea, and we fleshed it out in a series of meetings and phone calls, Alex did a rough breakdown of the story in thumbnails, and I scripted it based on Alex's sketches and my developed outline.

How satisfied were you with the published version of *Peace on Earth*? Where do you think it ranks when compared to the other books you did with Alex?
I think we were both very happy with the finished book. Lots of fans tell me it's their favorite of all the ones we did. To me, that and the *Shazam* book were the high points of the series.

139

Daily Planet Exclusive

Dana Delany

The longest-running Lois Lane to date, Dana Delany voiced the character in three seasons of TV's *Superman: The Animated Series* and the numerous DC spinoff series and films that followed. Though she's won acclaim for many other roles in other projects—from *China Beach* to *Body of Proof*—the Emmy Award–winning actress says the intrepid *Daily Planet* reporter will always hold a special place in her heart.

How did you come to be cast in *Superman: The Animated Series*?
I am old friends with Arleen Sorkin, who did the original voice of Harley Quinn, and she's friends with Paul Dini. When they were doing *Mask of the Phantasm*, the Batman animated movie, which was going to be a feature, she suggested me for the role of Andrea Beaumont. I'd never done voiceover work before, and so they brought me in to audition for that and I got it. That was the first thing that I did with Paul Dini and Bruce Timm and Andrea Romano, that movie. I just loved doing it. Then, when they were doing the *Superman* series, I came in and auditioned for Lois Lane. I was thrilled, because I grew up reading those comics. My cousins had stacks of the DC comics. I'm of the age where Lois Lane had her own comic back then. It was a big thing after church—you would get to go to the drugstore and take your allowance and buy a comic. Originally they were 12 cents, I believe, and then I remember when they went up to 25 cents. But my purchase every Sunday was a Superman comic.

The great thing about the Lois Lane comics back then was that, in the '60s and the '70s, they really reflected what was going on with women. I mean, Lois to me has always been a career girl, which I related to even as a child. So she was sort of a role model for me in many ways. But the comics kind of reflected the times, and they went through women's lib and all that kind of stuff. I also was a huge fan of the [*Adventures of*] *Superman* TV series. That was a big thing for me. I used to come home after school and watch that regularly. In fact, we were a Nielsen family back in the late '50s and '60s. I must have been three years old, and I was already a TV addict. [Laughs.] Seriously,

I never went outside. I sat in front of the TV the minute I got home from school. I used to watch the *Superman* series, and when we were a Nielsen family I said, "I'm gonna be in charge," because nobody else really cared. Back then they would give you this little cheap paper pamphlet. You would write down with a pencil what shows you watched every day. Because I was in charge of it, I think the only thing I wrote down was "*Superman.*" Then the maid, who would take care of us after school, watched *The Edge of Night.* So those were the two things we wrote down. [Laughs.]

Did that show, or the comics you read, influence your own take on Lois?
Yeah. I mean, certainly that was all in me. Because, as I said, Lois really was a role model for me because she was just so sassy and a career girl, which is what I wanted to be. Also, I did get to meet Noel Neill, the second Lois Lane on the TV series. That was a thrill…My take on what Bruce and Paul had done, and also Alan Burnett, was she was very much in the vein of Rosalind Russell in *His Girl Friday.* I said to them, "Is this the way you're going?" They said, "Yeah, that sounds right." Because Rosalind Russell was a reporter and she had that fast patter. So Rosalind Russell's relationship with Cary Grant in *His Girl Friday* was my model. I just went in and talked really fast. [Laughs.]

Though it was marketed toward kids, the show actually offers a more subdued and in some ways more mature take on Superman than the live-action *Lois & Clark: The New Adventures of Superman*, which also aired in the '90s.
Interesting. Yeah, I really think that's due to Bruce Timm. He's kind of a genius, Bruce. He definitely was referencing past things and bringing very much a classical feel to it. You could see a lot of movies that he used to influence him in the show. It was very mature, and dark. There was a lot of darkness to it. I remember in the beginning all the fanboys were saying, "She's so mean! Why does she have to be so mean?" [Laughs.] But I liked it. Because if you really stuck with it you knew that she could hold her own in the office, but in the meanwhile she was just pining for romance.

Do you have a favorite episode?
Well I really liked the one in which Batman came on ["World's
Finest"]. She goes on a date with Batman and Superman gets
jealous. That was the episode where she said to Bruce Wayne, "When
were you gonna tell me, the honeymoon?" I thought that was a
great line. [Laughs.] That was so much fun. But also I loved all the
screaming. He was always swooping in and saving her just as she
was plummeting down to Earth. [Laughs.] There was a lot of fun
screaming going on as she nearly hit the ground.

**To date, yours is the only screen Lois Lane who's had a romance
with both Batman and Superman.**
Yeah, I'm very lucky that way. I'm not sure what the statistics are, but
I think I've been Lois longer than a lot of people, for quite a while...I
understand they like to bring in the new blood, the new girls. But once
in a while Andrea will call me up and say, "Do you want to come in
and do Lois?" Which is really fun for me. That's the great thing about
voiceovers. It doesn't matter how old you are. [Laughs.]

**I'm sure many would be thrilled to see you play Lois in live action
even today.**
Honestly, when I auditioned for the part, I was so thrilled to even get
to do that. Because she was such a huge influence on me as a child.
In many ways I feel like I've become Lois Lane, you know? [Laughs.]
I mean in my own life—her independence, always a career person,
and always up for adventure. She taught me to try to be my own
person. So I think she's great. She's certainly evolved with the times.

But they're great archetypes. I went with Tim Daly to Cleveland,
the birthplace of Superman. It was so much fun. It was when the
post office was issuing its stamps with him on it. There was a big
ceremony for it...I just think he's a great archetype of America.
Certainly his roots say that. What are they? Truth, justice, and
the American way? It's what we really want to believe. I often feel
heartened by the fact that the female, the anima in the story, is such
a strong woman, and that she's not just a helpmate. She's her own
person. That started right back in the '30s...Believe me, I'm always
happy to talk about Superman. Because it just makes me happy.
[Laughs.]

50 The Legion of Super-Heroes

Like many parts of Superman's life, entire books could be (and have been) written about the Legion of Super-Heroes. For the Man of Steel has been shaped by, and in turn helped shape, his extraordinary gang of friends from the 30th century.

One of many key elements of the Superman mythos conceived during the tenure of Silver Age editor Mort Weisinger, the Legion was introduced in April 1958's *Adventure Comics* #247 ("The Legion of Super-Heroes," by writer Otto Binder and artist Al Plastino). In this issue, Superboy met Cosmic Boy, Saturn Girl, and Lightning Boy (their names helpfully spelled out on their uniforms). Three jetpack-propelled teenagers from Smallville 1,000 years in the future, each of them possessed one superpower—"super-magnetism," "super-thought casting," and "super-lightning," respectively—and traveled back in time via their Time Bubble to invite the Boy of Steel to join their club.

Lightning Boy became Lightning Lad in the group's next appearance, December 1959's *Adventure Comics* #267 ("Prisoner of the Super-Heroes!" by writer/Superman co-creator Jerry Siegel and artist George Papp), and Supergirl was invited to join the team when they appeared a third time, in August 1960's *Action Comics* #267 ("The Three Super-Heroes," by writer Siegel and artist Jim Mooney). This time, three additional members were introduced: Chameleon Boy (with his "super-disguise" power), Colossal Boy ("super-growth"), and Invisible Kid ("super-invisibility"). May 1961's *Action Comics* #276 ("Supergirl's Three Super-Girlfriends!" by writer Siegel and penciller Mooney) introduced Phantom Girl, Triplicate Girl, Shrinking Violet, Bouncing Boy, Sun Boy, and Brainiac 5 (who was briefly glimpsed in the Legion's first appearance in *Adventure* #247).

Though he shared the name of Brainiac, Brainiac 5 was later revealed to be a descendant of the villainous AI's adopted human "son." He began a romance with Kara Zor-El that would last for years.

August 1961's *Superman* #147 ("The Legion of Super-Villains!" written by Siegel and pencilled by Curt Swan) marked the first appearance of the adult Legion—with Cosmic Man, Saturn Woman, and Lightning Man—as well as their archenemies Cosmic King, Saturn Queen, and Lightning Lord. (Aristocracy was apparently synonymous with evil.) This issue marked the first time Super*man* worked with the Legion. The Man of Steel and the Boy of Steel would henceforth interact with the team's teenage and adult incarnations, to which dozens of members were eventually added. Through the Legion's futuristic adventures (with *Adventure Comics* #300, they began appearing regularly as "Tales of the Legion Super-Heroes"), readers learned of such things as the existence of Comet the Super-Horse (*Adventure* #293) and the fact that the inhabitants of the Bottle City of Kandor would one day be restored to their regular size and settle on the planet Rokyn (in *Adventure* #356) long *before* they were revealed in the 20th century.

After the final "Tales of the Legion of Super-Heroes" install-ment ran in May 1969's *Adventure Comics* #380, the Legion moved to *Action Comics* and became a backup feature in *Superboy.* The team received its own four-issue reprint series in 1973, after which *Superboy* became *Superboy starring the Legion of Super-Heroes* with #197, *Superboy and the Legion of Super-Heroes* with #231, and finally, upon Superboy's departure, *Legion of Super-Heroes* in January 1980 with #259.

Along the way, readers were swept up in tales that featured the weddings of Duo Damsel and Bouncing Boy and of Saturn Girl and Lightning Lad, the deaths of Ferro Lad and Invisible Kid, and a host of original villains. After the 1986 post–*Crisis on Infinite Earths* reboot of the DC Universe, Superboy was no longer a part of the Man of Steel's history, and so the Legion was explained to

have come from a parallel universe. Further reboots followed in 1994 and 2004, until the Legion's original continuity was restored in 2007 as a result of DC's *Infinite Crisis* crossover event.

The Legion made its screen debut in 1998 in the *Superman: The Animated Series* episode "New Kids in Town." In 2006, the *Legion of Super Heroes* animated series premiered, and ran for two seasons produced by *Justice League*'s James Tucker. The team's live-action debut came in 2009, with the *Smallville* episode "Legion."

While Superboy and Supergirl offer every kid a fantasy of power, the Legion of Super-Heroes offers something often just as powerful—a group of friends.

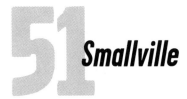

Smallville

No live-action superhero television show to date has enjoyed a run as long as that of *Smallville*. Through a full 10 seasons, the Warner Brothers series introduced Clark Kent, his friends, and his foes to a new generation of fans in the first live-action Superman production of the 21st century. While telling the story of a young man's coming of age, *Smallville* encompassed many genres, including mystery, procedural, romance, and comedy. It also paved the way for later DC series like *Arrow, The Flash, Supergirl*, and *DC's Legends of Tomorrow*.

Set in Clark's titular Kansas town, *Smallville* premiered on the night of October 16, 2001. It was developed by writer-producers Alfred Gough and Miles Millar, who served as showrunners for its first seven seasons, in which they enforced a much-publicized "no tights, no flights" policy concerning Clark's abilities and outfits. The series immediately distinguished itself from all prior screen

interpretations of Superman via its pilot's cold open, in which Kal-El's rocket ship arrives on Earth amidst a sea of meteors that would provide *Smallville's* first season with weekly "meteor freaks," which Clark confronted as his powers slowly emerged. Tom Welling won himself a legion of admirers for playing the teenage hero with unflappable earnestness, while Michael Rosenbaum all but stole the series as his wealthy friend Lex Luthor, whose struggles with his corrupt father, Lionel (played by John Glover), mirrored Clark's own conflict between destiny and free will. Kristin Kreuk's Lana Lang prompted a love triangle between the three, but the series' all-too-human heart was Allison Mack, as Clark's best friend and confidante Chloe Sullivan. John Schneider and Annette O'Toole made for a younger-than-usual Jonathan and Martha Kent, who supported Clark though his growing pains. Additional support was provided by *Superman* movie star Christopher Reeve, who guest-starred as Dr. Virgil Swann, the scientist who informs Clark of his Kryptonian heritage.

Midway through *Smallville's* run it introduced Erica Durance's charismatic Lois Lane, along with other DC stalwarts like Jimmy Olsen (Aaron Ashmore played the first incarnation of the photographer), Supergirl (Laura Vandervoot), the Justice League (including eventual series regular Justin Hartley as Oliver Queen), and Brainiac (James Marsters). When Rosenbaum left the show, later seasons introduced villains like Zod (Callum Blue), Metallo (Brian Austin Green), Doomsday (Sam Witwer), and Darkseid. Next to Chloe, *Smallville's* best original character was Cassidy Freeman's Tess Mercer. Revealed as Lex Luthor's sister, her name was a combination of *Superman: The Movie's* Miss Teschmacher and *Superman: The Animated Series'* Mercy Graves.

After Gough and Millar left *Smallville*, the show debuted even more DC comic book characters, including Booster Gold (Eric Martsolf), the Legion of Super-Heroes, and the Justice Society. In its final episode, broadcast on May 13, 2011, Lois and Clark finally wed, and Clark at long last donned the costume of Superman

(specifically the one worn by Brandon Routh in 2006's *Superman Returns*). After 218 episodes, the show's run had ended, but a *Smallville Season Eleven* comic book debuted shortly thereafter, in which the show's Superman met Batman.

"We hit a demographic that hadn't been touched before, in a way that was really exciting and new," says Mack. "There was a broad appeal. It wasn't just sci-fi geeks who liked our show or comic book fiends who watched it. Everyone could enjoy it."

Tom Welling played Clark Kent for 10 seasons on TV's Smallville. (Getty Images)

Daily Planet Exclusive

Allison Mack

While *Smallville* offered more than its share of established characters from the DC Universe, the show's most popular character was arguably that of Chloe Sullivan, created exclusively for the series. As played by Allison Mack, Chloe was not only Clark Kent's best friend and the founder of the Justice League, but also served as the show's very human heart. Mack directed two episodes of the series and appeared in numerous other shows. Currently teaching at a New York conservatory program for actors, she reflects on her decade starring in American TV's longest-running superhero epic.

Did Chloe change from the way she was envisioned once you were cast?
She was always supposed to be this sassy sort of sidekick, but it's hard to say what I brought to it. I guess my own twist. Chloe has always been a very empathetic character over the course of the 10 years of the show, and she really became sort of the mother to essentially the superheroes in the comic book world. I think a lot of that had to do with my focus on relationships and people. That couldn't help but impact the direction of the character. At a certain point my character's powers were tears that would bring people back from the dead. A lot of the values and interests that I have outside of the show made their way into the show, and I'm grateful for that. I love the character, and I love where I ended up. I think she was one of the stronger women on television, at least during that period of time. It's really neat to be able to say that, and to say it honestly.

Chloe won a lot of admirers, especially among young women.
Every time someone comes up to me and says, "I pursued my passion as a lawyer, as a reporter..." As anything. They started from my character and they understood their importance better in their world and in their lives. That's a wonderful thing. Because so often women, especially young women, are portrayed with their value based on their appearance. Even in the first season they used to dress me

down, and try and keep me very funky and quirky instead of pretty. That was even better, really stressing the importance of the ideas of my character, and the passion of my character. As opposed to just the arm candy of my character.

Chloe was probably the first significant character created for a DC superhero show who wasn't based on a preexisting comic character. Did that make her more appealing to play?
Totally. It was so satisfying being able to generate something completely from the ground. Though it wasn't *completely* from the ground. I had this incredible legend to play with. The writers, Al [Gough] and Miles [Millar], were so flexible and creative with how they would use my character to add to the legend. I became this sort of irreplaceable addition, almost by accident in a lot of ways. The fact that I was the one who was responsible for creating the relationship between Lois and Clark, and I was the one who was responsible for bringing together the Justice League, and I was the one responsible for creating and running Watchtower. All of these very legendary components of the Superman story—and in the DC world—were tied through my character in our version of the story. I felt like this piece of concrete that was slipped in at the bottom after the building had already been built. That was very cool.

Why do you think _Smallville_ had such a long run on TV?
It was a number of things. It was timing. There wasn't anything like us on TV at that point in time. This is before _Heroes_, this is before _Arrow_, this is before _Daredevil_. This is before any of the comic book shows that happened and exist now on TV. But also our show offered the best of all worlds. We were a drama, we were romantic, we were funny, we were adventurous, we were a thriller, we were suspense, we were sci-fi. We were every single different genre that you can imagine. Then there was the attention to detail with respect to the aesthetic of the show that was appealing. David Nutter directed the pilot, and it was like a feature film. Miles Millar and Al Gough put a lot of care and love into making sure that the tone of the show set a very high standard.

Did you have any favorite episodes or moments in the show?
I have many...The first episode of Season 5, right after I go up to Clark and tell him that I know his secret, when he finds me in the Fortress of Solitude, up in the glaciers, and he rushes me to the hospital because I'm about to freeze to death—and he realizes that I know his secret. It's such a great scene between Tom and I, where he's like, "Wait a minute, you know?" And I say, "Yeah, I know," and he's like, "How long did you know?" And I'm like, "I've known for a while." It's this sort of reaffirmation of her commitment to him, and it's the first time that he gets to be totally vulnerable and intimate with somebody that's not just his parents, in a way that solidifies this beautiful partnership that carries through the rest of the show. I loved the simplicity of the way it was filmed. I love the breadth of what was being established and how that related to the rest of the show. And I love just the fact that I think it really reflected, just on a personal level, the care and affection that Tom and I have for each other, and the commitment that we made off the set to what we were doing on *Smallville*. It encapsulated our relationship personally and professionally in a very cool way.

Daily Planet Exclusive

Erica Durance

When 26-year-old Erica Durance joined the cast of *Smallville* in the show's fourth season, she pulled off the seemingly impossible—making her Lois Lane as memorable as those of Noel Neill, Margot Kidder, and Teri Hatcher. In so doing, she defined the intrepid reporter, and soulmate of the Man of Steel, for an entire generation of fans.

How do you feel your Lois changed throughout *Smallville*'s run?
She just starts to embody that Lois Lane that people know, or I hope that she starts to embody that. But I love that she's changed so much. It was tough for people to deal with her being there at first. Because

I understand it didn't really go along with the mythos. So we just said, "Hey, this is her younger, and she keeps finding herself." I love that she was clumsy. I think that's part of who she is. She's human. She's like, "I say things that are inappropriate. I fall down. I make mistakes. I irritate people. But guess what? That's just me, and I do the best I can." That's what I love about her. She'll be the first one to say, "Okay, I messed up. I was wrong." But she always tries to make things right.

Were you aware of the lineage of Superman, of past Lois Lanes, when you signed on for the role?
To an extent I was. When I grew up I watched all the movies. I think Margot Kidder I related to a lot, because I loved the movie with Christopher Reeve. But as far as studying them, I avoided that. Because if I do that, I set myself up to try to be them. So I had to just try to do her a service. Not say, "Well, this has been done before 10 times," but "This is a new person for me." That's how I looked at it, with respect to the overall generalities of a Lois Lane character. Otherwise I just tried to think of it as fresh and new and just go with the truth of each scene, and kind of let her grow and develop.

I don't think you can ever really understand how big something is when you first start doing it. You just cross your fingers and hope that it's doing service. Because she's been around a long time.

How did *Smallville* change your life?
I'm not one of those people who said, "I never wanted to be an actress." I've always wanted to be doing something creative, whether it was singing or acting. And I fell into it. To be able to do that in a way that's so satisfying, with a group of people that are awesome and a character that's constantly changing and evolving...I think I stepped into something that's really good, and I'm really grateful for it.

Daily Planet Exclusive

Laura Vandervoort

No stranger to TV science fiction, Laura Vandervoort has starred in *Haven*, *V*, and *Bitten*. But her breakthrough role came as television's first live-action Supergirl, in *Smallville*. A regular in the show's seventh season, Vandervoort returned for several subsequent episodes as Kara Zor-El, who helped her cousin Clark Kent become Superman while shaping her own heroic destiny.

Looking back on *Smallville*, how would you describe the experience?
I played an iconic superhero. The fact that I can say that is amazing. And I had a lot of fun. It was my first bigger role; I'd been acting since I was 13, but that was the first time America brought me into its sci-fi realm, and it was great. I definitely learned a lot while I was on set, and it brought me into the sci-fi genre. I went into *V* after *Smallville*, and then *Bitten*. So I love sci-fi. I loved being Supergirl, and I know the new one's gonna be fantastic.

Did you grow up reading comics?
Not at all. When I auditioned I thought Supergirl was Superman's sister. So I had to do a little research on her background and history. Now because I go to comic conventions I'm learning a lot more. I actually just watched *Star Wars* for the first time this year. It's horrible. [Laughs.]

Do you have a favorite episode from the show?
My favorite episode was probably "Supergirl," because that was a fun episode for me. It was a lot to do. But I loved working with Tom Welling and Erica Durance. So everything with them was a lot of fun. He's really goofy, Tom. So there were always some good laughs.

Why do you think Supergirl has endured?
There aren't enough female superheroes out there. But the ones that are known, like Wonder Woman and Supergirl, are really incredible characters who have been around for so long. That's because, especially now, sci-fi is having its day, and superheroes are having their day, and women empowerment is having its day. Hopefully it doesn't just have a day, but an eternity. It's really nice to see empowered women on television. And Supergirl's gonna be around forever. I guarantee it.

52 The Bottle City of Kandor

In 1958, Superman was still very much the Last Son of Krypton. Though he'd reunited with his dog Krypto in *Adventure Comics* #210 (March 1955), he'd yet to meet his cousin Supergirl or the Kryptonian criminals imprisoned in the Phantom Zone. The first community of his fellow Kryptonians to survive their planet's destruction were the residents of the Bottle City of Kandor, introduced in July 1958's *Action Comics* #242 ("The Super-Duel in Space") by writer Otto Binder and artist Al Plastino.

Once the proud capital city of his native planet, Kandor had been stolen by the supervillain Brainiac, who—seeking a means of repopulating his homeworld, where a plague wiped out his people—travelled the universe, shrinking entire cities and imprisoning them in glass bell jars on board his spacecraft. When the green-skinned cad cast his eye on Earth, the Man of Steel intervened and discovered the still thriving Kryptonian community. Unable to return the city to its original size, Superman kept it at his Fortress of Solitude, where he searched for years for a means of restoring it.

Kandor's citizens include the villainous Zak-Kul, who possessed the power to restore its citizens via the "rare element" Illium-349—introduced in October 1958's *Action Comics* #245 ("The Shrinking Superman," by writer Otto Binder and penciller Wayne Boring)—as well as Superman's "distant kinsman" and doppelganger Van-Zee—introduced in February 1960's *Superman's Girlfriend, Lois Lane* #15 ("The Super-Family of Steel!" by writer Otto Binder and artist Kurt Schaffenberger).

Since Superman was powerless while visiting Kandor—due to the artificial Kryptonian red sun erected over the city—he would

occasionally adopt another identity in order to fight crime there, that of the Batman-inspired Nightwing. As such, he would partner with Jimmy Olsen, who became the Robin-like Flamebird, both heroes named after flying creatures from Krypton. They were introduced in a three-part story in January 1963's *Superman* #158 (written by Edmond Hamilton and pencilled by Curt Swan), in which they fought renegade scientist Than Ol, who sought to restore Kandor to full size via a flawed enlarging-ray projector that almost doomed the city.

Van-Zee inherited the mantle of Nightwing from Superman in May-June 1997's *Superman Family* #183 ("Death Is a Computer," written by Paul Kupperberg and pencilled by Carl Potts), and partnered with a new Flamebird—fellow Kryptonian Ak-Var, who had been sentenced by mistake to serve 30 years in the extradimensional Phantom Zone.

In August 1979's landmark *Superman* #338 ("Let My People Grow," by writer Len Wein and penciller Curt Swan), Superman finally manages to restore Kandor to its full size on a distant planet beneath a red sun. Alas, the Man of Steel's enlarging ray only worked on inanimate objects, and the city immediately crumbles to dust, forcing its citizens to build a new world for themselves in what Superman learns is another dimension.

In DC's post–*Crisis on Infinite Earths* continuity, Kandor was no longer Kryptonian, merely a city created to house different races by Tolos, an amorphous creature looking for various host bodies. Kandor's original origin story was reinstated by the 12-issue series *Superman: Birthright* (September 2003–September 2004) by writer Mark Waid and artist Leinil Francis Yu. In the 2008–09 story arc "New Krypton," Kandor serves as the foundation for Superman's regrown homeworld.

Kandor first appears on screen in a 1979 episode of *Super Friends*, "Terror at 20,000 Fathoms." Other noteworthy TV appearances include episodes of the animated *Legion of Super Heroes*

("Message in a Bottle"), *Batman: The Brave and the Bold* ("The Battle of the Superheroes!"), and *Smallville*, in which it is Kara Zor-El's home city, depicted in flashbacks.

53 Lori Lemaris

As befitting her aquatic nature, "Superman's mermaid sweetheart" Lori Lemaris is, more so than any other woman in the Man of Steel's life, the one who got away.

The lovely Atlantean first appeared in May 1959's *Superman* #129 ("The Girl in Superman's Past!" written by Bill Finger and drawn by Wayne Boring). With her "eyes as blue as the sea," Lori won the heart of the young Clark Kent after enrolling as his fellow student at Metropolis University, in order to report to Atlantis on "the surface people's progress." Her tail concealed beneath a blanket, she traveled on land via wheelchair, and with her power of telepathy she soon discovered Clark's secret identity. The two began dating, and the smitten undergraduate eventually asked her to marry him. Lori, however, told him their love was impossible since they came from different worlds.

The couple was reunited several years later (in *Superman* #135, "Superman's Mermaid Sweetheart!"), and Clark again proposed marriage. This time, Lori almost agreed, but was harpooned, prompting Superman to travel into deep space to find a surgeon capable of saving her from a life of paralysis. He found one in an alien merman named Ronal, but the doctor and his patient fell in love, and Superman lost Lori forever.

Married to Ronal, Lori aided Superman numerous times throughout the years. She was eventually killed, alongside many of

his other allies, in the 1985 limited series *Crisis on Infinite Earths* (in the 12th and final issue). But she was brought back by writer-penciller John Byrne in the post-*Crisis* DC Universe in *Superman* (Volume 2) #12. She's resurfaced several times since.

The joy of Lori Lemaris lies in the bittersweet fairy-tale element she brings to Superman's world. Like many of the most fondly remembered characters from the Silver Age of Comics, she's easily identifiable to children and born of enough whimsy to appear as though they themselves created her.

54 Superman's Pal, Jimmy Olsen

Though Superman, unlike Batman, does not have an official sidekick, he's sometimes found himself working with an unofficial one in the form of his longtime friend and colleague James Bartholomew Olsen, best known as Jimmy.

Historians debate Jimmy's first appearance. Some claim he first appeared as an unnamed bow-tied "inquisitive office-boy" in November 1938's *Action Comics* #6 ("Superman's Phony Manager," by Superman's creators Jerry Siegel and Joe Shuster). But the formal record shows he was created in an attempt to expand Superman's supporting cast, presumably to reduce the amount of time the Man of Steel spent talking to himself, in *The Adventures of Superman* radio show. Jimmy was introduced in the show's first full year, making his debut on April 15, 1940, in the "Donelli's Protection Racket" serial. Described as "a redheaded, freckle-faced copyboy who works in the editorial department" of the *Daily Planet*, listeners were told his father, Henry, had died three years prior and that the candy store his late father owned was now run

by Jimmy's mother, who was being extorted by petty racketeers for protection money. A desperate Jimmy turns to Clark, whom he clearly admires, introducing him to his mom as "the best reporter on the *Daily Planet.*" Superman, impressed with the 14-year-old's moxie, comes to his aid.

The countless youngsters who tuned in to the program several times a week could no doubt identify with the character, voiced by Jackie Kelk for the program's first eight years and Jack Grimes for its final three. Given to exclamations like "Jumpin' Jiminy!" Olsen proved popular enough to find a home in the comic books. Siegel and Shuster chronicled his official first comic appearance in "Superman versus The Archer" in *Superman* #13 (November-December 1941). He made appearances in the 1942 Famous Studios animated short *Showdown* (voiced by Popeye voice actor Jack Mercer) and the Kirk Alyn–starring serials—1948's *Superman* and 1950's *Atom Man vs. Superman*—in which he was played by Tommy Bond. But it wasn't until Jack Larson portrayed Jimmy on TV in 1952's *The Adventures of Superman* (in which he was labeled a "cub reporter") that the character became a DC Universe mainstay. In 1958, the year the show ended, Jimmy received his trademark ultrasonic frequency signal watch (in *Action Comics* #238) as a means of contacting Superman. He also acquired a fan club and his own comic book.

Illustrated by Superman artist *par excellence* Curt Swan, *Superman's Pal, Jimmy Olsen*, the first issue of which debuted in October 1954, offered lighthearted tales of the plucky lad. It even gave Jimmy a recurring love interest in Lois Lane's younger sister Lucy, an airline stewardess, who first appeared in issue #36 ("Lois Lane's Sister!" April 1959). But the comic is best remembered for the many extraordinary physical transformations that its protagonist underwent, from "The Super-Brain of Jimmy Olsen" (#22, August 1957) to stints as "The Wolf-Man of Metropolis!" (#44, April 1960), "The Human Porcupine" (#65, December 1962), and

The Superman's Pal, Jimmy Olsen *series saw the* Daily Planet *photographer endure numerous odd and incredible transformations.*
(Cover art by Curt Swan)

"The Colossus of Metropolis" (#77, June 1964), in which form he fights the King Kong–like Titano the Super Ape. The most fondly remembered transformations, however, were those Jimmy underwent to become "The Giant Turtle Man" (#53, June 1961), a monstrous giant who dumps a flotilla of US submarines into the mouth of an active volcano, and "The E-L-A-S-T-I-C Lad!" (#31, September 1958), in which Jimmy acquires superpowers like those of Plastic Man, powers he would use time and again as an honorary member of the Legion of Super-Heroes.

When legendary comics creator Jack Kirby left Marvel for DC, he first took over the writing and penciling of *Superman's Pal, Jimmy Olsen*, and rarely drew Jimmy wearing a bow tie. Kirby reintroduced his 1940s kid gang creation the Newsboy Legion in the book's pages, and introduced new characters and concepts like the high-tech mobsters of Intergang and Metropolis media tycoon Morgan Edge, along with the super hippies known as the Hairies and the mutant-spawning DNA Project (later renamed Project Cadmus). Kirby's most infamous Jimmy Olsen creation? Real-life comedian Don Rickles' superhero-costumed doppelgänger "Goody" Rickles. (Don't ask.)

When *Superman's Pal, Jimmy Olsen* ended its run in 1974, the title became a part of *The Superman Family*, in which Jimmy operated as an investigative journalist under the name "Mr. Action" until the anthology title folded in 1982. By then, Marc McClure was established as the decade's live-action Jimmy Olsen, playing the *Daily Planet* photographer in 1978's *Superman: The Movie* as well as all three of its sequels and 1984's *Supergirl* movie (in which he again courted Lucy Lane). Actor Michael Landes ushered the character into the '90s in the first season of *Lois & Clark: The New Adventures of Superman* (with Justin Whalin playing him for the show's remaining three seasons); David Kaufman provided his voice on *Superman: The Animated Series*. Sam Huntington played the role in 2006's *Superman Returns*, and Aaron Ashmore did the honors on *Smallville*. On the 2015 *Supergirl* TV show, Jimmy, who here prefers to be called James, is a potential love interest for Kara Zor-El. Played by 6-foot-3 actor Mehcad Brooks, his physique rivals that of Superman himself.

But no matter what changes he undergoes, Superman's pal will remain a favorite of fans, our surrogate within the Man of Steel's universe.

Daily Planet Exclusive

Mehcad Brooks

As of this writing, the latest actor to play Superman's pal, Jimmy Olsen, is Mehcad Brooks, of TV's *Supergirl*. A veteran of TV hits like *Desperate Housewives* and *True Blood*, Brooks is the first African American to portray the *Daily Planet* photographer, who, on the CBS show, joins Cat Grant's CatCo Worldwide Media as an art director. A love interest and confidante of Kara Danvers, the 6-foot-3 Brooks' Olsen helps the Last Daughter of Krypton battle evil in National City and abroad.

How would you describe your Jimmy? Or, as he prefers to be called, James?
He's a 21st century James Olsen. We're not worried about what he looks like at this point in time. Back in 1940 when Jimmy was created the creators lived a monochromatic existence. You can't blame anybody for that. But now it's changed. Had races intermixed back then, they might have written Jimmy as black or Latino…or Greek! You never know. [Laughs.]

The biggest change is not the color of his skin, but the fact that he's come into his own. He's trying to be his own man for the first time. He's sort of winning the battle that most of us fight, which is "Am I gonna be my higher self or not?" Because of that he's able to help Kara come out of her shell.

Most people know him and like him because he's Superman's best friend. Not really because of anything he's done. I'm sure most of us can relate to that, whether it's a bigger brother or a father or a friend, or it might be someone you've felt in friendly competition with. But at the same time they're doing things you couldn't believe…He also brings a unique perspective to Kara. Because she doesn't know what a superhero is at first.

Did any past incarnations of the character help inform your version?
The Jimmy Olsen from the Donner films, Marc McClure. He's fantastic. He's amazing. He will always be the original Jimmy Olsen to me. I grew up with that. And Christopher Reeve will always be my Superman.

Mehcad Brooks

What makes Melissa Benoist work in the role of Kara?
She is Supergirl. Through and through. If you know her personally, there's not a better representative of this character. It couldn't happen to a nicer person, a more hard-working person, a more cheerful person. She's really just a beautiful soul, and she's a great role model. I'm really looking forward to little girls looking up to her. I'm looking forward to that Benoist charm in everybody's household.

Were you into superheroes as a kid?
I was into Superman, Batman, and the X-Men. When they started redoing Batman in *Batman Beyond*, I was just old enough to appreciate the action and the fighting. I was into martial arts at the time…Also the Tim Burton *Batman* movies.

Why do you think Superman and Supergirl have endured for so many years?
The House of El symbol has grown in America to mean something, and in the world. It means bravery and courage and strength and honor, and helping your fellow man. All these "corny" characteristics that we don't normally exalt today. But it's what we all want to be, when you strip away the irony. Everybody knows that when they put that "S" on. That's why kids put the T-shirt on. That's why [Shaquille O'Neal] got that tattoo. [Laughs.]

Jimmy's had superpowers from time to time in the comics. At some point in the future would you like your character get them?
Are you kidding me? Of course! Everybody wants superpowers.

Which one would you pick?
A Green Lantern ring. [Laughs.] Because it's more or less a shapeshifting piece of jewelry, where you can do a bunch of different superheroic things with it. You can fly with it. You can be invisible. You can get super strength. You can punch people through a wall, shoot lasers, open multidimensional portals…Then you take the ring off and you're normal. You can go on a date. Supergirl can't hug somebody, because she might crush their ribs. I don't want that. I want to know what I'm doing. [Laughs.]

55 Titano the Super-Ape

A variation on "Beauty and the Beast," the King Kong story is one of the most enduring in pop culture. So it stands to reason that DC Comics would create its own version of the giant gorilla to thwart its most popular hero and his girlfriend.

"Titano the Super-Ape" was the tale in which he made his eponymous debut, in February 1959's *Superman* #127 (by writer Jerry Coleman and penciller Wayne Boring), published at the height of the Space Race. Originally a brainy bespectacled chimpanzee named Toto, whom Lois Lane befriended, he was sent into space in a rocket as part of a publicity campaign. After his satellite was exposed to radiation released from the collision of uranium and kryptonite meteors (because science), the animal returned to Earth and grew to enormous size. He took Lois, who renamed him Titano, and battled Superman with his newly acquired kryptonite vision. Protecting himself behind a lead shield, the Man of Steel was able to subdue Titano, and—with the help of Lois, who convinced Titano to don a pair of giant goggles with lead lenses—send him back to prehistoric times where he could live among other giant animals.

Following DC's *Crisis on Infinite Earths* miniseries, Titano was rebooted in 1987's *Superman Annual* #1 ("Tears for Titano!" written by John Byrne and pencilled by Ron Frenz). Here, he was a laboratory chimp whom Lois met during a visit to the government facility in which he was held. Exposed to radiation, he grew gigantic and went on a city-wide rampage. When Superman was unable to stop Titano, Lois calmed him down long enough for the scientist responsible for his condition to return him to normal size.

Sadly, the process was too much for Titano and he died, cradled by a tearful Lois.

A Bizarro Titano was introduced in April 1962's *Adventure Comics* #295 ("The Kookie Super-Ape," written by Superman co-creator Jerry Siegel with art by John Forte). Other versions appeared in writer Grant Morrison and artist Frank Quitely's *JLA: Earth 2* graphic novel and in DC's "New 52" reboot.

Titano's screen debut came in an episode of the 1966 TV cartoon series *The New Adventures of Superman* ("The Chimp Who Made It Big"). An amusing take on his origin tale was offered in the *Superman: The Animated Series* episode "Monkey Fun," in which Titano was again an astronaut, looked after by General Sam Lane, and a childhood playmate of his daughter Lois.

In addition to offering the spectacle of a giant ape trashing Metropolis, what makes Titano stories enjoyable is their offering Lois Lane an all-too-infrequent opportunity to work alongside Superman, and to share more fully his triumphs and tragedies.

56 Nightwing and Flamebird

While Superman may be the mightiest man on Earth, when he visits the last surviving city of Krypton, the Bottle City of Kandor (which he protects under an artificial red sun within his Fortress of Solitude), he's as weak as any mere mortal. Fortunately, there's more to the Man of Steel than his superpowers.

In January 1963's *Superman* #158 (containing a three-part story, written by science fiction author Edmond Hamilton and pencilled by longtime Superman artist Curt Swan), Superman and Jimmy find that a Kandorian scientist, Than Ol, has found a

means of restoring his people to their full size, consequently giving them superpowers via Earth's yellow sun. He convinces his people that Superman also has a means of doing so, yet refuses to use it so he won't have any rival Supermen on Earth. Hunted by his fellow Kryptonians within Kandor, Superman draws inspiration from Batman and Robin, and he and Jimmy don masks and utility belts, strap jet motors to their backs, and name themselves after two winged animals from Krypton—Nightwing and Flamebird. The "Dynamic Duo of Kandor" proceed to save the city, which Superman has learned will disintegrate should it be restored with Than Ol's enlarging-ray projector.

Other adventures followed, in which Nightwing and Flamebird continued to defend Kandor, with the help of their trusty Nightmobile, which they keep in their Nightcave. They even acquire a Nighthound. Eventually, in May-June 1997's *Superman Family* #183 (written by Paul Kupperberg and pencilled by Carl Potts), the two are succeeded as Kandor's champions by another duo, both of whom live within the Bottle City: Superman's kinsman Van-Zee and his assistant, Ak-Var, who was wrongfully sentenced to the Phantom Zone and released by Superman.

In *Tales of the Teen Titans* #44 (July 1984), written by Marv Wolfman and pencilled by George Perez, the adult Dick Grayson, having outgrown his identity as Robin, becomes a new hero, Nightwing—named in honor of his two mentors, Batman and Superman.

Tales of Kandor, like many of the best Superman stories, serve to humanize the Man of Steel, giving him a sense of community, as well as an element of tragedy, in that he's unable to restore, and thus live among, the last surviving Kryptonians. But the original Nightwing and Flamebird stories go one step further, proving Superman's heroism is only *enabled* by having superpowers, and not the result of having them.

The Parasite

What would happen if someone had the ability to rob Superman of his awesome strength and weaken him to the point of death? That's the simple question posed in August 1966's *Action Comics* #340 ("Power of the Parasite!" by writer Jim Shooter and artist Al Plastino), which introduced the last of the great Superman villains created during the Silver Age.

The Parasite began his career as Raymond Maxwell Jensen. A wage slave at a scientific research center, Jensen had the misfortune of being exposed to radioactive waste while trying to steal from his company. His cells bombarded with atomic particles, he was rendered a pitiful, featureless purple humanoid capable of absorbing the powers and memories of whomever he came into contact with. Fortunately, for the Man of Steel, his powers were so great that the Parasite died trying to steal them. Or so it would seem.

The creature returned on numerous occasions in the years that followed, leading up to his most memorable comic book appearance, when he was manipulated by the supervillain Victor Von Doom into battling both Superman and Spider-Man the second time the two comic book icons teamed up, in 1981's *Marvel Treasury Edition* #28 ("Superman and Spider-Man," by writers Jim Shooter and Marv Wolfman and penciller John Buscema). In this story, Doom secretly planned to overload the Parasite's cells with the energy of both heroes, as well as that of Wonder Woman and the Hulk, and thus transform the wretch into a crystal substance Doom needed to complete his world-threatening fusion reactor. But the Parasite absorbed Spider-Man's spider-sense and realized Doom's true intentions just in time, dissolving their partnership— and almost the Latverian monarch himself.

After the reboot following the events of DC's 1985 *Crisis on Infinite Earths* miniseries, a new Parasite was introduced: Rudy Jones, a S.T.A.R. Labs janitor who was manipulated by Darkseid (who remembered the events that had taken place before *Crisis*) into opening another chemical waste container. This version of the creature was initially green, and he battled Superman's fellow hero Firestorm. Many confrontations with the Man of Steel followed, some while the Parasite was a member of the Injustice League and the Superman Revenge Squad. In the 2009 reboot miniseries *Superman: Secret Origin*, Rudy is a janitor at the *Daily Planet* who is transformed by LexCorp chemicals. The Parasite also appeared in such miniseries as *Kingdom Come* and *All-Star Superman*.

A Parasite that looked nothing like that of the comic books appeared in Filmation's *New Adventures of Superman*. But the true first screen appearance of the character occurred in the *Superman: The Animated Series* episode "Feeding Time," in which the Rudy Jones version was voiced by the late character actor Brion James. The Man of Steel defeated him with a chunk of kryptonite he wielded while wearing a suit of protective armor, though the Parasite returned in two subsequent episodes, as well as the *Justice League* spinoff show, *Young Justice*, and several animated films and video games. The character made his live-action debut in the *Smallville* episode "Injustice," played by Brendan Fletcher.

Suffice it to say that as long as Superman has superpowers, the Parasite will try to strip them from him.

58 Curt Swan

No comic book artist has pencilled as many stories about the Man of Steel as the late Curt Swan, who defined Superman's look from the 1950s through the 1980s. Born February 17, 1920, as Douglas Curtis Swan, this Minnesota native was a self-taught artist (save for several months at Brooklyn's Pratt Institute) who joined DC Comics after serving in World War II; when he was a staff artist on the Army paper *Stars and Stripes*, he met and married his wife, Helene Brickley, a Red Cross volunteer. He pencilled his first Superman tale in "The Man Who Bossed Superman" (in *Superman* #51, March-April 1948), and became the principal penciller on *Superboy* with issue #5's "A Zoo for Sale!" (November 1949) and on *Superman's Pal, Jimmy Olsen* with its first issue (September-October 1954). He was the regular artist (along with Dick Sprang) on *World's Finest Comics* and eventually took over Superman's own comic, succeeding artist Wayne Boring, who in turn had taken over from Superman co-creator Joe Shuster.

If Shuster gave Superman life, and Boring gave him power, Swan imbued him with nobility and a hint of world-weariness. In his essay "Drawing Superman" (published in *Superman at Fifty: The Persistence of a Legend* by Octavia Press in June 1987), Swan remarks, "I didn't have any conscious models for Superman. I suppose I might have been somewhat influenced by Johnny Weissmuller. I had always been kind of fascinated, as a boy, by the *Tarzan* newspaper strip and the Weissmuller movies, and I guess may have imitated them subconsciously to a degree. Alex Raymond's strip *Rip Kirby* was probably also an influence."

Swan's work looked its best when inked by Murphy Anderson (together, they became known as "Swanderson"). Their collaboration

began when Julius Schwartz became editor of DC's Superman titles and relaunched the character's adventures in January 1971, with #233's "Superman Breaks Loose" (written by Dennis O'Neil).

Among the many highlights of Swan's long association with Superman was the Man of Steel's first comic book team-up with Batman in May-June 1952's *Superman* #76 ("The Mightiest Team in the World"); the first appearance of Superman and Jimmy Olsen's Batman-and-Robin-inspired alter egos within the Bottle City of Kandor, Nightwing and Flamebird, in January 1963's *Superman* #158 ("Superman in Kandor"); Superman's first race with the Scarlet Speedster in August 1967's *Superman* #199 ("Superman's Race With the Flash!"); the introduction of the deadly Composite Superman— with his "more than 20 superpowers!"—in June 1964's *World's Finest Comics* #142 ("The Composite Superman!"); the introduction of the equally deadly Terra-Man in March 1972's *Superman* #249 ("The Challenge of Terra-Man"); numerous tales of Superman's 30th-century comrades, the Legion of Super-Heroes, in *Adventure Comics*; and a run on the daily *Superman* comic strip from June 18, 1956, through November 12, 1960. The story of which Swan was most proud, however, as he explains in "Drawing Superman," was his 1973 version of "The Origin of Superman" (with layouts by then publisher Carmine Infantino), included in the tabloid-sized one-shot *The Amazing World of Superman*.

Swan's farewell to Superman as regular artist came with the character's two-part Silver Age "capstone" written by Alan Moore, "Whatever Happened to the Man of Tomorrow?" It was first published in September 1986's *Superman* #423 and *Action Comics* #583 (the former inked by George Perez, the latter by Swan's peer and fellow Superman vet, Kurt Schaffenberger). Afterward, Swan was succeeded by writer-artist John Byrne on DC's post–*Crisis on Infinite Earths* reboot of the character. Swan's five final pages of Superman art were included in December 1996's one-shot special *Superman: The Wedding Album* (in which the Man of Steel finally married Lois

Lane). It was published after the artist's death at the age of 76 on June 17, 1996. In 1997, he was inducted into the Will Eisner Hall of Fame.

Swan's greatest gift was his ability to help fans suspend any disbelief they might have in reading Superman's adventures by rendering the Man of Steel as nonchalantly as possible. As more than one critic has pointed out, Swan pencilled Superman as though he really existed.

In "Drawing Superman," the artist states, "I wanted to show strength, of course, and ruggedness. And character. He had to be the kind of person you'd want to have on your side. When I drew Clark Kent, on the other hand, I deliberately softened his features, made them less angular than Superman's. I wanted him to appear more meek. Just sort of a good Joe. I don't know if it worked, but that's what I was trying to do."

Artist Dave Gibbons—who illustrated the Alan Moore–penned Superman classic "For the Man Who Has Everything" as well as the duo's masterpiece *Watchmen*—considers Swan, alongside José Luis García-López, one of the two definitive Superman artists: "Curt Swan had that wonderful gift of making Superman seem so real and so natural, and the cast of characters so believable. You can often overlook that when the current vogue is for much flashier kind of art styles."

59 It's a Bird...It's a Plane... It's Superman

Besides the comic book, few storytelling mediums are so uniquely American as the musical comedy. So it's entirely fitting that the story of America's greatest superhero should be adapted to the Broadway stage.

Proving there really are no limits to his skills, the Man of Steel sang, danced, and joked his way through *It's a Bird...It's a Plane...It's Superman* during its brief run at New York's Alvin Theatre from March 29 through July 17, 1966. With music by Charles Strouse and lyrics by Lee Adams, and a book by David Newman and Robert Benton (who would again collaborate on an early draft of *Superman: The Movie*), *It's Superman* starred Bob Holiday as Superman/Clark Kent, Patricia Marand as Lois Lane, Jack Cassidy as disgruntled *Daily Planet* reporter Max Mencken, and Linda Lavin (of TV's *Alice*) as Sydney Carlton, Lois' rival for Clark's affection (a sort of proto Cat Grant).

It's Superman's story revolves around a mad scientist (played by Michael O'Sullivan) and his plot to destroy Superman out of spite when the world fails to recognize his genius. Though it ran for just 129 performances, *It's Superman* earned Tony Award nominations for Best Actor in a Musical (Cassidy), Best Featured Actor in a Musical (O'Sullivan), and Best Featured Actress in a Musical (Marand). Numerous revisions, revivals, and concert versions followed, with *It's Superman* finally reaching London's West End in 2015.

The play reached a new audience when it was abridged and presented as an ABC television special on February 1, 1975. This poorly received version starred David Wilson as Superman, Lesley Ann Warren (who would later audition for the same role in *Superman: The Movie*) as Lois Lane, *M*A*S*H*'s Loretta Swit as Sydney, and *Young Frankenstein*'s Kenneth Mars as Max.

While by no means a Broadway classic, *It's a Bird...It's a Plane...It's Superman* gave the world at least one undeniably great tune, Sydney's showstopping bossa nova ode to Clark Kent, "You've Got Possibilities."

60 *Superman Returns*

After *Superman IV: The Quest for Peace* failed at the box office, 19 long years passed before the Man of Steel's fans saw him again in a new feature film. In the interim, director Tim Burton's *Batman* movies gave audiences a taste for darker superheroics, and DC Comics' perennial rival Marvel finally saw its heroes successfully translated to the big screen in Bryan Singer's *X-Men* movies and Sam Raimi's *Spider-Man* films. After Christopher Nolan's *Batman Begins* relaunched DC's characters on screen, Warner Brothers followed it with 2006's *Superman Returns*.

Born out of the ashes of the studio's aborted *Superman Reborn* and *Superman Lives, Superman Returns* was directed by Singer, a lifelong fan of *Superman: The Movie*. In creating this unofficial pseudo sequel to the 1978 film and its follow-up *Superman II*, Singer reunited with his *X-Men* screenwriters Michael Dougherty and Dan Harris, and cast then unknown actor Brandon Routh in the lead role. Routh played both Superman and Clark Kent similarly to Christopher Reeve (who passed away two years before *Superman Returns* was released). Kevin Spacey took on the role of Lex Luthor and infused him with greater malevolence than had Gene Hackman. Kate Bosworth, at 22 years old, was a far less world-weary Lois Lane than Margot Kidder's. Sam Huntington and Frank Langella portrayed Jimmy Olsen and Perry White, while *X-Men* star James Marsden rounded out the *Daily Planet* staff as a new character, Perry's nephew Richard. It's Richard White, however, who makes evident *Superman Returns'* flaws.

The film's central conceit—that Superman left Earth shortly after the events of *Superman II* to search for Krypton's remains, while Lois bore his child in his absence—has the unfortunate

effect of making Superman look like a deadbeat dad. That Richard is now Lois' boyfriend, helping her raise her son, doesn't help viewers sympathize with the Man of the Steel, while making them unsympathetic toward Richard, who's taken Superman's place in Lois' life. By the end of the film, when Richard rescues both Lois *and* Superman, and Superman moves on, letting them live

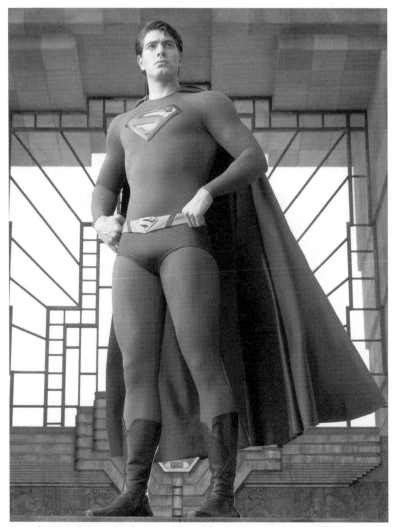

Brandon Routh brought the Man of Steel back to movie theaters after a 19-year absence, in 2006's Superman Returns. (Getty Images)

out their lives together, *Superman Returns* has managed to alien-ate comic books fans as well as moviegoers just looking for a little escape. Newton Thomas Sigel's cinematography and Guy Hendrix Dyas' production design are handsome, but the film's dark light-ing coupled with its downbeat story makes for a rather gloomy end product. Routh, to his credit, does the best he can with a near impossible task—succeeding Reeve. The actor has, thankfully, gone on to develop a more winning screen persona in the role of another DC superhero, Ray Palmer (aka the Atom) in TV's *Arrow* and *DC's Legends of Tomorrow*.

The film's box office was strong but unspectacular given its $200 million budget. While critics rightly observed that, like the first two Reeve films, it had a heart, perhaps *Superman Returns* greatest problem was that its beat was out of sync with the movies that preceded it.

Daily Planet Exclusive

Brandon Routh

Though he played Superman in just one film, 2006's *Superman Returns*, Brandon Routh won his share of admirers and deserves significant credit for keeping the character alive on movie screens between Christopher Reeve's run in the 1970s and '80s and Henry Cavill's turn in this decade. Most recently, Routh has perfected his take on DC Comics heroism, playing the fan-favorite character Ray Palmer (aka the Atom) on TV's *Arrow* and his own series, *DC's Legends of Tomorrow*.

How did you discover Superman, and how did he serve as your gateway into the superhero universe?
Watching the movies as a kid, it set up that vision of what Superman was. Christopher Reeve was and is still my Superman. It was an archetype for what it is to be a powerful person, even though he's an alien. It was always the ideal for me of what can be the best of humanity. So when I started getting into the process of Superman, I

Brandon Routh

started thinking back on all that. *What does that really mean? What do I really want out of Superman, and what does Superman mean to me?* I reflected on that, and that's what I got. That he's the ultimate.

What was the best thing about playing the character?
The flying and the learning to fly was amazing, that whole experience, the evolution of that. Getting down to the nitty-gritty of actually doing it every day was a little more work. But the learning aspects of it, being in the *Daily Planet* for the first time and doing those scenes…I loved everything that I got to do as Clark. I loved the humor and the life of it.

Was it satisfying to give a conclusion to the storyline of the first two Christopher Reeve films?
Yeah. What a great honor. I got to be the transitionary figure. People give a lot of flak to *Superman Returns*, that it was too much like a sequel. But I think *not* having had that film, it would have been harder for people to transition to the new Superman, with Henry playing Superman. Somebody had to close that gap between Christopher Reeve, the only known film version, and what is now. That was my opportunity.

Did the role also help you transition to playing the Atom on TV?
Oh, yeah. Being in that world, understanding the stresses of that. What people expect to see from superheroes, has allowed me to do this. Ten years have passed and I've learned so much. I've grown and matured as a person. Understanding and handling the stress, the work environment, being a nicer coworker to everyone, and a happier person overall in life has been a big help.

In doing *Superman Returns*, did you develop an appreciation for the DC Universe that you've carried forth to *DC's Legends of Tomorrow*?
The nature of DC Comics seems to be a little bit more inherently a brighter, shinier optimistic view of life. Batman is a little bit different. But that's what always appealed to me. That's essential. That's the core of Superman for me, and that's the core character for DC. I feel like he drives what DC is, and that's what I want from my heroes. That's what I want from Superman. I don't know if I'm just projecting that, but that's what I see when viewing DC properties versus Marvel properties. That all have their own positives, and not very many negatives.

61 Filmation's *The New Adventures of Superman*

Though the Fleischer Studios cartoons of the 1940s first brought Superman to the big screen in bold, dynamic color, they were lacking in one area—the Man of Steel's rogues gallery. With the exception of Lex Luthor (who appeared in the 1950 movie serial *Atom Man vs. Superman*), the villains of the comic books would make their screen debut (animated or otherwise) on television, in Filmation's *The New Adventures of Superman*.

Premiering the morning of Saturday, September 10, 1966, on CBS, *The New Adventures of Superman* began as a half-hour children's series that initially consisted of two six-minute segments featuring the Last Son of Krypton, between which ran a series of six-minute *The Adventures of Superboy* shorts. A total of 36 Superman cartoon shorts and 18 Superboy shorts were produced. Superman comic book editor Mort Weisinger served as story consultant.

In its second season, the show became *The Superman/Aquaman Hour of Adventure*, and featured 16 new Superman shorts and eight new Superboy adventures, along with 36 shorts featuring the King of Atlantis; additional assorted adventures featured fellow Justice Leaguers the Flash, Green Lantern, Hawkman, and Atom, as well as the Teen Titans. In its third season, the show underwent its most radical change when the character design was altered to resemble that of Superman artist Curt Swan. This time around, it was called *The Batman/Superman Hour*, and contained 16 new two-part Superman stories, eight new Superboy shorts, and 36 shorts featuring the Caped Crusader of Gotham City and his friends and foes. For its fourth season, the show was again named *The New Adventures of Superman*, focused once more only on Superman and

Superboy, and reduced in length to its original 30-minute format. This final season was comprised entirely of reruns.

As in the Fleischer shorts (as well as the *Adventures of Superman* radio show of the 1940s), Superman and Clark Kent were voiced by Clayton "Bud" Collyer, while Joan Alexander voiced Lois Lane. Bob Hastings, who would later voice Commissioner James Gordon in *Batman: The Animated Series*, provided the voice of Superboy. Janet Waldo (best known as the voice of Judy Jetson) was cast as the screen's first Lana Lang. *The Adventures of Superman* radio show's announcer and Perry White, Jackson Beck, performed similar duties for the Superman shorts, and voiced Lex Luthor. Filmation staple Ted Knight (of *The Mary Tyler Moore Show* and *Caddyshack*) narrated the Superboy segments and voiced the first Krypto. In addition to Luthor and Brainiac—here created by Doctor Heckla from the war-ravaged planet Mega, and looking to repopulate his homeworld on behalf of his master by shrinking and enslaving Earth's species—the show's villains included Mister Mxyzptlk, the Toyman, the Prankster, and Titano the Super-Ape.

With Filmation's limited animation and stories less sophisticated than those in the comics that preceded it, *The New Adventures of Superman* is the Man of Steel's least enduring animated incarnation. But like Hanna-Barbera's *Super Friends* cartoon which followed, the show maintained Superman's presence on screen, and in the public eye, between the 1950s George Reeves–starring *Adventures of Superman* TV series and the Christopher Reeve films of the '70s and '80s.

62 The Superman-Flash Races

Who's faster—Superman or the Flash? It's a question that's been asked in schoolyards around America since the day both heroes met. *Superman* #199 (August 1967), written by Jim Shooter and pencilled by Curt Swan, marked the first time the two tried to provide an answer by racing each other.

"Superman's Race with the Flash!" was the first of several comic book stories in which the Justice League teammates competed with one another in footraces, this time for the United Nations. Unfortunately, rival crime syndicates placed bets on the Leaguer they wanted to win, and tried to sabotage the other's chances. In the end, the race ends in a tie, thus preventing any criminals from winning.

Spurred, no doubt, by frustrated readers, DC Comics hosted a rematch just four months later, December 1967's *Flash* #175 ("The Race to the End of the Universe!" by E. Nelson Bridwell and Ross Andru). This time around, the Scarlet Speedster and the Man of Steel were forced to race—to the edge of the galaxy and back, no less—by extraterrestrial gamblers holding the lives of their other Justice League teammates at stake, and threatening to destroy the home city of the loser. Before the race ends, however, it's revealed to be a gigantic plot to kill the Flash by his archenemies. So it leads to another draw.

A third race between the two took place in November 1970's *World's Finest* #198 ("Race to Save the Universe!") and the following month's #199 ("Race to Save Time"), both by writer Dennis O'Neil and artist Dick Dillin. In this two-part story, the race occurred in another dimension, under a red sun (beneath which Superman is powerless), in which both the Flash and Superman

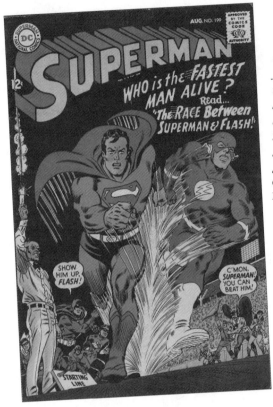

The first race between fellow Justice League members Superman and the Flash occurred in 1967's Superman #199. *Spoiler alert: it was a tie.* (Cover art by Carmine Infantino and Murphy Anderson)

fight to stop a race of destructive robots. The two wind up handicapped, and crawling to the finish. Superman concedes victory to the Flash, but only admits his friend is the fastest man alive in this dimension.

The first two issues of *DC Comics Presents* (August and October 1978's "Chase to the End of Time!" and "Race to the End of Time!" by Martin Pasko and José Luis García-López) find Superman and the Flash confronting a war between two alien races. Their competition against each other is only a small part of the story, but the Flash is deemed somewhat faster.

After the Silver Age Flash, Barry Allen, perished in *Crisis on Infinite Earths*, he was succeeded by his nephew Wally West.

The new Flash was forced to race Superman in February 1990's *Adventures of Superman* #463 (written and pencilled by Dan Jurgens) by Mister Mxyzptlk (Wally won). When Barry finally returned in June 2009's *Flash: Rebirth* #3 (by Geoff Johns and Ethan Van Sciver), he proved once and for all, in a clear victory over his old friend, that he was indeed the fastest man alive.

The Superman-Flash races were brought to life on TV in an episode of *Smallville*'s fifth season ("Run"), which introduced the speedster Bart Allen—who is, in the comics, Barry's grandson from the 30th century. Like his granddad, Bart too proved faster than Clark Kent. *Superman: The Animated Series* also contained an homage in its second-season episode "Speed Demons," which finds its race interrupted by Flash's foe Weather Wizard. In the *Justice League* spinoff series, the voice of the Flash is provided by Michael Rosenbaum, *Smallville*'s Lex Luthor.

63 Superman and Wonder Woman

Batman v Superman: Dawn of Justice, released in 2016, marks the very first time that Superman (as played by Henry Cavill) and Wonder Woman (actress Gal Gadot) have met in a live-action film. But in comics, the Man of Steel has enjoyed a lively relationship with the Amazon Princess throughout both of their long careers— as teammates, friends, and love interests.

The two first met and worked together in August-September 1947's *All-Star Comics* #36 ("5 Drowned Men!" written by Gardner Fox, in a chapter pencilled by Irwin Hasen), when honorary Justice Society members Superman and Batman worked on a case with the team. Though Diana Prince had, like her two male

counterparts, her own comic book, she was, at that time, cast in the unexciting role of the Society's secretary. When the Silver Age of Comics arrived in the 1950s, DC's top hero and heroine finally fought alongside each other regularly in the Justice League. But the first comic book to suggest a possible romance between the two was July 1969's *Superman's Girl Friend, Lois Lane* #93 ("The Superman–Wonder Woman Team!" written by Robert Kanigher and pencilled by Irv Novick). Though the two Justice Leaguers lock lips (to Lois' horror), "Wonder Woman" is revealed to be a villain in disguise, who'd planned to conquer the planet with Superman.

February 1974's *Superman's Girl Friend, Lois Lane* #136 ("Wonder Woman: Mrs. Superman," written by Cary Bates and pencilled by John Rosenberger) presents their first real kiss. Yet it turns out Wonder Woman only pretends to be in love with Superman in an effort to save Lois, since an enemy had sworn to kill the Man of Steel's girlfriend. After years appearing together as teammates on TV's *Super Friends*—and one knockdown, drag-out fight over America's nuclear arsenal in January 1978's *All-New Collectors' Edition* #C-54 ("Superman vs. Wonder Woman," written by Gerry Conway and pencilled by José Luis García-López)—the two hooked up twice more: in April 1981's *DC Comics Presents* #32 ("The Super-Prisoners of Love," by writers Gerry Conway and Roy Thomas and penciller Kurt Schaffenberger) and February 1983's *Wonder Woman* #300 ("Beautiful Dreamer, Death Unto Thee!" written by Roy and Dann Thomas, in a chapter pencilled by Rich Buckler), though in the former they're compelled by the god Eros, and the latter is only a dream.

Following a brief embrace in 1985's *Superman Annual* #11 ("For the Man Who Has Everything," written by Alan Moore with art by Dave Gibbons), Superman and Wonder Woman had perhaps their first bona fide makeout session in May 1988's *Action Comics* #600 ("Different Worlds," written by John Byrne with layouts by

Byrne and finishes by George Perez). It's their first meeting in the rebooted, post–*Crisis on Infinite Earths* DC Universe. But the Man of Steel soon realizes that although they share similar powers (and hair, eye, and uniform colors), he's a farm boy from Kansas and she's an immortal warrior princess.

The two became lovers in such Elseworlds miniseries as Frank Miller's 2002 *The Dark Knight Strikes Again* and Alex Ross and Mark Waid's 1996 *Kingdom Come* (in which they have a child together). But their first long-term romantic relationship began in DC's company-wide "New 52" relaunch, in October 2012's *Justice League* #12 ("The Villain's Journey, Chapter Four: Rescue From Within," written by Geoff Johns, pencilled by Jim Lee, Ivan Reis, Joe Prado, and David Finch). It would lead to their first shared title, *Superman/Wonder Woman*, in October 2013 (written by Charles Soule and pencilled by Tony Daniel), the first story arc of which is fittingly titled "Power Couple."

Though they come from different worlds and Superman is, in the eyes of many, destined to be with Lois Lane, perhaps the *real* reason why the Last Son of Krypton and the Daughter of Themyscira haven't pursued romance more frequently is given by Diana after their kiss in "For the Man Who Has Everything": "Too predictable."

64 Kryptonite Nevermore

By 1971, Superman had evolved far beyond the wisecracking tough guy who first appeared in 1938. He could move planets, withstand a nuclear blast, and fly faster than the speed of light. Some fans and creators began to complain he was a little *too* super, too unrelatable, especially when compared with the "flawed" superheroes Marvel

Comics had introduced to the world with November 1961's *Fantastic Four* #1, the popularity of which had steadily increased throughout the decade.

When longtime Superman comic book editor Mort Weisinger retired, he was replaced by Julius Schwartz, who had launched the Silver Age of Comics with October 1956's *Showcase* #4, (the first appearance of Barry Allen's Flash). One of Schwartz's first moves was to bring on writer Dennis O'Neil, who'd won much praise for his recent revamps of Batman, Green Lantern, and Green Arrow. O'Neil proceeded to script a run of stories, with art by the acclaimed team of penciller Curt Swan and inker Murphy Anderson (and eye-catching covers by Neal Adams), that's now known as *Kryptonite Nevermore*.

First collected in a 2009 hardcover edition, *Kryptonite Nevermore* begins with a chemical explosion that turns all kryptonite to lead, thus eliminating what O'Neil believed was an overused narrative device. Additionally, the explosion tore open a rift between our universe and an alternate dimension, the realm of Quarrm, which resulted in the formation of a second Superman, who siphoned his power from the first, slowly reducing the original's power levels. When he was completely drained, the Man of Steel initially wished to remain that way. "I've had a taste of the glory of being normal!" he says in August 1971's *Superman* #241. "To win through determination…courage…to be no more than myself—and no less! For years I've been dreaming of working and living as a plain man—without the responsibilities…the loneliness…of Superman!"

Soon, however, Superman's regained most of his powers, and the creature decided he had no right to Superman's body and returned to Quarrm—though not before the Man of Steel decided he would allow him to keep one third of his power, thus making him a little less godlike and, presumably, someone with whom readers could better identify.

As so often happens in mainstream comics, the changes didn't last. O'Neil decided he wasn't quite clicking with the assignment and left Superman soon after this story arc concluded in September 1971's *Superman* #242. And, as the writer points out in his afterword to the collected edition, a month after his last issue, Superman was towing a planet (on the cover of December 1971's *World's Finest* #208). But *Kryptonite Nevermore* had kicked open a door through which other writers would walk in the decades that followed, demonstrating that at the core of Superman there lies a man.

65 Tour the Super Museum

A visit to Metropolis, Illinois, is a requirement for every Superman fan. And no visit to Metropolis is complete without a tour of the Super Museum, located at 517 Market Street on Superman Square.

The Super Museum was founded by Jim Hambrick in 1993. A Superman collector since his mother bought him a Superman lunchbox for his fifth birthday, Hambrick's collection contains more than 20,000 items, including vintage toys, posters, puzzles, games, comics, artwork and animation cels...even a Superman talking telephone phone booth, inside of which visitors can hear a special greeting from the Man of Steel. The collection spans Superman's entire history, from the phone booth used by actor Kirk Alyn in the *Superman* film serials to props and costumes from the George Reeves–starring *Adventures of Superman* TV show to the Christopher Reeve *Superman* movies to *Superboy* to *Lois & Clark: The New Adventures of Superman* to *Smallville*. Supergirl too is represented, as are Lois Lane, Jimmy Olsen, Lex Luthor, and numerous other friends and foes.

Hambrick's most prized possession is George Reeves' brown-and-grey Superman costume, used during the black-and-white years of his TV show. Reeves' color costume is also on display, as is one of Christopher Reeve's costumes, and various outfits worn by Teri Hatcher in *Lois & Clark*. Many of the items on display change regularly to entice repeat visitors.

The museum is housed in a brick building trimmed in red, yellow, and blue, to the second story of which is mounted a statue of the Last Son of Krypton taking flight. Just outside of the museum is a sizable gift shop, with items guests can purchase to start their own Superman collections. For more on the Super Museum, visit www.supermuseum.com.

When you're in Metropolis, Illinois, make sure to stop at the Super Museum, a collection of more than 20,000 items related to the Man of Steel.

66 *Man of Steel*

In the wake of *Superman Returns*, concern was expressed about the Last Son of Krypton's viability as a movie star. Director Bryan Singer's film had cost well over $250 million and grossed $200 million domestically, while Singer's prior superhero film, the *X-Men* sequel *X2*, had grossed three times its budget. Additionally, some fans complained about its story, while others felt there wasn't enough action.

After a 2009 court hearing over a lawsuit filed by Superman co-creator Jerry Siegel's family to regain the rights to the character, the Siegels' attorney Marc Toberoff announced, "The Court pointedly ruled that if Warner Bros. does not start production on another Superman film by 2011, the Siegels will be able to sue to recover their damages." The studio then turned to Christopher Nolan and David Goyer, who'd directed and written the blockbuster trilogy of Batman films. Securing Nolan as producer and Goyer as screenwriter, Warners recruited Zack Snyder. Only one of Snyder's four films for Warner Brothers, 2006's *300*, had been a hit, but the director had experience working with large budgets and bringing films in on time.

Snyder had admitted during the press tour for his *Watchmen* that he was not a big fan of superheroes when he was a young boy (preferring *Heavy Metal* to metahumans), and he approached Superman as a darkly violent fantasy about a brooding outsider (played as an adult by Henry Cavill), raised by a cynical father (Kevin Costner) and a supportive mother (Diane Lane). Shot and lit like a horror film rather than a heroic epic—and co-starring Russell Crowe as Jor-El, Amy Adams as a strangely colorless Lois

Lane, and Laurence Fishburne as Perry White—*Man of Steel* opened on June 14, 2013, in the US.

Critics and fans were divided in their reactions, with some preferring the new action-oriented approach, the result of Superman's arrival on Earth coinciding with a Kryptonian invasion force led by General Zod (Michael Shannon). Others were disappointed in Superman's decision to face Zod in Metropolis—as opposed to outside the city (as he had in *Superman II*)—resulting in an almost orgiastic level of destruction, much of it employing 9/11 imagery. The most talked about moment occurred in the film's climax when Superman, quite audibly, broke Zod's neck (on camera) to prevent him from killing a family, rather than simply flying him into the sky. *Man of Steel* thus introduced Superman to a generation of young people as someone who, instead of inspiring humanity to greatness, lowers himself to the level of his enemies.

With a budget of $225 million, *Man of Steel* grossed almost $300 million domestically. As of this writing it's the highest grossing Superman feature film, and scored a sequel in 2016's *Batman v Superman: Dawn of Justice*. But as many fans have observed, if one chooses to tell a Superman story in which Superman has no choice but to kill, than perhaps one shouldn't be telling a Superman story.

67 Superman vs. Captain Marvel

Unlike Superman's rivalries with his archenemies, the conflict between him and his sometimes opponent Captain Marvel exists on two distinct levels.

Captain Marvel, the creation of writer C.C. Beck and artist Bill Parker, first appeared in February 1940's *Whiz Comics #2*

("Introducing Captain Marvel!"). He was born when newspaper boy Billy Batson was granted the power to transform himself into the World's Mightiest Mortal by the wizard Shazam. With powers similar to those then possessed by the Man of Steel, Captain Marvel went on to become the best-selling superhero of the decade, and the "Marvel Family" grew to include his sister Mary Marvel, as well as their friend and ally Captain Marvel Jr. All of them had tongue-in-cheek adventures with villains like the equally powerful Black Adam, the nefarious Doctor Sivana, and the diminutive Mister Mind and his Monster Society of Evil. But the success of Captain Marvel proved too great for DC Comics to ignore, and the company launched a copyright infringement suit against his publisher, Fawcett Comics. The Big Red Cheese disappeared from comics in 1953.

Years later, DC, in an attempt to expand its line of characters, decided to license the Marvel Family from Fawcett, and publish its own Captain Marvel comics. The company even recruited the good Captain's co-creator C.C. Beck to illustrate them. By this time, however, Marvel Comics had trademarked the name Captain Marvel for one of its own characters. So when it debuted in February 1973, DC was forced to title the hero's new comic book *Shazam!*

When Superman first battled Captain Marvel in comics (*Superman* #276, June 1974), the latter's name was changed to Captain Thunder. Writer Elliot S. Maggin explains in editor Michael Eury's *The Krypton Companion* (TwoMorrows, 2006) that this was because they "were trying to do the traditional Fawcett-style Captain Marvel in those days. The style of artwork was different from Superman's...The Captain Thunder story [pencilled by Curt Swan] was a piece of speculation as to what Captain Marvel might be like if lived in the 'real world.'"

Real or not, the "official" Captain Marvel finally took on Superman in April 1978's tabloid-sized, 72-page *All-New Collectors'*

Edition #C-58 ("Superman vs. Shazam!" written by Gerry Conway and illustrated by Rich Buckler and Dick Giordano). The Marvel Family was said to live on Earth-S, another Earth within the DC Multilverse.

The Marvel Family would encounter the Justice League, and take part in *Crisis on Infinite Earths*' company-wide "housecleaning," before being rebooted along with the rest of the DCU. The first official post-*Crisis* meeting between Superman and Shazam occurs in writer Judd Winick and artist Josh Middleton's *Superman/Shazam: First Thunder* miniseries (September 2005—March 2006), which culminates with Clark Kent agreeing to mentor Billy Batson.

Superman and Shazam would go head-to-head on screen in the 2009 DC Animated movie *Superman/Batman: Public Enemies*, and in the *Justice League Unlimited* second-season episode "Clash." Like their most famous post-*Crisis* battle, in Alex Ross and Mark Waid's 2006's miniseries *Kingdom Come* (which saw Marvel sacrifice himself for his fellow heroes), the latter tale finds the two manipulated into fighting each other by Lex Luthor.

68 Superman vs. the Amazing Spider-Man

America's Bicentennial year saw the long-awaited first meeting of the country's then two most popular heroes. Though the first joint publishing venture between DC and Marvel Comics was the preceding year's similarly tabloid-sized *MGM's Marvelous Wizard of Oz*, *Superman vs. the Amazing Spider-Man: The Battle of the Century* marked the first time that characters from the rival companies would interact. Written by Gerry Conway and drawn

by Ross Andru (with an art assist from Neal Adams and John Romita), each of whom had previously worked on both comic book icons, *Superman vs. the Amazing Spider-Man* saw its title champions manipulated by Lex Luthor and Doctor Octopus into battling each other, with Spider-Man receiving a power boost from red-sun radiation, courtesy of Superman's archenemy. It isn't long, however, before the heroes realize they've been duped, thwart their opponents, save the world, and enjoy a double date with their lady friends, Lois Lane and Mary Jane Watson.

Even more satisfying is the follow-up book, 1981's *Superman and Spider-Man* (*Marvel Treasury Edition* #28, written by Jim Shooter and Marv Wolfman, and drawn by John Buscema), in which the two friends take on Marvel's greatest villain, Doctor Doom, and one of Superman's deadliest opponents, the Parasite. The story also features appearances by Wonder Woman (with whom Spider-Man is instantly smitten), as well as Lois Lane and Jimmy Olsen (who befriends Peter Parker and helps him find work at the *Daily Planet*). The highlight, however, is the battle between the Man of Steel and Marvel's strongest superhero, the Hulk.

Other Marvel-DC team-up books would follow, including 1996's *DC vs. Marvel Comics* and 2003's *JLA/Avengers* (by the talented Kurt Busiek and George Perez). But for the sheer wonder of watching comic book universes collide for the first time, it's hard to top the two initial meetings between the web-slinger and the Man of Tomorrow.

69 Superman vs. Muhammad Ali

While Superman is often considered the greatest superhero of all time, in the world of sports there exists another "Greatest"— boxing legend Muhammad Ali, whose one-time team-up with the Man of Steel made for one of the most memorable Superman stories ever.

Superman vs. Muhammad Ali debuted in 1978 as part of DC Comics' oversized tabloid format series *All-New Collector's Edition* (#C-56). It was illustrated by acclaimed draftsman Neal Adams, who drew its iconic wraparound cover featuring a host of 1970s celebrities and comic book creators. Adams adapted the 72-page tale from a story by frequent collaborator Dennis O'Neil, which saw Superman partner with the charismatic boxing champ to thwart the invasion of Earth by the alien Scrubb. The story begins when the leader of these "star-warriors" demands that Earth's greatest champion battle their own greatest fighter. But first, in order to determine whether Ali or Superman is the greatest, the two heroes are made to fight on the Scrubb homeworld, beneath a red sun that robs the Kryptonian of his powers. Ali emerges the victor. Then, while Superman flies off to disable the Scrubb's fleet of battleships, Ali defeats the Scrubb's champion to save Earth. Superman and Ali later agree, "We are the greatest."

Adams, an admirer of the three-time world heavyweight champion, remarks, "Ali was a fighter, and he didn't take [flak] from anybody...I didn't make Superman less. I just made Ali recognizable for what he is."

Daily Planet Exclusive

Neal Adams

Perhaps the greatest of comics' dynamic realists, Neal Adams has defined the look of some of the most popular superheroes of all time, with unforgettable runs on *Batman, Green Lantern/Green Arrow, Deadman, X-Men,* and *Avengers.* He's also contributed mightily to the Man of Steel's legacy, illustrating scores of Superman comic book covers (images from which are used to this day in DC licensing), as well as the one-shot special *Superman vs. Muhammad Ali.* But his greatest Superman contribution may have been in securing long overdue credit and pensions for the character's creators, Jerry Siegel and Joe Shuster.

Why has Superman endured for over 75 years?
First of all, he's the first comic book superhero. He is the alpha to Batman's omega. He is the most powerful superhero, whereas Batman is the least powerful superhero. They are the two ends of the comic book superhero spectrum—Superman at the high end and Batman at the low end. Everything else, every other comic book character, sits in between them. You don't throw away the alpha or the omega. That will never happen. They will always be here, because they represent the superhero genre.

What did you try to emphasize when you illustrated the character?
I've always felt that one day we'll discover that Superman is a human being. Because he's not an alien. He doesn't have three penises. The problem is that we're not comfortable. We like people to be different from one another, but we don't like people to be aliens. I think it's illogical. One of the things that's true in science fiction, you see it all the time, everywhere you go…Humans go out into space and they run into two kinds of creatures: human-being-looking creatures and really strange-looking creatures. There has to be something in us that says, "Those human-being-looking creatures are probably human beings." Because it doesn't make sense that they're not like us. There's too many similarities. They go to the bathroom like us, they eat like us, we eat the same food.

There's too many similarities. Does Superman kiss? What happens when he kisses? Does he hear the same way? Does he have the same material in his ear that causes vibrations? He's too human for him not to be human. So at some point we actually have to settle down to the idea that Superman is a human. He's a super man. Not a super alien.

Your images of Superman are among the character's most iconic. The picture of him in flight that adorns the "Welcome to Metropolis" billboard in Metropolis, Illinois, for example. Or the image of Superman breaking out of kryptonite chains on the cover of *Superman* #233. They've surfaced time and again on T-shirts and in advertising...
But in the same way, I'm drawing a man. I'm not drawing weird anatomy or anything else. I'm drawing a man. I think that Superman as a god is not as acceptable as Superman as a human being. I think we have to get to that.

He has powers that random writers seem to add to at a moment's notice. For no reason that I can explain, except that his superpowers seem endless. I think recently he can create explosions. In the first *Superman* movie he could go around the Earth so fast that could make time run backward...Creating these powers and doing these things with him is almost ridiculous. But people have gotten away with it, and then they do it again. We've turned this character of Jerry Siegel and Joe Shuster's into a joke. "Able to leap tall buildings in a single bound." That's not our Superman. He can transport across galaxies and never have to take a breath of air. That's insane. That's an insanely powerful character.

I think we have to humanize him and we have to give him superpowers that match the powers that Jerry Siegel and Joe Shuster did. Perhaps a little extra, but at a certain point we have to stop. He can't do anything. He can't crash into a sun. That can't happen. You almost can't work with the character. You're at a point where his powers are so powerful that he might as well be a god, and whatever he imagines he can do, he can do. It's a wrong direction.

One of the things that's happening over at DC Comics now... We had a writers panel, and every single writer from that panel had

Neal Adams

taken much of Superman's powers away. They're so frustrated over doing Superman that in order to solve the problem they take his powers away. How is that solving the problem? When in fact they are saying, "No, we can't do Superman."

Speaking of Siegel and Shuster, you were by most accounts the driving force in getting them their pensions and credit for creating the character.
I took on the battle. It lasted for about three and a half months, and I won. Because I was right and the companies were wrong. It's pretty much as simple as that. I don't know why they fought with me, I don't know why they argued with me. They were clearly wrong, I was clearly right. They ended up paying these guys what they would pay an expensive secretary at the time. Why is that such a big damn deal? When we made a settlement, all I asked them for was what a good secretary makes. And it was like pulling teeth.

It may have seemed to you and people on the outside that I was doing some noble thing. But I wasn't doing any noble thing. I was simply saying, "This is just bullsh*t, and you guys have to cut it out. Don't stand up and argue with me and tell me you're right when you're wrong, and you know you're wrong." I'm not the type of person to argue with and be stupid at the same time. I don't have that kind of patience with people.

You penciled *Superman vs. Muhammad Ali*. Ali, like yourself, was unafraid to speak his mind. Did you see him as a kindred spirit? Did that inspire the project?
I don't think of Muhammad Ali necessarily as an intellectual as much as I think of him as being emotionally driven to doing the right thing by the events of his life. He was, in fact, driven in those directions, and he did stand up for the right things, and he stood up for his people. Some people may not agree with that. But you know what? They can go to hell. You can be tough and you can be strong and you can fight in a bar. But to stand up in the middle of a news conference and say what you believe and to stand for those things, and then be right in front of the whole world...You have to understand that the rest of the world agreed with Ali. We did not belong in Vietnam. And he was not going to kill people of another

skin color, just because he was told to by the government. This was a wrong thing, and it was proven that we were doing bad things in Vietnam and we should have gotten out of there. So I think Ali is a hero, and putting him in a comic book, to me, is the perfectly logical thing to do. That's the reason I was gung-ho for it, and the reason I think I did kind of a good job of doing it.

That comic book was famous all around the free world, published in every country around the free world. It was not necessarily approved of in America. It was much more approved of in the rest of the world. It's sort of like when [Barack] Obama became president the first time—the rest of the world cheered, and America was kind of split. The rest of the world had parties. Because we had a black guy for president! And all the fat white guys with their white shirts and suits in Washington, their jaws must have hung slack watching the rest of the world celebrate us making a decent decision. [Laughs.]

70 The *Supergirl* TV Series

With the critical and popular success of 2012's *Arrow* and 2014's *The Flash*, TV producers Greg Berlanti and Andrew Kreisberg had created the most faithful adaptations of DC comic book super-heroes yet seen on live-action television, and were interested in doing more. But new TV incarnations of DC's Big Three—the adult Superman, Batman, and Wonder Woman—were off-limits to them, due to Warner Brothers' plans for those characters on the big screen. So Berlanti and Kreisberg applied their formula to Superman's cousin, DC's second-most-popular female superhero. The result was the Maid of Might's first TV show—*Supergirl*.

Taking its cue from the comics, *Supergirl*, which debuted on October 26, 2015, finds 13-year-old Kara Zor-El surviving the destruction of Krypton via a rocket much like that which carried her cousin, Kal-El. In this version of the tale, however, Kara is older than Kal-El, and sent to Earth by her parents to look after her baby cousin. Her ship is delayed in its voyage, and by the time Kara arrives on her new planet, Kal-El is already operating as Superman. As in the comics, Kara is raised by the Danvers (played by *Lois & Clark*'s Superman, Dean Cain, and the 1984 *Supergirl*'s star, Helen Slater), though she now has an older sister, Alex, who grows up to work for the Department of Extra-Normal Operations (DEO). In the show's pilot, Kara (played by *Glee* alum Melissa Benoist), after years of not using her superpowers, becomes Supergirl, donning a costume like that of Superman. Keeping her new identity a secret, she works in National City at CatCo, as an assistant to CEO media tycoon Cat Grant (Calista Flockhart), while developing a relationship with the buffest Jimmy (now James) Olsen ever (played by Mehcad Brooks). In the show's first season, Kara is challenged by a series of superpowered escapees from the Kryptonian prison Fort Rozz. She faces them with the help of Alex (Chyler Leigh); the no-nonsense head of the DEO, Hank Henshaw (David Harewood), later revealed to be Justice Leaguer J'onn J'onzz, the Martian Manhunter; and her friend at CatCo, Winslow "Winn" Schott (Jeremy Jordan).

Like *Arrow* and *The Flash*, Supergirl features an assortment of guest stars from the DC Universe, including Maxwell Lord (Peter Facinelli), Lois Lane's sister, Lucy (Jenna Dewan-Tatum), and the Red Tornado (Iddo Goldberg). But the show's greatest strengths are Benoist's wide-eyed, optimistic performance as Kara and Berlanti and Kreisberg's obvious affection for their source material.

Daily Planet Exclusive

Andrew Kreisberg

With television's *Arrow* and *The Flash*, Andrew Kreisberg—along with fellow executive producer Greg Berlanti—cracked the code that so long prevented live-action superhero TV shows from remaining faithful in their action, effects, and drama to the comic books from which they were adapted. Their third effort, 2015's *Supergirl*, furthered the winning streak and introduced the first fully successful live-action version of the Girl of Steel, played by Melissa Benoist.

With *Supergirl*, you're producing a show that blends several genres, including romantic comedy and coming-of-age drama. Has it been a juggling act?
Yes, but at the same time, all of our shows are a juggling act in a way. With *Arrow* you were juggling the Dark Knight vigilante with the Shakespearean family drama. With *Flash* we're juggling superheroes with all of this great father-son drama. With *Supergirl* there is much more romance than we've done in the past, and an opportunity for workplace comedy. But for us it's always about characters, and that's always how we approach it, whether it's the Girl of Steel or the Scarlet Speedster or the Emerald Archer. *Supergirl* is about sisters, it's about mothers and daughters, and it's about finding your place in the world. In some ways it takes place in a little bit more of a real world than some of the other shows.

Many fans have long wanted a new DC or Marvel superheroine movie on screen. Is *Supergirl* under more of a microscope than your other TV shows?
I think the trap becomes when you start letting that be your guiding star. For us, for better or for worse, the success that we have had has always been because we made the show we wanted to see, and the show that made us happy, and the show that we thought was cool. It's not because we think we know more than anybody else. We're just fanboys at heart. So our guiding star is what's entertaining us. If you start trying to figure out what the audience is going to want, you start trying to make something not what it is. The best shows

are the shows that let themselves be what they want to be, without them being carved up to fit a certain demographic or fit a certain expectation. The best validation that we've gotten is when you see Kara doing all of the amazing things she does in the pilot as Supergirl, it's just as exciting and cool as you've ever seen Superman doing anything.

When she's flying around and she lands and she beats the crap out of the alien villain, it's like, "Does it really matter? It's the Big S! It's the Big S!" [Laughs.] The thing that's more exciting to us is she hasn't really ever gotten her proper due in live action. And to really just be able to tell that story. That's making us excited more than it's making us scared.

As someone knowledgeable about the history of both Supergirl and Superman, what elements did you want your first TV series set in their world to have?
Neither *Arrow* nor *Flash* nor *Legends of Tomorrow* nor *Supergirl* are direct adaptations of a storyline from the comics. We sort of cherry-pick the best parts—some of it's from wildly different eras—then add our own thing. Somehow that's how we find the secret alchemy that makes these things work for us. One of the biggest things from the comics that we really responded to for Kara was, this notion that when Clark came to Earth, he was a baby. He doesn't remember Krypton. So he has a little bit more of an ephemeral ennui, in that he longs for this world that he never knew. He can feel that missing piece, and he knows that he's different than everybody else. But with Kara, she had a mother and a father and a life and a home and friends and family. All of which gets dramatized in the pilot and subsequent episodes. She talks a lot about it. She remembers it. Suddenly she left that world and came here. One day she was on Krypton and the next day she was in junior high in Midvale. That's a real shock to the system. And so much of what happened on Krypton really is playing out in the series.

You've said that Melissa Benoist was the first actress you saw, and despite all the other actresses you tested, she was the one you came back to. What was it about her that told you she was Kara?
She's just so lovely. I don't just mean her looks. She is just such a bright, fun, happy, quirky, smart, amazing young woman. The

minute you meet her you're just completely taken by her. When you have somebody with these extraordinary abilities...Sometimes I think it's very easy to make Superman standoffish, because he's so sort of—quote, unquote—good. And Melissa just pulls you right in. The other thing that's so amazing about her is she's able to play Kara and Supergirl as two completely different people. It really reminded us of that great moment in *Superman: The Movie* when Christopher Reeve is being Clark in Lois' apartment, and then he takes off the glasses and stands up, and it's almost like a visual effect how he changes from Clark Kent to Superman. Melissa really is able to make Kara her own complete person, while also fronting as Supergirl, and not having that seem like an act. She really pulls off this amazing balance.

Both you and executive producer Greg Berlanti have spoken before about how director Richard Donner's work on *Superman* influenced your own adaptations. What was it about that film that so seized your imagination?

First of all, it's built into our collective DNA because it's the version that we all grew up with. But I think that there was an unabashed earnestness to it, and it wasn't pretending to be something that it wasn't. Dick Donner's famous for having put a sign everywhere that said VERISIMILITUDE—truth—and playing it as real as possible. It was really, truly the first superhero movie that wasn't afraid to be what it was. It really is about a guy that dresses up in blue and a red cape and flies around saving people. I think in too many instances the adaptations or what have you that fail are the ones that don't really put their arms around it and say, "This is what it is. Here you go." That was really the first movie that did that. And there was just a sense of epicness to it, and emotion and scope and humor. It really had everything. Sometimes there are adaptations of things that are too dark, and sometimes they're too silly. Sometimes it's too faithful to the source material, sometimes it's not at all. That movie just seemed to get everything right. That's always been our touchstone. Without making it seem like it's connected to that movie, there are some subtle nods to it in the show.

Daily Planet Exclusive

Melissa Benoist

The reigning Last Daughter of Krypton, Melissa Benoist has earned much praise for her turn as Kara Zor-El in TV's *Supergirl*, the first live-action series devoted to the character's adventures. Here she explains what it's like to don the costume of an iconic American superhero.

With the exception of Wonder Woman, Supergirl is arguably the most famous superheroine around. What does she mean to you?
I think that there's something about her and Superman that just emanates hope and this all-American feeling of positivity and bravery. I think they really do represent America. It's a privilege and an honor to be playing her.

When did you discover Superman and Supergirl?
My grandfather showed me the older movies. You know, I didn't start reading the Supergirl comics until I was auditioning for this role. A good friend of mine is really, really into comic books. He was freaking out. He was like, "Read this one, this one, this one, and this one." That's when I really got educated about her.

What's most intimidating about stepping into the role of Kara Zor-El?
I definitely want to do right by the fans. I want to represent her in a way that makes everyone happy. I want her to be accessible. That's the scary thing, and the sheer vastness of it is a little scary. I'm a really big homebody. I'm a little shy. Putting myself out there on such a grand scale, that's pretty scary. But in a good way.

What do you think distinguishes your Supergirl from her past incarnations?
[Executive producers] Ali Adler and Andrew Kreisberg and Greg Berlanti are really doing such a good job about updating her, and really creating this fresh universe that spans so many characters and storylines. So I think it's just really exciting and new and updated and modern and current.

Of all her powers, which would you most like to have in real life?
Flight. I know it sounds like a cop-out, but it isn't. Who doesn't want to fly? [Laughs.]

Have you spoken with any previous Supergirls to get any advice on filling the boots?
I have spoken to Helen [Slater]. She is so sweet. I don't think she's ever lost Supergirl. She is a Supergirl. We talk about training, what she had to do. She was really lucky and got to do archery and horseback riding. She was in England, and I guess they think about working out differently than we do. [Laughs.] Because I'm getting my butt kicked.

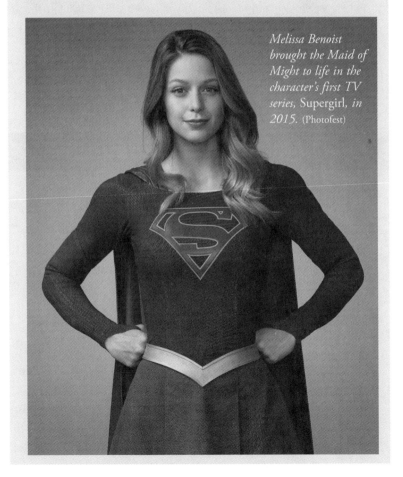

Melissa Benoist brought the Maid of Might to life in the character's first TV series, Supergirl, *in 2015.* (Photofest)

Like Helen Slater's Supergirl, yours is an upbeat character who looks for the good in people.
Of course. I think that Greg Berlanti and Ali Adler have made that a priority. We want to stay on the hopeful, light, sunny side of this. Recently there's been a lot of dark, gritty superhero stories. I think that's awesome. I love them. I think Chris Nolan's Batman movies are unbelievable. But I think there's also something really beautiful about positivity, and the really uplifting story of Supergirl.

What were your feelings the first time you got into the costume?
The first time I got into costume I wasn't really expecting the feelings I had, putting on the tights and putting on the leotard. But once it was fully assembled and I looked in the mirror, it's like this internal transformation. Something definitely changes, and you can't help but feel so strong and so confident. I feel like a different person when I put on the costume.

Daily Planet Exclusive

Calista Flockhart

While Calista Flockhart's titular character on *Ally McBeal* was often called the face of feminism in the 1990s, the actress has gone on to play the boss of the most powerful woman on Earth—sharp-tongued DC Comics staple Cat Grant on TV's *Supergirl*. Flockhart explains how the role has taken her full circle.

Cat Grant's been a fixture of the Superman universe for several decades. Did you do much research on her other incarnations or did you start from scratch for your version?
Well, a little bit of both. I kind of wanted to start from scratch because it's a very different version. She's very reinvented for the television show. But I was really intrigued, because I didn't know anything about it. And I did do a moderate amount of reading about her.

What did you discover?
She is a fascinating character. She was married to Joe Morgan, she became an alcoholic, she had a son who died, she had a romantic involvement with Clark Kent...It doesn't get any better than that! It's a really, really good history.

How would you describe your take on the character?
It's very new, so we're discovering things every day. But I think at the moment she's just unapologetic. She's uncompromising, strong, ambitious, competitive. She's the character who doesn't really care about what she says. She'll just whip out anything, and it's a private joke within herself. There's no filter. Her frontal lobe is not working well. But, at the core of who she is, I think she's a good person.

Does she look to remain on Kara Zor-El's side?
I don't think she'll ever be a bad guy. She could be a lot of things, but I don't think she'll be a bad guy. She can be the one who pretends she's a bad guy and then not be a bad guy.

Does she think of herself as a mentor to Kara?
She might. At the moment, no. I don't think she's a mentor. But I think she's starting to see things in Kara—she calls her "Care-a" not "Car-a"—that she's regarding as special. I think she will become a mentor. I don't know for sure, but I think so.

Were you a superhero fan when you were growing up?
No, it wasn't my thing. I was into *Laverne & Shirley* and "We're Gonna Do It Our Way." Remember that theme song? Girl power!

71 Power Girl

Although Supergirl has struggled over the years to maintain her own identity while honoring the legacy of Superman and her memories of Krypton, Power Girl has faced an even greater challenge: to distinguish herself from both champions.

Created by writer Gerry Conway and artists Ric Estrada and Wally Wood for January-February 1976's *All Star Comics* #58 ("All-Star Super Squad"), Power Girl began her career as the cousin of the Superman of Earth-Two. A world parallel to that of Supergirl, its superheroes emerged in the 1930s instead of the 1950s (and it was thus comprised entirely of DC's Golden Age heroes).

Her origin is largely similar to the Girl of Steel's, with some important differences. She was born Kara Zor-L, daughter of Allura In-Z and Zor-L, who is the brother of Jor-L and uncle to Kal-L. When Krypton-Two was about to be destroyed, her parents sent her to Earth-Two in a rocket. Unlike Supergirl, Power Girl arrives on Earth when she's already reached adulthood. Adopting the secret identity of computer whiz Karen Starr, she's a lot more rambunctious and headstrong. She's also eager to remain independent of both her cousin and her parallel-universe counterpart; hence her hairstyle, name, and the red-white-and-blue costume she wears (one of the more infamous in mainstream comics, due to its cleavage-exposing window) differ from those of Supergirl and Superman.

After the 12-issue *Crisis on Infinite Earths* (April 1985–March 1986), in which the countless worlds of the DC Multiverse were compressed into one, Power Girl's origin was retconned so that her powers were based in magic instead of science, and she became a

daughter of Atlantis instead of Krypton-Two. But the seven-issue *Infinite Crisis* (December 2005–June 2006) retconned the retcon, and she was given her original origin back. In DC's "New 52" continuity, she's both the cousin and the adopted daughter of the Superman of Earth 2.

Popular with girls for her strong feminist beliefs and with boys for her frequently full-figured depictions, Power Girl has enjoyed membership in the Justice Society of America, the All-Star Squadron, Infinity, Inc, the Justice League, Sovereign Seven, and, for a brief time, the Birds of Prey. Her most enjoyable comic book adventures, however, can be found in the first 12 issues of *Power Girl* Vol. 2 (July 2009–July 2010), written by Jimmy Palmiotti and Justin Gray and illustrated by Amanda Conner.

Though nods to the character exist in several TV shows, her first true screen appearance is in the 2009 animated feature *Superman/Batman: Public Enemies*, in which she's voiced by Allison Mack. The casting is appropriate, since Mack's similarly blonde-bobbed and empowered Chloe Sullivan aided Clark Kent in 10 seasons of *Smallville*.

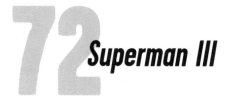

Superman III

While *Superman: The Movie* and *Superman II* both proved to be blockbuster hits, the latter of the two films saw its director, Richard Donner, unceremoniously removed in the middle of production by producers Alexander and Ilya Salkind. Donner's replacement, Richard Lester, returned for the follow-up, *Superman III*.

The last film in the franchise produced by the Salkinds, *Superman III* again stars Christopher Reeve as the Man of Steel,

Though it performed adequately at the box office, the often silly Superman III failed to live up to the standard set by the earlier Christopher Reeve–starring films.

and features Jackie Cooper as Perry White and Marc McClure as Jimmy Olsen. Margot Kidder, who had publicly criticized the Salkinds' treatment of Donner, appears only briefly as Lois Lane. The role of leading lady instead went to Annette O'Toole, who portrays Clark Kent's high school crush Lana Lang. Greater screen time, however, is given to Richard Pryor as socially awkward computer genius Gus Gorman.

The plot concerns Gorman's recruitment by corporate tycoon Ross Webster (Robert Vaughn), who, with his shrewish sister Vera (Annie Ross) and Marilyn Monroe-esque girlfriend Lorelei Ambrosia (Pamela Stephenson), is out for world domination. In aiding his new boss, Gorman synthesizes a form of kryptonite that corrupts Superman into a lustful force of destruction (reminiscent

of his turn in *Action Comics* #293's "The Feud Between Superman and Clark Kent!" by writer Edmond Hamilton and artist Al Plastino). The Man of Steel is eventually able to conquer his demons just in time to—with the aid of Gorman—prevent Webster from taking over the planet with a supercomputer. (*Superman III* was released in the United States on June 17, 1983, at the height of the computing craze.)

Though the film performed well enough at the box office to spawn a fourth Reeve-starring Superman adventure, fans were critical of *Superman III*'s overreliance on slapstick humor (which Lester handled more successfully in earlier films like *A Hard Day's Night* and *The Three Musketeers*), and David and Leslie Newman's campy script. Pryor was a comedic genius beloved by millions, but one wouldn't know it from what he's given to work with here.

Superman III is worth watching, however, for two things. Annette O'Toole gives a winning performance as Lana, marking the first time the character has appeared in live action as an adult woman. A struggling single mom, O'Toole's take on the character is so charming it's understandable why Reeve's Clark would fall for her, even after his doomed romance with Lois in *Superman II*. Also, the battle between Superman's good and bad selves provides Reeve with an opportunity to explore his character more fully, and perfectly captures the greatest struggle faced by the Last Son of Krypton—to suppress his own desires and use his godlike powers for the benefit of all.

"I liked Chris so much," says O'Toole, "and I liked my character. I thought it was an interesting role, and I thought it was so different from Margot's role that it might work. So I'm glad to hear that some people think it does."

Daily Planet Exclusive

Annette O'Toole

While several actors have played more than one role in Superman films and television shows, few have played two roles as big of those of Annette O'Toole, who portrayed Lana Lang opposite Christopher Reeve's Clark Kent in *Superman III*, and, 18 years later, Martha Kent to Tom Welling's Clark in TV's *Smallville*. Now performing on the New York stage, the Emmy and Oscar nominee shares her memories of the Man of Steel.

Were you familiar with Lana Lang before portraying her on screen? Had you read Superman comic books?
I loved Superman. I grew up with the [*Adventures of Superman*] TV show, but I also grew up with the comic books. I wish I'd kept them. I was sort of this geek. [Laughs.] I always loved the comics, and I always really loved Lana Lang, I have to say. It's not that I preferred her over Lois, because I thought Lois was always really cool. But I kind of identified with Lana. I thought that they were a nice couple together, her and Clark Kent. So when the opportunity came up to play her, I was just over the moon. Because it was the third film in the franchise, and I was in love with the movies, the first one especially.

How were you approached for the role?
They had me in mind when they wrote the part. I guess I was the obvious choice because I kind of resembled the character from the comic books. I was doing *48 Hours*, so I had to leave one movie and fly to London. It was one of those very quick, exciting things. You were on the plane and go over there and go directly to wardrobe, start shooting the next day, meet [director] Richard Lester. The first thing I shot was the scene where I'm on the phone and he calls me… All I remember is that Richard Lester wanted to see how I would look with glasses. That was my first scene. He wanted to shoot a lot of it the first day out. I think it was trial by fire. [Laughs.] But it was great fun. I just adored Chris Reeve of course, he was such an angel. And now he really is one…He was just so welcoming to me. And Margot Kidder was just so sweet. I guess there was some contractual issue

with her, and she had, like, a day on the movie. I think the world of her for being so sweet to me when I was coming in as the new kid.

Did you spend much time with Christopher Reeve prior to shooting?
We did spend a little time together. He had his family there, and he'd spent so much time in London by that time doing the other films that he had an apartment and his wife, or his companion at the time, they had two little kids. He invited me over to the house for dinner and to go to this Simon and Garfunkel concert at Wembley Stadium. So I just felt included in that way. He was such a great pal, and just so welcoming and sweet. It all happened so fast. I think we did the rehearsing on set, and there was something nice about that. It was better for us to feel like we were friends and then just do the scenes. Some parts you really want to rehearse and go over. This one, it was just nicer for it to be spontaneous.

I do remember the first time I saw him in the Superman costume. I'd been working with him, and he'd only been Clark up to that point. He was just in the shadows and he was standing there and he said, "Hi, Annette." I looked over and I looked up at him—he looked like he was about eight feet tall—and I just got these chills up and down my spine. I thought, *Oh, my God. It's freakin' Superman!* It really was. He was so different from the Chris that I knew, that I had known up to that point. It was kind of like, "Ooh!" [Laughs.]

The only thing I was upset about was that I didn't get to fly. I thought, *Can't he just pick me up at some point and take me somewhere?* I really wanted to fly with him. I was very, very jealous of Margot getting to do all the good stuff. [Laughs.]

What was it like working with director Richard Lester?
That first day was the most interaction we really had together, where I was on the phone. I never got a sense really of what he wanted from me. He didn't communicate a lot, and I was very, very shy. He was such a legend of a man, and I thought, *Okay, he cast me in this. He must want what I'm bringing to it. He must be okay with that.* But there wasn't a lot of dialogue. I kind of felt he maybe wasn't that interested in that part of the story. I don't know, I haven't read anything about it. He wasn't a very approachable man. He wasn't rude, to me anyway. He

was fine. But I don't remember a lot about anything he said to me other than that very first day.

Was there any talk about bringing Lana back for another film? By the end of *Superman III* she's working at the *Daily Planet* with Clark and Lois.
No. I was kind of surprised there wasn't. I was very disappointed when I knew they were going to do a fourth film and nobody called me. I thought the relationship worked well in the movie. But they just let that drop. I thought, *This could be great to have a little rivalry here. It could be really interesting.* Yeah, that was really disappointing.

I still love the first one. The most exciting part of the whole [*Superman III*] experience was when I saw the film and that John Williams score comes on and my name comes up as part of it. I mean—as a little kid in the third grade swapping Superman comics books, who loved the TV show—that was *it!* [Laughs.]

You later made a welcome return to the Superman universe with *Smallville*. How did that come about?
They'd already shot the pilot, David Nutter was the director, and they'd done it in Vancouver. I guess they wanted to replace the actress who played Martha Kent. I never saw the performance, I don't know what the issue was. I was suddenly available, and they contacted me. If they're telling the truth, [Alfred] Gough and [Miles] Millar, the creators, did not know I'd played Lana Lang. They claimed that they didn't know. I kind of find that hard to believe, since they were involved in the whole Superman mythos.

So I go into this meeting thinking, *That's why they want me. As an Easter egg.* We had this lovely meeting and they really liked me. I said, "Wait a minute. Martha Kent? Martha Kent's an old lady." They said, "That's the whole idea. The Kents are in their forties. Young, vital people. Let us send you the script." So they sent it to me, and I saw it and I thought, *Oh my God, I love it. Well, maybe we can work it out...*

Of course at the time you think it's all gonna be easy street, you're gonna be able to do it. And I did it, I did six years of commuting, pretty much every week from LA to Vancouver. That got old. The best thing to come out of it was my friendship with John Glover. We were on the plane a lot together. So we became fast

friends. Then I loved when our storylines connected for a little while. But it was ultimately a little frustrating, just because the work became not very interesting, just the same thing over and over and over again. I really didn't like it when John Schneider was killed off, and I thought the parent relationship went way downhill after that. But I had a good time and it has supported me very well so I can now be in New York doing the theater work that I love to do. As John Glover says, "It's the golden handcuffs." [Laughs.]

Did you have a chance to reconnect with Christopher Reeve when he and Margot Kidder appeared on the show?
I had a lot of scenes with Margot, and I loved working with her. We talked about the old days of her being so kind to me in London. I hope that I was able to return the favor, because she was now on the show that I'd been on for a long time. I wanted to make her feel welcome, and I think she did. We had fun…I was really disappointed that they didn't include me with Chris. I know they shot it in New York. They had to make it as easy as possible for him, of course. They brought Tom [Welling] to New York, and a skeleton crew to do these scenes. I thought, *Listen, you don't even have to pay me. I would go* anywhere *to do this scene with this man, to see him again.* I don't think it even crossed their minds. Who knows why. It was the only way that I was ever gonna get to see Chris again. So I was very disappointed about that.

Your role on *Smallville* really cemented the tradition of veteran Superman stars returning to play new roles in the character's universe.
My husband [Michael McKean] right now is in Los Angeles, but when I talked to him this morning and I mentioned this interview, he said, "Well, please mention the fact that the actor playing Perry White was really, really good." I said, "Oh yes, I do intend to talk about Jackie Cooper!" So I do have to say officially that even though I love Jackie Cooper, my favorite Perry White is Michael McKean. [Laughs.]

73 Superman IV: The Quest for Peace

While *Superman III* didn't have quite the same impact at the box office as the two films that preceded it, and critics were mixed in their reviews, it possessed some worthwhile elements. Despite the presence of the always welcome Christopher Reeve (the last time he would play the Man of Steel), director Sidney J. Furie's *Superman IV: The Quest for Peace* is devoid of any.

Alexander and Ilya Salkind had served as producers on the first three *Superman* films, but *The Quest for Peace* was produced by Menahem Golan and Yoram Globus, who throughout the 1980s ran the infamous B-movie studio Cannon Films. Its budget a mere fraction of its predecessors', *Superman IV* looks cheap, and its visual effects were nominated for the 1987 Golden Raspberry Award. Also nominated was actress Mariel Hemingway, who plays the daughter of a media mogul who takes over the *Daily Planet*, but whose own interests are in Clark Kent.

The idea behind the film—what if Superman decided to rid the world of nuclear weapons?—was suggested by Reeve himself, but screenwriters Lawrence Konner and Mark Rosenthal do little with the premise. Instead, they have Superman fight a cheesily costumed clone of himself dubbed Nuclear Man. He's created by archvillain Lex Luthor (the returning Gene Hackman), who again aligns himself with a dimwitted henchman, his nephew Lenny (Jon Cryer). Margot Kidder reprises her role as Lois Lane, but there's little heat to her relationship with Clark or Superman. And fans still shudder at the memory of Superman using previously unseen telekinetic powers to rebuild the Great Wall of China.

Before its release, 45 minutes were cut from *Superman IV: The Quest for Peace*. But a quick look at some of the deleted scenes on

the film's DVD release eradicates any thoughts about whether a good film was left on the cutting-room floor. A box-office bomb, it's no wonder that when the Superman film franchise was restarted 19 years later, *Superman Returns* ignored the events of *Superman III* and *Superman IV*.

Daily Planet Exclusive

Marc McClure

Marc McClure has appeared in a number of blockbuster films, including *Back to the Future* and *Apollo 13*. But his turn as Jimmy Olsen in *Superman: The Movie*, its three sequels, and the spinoff film *Supergirl* has endeared him to countless fans of the Man of Steel and his pal.

What informed your take on Jimmy Olsen in *Superman: The Movie*?
I kind of just came in with it. I understood who Jimmy Olsen was, just on an energy level. His energy was what he was about, his excitement for life, just never even questioning decisions he would make. Jimmy Olsen would find himself in situations before he knew how he got there.

Early on, I was on the wires with Chris [Reeve], and I was just kind of laying it on. He asked me, if I could, to just be like Jimmy Olsen. I think what he meant there was that he had a real job to do with Superman, a lot of responsibility, and if there was anything I could do, as Jimmy Olsen, if I could do that for him it would help him be better. I'm always very grateful for that moment he said that. Because right then I realized what he had to do, to pull this off. From then on, I would always be on the set with my camera, in my suit. I'd go through wardrobe, go through makeup, and I'd be on the set. That's where I'd like to be. I didn't want to be in a trailer, I didn't want to be anywhere but on the set. Anytime we were there I was just constant energy with everybody.

If it wasn't for [Richard] Donner we all would have ended up just staring at each other. He really was magical. He was the magical magician on that thing, man. No doubt about it. When we lost him, we lost it. He was it. He was the beginning point.

What was the mood on set when it was announced that Richard Donner wouldn't be coming back to finish *Superman II* and that Richard Lester was taking over?

I was young and not too versed in stuff. Margot [Kidder] was a bit more opinionated. We did the premiere of *Superman* in Washington, and when we returned Donner wasn't there to finish up the second one. He'd worked until the final hour just to get the first one done and ready. Then we all returned and Donner wasn't there, and we heard that he'd been fired. Margot, she wasn't ready for that, and she wasn't ready to move on without Donner. Oh yeah, it was a problem. We ended up having to go back just for Lester, because 51 percent of the film had to be his footage. So we had to redo a lot of stuff. His directing style was completely different from Donner's style, and the energy in the room was *long* gone. Chris, I don't know, he probably could have done something, but he just wasn't in a position to do it at that point in his career. Margot, she doesn't care what anybody thinks. She's gonna say what she feels. She was a great, strong woman. She was cool. And everybody just kind of went through the motions with Lester. His directing style was, "Stand here. Say a line. Go stand over there. Go say another line." He had three cameras set up. He couldn't get out of there fast enough! He really couldn't. He could not shoot it fast enough. I mean, my god. Then in the third one, Margot just put her foot down. She had to finish the second one, I guess…We were almost there. Donner had it all done.

You have the distinction of being the only actor in all four *Superman* movies and *Supergirl*. What was it that kept bringing you back?

I just like Jimmy. You could only hope that a director was in charge who could do that world justice. It's all about believability, with any movie you do, let alone one based on a comic book. You have to believe it. If you don't make it real, you're gonna have a problem. After Donner was released, all the films were just teetering on absurdity. There wasn't that gel of smart filmmaking.

Jeannot Szwarc was the director of *Supergirl*, and he'd just come off of *Jaws II*, I believe. I remember him saying he thought it was the greatest sequel of all time. That should have been a red flag right there. But he may not have been the right choice for the subject.

Helen [Slater] was really great. She really was great. [But] the story didn't hold up, and the director...There were variables in *Supergirl* that could have been better. Faye Dunaway, she kind of created an atmosphere when she was on the set that maybe was a little too heavy for the subject. Everybody had to be really quiet when she was on the set. That may not have been the right tone for *Supergirl* and what we were trying to do.

Gene Hackman appeared to find the right balance with Lex Luthor in *Superman: The Movie* and *Superman II*.
Oh, what a dude, yeah. He's the best. He's the greatest. He's a pro. I always hear that I look like Gene...Gene Hackman is one of the actors of whom I can say I never caught acting. He had done performance after performance and, on the set, he was a total pro. His brother was his stand-in. [But] Gene Hackman was it. He really was. From what I've heard, he had a great time with Donner. I mean, Donner's such a great person, just a great human being. And I understand that Gene really loved him, and they really clicked.

There is a trick to hiring a director who knows how to treat a script, and a script has to be done *before* you shoot it. [Writer] Tom Mankiewicz, Dick Donner...*Superman: The Movie* was just a lot of great people in the right place at the right time, and the leader was Donner. Everybody believed in themselves because of Donner. The director is so important. As I get older and I look back, that's the one and only variable for every film.

Do you have a favorite scene in *Superman: The Movie*?
I really enjoyed myself all through it, but the one I'm most proud of, and it's kind of how Donner worked...Jackie Cooper and I were doing a scene in the office in *Superman*. He, off camera during my closeup, messed up his line. Instead of "Don't call me 'Chief,'" he said, "Don't call me 'Sugar.'" I reacted to his line and said, "Okay, Sugar." Donner, being who he is, turned the camera around, and said, "Jackie, do the line like it's written. But then we'll do the line where you say, 'Don't call me "Sugar."' Just so we got it." Because the chief is so scattered yelling at Jimmy. And that's what made the film. That's what that film is all about, those moments where Donner was able to catch

that stuff. Usually, in most cases, that's what works. When it's really honest. I'm kind of proud of that one.

It's amazing that in that mega-budgeted production he was able to find such spontaneity.
Yup. And that's what we saw, just a bunch of human beings *being* human beings in a world that everybody already kind of knew.

And Chris really set the bar so high. I mean, he just set the bar *so* high. Maybe that's why they're changing it so much and darkening the [Superman] outfit. I don't know. I'm not sure. I would love them just to go back to the original colors, the original purpose of Superman, instead of trying to darken it up or whatever they're doing…
Superman's gotta be above. He's gotta be above people. Just the way he stands, the way he enters a room. It's gotta be special. It's gotta be more special than anybody else in the room. Otherwise he's just another guy in the room. When Superman walks in, we should *know* that Superman's in the room, and all focus goes to him. Unless that can happen…I don't know. In my lifetime in may never happen. But maybe I'm just too close to it.

74 The Top Five Superman Action Figures

Superman merchandising has been around since 1939, when a membership button was offered to those who joined the Supermen of America club, advertised in the pages of Superman comic books. But the most perennially popular piece of merchandise among connoisseurs is the action figure. Here are the five best.

The First Superman Action Figure
In 1940, the Ideal Novelty and Toy Company manufactured the very first Superman action figure. A one-foot-tall wooden doll with

a cape made of cloth and limited articulation, it featured the distinctly squinting eyes of Superman co-creator Joe Shuster's original design for the character.

Mego Superman

The Mego Corporation's "World's Greatest Super Heroes" line of eight-inch-tall action figures in cloth and vinyl costumes, based on both DC and Marvel's characters, was coveted by many a young child after it was introduced in 1972. Superman was released in the line's first wave (along with Batman, Robin, and Aquaman). The line was discontinued in 1983, by which time three-and-three-quarter-inch figures had become the toy industry standard.

Super Powers Superman

The best three-and-three-quarter-inch Superman figure ever made was part of the first wave of Kenner's Super Powers Collection. Launched in 1984, the line ended just two years later, but its unique "power action"—mechanical features that replicated each hero's signature abilities—made the figures come alive like no toys had before, and few have since. Superman, like most of the line's Justice Leaguers, was based on the DC Style Guide illustrations of comic book artist José Luis García-López.

Showcase Presents Superman

By the 21st century, a diverse array of Superman action figures, in all shapes and sizes, were made available based on every conceivable version of the character. But the most welcome for longtime fans was DC Direct's Showcase Presents Series 1 action figure (named after DC's line of trade paperbacks collecting various comic titles). Not only is its design based on artist Curt Swan's Superman (for many, the definitive version of the character), but it comes with three interchangeable bonus heads, each of them representing a different reaction Superman had during the Silver Age to red kryptonite.

Released in 2011, this ⅙ scale figure of Christopher Reeve's Superman by Hot Toys bears an uncanny resemblance to the late actor.

Hot Toys Superman

Featuring the most accurate version of Christopher Reeve's appearance in *Superman: The Movie* ever seen in toy form, Hong Kong manufacturer Hot Toys' one-sixth-scale figure is the *ne plus ultra* of Superman action figures. As a bonus, it comes packaged in a giant box shaped like the Man of Steel's "S" shield, and with a display base resembling a part of the film's Fortress of Solitude.

Daily Planet Exclusive

José Luis García-López

One of the finest draftsman ever to work in mainstream comic books, Spanish comic book artist José Luis García-López has defined the look of DC Comics for the general public through his work on the company's official *Style Guide*. Used by licensees since 1982, García-López's images have appeared on merchandise around the world, and served as the basis for Kenner's popular Super Powers line of action figures. García-López has also illustrated Superman in titles like *DC Comics Presents* (which he helped launch) and the tabloid-sized *All-New Collectors' Edition* (for which he pencilled 1978's "Superman vs. Wonder Woman"), and in the *Elseworlds* books *Superman, Inc* and *Superman: Kal*.

When did you discover Superman?
I discovered Superman in black and white in Argentina. They used to publish over there the stuff from Curt Swan and Wayne Boring and others. This was in the '50s and early '60s. I didn't have that much sympathy for the character. At that time I liked Batman.

Was he popular in Argentina?
Superman, Batman, Coca-Cola, McDonald's…They're popular everywhere. But in Argentina they have more sympathy for Batman. Superman was used for different things. He was at one time a symbol of America, and America sometimes does good things and sometimes does things that…But it's nothing serious.

In time, how did you come to appreciate the character?
I thought, *I'd better have a good relationship with him, because if not then I'm not going to be able to do it right.* [Laughs.] He was a good moral figure. Because he stands for good things. Sometimes he made mistakes, because somebody else made him do bad things. But he was good inside. Nowadays, it's a different Superman.

The reason I started drawing Superman is not because I was looking to draw the character. It was because the editors at DC at that time, they wanted me on the book. That's the reason I did a few

books at the beginning and also a few covers. I guess they liked my interpretation, because they chose me later to do the *DC Comics Style Guide*. The chief character of course was Superman, and Batman and Wonder Woman. I supposed my renditions of those characters were very generic. They were going to be accessible to the people who buy a T-shirt or a blanket or pajamas. Something like that. I guess the idea was to appeal to everybody. Not something too dark or too light. In all those *Style Guides*, in the beginning, everybody was smiling. Even Batman. [Laughs.]

Your Superman is, for many, the most definitive depiction of the character, in much the same way as Christopher Reeve's Superman.
The best compliment I've had about Superman is when I was asked if I modeled Superman after Christopher Reeve. I said, "No." Because before [*Superman: The Movie*] I did "Superman vs. Wonder Woman." But in some ways, perhaps I captured the sympathy of Christopher Reeve. I don't know. For me, he was the perfect Superman. I believe he was the idea that everybody used to have about Superman. Nowadays…It's changed a little. I don't know. It's different.

What's your favorite Superman story from among those you've illustrated?
The ones I did for the *Elseworlds* books. *Superman: Kal, Superman Inc.* I liked to play with the character. At the beginning, when I did Superman, I based my Superman on what was available at that time—Curt Swan and Neal Adams. They wanted the character in a certain way. I'm talking about the '70s. Then later on when I started doing the *Style Guide*, I couldn't evolve. I had to continue in more or less the same style. All those little things are the reason I like most the *Elseworlds*. In the *Elseworlds* books, I got to do my own version of Superman.

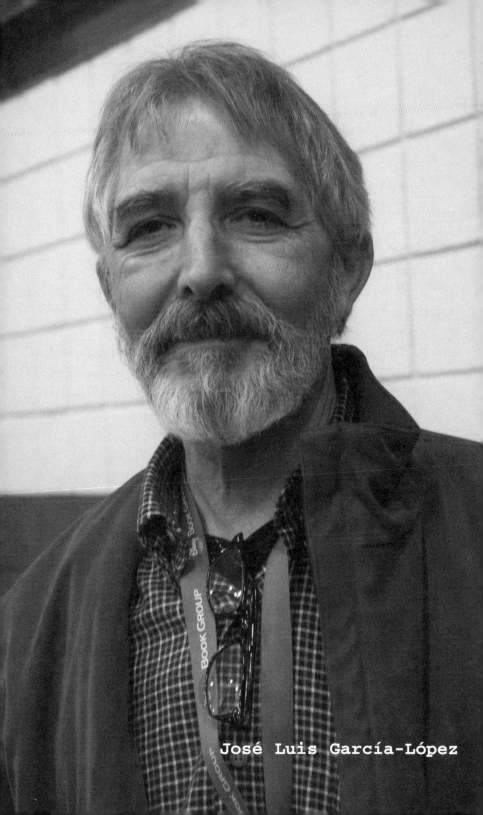

José Luis García-López

75 The *Supergirl* Movie

When Christopher Reeve decided to retire from the role of Superman in the wake of 1983's underperforming *Superman III*, executive producers Alexander and Ilya Salkind considered other means of exercising their film rights to the character and his universe. Rather than recast the role of the Man of Steel, and face the wrath of a public still very much in love with Reeve, the two instead decided to base a film on his cousin, Kara Zor-El. The result was *Supergirl*, the Girl of Steel's screen debut.

Directed by *Jaws 2* and *Somewhere in Time* helmer Jeannot Szwarc (who would go on to direct episodes of TV's *Smallville*), *Supergirl* starred 19-year-old Helen Slater in the title role. Unlike the comic book character, this Kara's Kryptonian home, Argo City, exists in trans-dimensional space, and is powered by an object called the Omegahedron. When this MacGuffin is lost, thanks to the city's resident crackpot Zaltar (Peter O'Toole), Kara chases after it. Arriving on Earth as Supergirl, she, like her comic book counterpart, creates the secret identity of Linda Lee, cousin to Clark Kent. (Kent does not appear in the film, though Christopher Reeve's Superman is soon on a poster.) Enrolled at a private school, Kara befriends Lois Lane's sister, Lucy (Maureen Teefy), who's dating Jimmy Olsen (Marc McClure—the only actor from the Reeve films to appear). Kara spends the remainder of the film battling a would-be sorceress named Selena (Faye Dunaway) for the Omegahedron, as well as the affections of the school's hunky handyman Ethan (Hart Bochner).

A box-office bomb, *Supergirl* was criticized for its uneven script (by *The Dark Crystal* and *Masters of the Universe* scribe David Odell), and for Dunaway and O'Toole's hammy performances;

both received Razzie Award nominations. But Jerry Goldsmith contributes a typically robust score, and the stunning Slater is charming in the role of Kara, a wide-eyed stranger in a strange land who displays an infectious joy upon receiving her superpowers. The actress would go on to appear in, among other film and television roles, *Smallville* as Kal-El's mother and TV's *Supergirl* as Kara Zor-El's adoptive mother, Eliza Danvers.

Though *Supergirl* isn't remembered as the best feature-film adaptation of an American superheroine's adventures, it is the first. For that reason alone it merits inclusion in the pop culture history books.

Daily Planet Exclusive

Helen Slater

The first actress to portray the Last Daughter of Krypton on screen, Helen Slater brought a sense of wonder and wide-eyed innocence to 1984's *Supergirl* film, and later returned to the character's universe in *Smallville*, in which she played Kal-El's biological mother, Lara, and in the 2015 *Supergirl* TV show, in which she portrays Eliza Danvers, Kara Zor-El's adoptive mother. The following interview was conducted when Slater debuted on *Smallville* in 2007.

What was it like to return to the world of Supergirl?
Somebody said to me, "You're going back to your roots!" Which I thought was funny…It has been surreal. I'm a fan of this genre of TV and film. I just think for kids—I have a daughter—just that idea of having superpowers and being able to be ethical, I'm a big fan of it…I feel very grateful to be doing it.

Have you noticed a difference in the way Supergirl's flying has been shot since you portrayed the character?
Yes. They do much more CGI now, right? When I did it you were on wires and you were on a construction crane being hauled 80 feet up in the air. [Laughs.] Straight across the nose of the crane.

After all this time, what are your feelings on the original *Supergirl* film?
It's funny. It was so many years ago, and in my memory I have only good feelings and gratitude for that opportunity. I really feel grateful. I was 18 years old. I was just out of high school. It was a risky thing—not going to college was unusual in my family because everybody went to college. Then I got this job. I knew nothing about filmmaking before, so it was a pretty astonishing education for that year, for my 19th year of life. [Laughs.]

Since your first film was such a big production, did you feel a little spoiled by the experience when you went on to do other movies?
I don't think fame is healthy for anyone when they're young. This is just my personal feeling about it. I was very level-headed throughout that experience, but I don't think it's particularly healthy because you miss out developmentally on some important pieces that you can't ever really get back. Because all of a sudden, at a very young age, you have money and you have people kind of catering to you to a certain degree. Even staying very grounded, which I believe I did, there's still something that you're not getting. I mean, some people might read this or hear this and say, "Well, who wouldn't want fame? My gosh, who wouldn't want to not have to think about money or working?" But I do think it's valuable to have those experiences at a young age, learning about things in a more chronological order, as opposed to having that aspect of your life totally removed.

Has your own daughter seen your Supergirl?
She saw the whole film a few years ago...For my birthday, this really incredible film editor took scenes from the film and got a green screen on eBay and set it up in the living room and made me a movie...At one point there's a scene where my daughter flies into the *Supergirl* movie, flies next to me, and looks over and says, "Hi Mommy! See you in 20 years! Don't forget to name me Hannah!" and then flies out of the frame. [Laughs.]

The character's been through a number of permutations, yet fans seem to prefer the original version, which you embodied.
I think they have a hard time with the Supergirl story, because it's a challenge to have it not just seem like Superman, right? What is a Supergirl in this day and age? It's tricky.

Had your Supergirl aged, where do you think she would be today?
I would hope she'd be working to bring peace to the world. Helping to solve the problem of hunger and disease. I would hope she'd be doing community service, either in the United States or elsewhere. That she'd figure out with her skill and power how to turn that around on a more global level. Helping Doctors Without Borders and that kind of stuff.

Is there any one ability of Supergirl that you'd most like to have?
I always say flying. It's the obvious, but I do feel that way about being able to fly. That doesn't necessarily help the world. Just for selfish reasons, it would be most fun to be able to fly. [Laughs.]

76 Visit Superman's Birthplace

Though we can't travel back in time to the moment Superman was created (yet!), we can visit the place where he was born: Cleveland, Ohio.

On the city's East Side, the home of writer Jerry Siegel still stands at 10622 Kimberly Avenue. Almost 100 years old, it was restored in 2009 with the help of the nonprofit Siegel and Shuster Society; it spent $70,000 to renovate the property, owned by Jefferson and Hattie Mae Gray since 1983. The iconic "S" shield hangs on the front fence, alongside a plaque that reads, THIS IS THE HOUSE WHERE SUPERMAN WAS BORN. The second-floor bedroom in which the 18-year-old Siegel conceived of the Man of Steel one fateful night is visible from the street. Kimberly Avenue has the honorary name JERRY SIEGEL LANE emblazoned on its street sign.

A few blocks away, at the corner of Amor Avenue and Parkwood Drive, where the apartment house in which Joe Shuster

and his family lived once stood, there is now a vacant lot. But on the fence surrounding this lot hang a series of large metal panels featuring the cover and 13 pages of the story in which Superman first appeared, drawn by the artist in June 1938's *Action Comics* #1. On the sign for Amor Avenue is the name JOE SHUSTER LANE, while Parkwood Drive has been renamed "Lois Lane."

In a little park on the northeast corner of East 105th Street and St. Clair Avenue/Highway 283, there's a historical marker honoring Siegel and Shuster, erected in 2003 by the Ohio Bicentennial Commission and the Ohio Historical Society. One side of it reads:

Jerry Siegel and Joe Shuster, two Glenville High School students imbued with imagination and talent and passion for science fiction and comics, had dream become reality in 1932. They created Superman, the first of the superheroes ever to see print. The 1932 prototype was of a villainous superhero. Superman then became the hero who has been called the Action Ace, the Man of Steel, and the Man of Tomorrow.

The words continue on the marker's other side:

Although the success of Superman spawned an entire industry, publishers and newspaper syndicates did not originally accept the creation. Superman did not appear until 1938 when he became a lead feature on the cover of Action Comics No. 1. As co-creators of the most famous of mythical beings, Siegal [sic] and Shuster infused popular American culture with one of the most enduring icons of the 20th century. Superman has appeared in animated series, live-action series, major motion pictures, advertisements, and comic books, where his popularity grows with each generation of readers.

77 "For the Man Who Has Everything"

Would Superman's life have been better if Krypton had never exploded? On paper, the question could lead to the kind of alternate-reality tale that's a comic book staple. But in the hands of writer Alan Moore and artist Dave Gibbons, it becomes something much more.

"For the Man Who Has Everything" was presented in 1985's *Superman Annual* #11. It opens with the Man of Steel's then closest comrades—Batman, Robin, and Wonder Woman—arriving at the Fortress of Solitude bearing gifts for their friend's birthday. But they soon learn the Fortress already has a guest in the form of Mongul, an alien dictator with whom Superman had previously tangled. Mongul had trapped Superman with a Black Mercy, "something between a plant and an intelligent fungus," that gives its host their heart's desire while keeping them in a state of paralysis. In the case of Superman, it offers him a life on his native planet, with two children and a wife (actress Lyla Lerrol, Krypton's "most glamorous beauty," introduced in November 1960's *Superman* #141), along with his still-living, though increasingly bitter, widowed father, Jor-El. Unfortunately, the fantasy, comprised of lives that Kal-El has both been denied and denied himself, is destroyed when his friends turn the would-be conqueror's weapon against him.

"For the Man Who Has Everything" (which was adapted into a 2004 episode of TV's *Justice League Unlimited*) uses a classic science fiction trope like that employed by Moore in his "Tharg's Future Shocks" short stories for the UK's *2000 AD* comic in the early 1980s. The writer would pen additional Superman stories, "The Jungle Line" (in *DC Comics Presents* #85) and the character's unforgettable "final" tale "Whatever Happened to the Man of

Tomorrow?" (in *Superman* #423 and *Action Comics* #583). And Moore and Gibbons would again collaborate on their masterpiece *Watchmen*. But "For the Man Who Has Everything" gives readers an experience unlike that of any other. Like the Black Mercy itself.

"It was really one of the best experiences that I've had in comics," says Gibbons. "When DC put it into their *Greatest Superman Stories Ever Told* I was just blown away. To actually feel like you contributed something that special to a character that had been such a huge influence was just wonderful."

Daily Planet Exclusive

Dave Gibbons

Few Superman stories are so diamond-perfect as writer Alan Moore and artist Dave Gibbons' "For the Man Who Has Everything." The *Watchmen* creators poured a lifetime of love into the tale (first published in 1985's *Superman Annual* #11), and it launched Gibbons' professional relationship with the Man of Steel, which continued with his own writing efforts, the 1995 graphic novel *Superman: Kal* and, most significantly, the 1990 limited series *World's Finest* with artist Steve Rude.

When you began working for DC Comics, you hit the ground running with your run on Green Lantern. But it wasn't much later that "For the Man Who Has Everything" came out. What led to that story?
I'd become very friendly with Alan Moore, who as you know is a man of many, many words and is a wonderful storyteller. I had long conversations with him about Superman, and I remember that one idea he had was along the lines of, "What if Krypton hadn't exploded? How would its civilization have evolved? What would have happened to Jor-El and the Council of Scientists? Who would Kal-El be if he hadn't come to Earth?" It was a fascinating story that Alan had obviously worked out in his head in some detail. Anyway, I was at a convention in Chicago, and I'd read the synopsis that Alan had done for *Watchmen*, and Alan wanted me to draw it. I was at a DC party and I went up to Dick Giordano, who was then in charge of DC, and said,

Dave Gibbons

"Hey, Dick, this Charlton comics project that Alan's writing, I'd like to draw it." And he said, "How does Alan feel about that?" I said, "Alan wants me to do it." He said, "Okay, Dave, it's yours!" So I reeled away from that thinking, *Oh, that's great. I can't wait to get started on it.* I almost literally bumped into [Superman editor] Julie Schwartz, who I'd only been introduced to the day before. He said to me, "Hey, Dave, when are you gonna draw some Superman for me?" I said, "Anytime you like, Julie." He said, "Who do you want to write it?" I said, "Alan Moore?" He said, "Yeah, sure, fix it up!" We went from Chicago back to New York, where, from Julie's office phone, I called up Alan in England and said, "Do you want to do a Superman story with me?" Alan said, "Yeah, and I've got just the story." It was that story about "What if Krypton hadn't exploded?"

Julie said that would fit in the next *Superman Annual*, which was absolutely perfect, because we were able to do a self-contained story. We were able to do just the things with Superman that we'd always loved. We saw Krypton, we saw Batman, we saw the Fortress of Solitude, we saw Superman in a really balls-to-the-wall fight with a bad guy. It was just the greatest thrill. First of all, to work on Superman, and to work with Alan, and also to work with Julie Schwartz.

Since you were already so well versed in the DC Universe, did the story require little in the way of research for its scenes on Krypton and in the Fortress?
Oh, sure. There were two particular items that Alan and I looked at closely. One was the wonderful story that I think was called "Superman's Return to Krypton," which Jerry Siegel, the creator of Superman, wrote, and Wayne Boring drew. As the story suggests, it's his return to Krypton. There was something about Superman and his relationship with the lost world of Krypton that I've always found very poignant. Sometime later, when I got to write a *World's Finest* story of Superman and Batman, I think I actually came upon what is the essential difference between Superman and Batman. They're both orphans, but Batman saw his parents gunned down in cold blood in front of him and saw them die. He has no doubt that they are dead, and all that's left for him in his worldview is vengeance. But with Superman, he intellectually knew that Krypton had exploded and that

his parents had died, but there was always a hope that maybe through some quirk of space-time they were still alive. I think Alan captured that lost possibility through a marvelous story. So I could see in my mind that sort of Wayne Boring, huge-spires-of-Krypton cityscape.

Also, DC had done one of those big Treasury Editions, one of those big oversized comics, that had a wonderful cutaway diagram of the Fortress of Solitude. Our battle took place in the Fortress, with Superman and Mongul smashing each other through rooms into various rooms. And we made sure that all that continuity fitted. It gave us a great framework to stage our story in.

You mentioned the *World's Finest* limited series. That book came out in 1990 when there had not yet been a series devoted to examining the dichotomy between Superman and Batman.

World's Finest was my favorite comic growing up. Because it was the only team-up comic. There was no Justice League. There was no Avengers. For Superman and Batman to go on the same page was a huge thrill. So when Mike Carlin phoned me up to offer me a writing gig, I was absolutely thrilled. It was the first writing assignment that I'd been given by a major publisher. I'd loved [artist] Steve Rude's work and I knew what dedication he brought to things. And indeed he did. He very much pictured it as being the classic Fleischer Studios animated Superman, and Bob Kane, Bill Finger, and Jerry Robinson's original vision of Batman as a really sinister character. That fitted beautifully with the kind of emotion I evolved for this story, which was basically about the contrast between Superman and Batman—Superman being a creature of the light, Batman being a creature of the dark. Superman being yang in Chinese cosmology, clear and powerful and bright. And Batman being yin, dark and hidden and shadowy. I thought I could play off something there, and I could play off Metropolis, the clean, bright, optimistic city of tomorrow against Gotham City, and then play off the seriousness of Luthor against the frivolity of the Joker. And sort of mix and match them all to play off their differences. I kind of set it so that there was an orphanage involved and a kind of Fagin subplot, with a nasty guy teaching people to be crooks. Looking back on it, I perhaps in some cases tried to get a bit clever. But Steve brought a humanity to it all that really enhanced anything I'd come up with.

78 "Whatever Happened to the Man of Tomorrow?"

While the origins of most superheroes are as well known as their costumes, powers, and secret identities, few four-color champions are given an end to their life stories. Even *The Dark Knight Returns*, that most famous of comic book capstones, is still debated amongst fans for its veracity as canon. Yet numerous tales have been told of Superman's final struggle, of the day his never-ending battle at long last ends. One possible future history was presented in the landmark *Superman* #400, while the apocalyptic miniseries *Kingdom Come* offers an end for many of DC's beloved heroes. The most celebrated "last" Superman story, however, is "Whatever Happened to the Man of Tomorrow?" It was written by Alan Moore and illustrated by the most prolific of all Superman pencillers, Curt Swan.

Originally presented in two parts, in September 1986's *Superman* #423 and *Action Comics* #583 (the former inked by George Perez, the latter by Kurt Schaffenberger), "Whatever Happened to the Man of Tomorrow?" was intended as a what-if ending to Superman's original comic book continuity before the *Crisis on Infinite Earth* miniseries (which had begun the year prior) rebooted the entire DC Universe. As departing Superman editor Julius Schwartz recalled (in Paul Kupperberg's introduction to the story in *DC Universe: The Stories of Alan Moore*), "...it was incumbent upon me to clean up, to explain all the things that had been going on in the previous years. For example, did Lois Lane ever find out that Clark Kent was Superman? Did they ever get married? What happened to Jimmy Olsen, to Perry White, to all the villains? I had to clear it up." At Moore's insistence, Schwartz hired him, and he turned his housecleaning assignment into a masterpiece.

Told in flashback from the point of view of Lois Lane, 10 years after Superman's last public appearance, "Whatever Happened to the Man of Tomorrow?" describes the last days of not only Superman, but those of Krypto, Lana Lang, Lex Luthor, Bizarro, and Brainiac, while offering the most chilling depiction of Mister Mxyzptlk ever seen—as an immortal grown bored with being mischievous, who decides to become truly evil. As he often does, Moore offers startlingly new perspectives on characters and situations we've known all our lives. "I was falling, and a violet comet was falling alongside me," says Lois, recalling being pushed out a *Daily Planet* window by Metallo. "The reds and blues ran together, you see, so that's how he looked when he flew...a violet comet."

Alas, it's hardly canon. Just an imaginary story. Then again, as Moore points out in his original introduction, "Aren't they all?"

79 Superman: The Parade Balloon

Wondering just how quickly Superman's popularity rose after his first appearance in *Action Comics* #1? Consider that just *19 months* after the magazine first appeared on newsstands, the Man of Steel received the ultimate tribute paid to any pop culture icon of the time—a Macy's Thanksgiving Day Parade balloon.

Licensed characters became a part of the New York City parade in 1927, when the Felix the Cat balloon debuted. But in the years that followed, only Mickey Mouse, Donald Duck, and the Marx Brothers had appeared. On the morning of November 23, 1939, however, the throngs of spectators who filled Manhattan's streets were greeted by the sight of the first-ever superhero balloon

featured in the parade: the Man of Steel. Hands on hips, he stood 80 feet tall with a chest 23 feet wide.

In 1966, a second (albeit portlier) Superman balloon was introduced, which again stood upright. And in 1980—the year of *Superman II*'s release—a third balloon debuted, this time depicting the Man of Steel in flight. The largest balloon ever featured in the Thanksgiving Day parade, it was 104 feet long. Its size is unlikely to be eclipsed, since restrictions are now in place limiting the size of the parade's balloons. That is probably for the best, since this nylon and rubber balloon was *so* big that, in 1986, a mere tree was able to accomplish something Superman's enemies never could: it tore his left hand off.

80 The Death of Supergirl

Few events in superhero comic book history are as significant as DC Comics' *Crisis on Infinite Earths*. Running from April of 1985 through March of 1986, this 12-issue limited series, written by Marv Wolfman and pencilled by George Perez, was intended as a complete housecleaning of the company's multiverse. The multiverse consisted of numerous parallel worlds created in order to explain the many versions of characters introduced over DC's then 50-year history, as well as the additional characters acquired from comic publishers like Fawcett (the Marvel Family), Quality (Plastic Man and Blackhawk), and Charlton (Captain Atom, the Question, and Blue Beetle). Among the many casualties of this epic tale, which saw the myriad of worlds compressed into one, were Superman's close friend and ally the Silver Age Flash (aka Barry Allen), his mermaid sweetheart Lori Lemaris, and his cousin, the original Kara Zor-El.

Supergirl's death—born of a desire on the part of DC's editorial staff to make Superman once more the sole survivor of the planet Krypton—was the series' most shocking. Suggested by the company's vice president Dick Giordano, it occurred in October 1985's *Crisis on Infinite Earths* #7 ("Beyond the Silent Night"). In this issue, the Maid of Might saves Superman from the series' godlike villain, the Anti-Monitor, but at the cost of her own life. The issue's cover, on which a tearful Man of Steel holds the fallen Kara in his arms, the last of his family (since in this continuity his adoptive parents died when he was Superboy), is reminiscent of that of *Uncanny X-Men* #136, with Cyclops holding Dark Phoenix in a similar pose. But it remains one of the most iconic in DC's history, inspiring parodies and homages in equal measure.

Its sadness is reflected in the issue's final scene, in which Superman releases Kara's body into outer space with the words: "We live on remembering and honoring the past, but always looking to the future. Good-bye, Kara...Linda Lee...Supergirl. I will miss you forever."

John Byrne

Ask fans of superhero comics from the 1970s and '80s to name their favorite artist, and there's a good chance they'll name John Byrne.

Born July 6, 1950, in the West Midlands of the United Kingdom, Byrne made a name for himself pencilling numerous Marvel comics, including *Avengers, Captain America, The Incredible Hulk, Fantastic Four, Alpha Flight* (his own creation), and, with writer Chris Claremont, *Marvel Team-Up* and *Iron Fist*. Byrne

and Claremont's greatest success at Marvel was the era-defining *Uncanny X-Men*, on which they crafted such epics as "Days of Future Past" and "The Dark Phoenix Saga."

In 1986, Byrne migrated to DC, where he became longtime Superman artist Curt Swan's successor as the character's regular penciller, as well as his principal writer. Bryne's debut was the best-selling six-issue miniseries *Man of Steel* (July–September 1986), which rebooted the character in the wake of DC's apocalyptic *Crisis on Infinite Earths*. Byrne streamlined Superman's mythos, while retaining what he felt were his best characteristics.

"What I thought," said Byrne (to interviewer Dwight Zimmerman in Fictioneer Books' 1991 *Comics Interview Super Special: Big Byrne Book*, edited by David Anthony Kraft), "was, 'This is great, I'm sitting down to essentially "create" a character, but I've got [50] years' worth of stuff to draw on, I can pick the stuff I like best, that I think works the best.' I could pick not just from the comics but from the cartoons, the TV show, the radio show, the cereal boxes, *everything*!"

Gone were Supergirl, Krypto, Kandor, and all other survivors of his native planet, making Kal-El the true *Last* Son of Krypton. His power levels were also reduced. He could no longer move entire planets with his bare hands, and though he could hold his breath for extended periods of time, he needed to breathe, thus limiting his ability to travel through space. Lex Luthor was no longer an evil scientist, but rather (per the suggestion of Marv Wolfman, who was made writer of the retitled *Superman* comic, *Adventures of Superman*) a corrupt industrialist, hellbent on making sure he was Metropolis' favorite citizen. The biggest break from tradition, however, was that Clark Kent's adoptive parents remain alive after Clark leaves Smallville. Clark only dons cape and tights after leaving his home town, which meant there was no longer a Superboy.

As Byrne explained (in *Comics Interview Super Special: Big Byrne Book*), "I always thought, 'He landed, he was raised by the

Kents, everything he is is due to the Kents.' It's not due to Jor-El sending along a secret message tape that says 'do good stuff'—he does good stuff because he had a good strong, middle American BIBLE Belt *upbringing*. It troubled me so much every time he would say 'Great Krypton' or check the Jor-El tapes. I felt he was spitting in Pa Kent's eye every time he did that."

While some fans criticized the changes, most were happy to see Superman receive a new lease on life, especially when Byrne took over the writing and pencilling of *Action Comics* and his own new monthly *Superman* comic. Here, Byrne demonstrated the same fondness for tightly plotted stories that had informed his run on *Fantastic Four*, producing memorable tales of Metallo, Mister Mxyzptlk, and his own creation, Silver Banshee (who debuted in December 1987's *Action Comics* #595). He also created Metropolis Special Crimes Unit's Captain Maggie Sawyer (first seen in *Superman* Vol. 2 #4, April 1987), Superman's primary police liaison.

Byrne's best story was "The Secret Revealed!" in *Superman* Vol. 2 #2 (February 1987), in which Lex Luthor finally learns Superman is Clark Kent, but, due to his own overinflated ego, refuses to believe the most powerful man in the world would choose to live his life as a lowly newspaper reporter.

In 1988, Superman's 50th anniversary year, Byrne wrote three miniseries exploring the character's universe—*The World of Krypton*, *The World of Metropolis*, and *The World of Smallville*—as well as the one-shot prestige-format special *Superman: The Earth Stealers* (illustrated by Curt Swan). His work reached its widest audience, however, when he illustrated *Superman* for the March 14, 1988, cover of *Time* magazine.

After two years, Byrne said farewell to Superman and returned to Marvel. But elements of his interpretation of the Man of Steel, the most human since Jerry Siegel and Joe Shuster created the character, have since been used in many comics, films, and TV shows, most

notably *Lois & Clark: The New Adventures of Superman, Superman: The Animated Series, Smallville, Superman for All Seasons, Superman Returns,* and the 2013 *Man of Steel* movie.

"What makes him Superman," added Byrne (in the same *Comics Interview Super Special*), "is not that he can leap tall buildings or see through walls. What makes him Superman is that he doesn't use these abilities to make himself king of the world. He's got all this *stuff,* but he uses it for good. That's the definitive superhero…"

82 The Ruby-Spears *Superman*

Between Hanna-Barbera's *Super Friends* in the 1970s and '80s, and Warner Brothers. Animation's acclaimed *Superman: The Animated Series* in the 1990s, there existed another cartoon show featuring the Man of Steel on American television—animation studio Ruby-Spears' often forgotten *Superman*. Though it ran for just 13 episodes during the character's 50th anniversary year (from September 17 through December 10, 1988), the Ruby-Spears *Superman* can be viewed as a kind of missing link between its kid-oriented predecessor and the more ambitious animated incarnation that followed it.

Featuring such staples as Clark Kent (voiced, as is his alter ego, by Beau Weaver), Lois Lane, Jimmy Olsen, Perry White, Lana Lang, S.T.A.R. Labs, and Inspector Henderson, each half-hour episode included "Superman's Family Album," a four-minute vignette focusing on young Superman's adventures in Smallville, from his adoption after landing on Earth straight through to his departure from his boyhood home. The show marked the first time the post–*Crisis on Infinite Earths* version of Lex Luthor is depicted

on screen (a corrupt industrialist as opposed to an evil scientist). Gene Hackman's car-salesman interpretation of the villain from the *Superman* films informs the show's take on the character, along with his taste in sidekicks. Here, Miss Teschmacher is replaced by equally daffy Marilyn Monroe sound-alike Miss Morganberry. The show also incorporated General Zod, along with composer John Williams' *Superman: The Movie* theme in its opening titles. Best of all, its character designs were created by Superman comic book artist Gil Kane, while comic writer Marv Wolfman served as story editor.

"I wrote the pilot and I wrote the first of the back-up stories," says Wolfman. "I really liked the show, and I really enjoyed doing it. Unfortunately, because they put it on at a bad time, the show didn't do that well."

Daily Planet Exclusive

Marv Wolfman

Among the countless comic book characters created by Marv Wolfman in his almost 50-year career are such iconic heroes as Blade and the New Teen Titans. But the legendary writer still holds Superman—whose adventures he's told in comics such as *Adventures of Superman* and *Crisis on Infinite Earths*, as well as in novels and on television—as his favorite.

You've worked on many comic book characters, but you've often said you're most fond of Superman...
I've never tried to hide that and I've written him over many, many years. It sounds weird to say this, but I've written him over six decades. My first Superman story was in 1969. I wrote him in the '70s, I wrote him in the '80s, I wrote him in the '90s, I wrote him in the '00s, and I wrote him in the '10s. It sounds ridiculous based on my age that I could say I wrote him over six decades, but it's absolutely true.

I love the character, and every time I've approached him I've approached him slightly differently, based on where my head was at. But I never wrote the character's dialogue differently. So he was always in character. Just where I was centering my interests changed. Unlike, say, John Byrne, who had been at Marvel, I was writing Superman in one style for [editor] Julie Schwartz, and then switched it to the new style [post *Crisis on Infinite Earths*].

I love the Fleischer Studios cartoons, and I love the first two years of the original comic book series. I loved the fact that he dealt with more human problems. Now I love writing the big stuff, because you can let loose with Superman. I did a four-part miniseries at one point where he was fighting this incredible galaxy-wide virus. But in the reinvention of Superman, I wanted him to be a little bit more down-to-earth. So on *Adventures of Superman*, which I wrote and named, based on the TV show, I wanted him to be dealing far more with human problems.

In doing so, you expanded his supporting cast of characters.
I created Cat Grant. Because it never made sense to me, when you analyze it, that Lois would think Clark was a total loser. He looks like Superman. He's built like nobody's business. He's a brilliant, Pulitzer Prize–winning writer. To have that disdain for him is a little ridiculous. What I wanted to do was ignore Lois completely for this storyline and create a character who was herself outrageous. She was a gossip columnist who thought Clark was phenomenal. As you learn later, she had a kid, she had a bad marriage. Clark, on top of being gorgeous and strong-looking and a great writer, he's a kind man. She needed that as well. So I wanted someone to point out how good Clark was. The stories I wrote all dealt with, for the most part, human-type characters and human-type situations. For my run of *Adventures of Superman*, I did no space stuff. I did no villains of that sort of magnitude. I wanted it more down-to-earth.

You're also responsible for the post-*Crisis* Lex Luthor.
My attitude was…Luthor's power is his mind. Putting on a supervillain suit is ridiculous for a character like Luthor. He is so smart that he should be able to befuddle Superman. The attitude that I had was that he was so good as this businessman that Superman could not find anything to pin on him.

Marv Wolfman

That was my version of Luthor. Luthor had everybody look up to him. And he tried to get Lois all the time. She was sort of ambivalent, but he was this incredible character who donated tons of money, all of this stuff. Everyone's eyes were always on Luthor. Then Superman pops up and they all turn. That's what makes Luthor angry. He used to be number one, and he can't be anymore. It's that utter failure that makes him interesting to me. It's not the original concept of Luthor—that his hair blew out in an accident, and that he got angry at Superboy for doing that.

You and artist Gil Kane, with whom you'd collaborated on Superman comics, oversaw the 1988 *Superman* cartoon series. It was the first animated Superman series that tried to be something more than Saturday morning TV fodder.
We went as far as we were allowed to. Boy, getting anything through was really difficult. Because the person in charge of CBS children's television did not want Superman. She hated superheroes. But her bosses wanted Superman. So she put us on at 7:00 in the morning. She did a whole bunch of stuff to make it hard, and we had to fight constantly to get anything. But I thought that, considering what had been at the time, we got away with a lot more than what could be expected.

Among your Superman comic stories, do you have a favorite?
In the run under [editor] Julie Schwartz, the one I wrote that honored Jerry Siegel and Joe Shuster [April 1984's *Action Comics* #554, "If Superman Didn't Exist"]. In the later run, there was an issue [May 1987's *Adventures of Superman* #428, "Personal Best," which introduced fan-favorite character Bibbo Bibbowski] that was all about Perry White and his son. I really loved that story, too.

83 The *Superboy* TV Series

After the tepid critical response to *Superman III* and the critical and box office failure of *Supergirl*, producers Alexander and Ilya Salkind sold their movie rights to Superman to Cannon Films, resulting in the 1987 misfire *Superman IV: The Quest for Peace*. But the Salkinds retained the screen rights to associated characters within the Man of Steel's universe. And so, in 1988 (Superman's 50th anniversary year), they launched the first live-action TV series since the 1950s *Adventures of Superman* devoted to the adventures of Clark Kent. Albeit a younger Clark Kent...enter *Superboy*.

Starring John Haymes Newton in the title role, Scott James Wells as Lex Luthor, and Stacy Haiduk as Lana Lang—all of them students at the Siegel School of Journalism at Shuster University, located in Shusterville, Florida (named in honor of Superman creators Jerry Siegel and Joe Shuster)—*Superboy*, the first live-action series focused on the Boy of Steel, premiered on October 8, 1988. The first half of the syndicated show's first season was a low-budget affair, primarily concerned with mundane human criminals. But after the series received a full-season order, the production values improved, and the villains became increasingly more science-fiction-oriented. The first season even saw the live-action debut of Mister Mxyzptlk (in the episode "Meet Mr. Mxyzptlk"), played by Oscar-nominated character actor Michael J. Pollard. In the first-season finale, Luthor's hair falls out in a lab accident, for which he blames Superboy, thus mirroring his Silver Age comic book origin.

In the show's second season Newton was replaced by actor Gerard Christopher (possibly as a result of a salary increase demand) and Lex Luthor was replaced by *Day of the Dead* star Sherman Howard. More longtime Superman enemies appeared for the first

time in live action, including Metallo and Bizarro (played by Michael Callan and Barry Meyers, respectively). Among the new villains introduced was the Toyman-like Nick Knack, played by comedian Gilbert Gottfried (who would voice Mxyzptlk in *Superman: The Animated Series*). In the third season, Lana and Clark came to work at the Bureau for Extra-Normal Matters (reminiscent of *The X-Files*), and the show's title changed to *The Adventures of Superboy*. In the wake of the *Batman* movie's success, the show's stories grew increasingly dark, especially for a half-hour kids' show; the trend continued in the fourth and final season, which guest-starred *Adventures of Superman* stars Noel Neill and Jack Larson.

After 100 episodes—many of them scripted by Superman comic book writers and editors, including Mike Carlin, Denny O'Neil, Cary Bates, and J.M. DeMatteis—*Superboy* came to an end when Warner Brothers decided to launch its own Superman TV series (1993's *Lois & Clark: The New Adventures of Superman*), and regained the full screen rights to the character's universe. *Superboy*'s finale aired on May 17, 1992. Its success, however, paved the way for the studio's own version of a TV show about the young Clark Kent—*Smallville*.

 Steel

Born out of the "Reign of the Superman!" storyline, which followed "The Death of Superman," Steel is one of the most popular additions to the Man of Steel's universe in the last 50 years.

Introduced in June 1993's *The Adventures of Superman* #500 (in "First Sighting—The Man of Steel," by writer Louise Simonson and penciller Jon Bogdanove), Dr. John Henry Irons was a military

weapons designer who rejected his career when his weapons resulted in the deaths of innocents. He then took a job as a construction worker in Metropolis. As revealed in June 1993's *Superman: The Man of Steel* #22 ("Steel," by Simonson and Bogdanove), he was almost killed while saving the life of a co-worker, but Superman intervened. "I owe you my life," said Irons. "Then make it count for something," replied the Man of Steel.

After Superman's death at the hands of Doomsday, Irons learned that the weapons he'd created were being used in a Metropolis turf war, in which innocent children were killed. Referring to the American folk hero who inspired his name, Irons remarked, "John Henry fought the machine and won. What I'm fightin' is a deadlier kind of machine—one I helped put in motion. One I'm gonna stop...even if it kills me."

Fashioning a suit of superpowered armor for himself, complete with "S" shield and red cape in honor of the fallen hero, Irons was one of four Supermen who emerged to replace him, each adopting a nickname given to Superman. In addition to Steel (originally "The Man of Steel"), there was a genetically cloned Superboy ("The Metropolis Kid"), a cyborg ("The Man of Tomorrow"), and a vengeful alien ("The Last Son of Krypton"). When the cyborg's intentions were revealed to be malevolent, Steel played an integral role in helping the resurrected Superman defeat him.

Steel went on to star in his own eponymous comic book, which ran from 1994 to 1998. He also joined the Justice League. During DC's "Our Worlds at War" crossover event, Steel retired, but remained a close ally of Superman, assisting him with his technological genius. He created another suit of armor for his niece, Natasha Irons, who succeeded him as Steel. In DC's *52* limited series, Natasha acquired superpowers and became Starlight. When those powers changed, she became Vaporlock. John Henry Irons' Steel returned in DC's "New 52" reboot.

Irons appeared in the second season of *Superman: The Animated Series* (in the episodes "Prototype" and "Heavy Metal"), in which he was voiced by Michael Dorn, and later in *Justice League Unlimited.* The character made his screen debut in the 1997 live-action feature film *Steel,* in which he was played by professional basketball player Shaquille O'Neal. Though the movie was panned by critics, it's noteworthy for being the first film adapting a DC or Marvel African American superhero's adventures.

"The film was awful," says Steel co-creator Louise Simonson. "Honestly, the costume itself was so bad that maybe that was the best you could do at the time. I hated the script. I thought the villain was lame. It wouldn't have been as terrible if they had had a better costume and a better major villain…Everybody kind of dumps on Shaq, because they can I guess. But I have kind of a soft spot in my heart for Shaq. I thought Shaq was fine as Steel."

Daily Planet Exclusive

Louise Simonson

The first woman to be credited for chronicling Superman's comic book adventures, Louise Simonson was the writer of the monthly *Superman: The Man of Steel* from its first issue in July 1991 through 1999, during which time the character died at the hands of Doomsday, was resurrected, and finally married Lois Lane. Simonson is also the co-creator of Steel, the most popular breakout character from the Man of Steel's universe in the '90s.

Who came up with the idea to kill Superman off?
We had been working on a storyline which I think involved the marriage of Superman. I'd heard that the decision was made to postpone the marriage because the *Lois & Clark* TV show was coming out. We had spent two days on that, coming up with the whole thing. So Jerry Ordway said, "Let's kill him," and we said, "Yeah, great idea.

Let's kill him!" It seemed like a great idea, even though it was a joke. Then we thought about it. For each of us there was a different lure in the let's-kill-him scenario. A different thing that we ourselves wanted to focus on. We had to wait a while, but Jerry's brilliant idea paid off. So give Jerry the credit. [Laughs.] You can give us the credit for thinking it was brilliant.

Then of course the question was "How do we do it? Who could possibly kill Superman?" Oddly enough, the story itself came together very quickly, much more quickly than the initial marriage thing had. I think the death was a better story. More dramatic certainly.

How did DC react to the idea?
Initially I think the corporate people weren't that happy that we had killed Superman, just because they had a lot of advertising riding on the character. He's a licensed character, and he has his own value aside from being a character in a comic book. But then when it sold so well that it reintroduced the idea of Superman to the world, people were like, "Oh, yeah. We've got to do a big event every year. Preferably every issue, because big events sell." But I think some of the point that was missing and continues to be missed with these big crossovers is that you have to buy every single comic book to actually know what's going on. I sort of mourn the loss of being able to do the smaller story that would then build to a larger story. I like the soft notes in between the big booming volume.

Steel was introduced as a result of "The Death of Superman." Was he originally intended just to be one of the four mystery men who stepped in to replace Superman after he was killed?
I think the idea is every time you make a character you make him the best character you can possibly make him. We had created him, [artist] Jon Bogdanove and I, to be the soul of Superman. Other people had taken different aspects, but we wanted a character who was just basically a good guy. It was a character who maybe had made a mistake in the beginning, of working for this company that created weapons, and the weapons were used in a way that he had not intended, and what he had created was weaponized in a way that had not been intended. He felt the need to atone for that. Superman saved him and sort of showed him the way. And when Superman

Louise
Simonson

died he wanted to then do as much good as he could. Not to take Superman's place exactly, but to honor Superman. So we came up with a character who would do that. Then people liked him, which was really cool. Then they wanted to see more of him, and that was even cooler. So then we added a *Steel* book, which was even cooler than that. Then we moved him out of Metropolis and into Washington, and he had his own adventures there.

Do you have a favorite Superman story, or run of stories?
I do think that the stories themselves got absolutely wonderful after Mike Carlin became the editor on the Superman books. Those were great stories, almost from the beginning. The fact that he managed to link these stories with the little triangle with the number on the cover. Each story would have its own number and you could follow from issue to issue. I just thought it was brilliant. The logistics of creating a series like that where you have to give everybody all this information from month to month so that one person can write the next story, picking up where the other one left off; and they'd leave it at a good spot so that everyone has all the visual reference, and everybody turns in their work on time so that the next person has their full allotted time to work on their story…Mike Carlin could have been a general, I swear. [Laughs.] The Carlin years were actually my favorite as far as that goes.

85 Superman: The Wedding Album

Superman and Lois Lane have married many times in imaginary stories (July 1963's *Superman* #162, "The Amazing Story of Superman-Red and Superman-Blue"), dream sequences (*The Adventures of Superman*'s "The Wedding of Superman" episode), and on parallel worlds (June 1978's *Action Comics* #484, "Superman Takes a Wife!"). But their 58-year-old courtship came to an official end with the release of the one-shot comic book *Superman: The Wedding Album* in 1996.

Clark began dating Lois in June 1990's *Superman* #44 ("Dark Knight over Metropolis Part 1: Green Death in Crime Alley," written and pencilled by Jerry Ordway). Just six months later, in December 1990's *Superman* #50 ("The Human Factor," written by Ordway and pencilled by numerous artists), he proposed marriage. To his delight, Lois accepted his proposal. Two months after that, in February 1991's *Action Comics* #662 ("Secrets in the Night," written by Roger Stern with art by Bob McLeod), Clark told her he was Superman. But with the arrival of *Lois & Clark: The New Adventures of Superman*, their wedding was postponed until their TV counterparts headed for the altar. In the show's fourth-season episode "Swear to God, This Time We're Not Kidding," first broadcast on October 6, 1996, the two at long last exchanged vows. That same month—after a series of setbacks that included Superman's death at the hands of Doomsday and an extended breakup—*The Wedding Album* saw them wed in print.

Featuring a who's who of seminal Superman artists—including Curt Swan, John Byrne, and Al Plastino—this 91-page tale was written by the same team of writers that chronicled the Man of Steel's adventures throughout the 1990s: Dan Jurgens, Karl

Kesel, David Michelinie, Louise Simonson, and Roger Stern. The wedding featured Jimmy Olsen as Clark's best man, Lois' sister, Lucy, as her maid of honor, and a priest who looked suspiciously like Superman co-creator Jerry Siegel. The congregation consisted of many other comic creators. Even the Dark Knight got involved in the festivities, by recruiting DC's other heroes to protect Metropolis during the couple's honeymoon in Hawaii.

Though Lois and Clark were no longer married when DC relaunched its universe in 2011's "New 52" series of titles, the married version of Lois and Clark were reintroduced into the company's new continuity in 2015, in which they exist alongside the rebooted couple. A rare case in which fans got to have their (wedding) cake and eat it too.

86 The Top Seven Songs about Superman

It's more than a little unfair to fans of Batman, Spider-Man, the X-Men, and the Avengers that while their favorites have dominated this millennium's big-screen box office, the Man of Steel continues to conquer its music charts. But, as befitting the world's most famous superhero, there have been hundreds of songs referencing Superman. Here are seven favorites.

7. Crash Test Dummies, "Superman's Song"

DC Comics decided to (temporarily) kill off Superman in the infamous 1992 "Death of Superman" storyline. A year prior, however, Canadian alt-rockers Crash Test Dummies had already recorded a funeral song for Earth's champion, with "Superman's Song," the band's first single, featured on their

debut album *The Ghosts That Haunt Me.* Singer-songwriter Brad Roberts pays tribute in mournful lyrics that contrasts the Last Son of Krypton with the Lord of the Jungle, Tarzan, while marveling that Superman, who could do anything with his powers, instead "never made any money for saving the world from Solomon Grundy."

6. Bonnie Tyler, "Holding Out for a Hero"

It's easy to dismiss the music of Bonnie Tyler as 1980s cheese. But cheesy or not, "Holding Out for a Hero" packs a punch worthy of Superman. Though he's only mentioned once, the Man of Steel's spirit soars through the song's five minutes, laced with Tyler's tornado vocals. Written by her "Total Eclipse of the Heart" tunesmith Jim Steinman and Dean Pitchford for the latter's 1984 *Footloose* soundtrack, it was made famous via the scene in which Kevin Bacon's protagonist engages in a chicken fight (fought with tractors) against his romantic rival. Superman fans could later claim it as their own when "Holding Out for a Hero" was used in *Lois & Clark: The New Adventures of Superman*'s pilot, as Dean Cain's Clark Kent suits up as his alter ego for the first time.

"Holding Out for a Hero" has since become a torch song standard. It was sung in the "Dynamic Duets" episode of *Glee* by Becca Tobin and *Supergirl* TV star Melissa Benoist (in a quasi Wonder Woman costume), and released as a single.

5. Donovan, "Sunshine Superman"

Scottish import Donovan wrote and recorded this *Billboard* chart-topping single. Released in July of 1966, it's a quintessential work of '60s summer psychedelia, and "Sunshine Superman" wound up as the title track on the singer-songwriter's third album. Backed by future Led Zeppelin members Jimmy Page on electric guitar and John Paul Jones on bass, it

not only pays homage to Superman but to his Justice League teammate Green Lantern as well. And the song inspired comics writer Grant Morrison (another Scot) to create an African American take on the Man of Steel named Sunshine Superman during his run on DC's *Animal Man*. Morrison would go on to write one of the most acclaimed of all Superman comic runs with *All-Star Superman*.

4. Laurie Anderson, "O Superman (For Massenet)"

Performance artist/musician Laurie Anderson broke into the music biz with her 1981 single "O Superman" (included on her 1982 debut album *Big Science*), which makes allusions to the Man of Steel as the ultimate paternal figure, and, for better or for worse, a symbol of the most powerful nation on Earth. Anderson's trademark spoken-word riffs aren't to everyone's tastes, and the synthesizer effects may sound dated to some, but there's an undeniable power to this eight-and-a-half-minute experiment that remains timeless.

3. Sufjan Stevens, "The Man of Metropolis Steals Our Hearts"

Though Superman was created in Cleveland, Ohio (by writer Jerry Siegel and artist Joe Shuster), his home city of Metropolis is said to be based on Chicago, the largest city in the Midwest. Sufjan Stevens paid tribute to both real and fictional towns in "The Man of Metropolis Steals Our Hearts," the 12th track on his acclaimed 2005 album *Illinois*, fittingly released on the Fourth of July and comprised entirely of songs inspired by the Prairie State. French horns and choruses make for as lush a listening experience as anything on the LP, and Stevens makes full use of the state's association with Superman's honorary alloy, steel, while touching on his frequent use as a messiah figure. Fun fact: the Big Blue Boy

Scout appeared in the album's original cover art until Stevens' lawyers requested he be removed, lest they face the wrath of DC Comics.

2. The Clique, "Superman"

Texas pop act the Clique is best known for what was originally a B-side on their 1969 single "Sugar on Sunday." Breezy, lazy, and cheerful—with more than a hint of the Beatles' influence—"Superman" perfectly captures the feel-good vibes found in the best Silver Age comic book stories about the Last Son of Krypton. Fellow southern rockers R.E.M. covered it on their *Lifes Rich Pageant* LP, and their version was used in a third-season episode of TV's *Lois & Clark* ("Tempus, Anyone?"). It's also featured in *Glee*'s "Dynamic Duets" episode.

1. The Flaming Lips, "Waitin' for a Superman"

Subtitled "Is It Gettin' Heavy?" for its US release, the Flaming Lips' "Waitin' for a Superman" is arguably the finest track on the band's finest album, 1999's *The Soft Bulletin*. It's all the things that make the Lips' music memorable, by turns dreamy and practical, hopeful and melancholic. It speaks to the limitations that even a Man of Steel must face, bringing him one step closer to humanity, and making us love him all the more for it.

Here are seven honorable mentions: XTC's "That's Really Super, Supergirl," 3 Doors Down's "Kryptonite," Our Lady Peace's "Superman's Dead," Jim Croce's "You Don't Mess Around with Jim," The Kinks' "(Wish I Could Fly Like) Superman," The Dukes of Stratosphear's (aka XTC's) "Brainiac's Daughter," and The Spin Doctors' "Jimmy Olsen's Blues."

87 *Kingdom Come*

Superman's last days have been chronicled in several essential comic book tales, including writer Alan Moore and penciller Curt Swan's "Whatever Happened to the Man of Tomorrow?" (in September 1986's *Superman* #423 and *Action Comics* #583), the short stories written by Elliot S. Maggin in *Superman* #400 (October 1984), and Mark Waid and Alex Ross' *Kingdom Come*.

Initially published as a four-issue limited series (dated May through August 1996) under DC's Elseworlds banner (reserved for "imaginary" stories), *Kingdom Come* depicts not only Superman's final battle, but that of Batman, Wonder Woman, and Captain Marvel. Ross was inspired by the success of his breakthrough 1994 Marvel limited series *Marvels* to craft a similar epic set within the DC Universe, again told from the point of view of a bystander. In this case, it was minister Norman McCay, modeled after Ross' own father, Reverend Clark Norman Ross. Mark Waid, who'd co-created the Elseworlds imprint when he edited *Batman: Gotham by Gaslight* (with Brian Augustyn), joined Ross as the book's writer.

Kingdom Come begins 10 years after DC's principal heroes have retired from their roles as Earth's protectors, falling out of favor with the public after the emergence of a new champion, the golden horned and armored Magog (inspired by then-hot comic creator Rob Liefeld's superhero aesthetic). Unfortunately, Magog and his followers' tendency toward hyperviolence and capital punishment makes them all but indistinguishable from the villains they fight, as seen when Magog killed the Joker after the Clown Prince of Crime murdered Lois Lane.

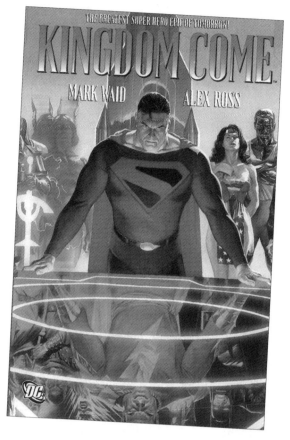

Mark Waid and Alex Ross' legendary Kingdom Come *depicts an aged Superman coming out of retirement for one final battle.*

When Magog's Justice Battalion confronts Superman's long-time foe the Parasite, the radiation released wipes out much of America's Midwest, prompting Superman to form a new Justice League. Hellbent on stopping Magog's forces, the Man of Steel tries to recruit Batman, but the Dark Knight, still bitter at Superman for abandoning his post as Earth's protector, refuses to join him. Believing Superman's efforts will make things worse, he unites his own team, the Outsiders (comprised of heroes like Green Arrow and Black Canary), and forms an uneasy alliance with Lex Luthor.

Now at his most powerful, due to many years of absorbing the sun's rays, and immune to kryptonite, Superman replaces his costume's yellow highlights with black, reflective of his somber mood. He becomes a target of not only Luthor's Mankind Liberation Front, which manipulates Captain Marvel into battling him, but a metahuman-targeting United Nations. In the end, the Man of Steel decides to lead by example, rather than physical force. He fathers a child with Wonder Woman, and like his own father before him, takes on the job of farmer and sets about restoring the Midwest.

Fully painted in gouache by Ross, *Kingdom Come* inspired action figures, statues, trading cards, a novelization (by Elliot S. Maggin), and an audio drama adaptation, as well as the Man of Steel's battle with Captain Marvel in the *Justice League Unlimited* episode "Clash." But its greatest legacy is its underlying message that might doesn't make right. It's a message that, sadly, hasn't lost its relevance.

"It was constant back and forth between me and Alex," says Waid of the collaboration with Ross. "Sometimes very pleasant conversations and sometimes lots of yelling and screaming, because—I swear to God—you've never met two people in the world who could have a three-hour argument about Aquaman like Alex and I can. But I'm very happy with what we came up with."

88 *Superman For All Seasons*

One of the loveliest tales ever told of the Man of Tomorrow, *Superman For All Seasons* debuted in September 1998. Written by Jeph Loeb and illustrated by Tim Sale, this monthly prestige-format miniseries presented each of its four issues from the

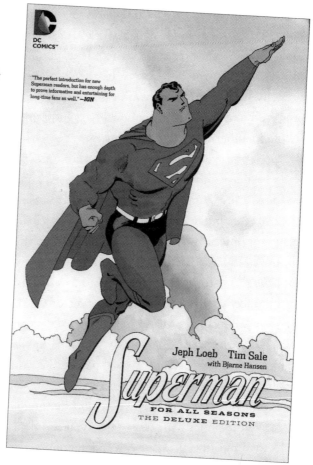

Superman For All Seasons *took an innovative approach to the Man of Steel, telling its story from the perspective of four different characters.*
(Cover art by Tim Sale)

perspective of a different character in the post–*Crisis on Infinite Earths* Superman's life, at a different season of the year, beginning with his adoptive father Jonathan Kent (spring), and continuing on through Lois Lane (summer), Lex Luthor (fall), and Lana Lang (winter). By turns pastoral, meditative, and bittersweet, its art was inspired by Sale's desire to bring the Americana of Norman Rockwell into comics via the Last Son of Krypton. Like Loeb and Sale's much darker miniseries *Batman: The Long Halloween,*

published the year before, and the duo's later *Daredevil: Yellow*, *Spider-Man: Blue*, and *Hulk: Gray*, *Superman For All Seasons* looks at the early days of an iconic superhero without retelling his origin. Colorist Bjarne Hansen's understated tones help immensely in giving this coming-of-age story a wistful, nostalgic quality, offering readers the best loved Superman of all: the one they remember from their dreams.

Loeb and Sale would also collaborate on NBC's *Heroes* (Loeb was a writer-producer; Sale's comic images appeared throughout the show's run), and on the miniseries *Catwoman: When in Rome* and *Captain America: White*. But *Superman For All Seasons* stands the test of time as their most enjoyable collaboration. It won Sale an Eisner Award (for Best Artist/Penciller/Inker), and helped inspire TV's *Smallville* (on which Loeb served as supervising and consulting producer), particularly in its portrait of Clark Kent and Lana Lang's relationship. "Maybe standing in that field that night," recalls Lana of the last time she saw Clark before leaving Smallville, "telling me how, with all his special powers, he would help as many people as he could—maybe it wasn't such a good idea or, at least, not nearly as easy as that boy who could fly thought."

"If you're Superman," says Sale, "you can do a lot more, obviously, than most people. But you're still going to be constrained by what you can do and can't do. [*Superman For All Seasons*] is about what you can't do."

Daily Planet Exclusive

Tim Sale

Few mainstream contemporary comic book artists have a style as idiosyncratic as that of Tim Sale. But from his work on *Batman: The Long Halloween* to his Marvel books *Daredevil: Yellow, Spider-Man: Blue, Hulk: Gray,* and *Captain America: White,* Sale has won scores of fans and critical acclaim for his distinct vision. His *Superman For All Seasons,* written by frequent collaborator Jeph Loeb, is arguably his finest work.

After your work on the *Batman* Halloween specials and *The Long Halloween*, were you starting to get a little sick of the character? Is that what inspired *Superman For All Seasons*?

Well, "sick of" is too strong, but yeah. What I remember is that Jeph had always been interested in doing a Superman with me. Because he loved Superman. But also because he saw the business sense in it. In my opinion, there are only three real icons in comics, and Batman and Superman are two of them; Spider-Man being the other one. We've now done all three, but having done a lot of Batman there was a sense of "Why not do the other one?" I just didn't see it. I couldn't feel it. In my memory, it was very quickly that I suddenly did, and I don't know what prompted it. But I know that my [way] was influenced by two things. One was Norman Rockwell, and an idea of describing America and goodness via an image of it. So Americana, not America. And goodness as an ideal, something to aspire to. Not reality necessarily.

So that was one thing. The other thing was…There was a DC Christmas Special that was an anthology [*Christmas with the Super-Heroes Special* #2]. Paul Chadwick wrote and drew the Superman story ["Ex-Machina"]. And this is one of the things that will happen with Jeph and me—we both remembered it, and we'd never spoken of it prior. It's relatively obscure. It's not like it was a big hit or anything. It's about an old man in a car in the middle of winter. His life is in the crapper for some reason. I can't remember why—I think he's lost his job. It may be the kind of thing that if he dies, his wife is maybe gonna get some insurance money. He's sort of doing it for her. But he's also very sad and self-pitying. And Superman shows up. What he does is, he gets in the car with him, and talks to him, and talks

about doing the right thing, and talks him out of killing himself. Then he becomes Superman. He uses his heat vision to heat up the entire engine block, which was frozen, digs him out of the snow, things like that. But it was about the goodness and humanity of who Superman is. I loved it. I haven't looked at it in at least a decade. I know that Paul didn't ink it himself, and it's fairly crudely drawn. But it was a great take on the character. For both Jeph and I, it was a big influence on *Superman For All Seasons*; as a way of looking at the character, and who he was and wasn't. Ways that he was special that were not just bouncing bullets off his chest and changing the course of mighty rivers. So all of a sudden—at least my memory of it was that—it made sense to me…It was one of those things that just solidified in our brains.

How did you develop the look of the story?
The actual process of doing Superman was an entirely different thing. How I was gonna draw it and how we were gonna write it were in flux, and we knew we wanted it to be really different. There was no point to doing it like Batman. The whole idea was that is was an entirely different character, and that should be reflected in both our work.

There was a lot of back and forth about the way I was gonna draw Superman. My idea was that I wanted it reflected in the physicality of Superman that he wouldn't have to go to a gym and work out. He's an alien, so he was this kind of giant. The intent was that he looked like he was a corn-fed country boy. But if you don't do that just right, he looks kind of…slow, you might say. DC freaked. I think they expected *Long Halloween Part 2*. It certainly wasn't that. And when you've got their flagship character maybe looking like a doofus—"What the hell is going on? This isn't what we're paying for." It took a while to calm everybody down and prove to them that we had an idea that made sense.

To give them their credit, I didn't have it quite right at first, and they had a point. He did look like kind of like a doofus sometimes. Also to give them credit, they did ultimately allow us to do, and me to do, our vision of what we wanted it to be. But there were some growing pains along the way. All of which, when I won the Eisner for Best Artist of the year, was forgiven. That was a nice point of validation for me. [Laughs.]

89 Superman: Peace on Earth

While Superman is best known for protecting mankind from a variety of *external* threats—be they alien invasions or earthquakes—the Man of Steel, in his original 1938 incarnation, was a crusader who fought social problems—from spousal abuse to war profiteers—each of them reflective of a far greater *internal* evil. Fully painted by Alex Ross (who'd illustrated *Kingdom Come*) and written by Paul Dini (who'd produced *Superman: The Animated Series*), *Superman: Peace on Earth* carried forth that tradition to today's world.

Originally published in November 1998 (in the tabloid-sized format of DC's *Limited Collectors' Edition* series from the 1970s), the 64-page *Peace on Earth* finds Superman confronting one of humanity's greatest plights—world hunger. Determined to do all he can to feed the starving, the Man of Steel travels to the American Southwest, South America, Asia, Europe, and Africa with supplies of food. But his mission is thwarted by the cause of the problem: a poverty "within selfish men's souls," personified here by despots and governments who refuse his help and their people his gifts. He soon realizes that the solution to hunger "must be one that comes from the compassionate heart of man and extends outward toward his fellow man." Determined to lead by example, the story ends with Clark Kent teaching a handful of schoolchildren how to sow seeds, as his adoptive father once taught him.

Superman: Peace on Earth was the first in a series of fully painted graphic novels by Dini and Ross, each of them pairing a DC hero with a different concern: *Batman: War on Crime* (urban poverty), *Shazam!: Power of Hope* (disabled children), and *Wonder Woman: Spirit of Truth* (women's rights). The series culminated with *JLA: Liberty and Justice*, featuring the entire Justice League

of America. (All of the titles were collected in 2005's *The World's Greatest Super-Heroes*.) *Peace on Earth*, however, may be the best of the bunch, aided in no small measure by Ross' photorealistic figures and diverse assortment of landscapes, and by the bittersweet truth at its heart. Originally released at Christmastime, it's a perfect yuletide tale of the Man of Steel.

Superman: Birthright

Superman's origin story has been told and retold so many times that it's often difficult to distinguish one version from another. Not so with writer Mark Waid and penciller Leinil Francis Yu's *Superman: Birthright*.

This 12-issue limited series, published monthly from September 2003 through September 2004, focuses on a young Clark Kent as he tries to find his place in the world by reconciling the human and superhuman sides of his nature. While wandering the planet as a journalist, he comes to appreciate the importance that humanity gives tribal symbols, and clads himself in the colors and flag of his birth planet, assuming the mantle of Earth's champion. Here, Superman's crest is established as representative of not only the El family—as it was in *Superman: The Movie*—but the symbol for hope on Krypton.

Clark then gets a job at the *Daily Planet*, and becomes a mild-mannered reporter. In DC Comics' prior official Superman continuity—established after the company's *Crisis on Infinite Earths* reboot by writer-artist John Byrne in the 1986 miniseries *Man of Steel*—Clark was a far more confident and no-nonsense individual. He was thus less distinguishable from Superman.

But the most significant difference from what had come before is found in *Birthright*'s Lex Luthor. He and Clark are revealed to have

been boyhood friends, as they had been in pre-*Crisis* comics (and on TV's *Smallville*). Like Clark, Luthor is established as an outsider, due to his scientific brilliance and troubled home life. The damaged youth's hubris, however, drives them apart (and, via a lab accident, causes Luthor's hair to fall out as it had in his original origin story). As an adult, Luthor retains the evil businessman persona he'd had post-*Crisis*, but becomes an even more brilliant and chilling sociopath. He introduces Superman not only to kryptonite, but to his Kryptonian heritage as well. Luthor then uses his knowledge of that heritage, and its advanced technology, to turn Metropolis against its protector—by convincing people that Superman is part of a Kryptonian invasion force that Luthor himself has actually staged.

Waid employs the rat-a-tat dialogue of 21ˢᵗ-century superhero comics to great effect, particularly in regards to Lois Lane (who always did talk faster than everyone else). His words and story couple with Leinil Francis Yu's idiosyncratic images, which render Superman once more a "strange visitor from another planet," to offer readers a markedly different lens through which to view the Man of Steel's world. Most impressive is how *Superman: Birthright* honors the work of other creators without feeling derivative, present-ing Superman once more as a tireless defender of the downtrodden. Though its continuity was later ignored by DC—which rebooted the character yet again in *Superman: Secret Origin*—*Superman: Birthright* is this millennium's definitive version of the Last Son of Krypton's early years.

"Often Superman is perceived as a little dull or a little boring by readers," says Waid, "because there's this sense that nothing can hurt him...Nothing could be further from the truth. Emotionally, we can cripple him. Even the strongest man in the world has tragedy that he can't overcome—the death of his parents, the death of his world, the loss of a great friendship. I think those are important parts of the Superman myth."

Daily Planet Exclusive

Mark Waid

Writer Mark Waid's superhero stories stand out not only for the quality of their writing, but the unapologetic emotional core of their derring-do. But as much heart as Waid's tales contain, they never drift into sentimentality. Instead, his runs on *Flash*, *Fantastic Four*, and *Daredevil* exhibit a momentum that puts them at the forefront of the genre. The 1996 limited series *Kingdom Come* and *Superman: Birthright*, his 2003 retelling of the Man of Steel's origin, are equally propulsive.

You've said that *Superman: The Movie* influenced *Birthright*. But you brought in a number of new elements that spoke to 21st century audiences, chief among them the idea that Superman is a global savior and not just an American hero.
Right. I felt like it wasn't my job just to replicate the movie when I was given a chance to sort of drag Superman into the 21st century. The mandate from publishing was, "Without losing the things that make Superman Superman, make it contemporary." A big part of it was taking this idea that had sort of been seized a little bit by John Byrne when he'd relaunched Superman in 1986—this idea that Superman traveled the world as a young Clark Kent before he became Superman, learning other cultures. That's kind of where the first act of *Birthright* springs from, the idea that there's so many other ways of viewing the world other than through just the truth-justice-and-the-American-way lens. It was a matter of doing a lot of research and talking to a lot of people from different cultures.

What other new elements did you want to include in your version of the story?
I asked myself all the questions that you would ask about the character if you were creating him today. One of the big ones was, "Why does he wear a costume?" My answer for that in *Birthright* comes from the idea that it is tribal wear in a sense. When he gets a glimpse of Krypton, when he gets a glimpse of his past through the artifacts that are sent with him on the rocket ship, he sees the look of the Kryptonians and he sees the "S" symbol as what he interprets to be the flag of Krypton. It's the family crest, but also a big part of the

Mark Waid

flag of Krypton. So the fact that the costume becomes a link to his past, a nod to his heritage, was something I wanted to bring up.

But the other question became, "Why doesn't he wear a mask, like Batman, like the other superheroes?" The answer is "Because masks make people afraid." They make people suspicious, they make you feel like you've got something to hide. With Superman, he wanted the opposite effect. He already had powers. He was working hard to make sure people were not afraid of him, even though he had powers and abilities far beyond those of mortal men. So his take from that was to show his face, to be as open and as bright and as welcoming as he possibly can. If you've got a guy without a mask who's wearing a big red-and-blue suit flying around the city skies, it's pretty open, y'know?

Your artist on the book, Leinil Francis Yu, was a bold choice. No one could have been further from the traditional Curt Swan model of a Superman penciller.
Right, and that's what we went for. We had several artists to choose from. But I really wanted somebody who could give you a Superman that you'd never seen before, and a Superman you couldn't imagine. There were several people who were up for the job, who were very, very good, and great collaborators, but we'd seen them draw Superman before. Leinil Yu was a perfect choice. There's such energy and grace to his work.

How did you and Alex Ross collaborate on *Kingdom Come*?
Alex came to the table with a bunch of sketches, a rough outline of what he wanted. They were brilliant sketches. He had moments in mind. He had ideas for scenes. So he sat down with me and we started to build a plot from scratch out of his basic ideas. We worked very closely on it. I don't think Alex gets enough credit as a co-plotter on this thing…But as far as Superman goes, Alex's vision of Superman was not exactly the main character. There was no real main character in Alex's original vision of it, I don't think. It didn't really have a focus. But long after the fact, when I said, "Why is it that the story turned out to be essentially a Superman story?"—DC's publisher Paul Levitz pointed out that Superman is such a strong character and a primal character that it's really hard to do a story with Superman in it that doesn't basically become a Superman story. He was absolutely right.

The idea that Superman had retired and gone back to create a farm, like a hologram farm in the Fortress, or a fake farm, that was Alex's. But the struggle that I had as a Superman fan was trying to come up with an answer to why he would quit. See, in my mind, Superman would never retire. It's a never-ending battle, right? That's the phrase. So why would he give up? The only answer I could come up with was this idea that the city of Metropolis and the world said, "We don't believe in your values anymore when it comes to life and the preservation of life." Then Superman very much would feel like withdrawing from the world. It was the only answer I could come up with, [and] it seemed to work. But it was a very collaborative project.

Your work is unafraid to explore a non-cynical view of superheroes, which often goes against the grain of the genre in the 21st century. There's a tendency to make things dark and gritty, perhaps as a way of justifying one's love of material traditionally viewed as the domain of children. Your work suggests we should just like what we like. Right! That's absolute crap. It's true, but it's a horrible attitude to have. A lot of the darkness that permeates superhero comics, that permeates superheroes in all media, is a fear that other people who aren't into comics will think it's silly and childish and so forth. But in fact it's the sense of wonder and amazement that is what makes superhero comics superhero comics. You need to embrace that stuff. It doesn't mean comics need to be written for seven-year-olds. But if you look at the success, for instance, of the Marvel movies—*Iron Man, Captain America, The Avengers*…Clearly that has the same tone. There's moments of realism in there, there's moments of genuine drama. But on the whole they're optimistic movies. They're hopeful movies. They say something positive about the human condition. I think that's our job as storytellers with superheroes, because that's what they were *created* to do. They were created to idolize. They were created to show a path. They were created to be moral beacons. To drag them down to our level rather than elevate ourselves to their level is a disservice.

Believe me, I understand the notion that you want your superhero comics to be more realistic, and more grounded in reality. Because I was 15 years old, too. And I wanted my teachers and my parents and all the people around me to take comics more seriously. Because I took comics seriously. So I think that the 16-year-old in me would have probably enjoyed [2013's] *Man of Steel* [movie]. But as a

grownup I look at the cynicism and darkness of that—and there's a real cynicism—and just think, *Man, that is off base a thousand percent.*

Of course people like Superman for a variety of reasons. Is that part of why he's survived?
There's a number of reasons…If you ask any random dozen people on the street to tell you something about Superman, what would the vast majority of them say? What would you say? What's the first thing that comes to mind?

He can fly.
That's exactly it. He can fly. They built the entire marketing campaign for *Superman: The Movie* around that. "You'll believe a man can fly." It's one of mankind's primal dreams. The freedom of being able to soar effortlessly through the air. I honestly think that's a huge part of why casual non-fans think Superman is cool. Because he can fly. And they do think he's cool. I challenge you to go to any urban environment, any mall, any shopping center in the world, and see how long you can stand on a corner before somebody with a Superman T-shirt or a Superman baseball cap walks by. It doesn't take long. I'll make a game of it to see how many days in a row I can go out in public before somebody's not wearing a Superman T-shirt. It generally takes a while.

That's part of it. I also think on a more subconscious level, one of the keys to Superman's success, the way he connects with people, is Clark Kent. Because nobody knows what it's like to lift a car, nobody knows what it's like to have heat vision. But everybody knows what it's like to feel that feeling that Clark Kent is modeled on. The feeling that, "If they only knew me for who I was, they wouldn't make fun of me." Or, "If they really knew who I was deep down inside, then they would admire me." I don't know any adolescent kid in the world who hasn't gone through that phase, of feeling like "If they could see the *real* me, they would understand."

What do you love most about Superman?
What I love about Superman is…Here is a guy who can take anything, who can do anything, who can claim anything. Who could be a king or a ruler or a despot, and no one could stop him. And instead he chooses to use his powers selflessly to help other people. That to me is his greatest superpower: his selflessness.

91 Justice League and Justice League Unlimited

Superman has been a card-carrying member of the Justice League of America since DC's premier superteam debuted in March 1960's *Brave and the Bold* #28 ("Justice League of America," by writer Gardner Fox and penciller Mike Sekowsky). Although the League has enjoyed countless adventures in comics and on TV (where it reached its widest audience during the 13-year run of Hanna-Barbera's *Super Friends*), its most acclaimed run of stories is arguably in Warner Bros.' *Justice League*. Not only is it the best animated series to feature the titular team, but one of the finest TV series to feature the Man of Steel.

Broadcast on the Cartoon Network from 2001 to 2006, the show actually has two titles: *Justice League* (two seasons of which ran from 2001 to 2004) and *Justice League Unlimited* (three seasons ran from 2004 to 2006). Like *Superman: The Animated Series*, *Batman: The Animated Series*, and *Batman Beyond* (with which it comprises the DC Animated Universe), *Justice League* was created by Bruce Timm and Paul Dini. Timm would serve as producer for all five of its seasons, alongside James Tucker, Rich Fogel, Glen Murakami, and the late Dwayne McDuffie.

While Batman's voice is provided by Kevin Conroy, who'd played the Dark Knight in *Batman: The Animated Series*, a new voice for Superman was found in actor George Newbern when *Superman: The Animated Series* star Tim Daly was unavailable due to signing on for the 2000 reboot of TV's *The Fugitive*. Dana Delany and Clancy Brown returned to their roles as Lois Lane and Lex Luthor; Superman's archnemesis led the League's enemies, the Injustice Gang and the Secret Society.

Though Superman features prominently in most episodes, the Man of Steel gets the spotlight in such standout episodes as the Season 2 opener "Twilight," which sees the return of Brainiac and Darkseid; "Hereafter," in which Superman is paired with immortal villain Vandal Savage when he's stranded without his powers 30,000 years in the future; "For the Man Who Has Everything," based on the acclaimed tale in 1985's *Superman Annual* #11 (by writer Alan Moore and artist Dave Gibbons); "The Doomsday Sanction," which finds Superman battling Doomsday; "Clash," featuring an epic fight with Captain Marvel orchestrated by Lex Luthor; and the two-part series finale "Alive!" and "Destroyer," in which Superman unites with Luthor to battle Darkseid one last time.

"Overall, in as much as I love all of my series," says Timm, "from *Batman: The Animated Series* to *Green Lantern*, *Justice League* and especially *Justice League Unlimited* were probably my favorite shows to work on, just from a creative standpoint and how consistently good the shows came out. Dollar for dollar, I think *Justice League Unlimited* is probably our most consistent show, in terms of the ratio of good episodes to bad episodes. It was a total blast, from the very beginning."

Daily Planet Exclusive

Bruce Timm

From *Batman: The Animated Series* to *Justice League* (later *Justice League Unlimited*), animation legend Bruce Timm's DC Animated Universe has brought a sprawling, all-too-often-unwieldy mythos to wonderfully coherent life in what many fans feel is the best realized version of the world's greatest superheroes. Timm's *Superman: The Animated Series* may be the most underrated of his many achievements.

***Justice League* evolved from a series of self-contained stories to the ambitious serialized adventures of *Justice League Unlimited*.**
When we were doing the second season of *Justice League*, I discovered the works of Joss Whedon on DVD. [Laughs.] I actually had managed to pretty much miss all of *Buffy* and *Angel* when they were first run, but I started watching them on DVD. One of the things I really, really enjoyed about those shows was the long-form narrative epic qualities of the serialized storytelling. That was something that I wanted to play with in *Justice League*. So yeah, that was kind of where that came from.

With *Justice League Unlimited*, we saw what was probably Lex Luthor's most significant return to his larger-than-life, supervillainous roots since he'd gotten his businessman makeover in the '80s.
Oh yeah. That was kind of the fun thing about Luthor. With *Superman: The Animated Series*, we started with him being the evil corporate tycoon guy. Then by the time we did the beginning of *Justice League* we kind of went back and made him more like the costumed supervillain from the 1960s and stuff. Then we kind of went back the other way and rehabilitated him, to the point where he was kind of the corporate tycoon again. Then he was even running for president. Then we made him a supervillain again. [Laughs.] So he was kind of in this weird cycle.

One of the great female characters you introduced in *Superman: The Animated Series* was Livewire. How did she come about?
God, you know, I don't really recall the absolute genesis of that. I don't even remember whose idea it was at first. My vague memory is that it

was probably [producer] Alan Burnett's idea. For a while there was a VJ on MTV, back when MTV still ran music videos, named Kennedy, who was kind of like this brash hipster girl. I think the idea was to mash up Kennedy with Howard Stern, because Howard Stern was huge at the time we were doing *Superman*. It was a combination of shock jock and Kennedy; and turning that person into a supervillain. I think that was the initial idea for it. But I could be mistaken.

You're also responsible for probably the most distinct redesign of Supergirl to date. What went into her new look?
We wanted to do something a little bit different. One of the blessings and curses of Supergirl is that she's literally the gender-swapped version of Superman. She always has been. She's always been like Superman's little sister, even though she's his cousin. In the comics, she basically wore a Superman costume, but with a skirt instead of shorts, and bare legs. But the color scheme and everything was straight-up exactly like his. So we just wanted to do something a little bit different. We wanted to give her a little bit more of an individual look. We knew we still needed to have the red cape and the trademark "S" shield. But with everything else we said, "What else can we do?" So me and Glen Murakami and Shane Glines were just throwing out a bunch of ideas and sketching, and that was kind of the look we came up with. The kind of power T and the short skirt and the Doc Marten boots—it was kind of a safer version of the whole riot grrrl look. I think the headband just came because we're all fans of Gwen Stacy. [Laughs.] A blonde girl with bangs and a headband? It's like, "Okay, yeah. That's a good look." That's really where that came from.

How satisfied were you with *Superman: The Animated Series* overall?
I love the show. It was a big challenge for us because we didn't want to just kind of do a lot of the exact same visual tropes that we had done with *Batman*. We knew we wanted to keep it roughly in the same universe. Even though we didn't really have any idea at the time of tying the two shows together yet. But at the same time we didn't want to make it as dark and as film noir and as retro as *Batman* had been. So there were a lot of design challenges to it. Also the fact that Superman is just a completely different kind of mythic archetype than Batman is. He's got all those superpowers so you have to have him

face villains who are pretty amped up as well. So there's obviously going to be a lot more spectacle and action sequences. It's not quite as street level as Batman. That was a challenge for us.

But it was a fun show. I met some really terrific new artists that hadn't worked on *BTAS*. Like James Tucker and Shane Glines—that was their first job with us—and later Darwyn Cooke, Dave Bullock, people like that. It was a blast. It was a real fun show to do. Then of course getting to tie in all the Fourth World stuff with Darkseid. Being a huge [Jack] Kirby fan, that was just icing on the cake to get to play with those toys.

Superman: The Animated Series is responsible for making Darkseid a more important member of Superman's personal rogues gallery than he had been before.
Superman had always been tangentially related to the Fourth World, even going back to the very first Fourth World comic, which is *Superman's Pal, Jimmy Olsen*. But yeah, in terms of making him a direct Superman villain, I guess we're the ones who really pushed that.

Moving from Superman: The Animated Series to Justice League, the voice of Superman changed from Tim Daly to George Newbern. What do think each actor brought to the role?
It's interesting. We knew that Tim wasn't going to be available for *Justice League*, because he was doing *The Fugitive* on CBS at the time. So his agent just told us, "Yeah, he's just not gonna be available to do the *Justice League* show." We didn't deliberately set out to cast a soundalike. We actually, weirdly enough, went the opposite direction and we kind of wanted to find somebody who didn't sound like Tim. Who actually sounded a little bit more like the Superman voice we kept hearing in our heads from when we were little kids, which was much more like the bassy Bud Collyer kind of voice. So that's what we were looking for. Weirdly enough, we actually found somebody who was dead on for what we were looking for. An actor named Gregory Harrison. James and I were high-fiving each other, saying, "Yeah, that's exactly what Superman should sound like!" Then, at the end of the audition, he goes, "Yeah, I'm actually going off to New York for three months. I'm doing a show on Broadway." It's like, "Oh crap! Why'd you even audition then?!" [Laughs.]

Then we had to audition a bunch of new guys, and that's when George Newbern came in. He really knocked us out. It was eerie how

much he sounded like Tim in terms of the tenor of his voice, but he also had a lot of the same qualities. You hear his voice and it's like, "Wow, this just sounds like a *really nice guy*. He sounds like somebody you can trust. He's gonna be your best friend." All that stuff. That same kind of really likable guy-next-door quality that Tim Daly had. So we ended up casting a Tim Daly soundalike without really meaning to. I mean, Tim and George are very, very similar in terms of their acting styles. They can be kind of lighthearted and fun. Then they can also really go to the dark side when you need them to.

So it's kind of hard to contrast and compare them, because in my head…It always used to crack me up when I would read on the message boards people bashing on George all the time because he wasn't Tim Daly. They would say, "Oh, he sucks. Bring back Tim Daly. Tim's the only Superman." God, to my ear, they sounded so alike it was uncanny.

What are your favorite episodes of *Superman* and *Justice League*?
Oh god, there's so many. *Justice League* especially. Every now and then I'll pop a *Justice League* DVD in my player and just think, *Oh, I'll just watch one or two episodes*. Then I'll start getting hooked on the serialized nature of it, and before I know it, hours have gone by and I've watched six or seven episodes in a row. So it's tough. There's a lot of individual episodes that I think are really cool. Working with [producers] James Tucker and with Dwayne McDuffie, and with [writers] Matt Wayne and Stan Berkowitz, and the directors, we were on fire. We were having so much fun just throwing out crazy ideas and going big and using all these really obscure characters. It was fun to be able to use characters like the Question and the Vigilante and the Huntress. It was a total blast from the very beginning. That was just a lot of fun to work on. I think it's just a very satisfying group of episodes when you sit down and watch them again.

And your favorite *Superman* episodes?
There's a bunch. I really like the first three-parter. I really liked doing it. Even though it's like, "Yeah, yeah, yeah. Superman's origin story." But I had a lot of fun doing that, and I especially loved the middle segment, which was his Smallville stuff. I don't know. For some reason that just really resonated with me. But there were too many episodes to name just one.

Daily Planet Exclusive

George Newbern

As the voice of Superman in the animated *Justice League* and *Justice League Unlimited*, actor George Newbern has portrayed the Man of Steel in the most successful screen version of the character's adventures with DC's premier superteam.

What were the circumstances that led to your being cast as Superman in *Justice League*?
I knew the casting director, but it was an audition. You go on a million auditions. Tim Daly was not available. So they were opening it up to other folks, and I just happened to get it that day. I had a good Thursday.

In the first few [episodes] they pitched my voice down a little bit, because for whatever reason it wasn't in concert with all of the other voices. They wanted it to be a little lower. As you get older, your voice does tend to get into a lower register. This was nine years ago or so. So they pitched it down the first year, and then afterward I sort of fell in place. That was cool.

I've done a lot of animation voice acting. But the character of Superman is iconic. I wanted to honor that and make sure that he was tough enough and grounded enough. They kind of wanted him to be as much of a normal guy as possible, as opposed to a cartoony kind of person.

Were you a comics fan when you were a kid?
I was. I wasn't as much into Superman per se as I was comic books. I was really into the Archies and *Richie Rich* and *Cracked*, and there were some horror things that I thought were super neat. There was a period of years I was just way into comic books. I used to love the *Super Friends* cartoon in the '70s. Then of course I remember the original Superman TV show [*Adventures of Superman*], the black-and-white version way back when. But *Super Friends* was my first real exposure to Superman.

Then the movie *Superman*, that just blew me away. When I came to Los Angeles, the second film that I got [1988's *Switching Channels*] was

with Christopher Reeve and Burt Reynolds and Kathleen Turner. I spent months with Chris Reeve. I got to hang out with him and I talked to him about Superman. It was kind of amazing. The fact that I would end up doing Superman…Some things were meant to be it seems.

What did he share with you about playing the role?
He was such a big movie star from *Superman*. He had tried to do other things. I said, "Gosh, is that weird that everybody knows you so much from *Superman*? Does that make you angry? Are you frustrated?" He said he'd come to make peace with it. Because, he said, "At the end of the day most actors are never known for anything. At least I know that I'm known for one thing." At that time he was looking at it as a gift as opposed to something that was hung around his neck.

Did his take on the character inform your own?
I think maybe subconsciously I was thinking of Christopher Reeve. I think Chris Reeve had such a lovely kind of offhanded way about Superman, you know? He wasn't corny. He was not afraid to embrace the purity of Superman. In a world where there's not a lot of black and white, Superman embodies right and wrong. There's not a lot of gray area with him. It's kind of neat to get to play a character like him. I think Chris Reeve's take on it probably influenced me more than anything.

It must be a tremendous challenge to take a character without a gray area and make him relatable.
Yeah. In my career, I've gotten more work as a nice guy or as a dad or a friend. Generally, they're harder to play in many respects because to make them interesting they need to have some sort of flaw—like kryptonite, if I were to use another Superman term. Those are really hard characters to play. With Superman, instead of being a corny, preachy guy, it's good to find the humor that he inherently has without losing his point of view. You need that point of view in a world of Super Friends. [Laughs.]

What were your favorite stories in which you voiced the character?
The *Injustice: Gods Among Us* video game. I love that one, and I love the one with Superman and his evil twin, the dark part of him ("A

Better World"). That was pretty fantastic. Bruce Timm's animation is amazing.

How often were you able to record with the rest of the *Justice League* cast throughout the series?
I would say 90 percent of the time we were all together, which was super cool. It was like going to rehearsal for a play and looking at each other while you're doing it, as opposed to doing it in a vacuum, which is often times how it's done. It's great to have an ensemble energy with everybody together.

Maria Canals [Hawkgirl] certainly has a fiery temper, in a fun way. She would crack us up. Then Kevin [Conroy] would constantly berate [voice director] Andrea Romano from the booth. He would use his Batman voice—"Andrea, I'm watching you." He was funny. We were just at the New York Comic Con, and it was really fantastic to be together again. It was like Old Home Week. It was great.

We also had a lot of amazing guests who would come through. It was unbelievable who they would get through there. Nathan Fillion came through and Mark Hamill and John Rhys-Davies. So many great character actors came through there.

I had no idea. When I got that job I literally thought I was gonna do maybe 10 episodes. Then it turned into a 10-year thing between the DVDs and the movies and the games and the series. It was the longest job I've ever had. It was such a blast.

What's it like to get direct feedback from fans at conventions? Superman is obviously revered.
I gotta say it is absolutely a gift. Because as an actor, throughout your whole career you do things in a vacuum. Most of the stuff you do, especially in animation, people don't know that it's you, but they have a connection with the characters. Everyone knows Superman. But my voice doing Superman during that period of time…People would come up to me and say, "Oh my god, I would come home every day from school and I watched *Justice League* and you were such a big part of my childhood." I was like, "Wow." I forget that. I'd go to work, do the voice, come home, and say, "Yeah, it was fun today." Then they go do the animation and it gets scaled up in such an amazing way and it lives on for years and years and years. Those conventions are

really a neat way to connect with fans. They love seeing you and I love seeing them. When they see somebody from an iconic show it seems to be overwhelming to people, when they come up and they're like, "Do the voice!" Because it lives in their imagination, and your imagination is much more intense than what you actually see.

Who's your favorite villain?
There have been so many great ones. I gotta go old school—Lex Luthor. He's reliable.

For many, Clancy Brown voices the definitive screen Lex.
No question. I love Clancy. We went to the same university. He's a great guy. That guy has got the most amazing voice. Holy crap. In real life, he has a huge head, he has a huge cranium. His voice is so resonant because his head is huge. It's like, "Whoa!" He doesn't need to do anything. It's a big echo chamber in there. [Laughs.]

92 *Superman: Secret Identity*

Superman isn't just a superhero, he's an ideal. As such, many of the best Superman stories don't feature the Man of Steel at all, but instead focus on those who've been influenced by him. One such story is *Superman: Secret Identity*.

Written by Kurt Busiek and illustrated by Stuart Immonen (both of whom had previously scripted and pencilled Superman stories), *Secret Identity* is a four-issue miniseries, originally published in January through April of 2004. Taking the same personal, matter-of-fact view of superheroics as Busiek's wildly acclaimed *Astro City*, the story is told from the perspective of a man named Clark Kent. Born in a small town in Kansas—to parents who couldn't resist naming him after the famous fictional character—Clark is

amazed to discover one night that he really does have powers like Superman's. But as the first of his kind, he soon realizes his life will be better off if he keeps those powers a secret. Clark moves to New York City, gets a job as a writer, and begins dating a young Indian American woman named Lois, all the while using his powers to help people around the world. But despite his best efforts to remain undetected, he's continually hounded by the government. When Lois becomes pregnant with twins, he proposes an agreement— he'll help out those who've been chasing him if they'll leave him and his family alone.

Each of *Secret Identity*'s four chapters focuses on a different period of Clark's life: adolescence ("Smallville"), adulthood ("Metropolis"), parenthood ("Fortress"), and middle to old age ("Tomorrow"). Busiek, in his introduction to the series' 2004 collected edition, explains how the story was sparked by November 1985's *DC Comics Presents* #87 ("The Origin of Superboy-Prime!" by writer Elliot S. Maggin and penciller Curt Swan). That story focused on a young Clark Kent from Earth-Prime, a world in which there were no super-heroes—until he found he had those of Superman. Busiek's intent was to take the story further, and see if Superman could be used as a metaphor for the stages of life beyond adolescence.

To that end, he succeeds admirably, aided in no small part by some of the best art Immonen's ever produced. And somewhere along the way, this story that isn't at all about Superman becomes very much his story, allowing us a glimpse of what it would be like if he settled down, had children, and grew old, approaching each real-world challenge as heroically as he would any asteroid hurtling toward the Earth. Busiek would go on to chronicle Superman's adventures in the character's monthly comic and in 52 issues of the weekly *Trinity* (co-starring Batman and Wonder Woman). But *Secret Identity* remains his masterpiece within the world of the Man of Steel.

Daily Planet Exclusive

Kurt Busiek

Writer Kurt Busiek has thrilled comic fans for decades by offering both the humanity and wonder of superheroes in equal measure. His fan-favorite titles include *Marvels*, *Avengers*, and *Untold Tales of Spider-Man*, as well as his own world original world of characters in the acclaimed *Astro City*. His masterwork in the Man of Steel's universe is the 2004 limited series *Superman: Secret Identity*.

Did *Superman: Secret Identity* land fully formed in your mind? It has the feel of a great fever dream.
Not really, no. When I started thinking about it, I just wanted to do something with a character like the just-pre-*Crisis* Superboy-Prime, but I couldn't figure out a way to make it work, to make it something DC would willingly publish. Then when the idea that pulled it together came, it was a big, series-encompassing idea—to do the life story of a character like that, focusing on the stages he'd go through as a kid, a young adult, a married man, and so on, and how the whole idea of him having this big secret "inner self" would be shaped by those stages. Sort of like Gail Sheehy's *Passages*, but with a cape.

Once I had that idea, I had the central spine of it all. I had to figure out the various details, but I knew the big idea, and any of the plotting and character stuff had to serve that big idea. So it pulled together nicely.

Have you found it to be one of the most personal stories you've told in mainstream comics? Although it focuses on someone with a great deal in common with the Man of Steel, and presents a sweeping life story, it's emotionally intimate.
It was personal to him! To me, well, it wasn't my life, but it was fueled by things I thought about at those stages, about who I wanted to be, about falling in love and the vulnerabilities and strengths it brings, about changes in perspective as a father...

So it was designed to be intimate and fueled by [those kinds] of ideas, but I was trying to get at what would be in Clark's head, not merely what had been in mine.

What was your collaboration with Stuart Immonen like? Did you provide him with much description of, or any references for, the design of the characters, or did you prefer to let him handle those visuals?

I don't think I gave him much visual description of the characters, and if I did, he was free to ignore it. I mean, beyond "looks like Superman," of course. I do think I specified that Clark's father had a beard, and that Clark should have a beard when we see him as an older man. But if he'd had a different way to go, I'd have been fine with it.

I did write Lois in as Japanese, and he changed her to Indian because he thought making her Japanese would come off as a cliché. It was a great choice, and I keep getting praised for it by readers, and have to say, "No, no, that was Stuart."

But Stuart's a smart guy and a brilliant storyteller, so he took the scripts and did what he felt was best with them, and it worked out beautifully. We talked through the story a lot, before I wrote it, and even while I was writing it I'd call him up and bounce ideas off him when I was stuck. He was very patient with my ramblings. And then he'd draw it, and it was just glorious—I'd see the art and it often wouldn't be anything like what I'd imagined in my head as I was writing, but the story was there, the emotional beats, everything it needed. And he did it so well that I'd let it sit for a few days to get used to the way he'd paced it, then rewrite the captions and dialogue to take advantage of what he'd put on the page. There were a lot of times what I'd written wasn't necessary anymore, because the emotion came through so clearly. So I'd cut captions or trim dialogue or rewrite stuff to be more indirect and playful.

Mainly, I tried to make sure the script didn't look inept when paired with that wonderful art and visual acting.

What was your initial reaction to the final book?

Oh, I was absolutely thrilled. I think it's one of the best things I've ever written, and I think a lot of that came about because Stuart elevated the storytelling, so I had to up my game to keep up. I love the way he combined the pencil art and mostly-flat color, too; it's got a beautifully sophisticated look.

And now that it's finally out in hardcover (or about to be), I'm happy about that, too. We wanted a hardcover for it back when it first came out, and now we've finally gotten one.

Do you find that Superman—or *Astro City*'s Samaritan—often works best as an inspirational figure, rather than someone heavily involved in human affairs? Or do you believe a balance should be struck between the two? If so, where does that balance lie?

I'm not sure there needs to be a balance so much as variety. You can tell stories that feature Superman as an inspirational figure, and they can be great. And you can also tell stories where Superman's emotions and human struggle are at the heart of the piece, and those can be great, too. So I'd say follow whatever good ideas you have for the character and see where they take you, rather than trying to find one particular point of balance. Superman's an incredibly versatile character, and has been in powerful stories where he's a symbol, powerful stories where he comes of as a metaphor for very human struggles, great comedic stories, great action stories, great SF stories, and more.

I'd rather celebrate all kinds of things you can do with Superman stories than try to figure out the "sweet spot." A character like Superman has lots of different sweet spots, so let's have fun with all of them.

93 *All-Star Superman*

The most consistently entertaining run of Superman comic book stories since those of the Silver Age can be found in writer Grant Morrison and artist Frank Quitely's 12-issue comic book series *All-Star Superman* (the first issue of which bowed in January 2007). Already praised for their Vertigo miniseries *Flex Mentallo* and *We3*, their graphic novel *JLA: Earth 2*, and their work on Marvel's *New X-Men*, the Scottish collaborators reached new creative heights with their interpretation of the Man of Steel.

Rather than reboot the character and his mythology, *All-Star Superman* uses various elements from the Man of Steel's legacy to depict a version of the character that exists outside of

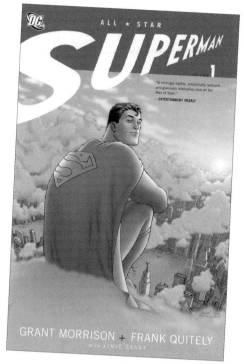

Grant Morrison and Frank Quitely's All-Star Superman *was a wholly original story about the Man of Steel that also managed to feel familiar to longtime fans.*

any previous continuity (and is thus accessible to new readers) while offering longtime fans a take unlike any they've seen before. Morrison and Quitely begin their saga with the most efficient retelling of Superman's origin ever, depicting, in just four panels, a "Doomed Planet," "Desperate Scientists," "Last Hope," and "Kindly Couple." From there, they flash forward to Superman rescuing the first manned sun mission, imperiled by Lex Luthor, who seeks to kill his nemesis via an overabundance of solar radiation. Stronger than ever, but facing "adoptosis," or "cell death," the Man of Steel at long last tells a disbelieving Lois Lane his secret identity, and gives her a birthday present: his superpowers "in liquid form." After living in his world for a day as Superwoman, her powers fade, and Superman goes on to have numerous other adventures, battling Bizarro and Kryptonian invaders, and meeting his own descendants. Luthor consumes a

solution like Superman gave Lois, and he too gains superpowers. Superman dies, but after meeting his father Jor-El in the afterlife, he returns to life to prevent Luthor from destroying Metropolis. Before losing his powers, the supervillain, in tears, sees the world the way Superman does. After punching out Luthor, Superman, his body changing to pure energy, must leave Earth to prevent the sun from exploding. A year later, Lois tells Jimmy Olsen, "…I know he's up there, building an artificial heart to keep the sun alive. He'll be back when he's done, Jimmy. And when he's done…He knows where to find me."

Quitely (born Vincent Deighan) is, along with Darwyn Cooke, arguably the greatest illustrator of superhero stories in mainstream comics today. Like so much of his other work, *All-Star Superman* draws inspiration from artists as disparate as Geoff Darrow, Katsuhiro Otomo, and the French master Moebius. But Quitely's universe, grounded yet ephemeral, is uniquely his own. Morrison, a lifelong fan of Superman, writes stories structurally within the Silver Age tradition (even the titles, such as "The Superman/Jimmy Olsen War!" and "Curse of the Replacement Superman" recall the 1950s and '60s), while filling them with a vision of the Man of Tomorrow that's both more alien and more familiar than any we've seen. The cumulative effect is a comic book as alive with wonder and possibility, even in the face of death, as Superman himself.

"I always kind of related to Superman," says Morrison, "because he was so kind. I didn't really relate to the Marvel heroes because they were so angry and they were always fighting each other. Superman was a moral exemplar. Especially if you're a little kid—he truly is a moral exemplar, more so even than Jesus. Because Jesus doesn't fly around and punch things and fight dragons. That made Superman cooler."

Daily Planet Exclusive

Grant Morrison

In theory, the pairing of Superman and writer Grant Morrison might seem odd. One is the ultimate square-jawed American hero, the other a Scottish champion of the counterculture. But in practice, Morrison delivered one of the most beloved Superman story runs of all, on his 12-issue *All-Star Superman*. Working with artist collaborator Frank Quitely—with whom he paired on *Flex Mentallo, Earth 2, We3*, and *New X-Men*—Morrison used the character's time-honored mythology to build a new universe of wonder.

What inspired your take on Superman?
As I say in my book [*Supergods: What Masked Vigilantes, Miraculous Mutants, and a Sun God from Smallville Can Teach Us About Being Human*], Superman's a better idea than the Bomb. When I was a kid, the Bomb was the biggest thing in my life because my parents were activists. Of course they talked about it a bit, but it was clearly something that frightened them. When you're a kid, something that frightens your parents is *really* bad. So the Bomb was this horror to me. There were all these magazines lying around on the floor showing irradiated landscapes and babies with one eye. Horrible stuff. So it really freaked me out. Then I discovered Superman. Here was a guy who, if the Bomb went off in his face, it might give him a mild tan. [Laughs.]

Like I said in the book, it wasn't that I needed Superman to be real. I needed him to be *imaginatively* real. The Marvel superheroes… The Hulk, for example, was created from the atom bomb. Suddenly it became a creative thing. It allowed me to conceptualize that fear in a different way.

As I got older I began to see that America had almost lost its grip on what Superman represented. So I felt that as an outsider I could bring back what it meant. I still see America as this weird thing where they keep trying to depower him and bring how down a level, as if that would make him relatable. And it makes him less relatable every time. I don't know why they keep going to that well.

It appears as though they're trying to replicate Batman's success in recent decades.
Yeah, of course. But Batman is Batman. It's not gonna work, to apply all those tropes to Superman and expect them to work with him. But they keep doing it, and I don't know why. I just wanted to say, "If you do it this way…Here's Superman at his ultimate power levels, but he's one of us. He suffers like we do." Of course it's not realistic!

Right, why would anyone want it to be?
Superman will *never* be anything but Superman. The idea that you would try and fix it when all you have to do is make it fantastical but make it human…Because Superman is just how we feel in our dreams. He is the emblem of our better selves. He is the emblem of our highest aspirations. He's everything we want to be in situations where we feel threatened and vulnerable. So I was writing him, particularly with *All-Star*…It was intended to be quite domestic. He's got a dog, he's got a house, he's got a girlfriend, and he's got problems with all of it. Just because his house is an arctic fortress filled with these treasures from other planets doesn't mean it's not just his house. He has to take Krypto for a walk. He takes him for a walk around the rings of Saturn, but he's still taking his dog for a walk. He still has problems with his girlfriend.

He still has human emotions.
And they are written on this large-scale cosmic canvas, which makes even a visit from your relatives into an epic drama. You've got your friends, but they live in the future. That's all. My friends live on the other side of LA—that's as much as the 31st century if there's a traffic jam. So I came to feel that the key to Superman stories was to just tell domestic stories about human emotions, but written on this giant canvas that made them mythic. Because that's how we feel inside—everything's mythic. You break up with your lover and it's an agonizing destruction of a romance. It's *Romeo and Juliet.* That's how it feels inside.

So it's about making the internal external?
Yeah, exactly. That's how I felt. Superman works best as a symbolic or an allegorical character, and it fails utterly when you try to pretend that something like that could *ever* live in this world.

Grant Morrison

> **One of the most striking things about *All-Star Superman* is how you appear to have digested everything that's ever been done with the character, and yet not simply regurgitated it but found a way to make something different.**
> I try to absorb everything. I read everyone's work and I do love everything. But through it all there's a kind of core. I thought, *Well, there's a Superman layer. There's a little bit of a layer. There's a bigger bit of a layer...*It was just like, *Well, I'll play that standard to make it sound like I just discovered the electric guitar and acid.*

94 *It's Superman!*

What if Clark Kent came of age in the real Kansas of the 1930s? What if he fought crime as Superman in the real-world equivalent of Metropolis, aka New York City? And what if Lex Luthor was a corrupt businessman and Lois Lane an ambitious young journalism student during the decade of the Great Depression? These questions form the basis of author Tom DeHaven's novel *It's Superman!*

First published by Chronicle Books on September 15, 2005, *It's Superman!* takes the Man of Steel into the medium of prestige literature, and foregoes many of the action-adventure tropes of the superhero genre in favor of a human drama focusing on a Clark Kent as full of self-doubt as any man who grew up on a farm and moved to the big city. Along the way, Clark gets a job in Hollywood, where he finds a red-and-blue costume from an unproduced science fiction movie and, unaware of his Kryptonian heritage, first takes to the skies. Upon arriving in New York, he meets Luthor, a city councilman as smooth as Clark is coarse, and as twisted as Superman is conscientious. Superman defeats Luthor's

mechanical "Lexbot," and Clark gets a job at the *Daily Planet* alongside Lois, who inspires him to continue his crusade against evil. Though Luthor escapes, he's responsible for an upgrade to Superman's costume in the form of a familiar red-and-yellow chest emblem.

By making *It's Superman!* a period piece, set in one of America's harshest periods, DeHaven (who also penned the excellent 2010 retrospective *Our Hero: Superman on Earth*) is able to ground his tale and give us a flawed, all-too-human human Superman like few others. All the while, he remains true to the character's roots as a social reformer and a champion of justice.

95 The Five Greatest Superman Pastiches

Like any pop culture icon, DC's Man of Steel has inspired numerous imitators, from various publishers. Here are five of the most noteworthy.

Hyperion

Created by writer Roy Thomas and penciller Sal Buscema, Hyperion first appeared in Marvel's *Avengers* #69 (October 1969) as a member of the Squadron Sinister, a team of villains analogous to the Justice League, assembled for the purpose of defeating Earth's Mightiest Heroes. A benevolent Hyperion was later introduced by Thomas and penciller John Buscema in *Avengers* #85 (February 1971). A member of the Squadron Supreme, the Squadron Sinister of a parallel universe, this Hyperion's alter ego operated under the suitably alliterative name Mark Milton.

Gladiator

A member of the Shi'ar Empire's Imperial Guard, Gladiator was introduced in Marvel's *Uncanny X-Men* #107 (October 1977), written by Chris Claremont and pencilled by Dave Cockrum. Like all the members of the Imperial Guard, Gladiator is based on a member of the Legion of Super-Heroes, in his case Superboy. His name is a tribute to the titular character in Philip Wylie's classic science fiction novel *Gladiator*, a major influence on Superman creators Jerry Siegel and Joe Shuster. The character's real name is Kallark (a fusion of Kal-El and Clark Kent).

David Brinkley

Robert Mayer's satirical novel *Superfolks* (Dial Press, 1977) has influenced comic book writers from Grant Morrison to Kurt Busiek, and prefigures *Watchmen* and *The Incredibles* in its depiction of a world in which superheroes are forced out of existence. Its protagonist is David Brinkley. And though his superhero name is never quite stated, he's clearly a stand-in for Superman, with powers like gamma ray vision and a vulnerability to Cronkite (since he comes to Earth from the planet Cronk).

Supreme

While Supreme—introduced in Image's *Youngblood* #3 (October 1992)—began as a simple riff on the Man of Steel by writer-artist Rob Liefeld, the character reached his full potential under Alan Moore as a means of exploring the Silver Age Superman's universe; similarly to how the writer's earlier take on *Marvelman* (titled *Miracleman* in the US) had examined the Captain Marvel legend.

Samaritan

News magazine fact-checker Asa Martin and his superheroic alter ego were created by writer Kurt Busiek and artists Alex Ross and Brent Anderson for *Astro City* #1 (published by Image in August

1995). The most famous champion of his world, Samaritan, unlike Superman, does not hail from a distant planet, but rather the 35th century. Sent back in time to prevent the Space Shuttle *Challenger's* destruction, he changes history and rewrites himself out of his own time, forcing him to live in our present.

96 Tour Geppi's Entertainment Museum

If you're a fan of comic books or superheroes, there's no better museum on the East Coast to visit than Geppi's Entertainment Museum.

Located in Baltimore, Maryland, at the city's famed Camden Yards (home of the Baltimore Orioles), Geppi's Entertainment Museum can be found on the second floor of the red-brick building at 301 W. Camden Street, directly above the Sports Legends Museum. Since the museum is devoted to pop culture in all forms of media—movies, TV, comics, toys, posters, games—the Man of Steel is featured prominently in its collection of 60,000 artifacts, most of which come from the collection of owner Stephen A. Geppi (the president and CEO of Diamond Comics Distributors).

The museum's love of Superman is evident from the moment one walks down its central hallway; at both ends are full-size statues of the Last Son of Krypton—one in flight, the other with both feet on the ground, fists raised, ready for action.

In the museum's largest gallery—"A Story in Four Colors"— you'll find, under glass, a mint copy of the most coveted comic book of all time: *Action Comics* #1, with Superman's first appearance. Many other landmark comics can be found here, including

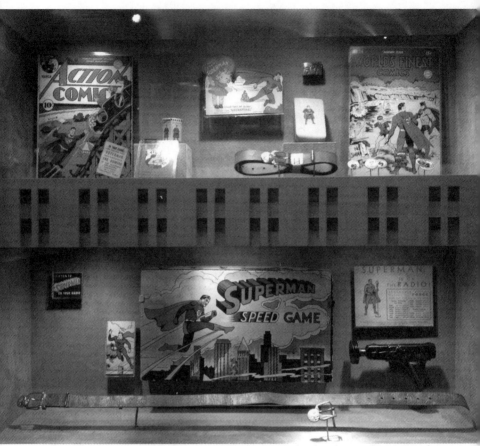

Geppi's Entertainment Museum in Baltimore, Maryland, is home to a variety of Superman-related artifacts.

the first-ever Batman comic book, *Detective Comics* #27, while video displays chronicle the entire history of the medium.

A neighboring gallery—"When Heroes Unite"—contains a large, illuminated replica of the *Daily Planet*, displaying additional Superman comics, and much-sought-after collectibles like the 1940 Daisy Superman Krypto Raygun. The walls here are adorned with vintage Superman advertisements, while another display case showcases antique Superman board games, gliders, pennants, and puzzles. Captain Marvel, Batman, and the other members of the

Justice League are given their due as well, as are pop icons like James Bond, Mickey Mouse, and the Beatles.

In other galleries, one can find original Superman comic art and the original posters for Superman movies and numerous other films. A variety of temporary exhibitions are hosted throughout the year, spotlighting a diverse assortment of nerd-friendly themes. When you visit, be sure to check out the museum store—Geppi's Comic World—which always offers 30 percent off all DC and Marvel trade paperbacks. For more information, visit www.geppismuseum.com.

97 Superman Lives

The years that followed 1987's *Superman IV: The Quest for Peace* saw more than one attempt to get a movie about the Man of Steel into theaters. But none are as infamous or intriguing as *Superman Lives*.

The brainchild of *Batman* producer Jon Peters, *Superman Lives* came about when Warner Brothers, inspired by the success of the "Death of Superman" comic book storyline, bought the film rights to the character from *Superman* movie producers Alexander and Ilya Salkind in 1993. Peters' first choice of screenwriter, *The Devil's Advocate*'s Jonathan Lemkin, was asked to script a film in the vein of Joel Schumacher's *Batman Forever*. The result (featuring "Death of Superman" villain Doomsday and dubbed *Superman Reborn*) was rejected, and Gregory Poirier (who scripted *Rosewood* for Peters) was brought in for a rewrite. Poirier's script featured longtime Superman foe Brainiac. But it too was rejected, and fan-favorite writer-director Kevin Smith was recruited.

According to Smith, Peters insisted that Superman not fly in the film—now titled *Superman Lives*—and that he battle a giant spider in its climax. But such ideas were abandoned when Tim Burton joined the project as director. Burton assigned Wesley Strick (a script doctor on Burton's *Batman Returns*) to rewrite Smith's work, and lifelong comic book fan Nicolas Cage signed on to play the Man of Steel. Unnerved by what it would cost to produce Strick's screenplay, which saw Brainiac and Lex Luthor fuse into one malevolent entity (similar to their union in Alan Moore's comic book story "Whatever Happened to the Man of Tomorrow?"), Warner Brothers recruited Dan Gilroy to rewrite. Finally, after almost a year of pre-production, the studio postponed the film and lost Burton.

Other directors were reportedly approached, including Michael Bay and Martin Campbell. Eventually Cage left the project, and Will Smith was approached to play Superman, though he declined. New scripts were written, including J.J. Abrams' *Superman: Flyby* (to be directed by McG or Brett Ratner) and Andrew Kevin Walker's *Batman vs. Superman* (to be helmed by Wolfgang Petersen). Eventually Warner Brothers settled on Bryan Singer to direct what became *Superman Returns*. A documentary exploring the film that could have been, titled *The Death of "Superman Lives": What Happened?*, was partially funded by a Kickstarter campaign and released in 2015.

98 "The Living Legends of Superman!"

There's nothing the American comic book industry loves more than an anniversary, and with more than 75 years of history under his yellow (or gold) belt, Superman has given DC Comics plenty of opportunity for celebration. The Man of Steel has enjoyed memorable anniversary stories from *Action Comics* #300's last-man-on-Earth tale "Superman Under the Red Sun!" (by writer Edmond Hamilton and penciller Al Plastino) to #500's "The Life Story of Superman!" (by E. Nelson Bridwell and Curt Swan). But the finest of them all can be found in October 1984's *Superman* #400.

This landmark issue consists of a book-length series of vignettes written by Elliot S. Maggin and illustrated by some of comics' greatest artists, collectively titled "The Living Legends of Superman!" Each vignette focuses on Superman's legacy as it changes in the distant future, from the year 2199 to a point more than 7 million years hence. Al Williamson, Frank Miller, Marshall Rogers, Wendy Pini, Michael Kaluta, and Klaus Janson all turn in sterling work, capped by Jim Steranko's bravura 10-page "The Exile at the Edge of Eternity," about the last man in the universe, A'dam'mkent. The issue is topped off with pin-up pages by the likes of Jack Kirby, Steve Ditko, Will Eisner, John Byrne, Walt Simonson, Brian Bolland, Bernie Wrightson, and Moebius.

Superman #400 has never been reprinted in its entirety. So if you see a copy at your local comic book stores, be sure to snatch it up. You might not see it again.

99 Fly with Superman

Want to soar with the Man of Tomorrow? You can—at Six Flags theme parks. Here's a handy guide to US rides celebrating Superman.

Superman: Escape from Krypton (Formerly Superman: The Escape)

Located at Six Flags Magic Mountain in Valencia, California, just north of Los Angeles, Escape from Krypton (Superman: The Escape from 1997 until 2010) is, at 415 feet, the third-tallest steel roller coaster in the world. Its 328-foot drop is the third largest for a steel roller coaster. It's also the fifth fastest, with a top speed of 100 miles per hour. Best of all, guests pass through the Fortress of Solitude on their way to the ride. Fans of Superman's archenemy take note—Escape from Krypton is connected to the Lex Luthor: Drop of Doom drop tower.

Superman: Krypton Coaster

Located at Six Flags Fiesta Texas in San Antonio, the floorless Krypton Coaster has the second-tallest vertical loop in the world, at 145 feet, a top speed of 70 miles per hour, and six inversions. It opened in 2000.

Superman: Ultimate Flight

A part of Six Flags Discovery Kingdom in Vallejo, California, Superman: Ultimate Flight, which opened in 2012, has the fifth-tallest roller coaster inversion in the world. Composer John Williams' "Superman March" is played outside the entrance to the ride. Other versions of Ultimate Flight, in which riders face

the ground and thus experience the sensations of soaring like Superman, can be found in Six Flags Over Georgia (located near Austell), Six Flags Great Adventure (in Jackson, New Jersey), and Six Flags Great America (in Gurnee, Illinois).

Superman—Ride of Steel

Since 2000, the Ride of Steel has hurled visitors to Six Flags America (in Upper Marlboro, Maryland) 208 feet into the air. It's based on an identical Ride of Steel at Darien Lake theme park (in Darien, New York).

Superman: Tower of Power

The Tower of Power is, as its name suggests, a drop tower. It's located at Six Flags St. Louis (227 feet tall) and Six Flags Over Texas (in Arlington, where it's 325 feet tall). In 2016, it will open at Six Flags Over Georgia, where it will be 65 feet tall, as a part of the park's kid-friendly DC Super Friends area.

Bizarro

Six Flags New England (in Agawam, Massachusetts) altered its Ride of Steel (a five-time winner of *Amusement Today*'s Golden Ticket Award for Best Steel Coaster) to pay tribute to Superman's imperfect duplicate in 2009. Another retheme is expected in 2016, when it becomes Superman: The Ride. A floorless version of Bizarro (a reworking of Medusa, the world's first floorless coaster) opened in 2009 at Six Flags Great Adventure in Jackson Township, New Jersey.

100 *Batman v Superman: Dawn of Justice*

A direct sequel to *Man of Steel*, Warner Brothers' 2013 reboot of its Superman film franchise, *Batman v Superman: Dawn of Justice* marks several screen firsts.

As odd as it sounds, the Dark Knight and the Last Son of Krypton have never before appeared together in a major motion picture. But *Dawn of Justice* sees the two icons—played by Ben Affleck and Henry Cavill, respectively—going *mano a mano* in scenes inspired by the best-known Batman-Superman smackdown of them all: writer-penciller Frank Miller's 1986 miniseries *The Dark Knight Returns*. Following the events of *Man of Steel*, in which Superman's battle with General Zod leveled a good chunk of Metropolis, there's been an outcry, and a growing distrust for Earth's new champion. It's an uproar that's exploited by the young Lex Luthor (played by Jesse Eisenberg), and it finds Gotham City's guardian setting out to rein in Superman.

Dawn of Justice—which, like *Man of Steel*, is directed by Zack Snyder and co-written by David Goyer—also sees the big-screen debut of Wonder Woman, the third member of DC's "Trinity." As played by Israeli actress Gal Gadot (who reprises her role in the character's first solo film, 2017's *Wonder Woman*), the Amazonian princess finds herself at the center of the film's conflict; and, with Batman and Superman, goes on to form the fabled Justice League.

Two other members of DC's premier superteam also make their live-action film debut in *Batman v Superman: Dawn of Justice*: Victor Stone (aka Cyborg, played by Ray Fisher) and Arthur Curry (better known as Aquaman, played by *Game of Thrones*' Jason Momoa). Additional newcomers include Jeremy Irons (as Alfred Pennyworth), Tao Okamoto (as Luthor's assistant Mercy Graves, in

the character's live-action debut), Holly Hunter (as a US senator), and Jeffrey Dean Morgan (as the late Thomas Wayne). Rounding out the cast are the returning Amy Adams (as Lois Lane), Laurence Fishburne (as Perry White), Diane Lane (as Martha Kent), and Michael Shannon (as Zod).

With a budget of well over $200 million, *Dawn of Justice*'s take on Batman, Superman, and Wonder Woman received some early criticism. ("It looks like three goths hanging out in a candle store," said comedian Patton Oswalt on *Screen Junkies* of its promotional images.) But, like *Man of Steel*, it carries Warner Brothers' hopes for a DC Extended Universe to rival that of the Marvel Cinematic Universe, and leads directly into 2016's *Suicide Squad* and 2017's *Wonder Woman* and *Justice League Part One*.

Acknowledgements

This book would not exist without the Kryptonian support, encouragement, guidance, and patience of Triumph Books' managing editor Adam Motin, and author and Nerdist Industries' senior editor Dan Casey.

Of course, the usual suspects are also to blame: Ed Burns, Patrick Killoran, Rich Rissmiller, David Angwin, Eric Cheung, Jeremy Meyer, Rebecca Compton, Matthew Budman, Cristina Beltran, Darrell Schweitzer, Jon B. Cooke, Yvonne Jones, Jeff Victor, Jami Philbrick, Tony Liberatore, James White, Silas Lesnick, Adam Sorensen, Jennifer Heddle, Jayne Nelson, Eik Kahng, Joakim Tan, Charlotte Martyn, Brian Walton, Sandy and Tony Darin, Mark and Carol Wheatley, Marc Hempel, Mark Buckingham, Dave Stannard, and Irma Page.

Additional thanks to the graduate students and friends of the Art History Department of the University of California, Santa Barbara. Especially Laura DiZerega, Ana Mitrovici, Justin Carey, Marta Faust, Alex and Jason Schultz, Thomas DePasquale, Teresiana Matarrese, and Robert Williams.

And to my family: Joan Marie McCabe (née Maguire) and Joseph Francis McCabe; and Jeanne, Jim, and John McCabe; as well as the entire Quach family.

I'm fortunate enough to have two work families. In the UK, Future Publishing's Dave Bradley, Rich Edwards, Nick Setchfield, Ian Berriman, Ade Hill, Russell Lewin, Jonathan Coates, Catherine Kirkpatrick, Will Salmon, Jane Crowther, Matt Maytum, Matthew Leyland, Jordan Farley, and Rosie Fletcher (Britain's own Lois Lane). In the US, Nerdist Industries' Rachel Heine, Alicia Lutes, Malik Forte, Matthew Grosinger, Michelle Buchman, Kyle Hill, and Kyle Anderson.

My deepest thanks to everyone I interviewed for this book, especially Mark Waid, who also penned a foreword befitting the world's first and greatest superhero.

Finally, eternal gratitude to Superman's creators, Jerry Siegel and Joe Shuster. Two teenagers from Cleveland, Ohio, who gave America a mythology of its own, and the whole world a friend.

Bibliography

Beauchamp, Monte (Author) and Heshka, Ryan (Illustrator). "Jerry Siegel and Joe Shuster." In *Masterful Marks: Cartoonists Who Changed the World*. 23-30. New York: Simon & Schuster, 2014.

Bond, Gwenda. *Lois Lane: Fallout*. North Mankato, MN: Switch Press, 2015.

Bridwell, E. Nelson, intro. *Superman from the 30's to the 70's*. New York: Bonanza Books, 1971.

Busiek, Kurt (Author) and Immonen, Stuart (Illustrator). *Superman: Secret Identity*. New York: DC Comics, 2013.

Byrne, John. *Superman: The Man of Steel*. New York: DC Comics, 1987.

Byrne, John (Author) and Mignola, Mike (Illustrator). *Superman: The World of Krypton*. New York: DC Comics, 2008.

Carlin, Mike, ed., et al. *Superman in the Fifties*. New York: DC Comics, 2002.

Chase, Bobbie, ed. *Lois Lane: A Celebration of 75 Years*. New York: DC Comics, 2013.

Chase, Bobbie, ed. *Superman: A Celebration of 75 Years*. New York: DC Comics, 2013.

Chase, Bobbie, ed. *Superman Vs. Darkseid*. New York: DC Comics, May 2015.

Conway, Gerry, et al (Author). and Various (Illustrator). *The Marvel/DC Collection: Crossover Classics, Volume 1*. New York: Marvel Comics, 1997.

Daniels, Les. *Superman: The Complete History: The Life and Times of the Man of Steel*. San Francisco: Chronicle Books, 1998.

_____. *DC Comics: Sixty Years of the World's Favorite Comic Book Heroes*. New York: Bulfinch, 1995.

De Haven, Tom. *Our Hero: Superman on Earth (Icons of America)*. New Haven: Yale University Press, 2010.

_____. *It's Superman!*. San Francisco: Chronicle Books, 2005.

DiDio, Dan, ed. *Superman: The Amazing Transformations of Jimmy Olsen*. New York: DC Comics, 2007.

DiDio, Dan, ed. *Superman: Bottle City of Kandor*. New York: DC Comics, 2007.

DiDio, Dan, ed. *Superman: The Man of Tomorrow Archives, Volume 1*. New York: DC Comics, 2005.

_____. *Superman: The Man of Tomorrow Archives, Volume 2*. New York: DC Comics, 2006.

Dini, Paul (Author) and Ross, Alex (Illustrator). *Superman: Peace on Earth*. New York: DC Comics, 1998.

Engle, Gary D. and Dooley, Dennis, ed. *Superman at Fifty!: The Persistence of a Legend*. New York: Macmillan Pub Co., 1988.

Eury, Michael, ed. *The Krypton Companion*. Raleigh, NC: TwoMorrows Publishing, 2006.

Fleischer, Michael. *The Great Superman Book*. New York: Warner Books, 1978.

García-López, José Luis (Illustrator). *Adventures of Superman: José Luis García-López*. New York: DC Comics, 2013.

Gerber, Steve (Author) and Colan, Gene and Vietch, Rick (Illustrator). *Superman: Phantom Zone*. New York: DC Comics, 2013.

Gibbons, Dave (Author) and Rude, Steve (Illustrator). *Superman/Batman: World's Finest*. New York: DC Comics, 2012.

Giordano, Dick, ed. *Legion of Super-Heroes Archives, Volume 1*. New York: DC Comics, 1997.

Gold, Mike, and Bob Kahan, ed. *The Greatest Superman Stories Ever Told*. New York: DC Comics, 1986.

Greenberger, Robert, ed. *Superman in the Forties*. New York: DC Comics, 2005.

Grossman, Gary. *Superman: Serial to Cereal.* New York: Popular Library, 1977.

Jones, Gerard. *Men of Tomorrow: Geeks, Gangsters, and the Birth of the Comic Book.* New York: Basic Books, 2004.

Jurgens, Dan, et al (Illustrator). *The Death of Superman.* DC Comics, 1993.

_____. *The Return of Superman.* New York: DC Comics, 1993.

_____. *World Without a Superman.* New York: DC Comics, 1993.

Kane, Gil (Illustrator). *Adventures of Superman: Gil Kane.* New York: DC Comics, 2013.

Kirby, Jack. *Jimmy Olsen: Adventures, Volume 1.* New York: DC Comics, 2003.

_____. *Jimmy Olsen: Adventures, Volume 2.* New York: DC Comics, 2004.

Loeb, Jeph (Author) and Sale, Tim (Illustrator). *Superman For All Seasons: The Deluxe Edition.* New York: DC Comics, 2014.

Maggin, Elliot (Author) and Various (Illustrator). *Superman #400,* New York: DC Comics, 1984.

Moore, Alan (Author) and Swan, Curt (Illustrator). *Superman: Whatever Happened to the Man of Tomorrow?* New York: DC Comics, 2010.

Morrison, Grant (Author) and Quitely, Frank (Illustrator). *All-Star Superman, Volume 1.* New York: DC Comics, 2008.

_____. *All-Star Superman, Volume 2.* New York: DC Comics, 2010.

O'Neil, Denny (Author) and Swan, Curt (Illustrator). *Superman: Kryptonite Nevermore.* New York: DC Comics, 2009.

O'Neil, Denny (Author) and Adams, Neal (Illustrator). *Superman vs. Muhammad Ali.* New York: DC Comics, 1978.

Peterson, Jonathan, ed. *Superman in the Eighties.* New York: DC Comics, 2006.

Reeve, Christopher. *Still Me.* New York: Ballantine Books, 1999.

Ricca, Brad. *Super Boys: The Amazing Adventures of Jerry Siegel and Joe Shuster—The Creators of Superman*. New York: St. Martin's Press, 2013.

Siegel, Jerry (Author) and Shuster, Joe (Illustrator). *Superman Archives, Volume 1*. New York: DC Comics, 1997.

Sutton, Laurie S., ed. *The Great Superman Comic Book Collection*. New York: DC Comics, 1981.

Swan, Curt, et al (Illustrator). *Superman: Tales from the Phantom Zone*. New York: DC Comics, 2009.

Waid, Mark (Author) and Ross, Alex (Illustrator). *Kingdom Come*. New York: DC Comics, 2008.

Waid, Mark (Author) and Yu, Leinil Francis (Illustrator). *Superman: Birthright*. New York: DC Comics, 2005.

Wolfman, Marv (Author) and Perez, George (Illustrator). *Crisis on Infinite Earths*. New York: DC Comics, 2001.

Wright, Michael, ed. *Superman in the Sixties*. New York: DC Comics, 1999.

_____. *Superman in the Seventies*. New York: DC Comics, 2000.

www.dc.wikia.com/wiki/DC_Comics_Database

www.comicvine.com/

www.supermanhomepage.com/news.php